HIST

OVE ZE

OVERSIZE

IN

HIST

"I see no end to travelling"

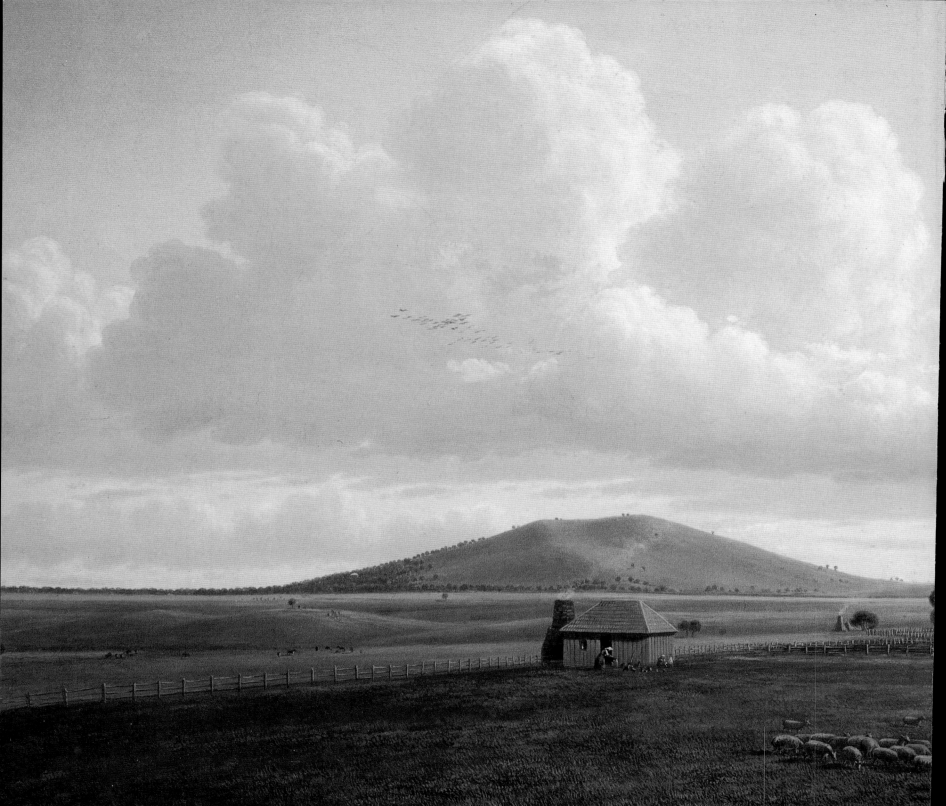

"I see no end to travelling"

> no Country can possibly have a more
> interesting aspect; so much so that, if a further
> trace into the interior is required at a future
> period, I respectfully beg leave to offer myself for
> the Service. I see no end to travelling. . . .
>
> from G. W. Evans' report to
> Governor Macquarie, 2 June 1815

Journals of Australian Explorers 1813–76

ANN MILLAR

Bay Books
Sydney & London

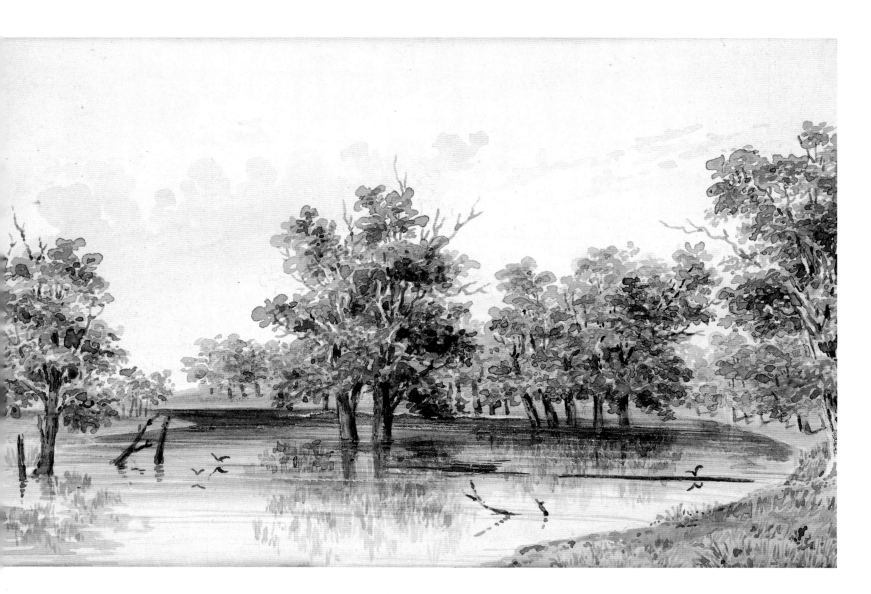

First published by Bay Books
Pty Ltd
61–69 Anzac Parade,
Kensington NSW 2033

Publisher: George Barber

Copyright © Bay Books

National Library of Australia
Card number and ISBN 0 85835 813 1

Picture research by Ann Millar
Typeset in Weiss by Savage Type Pty.
Ltd. Brisbane
Printed in Hong Kong by Toppan
Printing Co.

(previous page) This oil painting by Eugen von Guérard of a homestead near Camperdown exemplifies the prosperity of the landowners of the western district of Victoria — Mitchell's 'Australia Felix'.

(above) 'The Anabranch of the Darling' — painted by Gill after a Sturt sketch. The same image also appears as an illustration in Sturt's journal.

(opposite) 'The Merri Creek' by an unknown artist. It was at Merri Creek that John Batman is believed to have bargained with the Aboriginals for the land on which Melbourne now stands.

Contents

Foreword

The history of Australian exploration is a complex and fascinating one. It has been told in many different ways. This book, however, allows the explorers themselves to tell that story using extracts from their journals.

The book begins with the expedition led by Blaxland, Lawson and Wentworth, an expedition that changed the nature of Australian exploration and opened up the continent for a nascent pastoral industry. It concludes with the expeditions led by Giles and with them, the end of learned theories and fanciful notions of what the continent might hold. The process took less than 80 years.

Mainland settlement had been restricted to the Cumberland Plain and coastal river valleys of New South Wales until 1813 when Blaxland, Lawson and Wentworth pioneered a path across the watershed. Evans made the first crossing of the range in the same year.

Government began to take a more active interest in exploration, a change which reflected, in part, the Government's cautious desire to be well-informed of the nature of this new hinterland. The extracts printed in this book also reveal an underlying theme — the search for new pastures for a growing pastoral industry.

During the next two decades, the search for new grazing lands became dominant. Cunningham reached the Darling Downs, Hume and Hovell explored the country from Lake George to Port Phillip Bay and Mitchell 'discovered' Australia Felix. Sturt's expedition down the Murray system, which cast doubt on the existence of an inland sea, was one of the few undertaken for primarily scientific reasons. Eyre, with his expeditions of 1839 and 1840–41, was the first to suggest an inland desert and subsequent expeditions proved him to be correct. After the 1850s the search for mineral wealth also became a feature of Australian exploration.

The decades from the late 1830s are filled with images of incredible suffering and hardship, of a harsh environment, of tragedy, death and mystery. The most enduring mystery remains the disappearance of Leichhardt in 1848. As late as the 1970s expeditions were mounted to find his remains and his fate remains a subject of speculation.

Finally, and perhaps most dramatically, the decades following the 1830s are remembered for the attempts to cross the continent from the south to the north: the tragic story of Burke and Wills is well known. Stuart was the first to complete the crossing without mishap in 1862.

The journal extracts chosen for this book illustrate many of the facets of exploration in Australia. The hardships suffered are, for example, shown in the Eyre extracts. The personalities of the men are revealed in the way they kept their diaries, from the careful recorder to the slipshod entries of Burke. The changing perceptions of the Australian landscapes are seen when entries written by Sturt and Forrest are set side by side.

The motivations of the explorers themselves were varied. For some it was a job they had been ordered to do. Evans, with his careful surveys and constant directions from Macquarie is a good example. Others, like Sturt and Leichhardt, were spurred on by curiosity. Eyre and Sturt are examples of those who felt a sense of mission or fate directing them to exploration. The influence of the Romantic movement, with its emphasis on wilderness and the testing of the individual in a harsh environment, can also be seen in many of the extracts. For many though, the motivation was a mixture of adventure, fame, social standing and economic gain, and professional jealousy occasionally played a part.

The extracts in this book present, in brief, the history of Australian exploration. It is a fascinating story, well worth the telling.

John McQuilton

University of New South Wales

Preface

This is a book of extracts from the journals of the major Australian explorers between the years 1813 and 1876. My aim has been to let the original text speak for itself as much as possible, the purpose of the insertions being to link passages where material has been omitted. Modern place names have also been included to enable the reader to understand where the explorers were at various times — a point which is often a problem when reading the original books.

The journals were edited and extended and sometimes embellished before publication, either by the explorer himself or by someone else. Some are written in a literary style, rather than that of a diarist, but with long rambling, unindented passages. For the purposes of this book some paragraphs have been rearranged.

Occasionally, in order to preserve the explorers' own words, only one sentence may have been taken from a page before moving on further in the original journal. All omitted material is shown by the use of four ellipsis points; when material has been omitted within a sentence three only have been used. Original spelling, punctuation and capitalisation have been retained, and any interpolations within the extracts are indicated by the use of square brackets.

Original field books have not been used. The extracts have been taken from the published versions of the journals and these are available for reading at the National Library of Australia and at most State libraries. Some of those reproduced in facsimile form may be bought in bookshops.

By present standards of writing the journals frequently seem long-winded and their pages visually monotonous. It is often difficult to differentiate quickly between a major change of course or a minor sortie. It is easy to be overwhelmed by a mass of minor detail. The explorer himself could not always be fully aware of the importance of some of his discoveries. In attempting to make these extracts more intelligible and interesting, headings and sub-headings, which do not appear in the original texts have been added.

Ann Millar
Canberra

Acknowledgements

This book, like so many others on Australian shelves, owes its inception entirely to an idea of Bruce Semler's, who also guided its early stages. I am grateful to him.

My thanks are due also to the staffs of the Petherick and Pictorial Rooms at the National Library of Australia for their willing assistance on many occasions. In particular I would like to mention Margaret Brennan whose patience in meeting my constant demands over many months it would be impossible to surpass.

I would like to gratefully acknowledge the interest, encouragement and friendship of the members of the Petherick Club, some of whom have been kind enough to read portions of the manuscript and to offer advice from their wells of wisdom. Perhaps the others will forgive me if I mention one name only, that of Bill Talberg.

My long-suffering family deserve some praise. They have been unfailingly supportive, despite the fact that they were frequently obliged to have their evening meal accompanied by stories of hunger and thirst, and, in imagination, to tread weary miles in the cause of Australian exploration.

Introduction

The need for more land to enable colonists and their stock to escape the confinement of the coastal settlement near Sydney had become, by 1810, a matter of some urgency. Since 1793, all efforts to penetrate the ranges to the west had failed. But the drive for new pastures prompted three young entrepreneurs, Gregory Blaxland, William Lawson and William Charles Wentworth, to make another attempt to cross the Blue Mountains in 1813. Their achievement may seem less significant in an age when even space exploration is taken somewhat for granted; but the same thrust of curiosity urges man over mountain ranges, down unknown rivers and into waterless deserts, as beyond earth itself. Motivation may have stemmed from economic considerations, a desire for personal achievement, or love of Empire, but above all it was curiosity which turned pastoralists and surveyors, overlanders and travellers, botanists and geologists into explorers. Gradually they penetrated further inland until, by 1876, the general geography of the Australian continent was comprehended.

This book sets out to tell the history of Australian exploration through the words of the men who unravelled the mysteries of a vast and, for the greater part, dry land. Their stories have been told many times in Australian historical writing, but in the retelling several vital elements often seem to have been lost: the personalities of the explorers, which can be at least partially understood through their own accounts; the mood of the time expressed by language and attitudes of mind; and finally, the reader's feeling of being close to the events as they are related on a day-by-day basis. The aim has been, therefore, to select passages which will keep the narrative of each journey moving forward, omitting minor digressions, repetitions and much of the more detailed geographical description but including personal details. These last, while sometimes apparently trivial, reveal something of the explorer's personality and of the time in which he lived.

The keeping of field-books was a most essential aspect of the explorer's duties, for without a meticulous record of what he and his party had achieved and observed, the journey was practically valueless. Maps had to be drawn—or improved—and careful descriptions made of geographical features, of water supplies, of Aboriginal populations and their habits, of flora and fauna, and, above all, of the potential pastures for Australia's expanding flocks and herds. Robert O'Hara Burke failed utterly in this regard (as well, unfortunately, as in most others), for he kept no proper account of his daring dash to the Gulf of Carpentaria—only brief notes which were of slight subsequent usefulness.

The explorers' accounts were not only of immense practical value to the Imperial and colonial governments and to the pioneer settlers who followed in their tracks, but were also of considerable interest to the reading public in England (as well as in Australia), always keen to hear of the exploits of those in remote regions of the British Empire. For the explorers this was a fortunate by-product of adventure, rather akin to the instant biography or autobiography indulged in by many public figures of today. There was a market and it was sensible to tap it. The journals, therefore, frequently appeared in print soon after the return of the expeditions, although often with embellishments of style and language. Sometimes they included additional material such as Eyre's valuable account of the Aboriginals and their customs, and engravers enhanced (and thereby often destroyed) the authenticity of the original simple drawings; Sturt, Grey and especially Mitchell all drew well. Today, when verbal precision is more highly regarded than flowery phrases, it is hard not to feel that some of the accounts are unnecessarily wordy and at times quaintly tedious, but this old-fashioned, leisurely pace is also their charm.

Some journals, of course, were simple straightforward accounts of achievement and the exploit should be appreciated for its own value regardless of the explorer's literary prowess. Blaxland's journal, published nearly ten years after the event, has the tenor of the practical jottings of a farmer. The

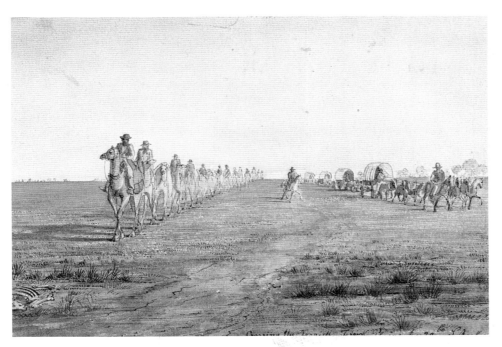

The Burke and Wills convoy a few days after leaving Melbourne as it appeared to Ludwig Becker, the naturalist and artist on the expedition.

excitement in the story stems from our knowledge of what it was to mean in the future when the famous trio found themselves looking over what Evans would soon name the Bathurst Plains. Evans himself reported directly to Governor Macquarie; the unadorned accounts of his important findings, published much later in *Historical Records of Australia,* read with freshness and authenticity. Hovell's diary (edited by William Bland) is no less readable for being a simple statement of events and includes appealing passages which indicate an appreciation of the sights and sounds of the bush. Hume and Hovell were the first to find an overland route between New South Wales and Port Phillip and perhaps were feeling homesick when they noted that 'the "bell birds" are "ringing merrily," a treat hitherto unusual, this being only the second time that they have met with this delightful bird since their departure from the Cowpasture'.

The journals reveal much about the explorers, both directly and indirectly. Many were surveyors — an almost indispensable qualification. Had either Hume or Hovell been trained in surveying, their mistake in assuming Port Phillip Bay to be Westernport may not have occurred. An understanding of Australian bushcraft would eventually become as useful as any professional training for the task of exploring, but in an alien environment this body of knowledge could only be acquired gradually. The expeditions led by military men such as Sturt, Mitchell and Warburton were orderly and disciplined which contributed largely to their success. The botanist Allan Cunningham brought to discovery the same careful and thorough attitude of mind which he displayed in collecting specimens of Australian plants. Eyre and Sturt were both drovers and landowners — occupations which tied in with exploring.

The unyielding tenacity of the hard-working, competent Scotsman is seen in John McDouall Stuart, who took one carefully calculated sally after another until he reached the centre of the continent and subsequently succeeded in the south–north crossing. He provides an interesting contrast with the impetuous Burke. Warburton tells of his terrible crossing into Western Australia in such a way that one ends up feeling not only thirsty, but debilitated. Giles, who had lived in Australia since boyhood, embodied the attitudes of the self-taught man of the bush, a wit, something of a 'Furphy' character who uses the exaggerated language of the aspiring colonial, quoting apt or inapt lines from the poets. Generally, the journals indicate warm friendship and mutual respect for brother explorers, who were, after all, a small band of men in an environmentally hostile land, although the much commented on jealousy between Sturt and Mitchell surfaces occasionally in the writings of both men.

This lithograph by Eugen von Guérard shows how rivers were crossed when neither boat nor bridge was available.

Although Leichhardt was German and Strzelecki a Pole, most of the explorers were Englishmen. Their observations were not only those of the incredulous European treading paths hitherto unknown to any but the original inhabitants, but often of the nature-lover from a small green island. They were accustomed to noting details of plant and animal life, to appreciating beauty, to taking time for contemplation.

The explorers of the first half of the nineteenth century, like the early artists, saw Australia through English eyes. They transferred their English attitudes, vision and language to an alien environment. Thus to Grey, Dirk Hartog's Island looked 'exactly like a Scottish Heath'. But by the middle of the century an Australian consciousness was developing. The bush began to look more familiar, one part of it not so different from another. In any case, the practical, hard-working man was too occupied in taming a harsh land and building a new society to have much time for the niceties of elegant language. The Forrests and the Gregorys belong to this later group. They were highly competent explorers but they make less interesting reading. They were now looking with 'Australian' eyes; they saw the country with unimpeded vision. They did not love it less because their approach was more realistic or their language less romantic or stylish than their more English-oriented and adventure-loving predecessors. Indeed, Forrest speaks of 'vast and wonderful Australia'.

Unlike Africa or Asia or the Americas, or even New Zealand, there was a lack of variation in the Australian landscape and in the customs of its indigenous people, which may at times account for some rather over-generous descriptive passages. Despite the fact that there are approximately 550 species of eucalypts, to the untutored eye one gum tree may look much the same as another. Oxley, in crossing the dense precipitous ridges of the Great Divide to Port Macquarie, refers to what he called 'Bathurst Falls' as a 'wonderful natural sublimity . . . scarcely to be exceeded in any part of the eastern world'. Was his journey so hard and monotonous that this modest cascade took on a disproportionate significance in his mind—or was he letting himself go in order to brighten up a tedious tale for his English public?

What did the bush look like in the early nineteenth century? The only visual records are colonial paintings and drawings, few of which have, to our eyes, an 'Australian' look. Settlement often followed hard on the heels of discovery and within as little as ten years the character of the bush must have altered dramatically. The Aboriginal people, even in the desert, used 'fire-stick farming' which encouraged fresh young feed and kept down the undergrowth. As settlement intruded, regular burning stopped. Many grassy plains quickly reverted to scrub, to the dismay of the pastoralists, only to be cleared again by felling and ring-barking. Huge tracts of forest and jungle disappeared and many native grasses, unable to withstand the onslaught of the new settlers' hard-hoofed animals, were replaced by imported pasture plants. We can only imagine the landscape the explorers saw.

The loneliness of the bush is a recurring theme. The distances between inhabited areas were vast. In 1818 Oxley wrote 'that the naming of geographical features was often the only pleasure within our reach'. Sturt on the Murrumbidgee found that neither 'beast nor bird inhabited these lonely and inhospitable regions'. Grey in Western Australia spoke of the 'most solemn silence' and Eyre of the 'inhospitable wastes of Australia'. Later, loneliness would be romantically expressed in the paintings of Strutt, McCubbin and Roberts but to the explorers it was stark reality.

Australian inland exploration started from scratch. In Africa there had been some European discovery in classical times and Alexander the Great had penetrated into western India some 300 years BC. The Polo family was in China in the fourteenth century, young Marco providing an excellent example of the importance of travellers recording their exploits if they are to be remembered. By the eighteenth century much of northern America had been tackled by missionaries and traders. But in Australia the Aboriginal people roamed the

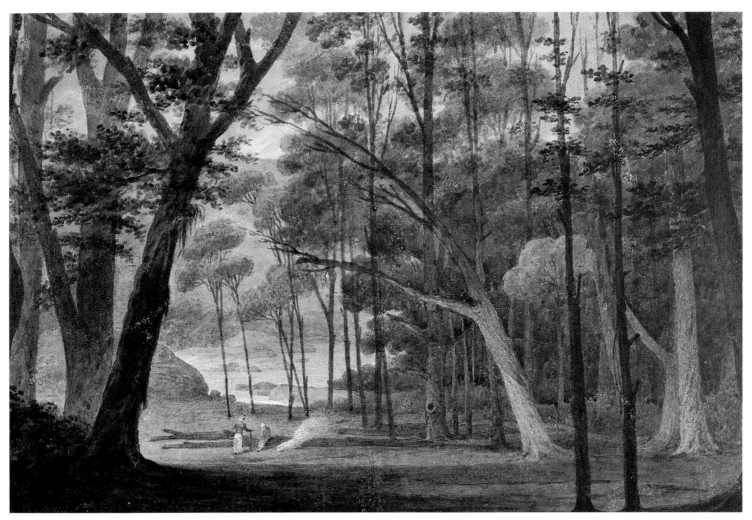

continent for at least 40 000 years, apparently largely undisturbed by travellers, traders or invaders. For centuries Asians had fished in its northern waters and by the seventeenth century Dutch navigators and other seafarers had dropped anchor along the western and northern seaboard, but neither the land nor its people attracted either Asian or European to return and settle.

The eventual prising open of this uninviting country can be seen as part of European mercantile aspirations fuelled by the demands and problems of the industrial revolution, which prompted expansion across the globe. The nineteenth century was an age of intense geographical discovery—an era of great exploits in solving the earth's remaining mysteries. It is interesting that 1788, as well as being the year which marked the foundation of Sydney, also marked the foundation of the African Association in Britain whose main object was the promotion of African discovery.[1] So, while Australia was the last habitable land mass to be discovered, its opening up was much in line with what was happening in other countries where Europeans were gaining a foothold. Referring to the nineteenth century, the historian J. N. L. Baker writes:

Its first fifty years are marked by events of great importance in all parts of the world. In South America Humboldt carried out his epoch-making travels; in North America Mackenzie crossed from the St Lawrence river to the shores of the Pacific; in Africa Bruce revisited the sources of the Blue Nile and Mungo Park reached the Niger river; in Asia Niebuhr began the modern exploration of Arabia and Rennell laid the foundations of the Indian surveys; in Australia the first settlements and the first inland exploration were made. Thus on all sides the blank spaces were being filled in . . . The most distinct turning-point is found near the middle of the nineteenth century. In the later years exploration was especially vigorous in Central Asia, Central Africa, and Central Australia; in the East Indies and in New Guinea; and in the North Polar regions.[2]

'Scene on the Coast of New South Wales', as portrayed by the artist and traveller Augustus Earle. Early settlers could not long remain on the coastal fringe without feeling an intense curiosity about what lay to the west.

1. The African Association was later absorbed by the Royal Geographical Society of London.

2. J. N. L. Baker, *A History of Geographical Discovery and Exploration.* New York, 1967.

Much land exploration in Australia is unrecorded because squatters and settlers frequently became explorers as they searched for new pastures.

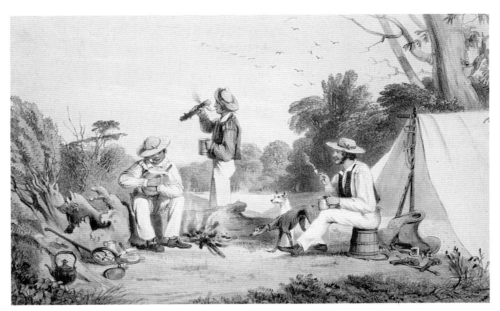

The extracts in this book indicate how Australian exploration fits, with a few ragged edges, into these two time slots. Cook's discovery of the east coast in 1770 and the subsequent establishment of the penal colony of New South Wales made Australia part of the global scene. By 1803 Flinders' circumnavigation of the coastline placed the continent firmly on the map. The blank spaces of the interior were waiting to be filled in, but why, one wonders, did anyone want to undertake the task?

Curiosity regarding the unknown was certainly the spark which ignited the passion to explore, but behind each outward journey there was also a complex web of reasons and influences. There was the romance of exploration—the desire, which it provided, of achieving 'great and noble deeds'. Grey typifies this element. Passionate, vigorous, a young man in a hurry, he brought his yearnings for glory to northwest Australia, for whose arid conditions he appears to have been unprepared. A minor Queensland explorer of 1873, George Dalrymple, wrote: 'There are few excitements so thorough in their enjoyment as those of the explorer when he finds himself suddenly a discoverer'

A certain crusading spirit prevailed. The conclusion of the Napoleonic Wars brought many military or ex-military men to Australia and some turned to conquering the land. Oxley, Sturt, Mitchell and Grey are in this category and were imbued with the idea of personal service to the Crown. Most turned to geographical discovery after having arrived in Australia for some other purpose, although the adventurous Grey came expressly to explore. The first-fleeter, Watkin Tench, had written that 'extent of empire demands grandeur of design' and none fits that concept better than Grey who near the Gascoyne River in Western Australia envisioned that 'within a few years . . . a British population, rich in civilization . . . would have followed my steps'. The concept of service to Empire remained throughout the century. Even Leichhardt, en route for Port Essington, regretted having neither sugar nor fat left with which to celebrate the Battle of Waterloo.

The most immediate reason for exploration was the need to extend the frontiers of settlement. The British government, ever parsimonious in its financial dealings with colonies, had from the start been anxious that New South Wales should quickly become self-supporting. The farm at Sydney must be extended. Phillip himself went exploring—to Broken Bay and up the Hawkesbury. Tench discovered the Nepean River, which he described as 'nearly as broad as the Thames at Putney'. Dawes, Hacking, Bass, Caley and Barrallier all tried in vain to cross the precipitous Blue Mountains and when Blaxland and his two friends succeeded, Australian inland exploration was away. Up to this point the motives were purely practical. No romance had yet entered the story.

Colonial governors continued to encourage exploration but they soon lost control of the land to the squatters, who quickly followed in the wake of the explorers or made their own tracks just as they made their own regulations and ignored those of the government. Sir Keith Hancock wrote that 'the history of Australian exploration is inseparable from the history of the pastoral industry'.[3] This was inevitable, for Australia had no great cities or civilisations, no spices or apparent fabulous wealth awaiting conquerors. From the time of John Macarthur's promotion of Australian wool in the early years of the century and before the major gold discoveries of the 1850s, there was one word dear to the hearts of all connected with the Australian colonies — wool. Australia was riding and would continue to ride on the sheep's back, but sheep required pastures. The pastoralists provided the momentum which pushed the explorers outward.

Man is after all territorial and in Australia to be a 'man of property' was to be a squatter or a settler. The agricultural companies, the colonial governments, individual patrons (such as Thomas Elder, Ferdinand von Mueller, Charles Nicholson and James Chambers) all fostered exploration and where there was good country for stock, settlement quickly followed. Nothing compared to the explorers' delight in beholding well-watered pastures: Evans in 1813 eulogised over the Bathurst Plains. Much South Australian and Western Australian exploration was instigated by landowners. But the greatest coup of all was Mitchell's discovery of Australia Felix, over which he was understandably ecstatic. Before he had even reached Sydney at the conclusion of this expedition, eager pastoralists were moving down his outward dray tracks — following 'the Major's line'. Land was a magnet to settlement and subsequently to immigration. Its importance as the prime stimulus to Australian exploration can hardly be overestimated.

To what extent did Australian exploration have a scientific motive? There was very little exploration within the period covered by this book (1813–76) which could be said to have mineral discovery or scientific research as its principal reason, although William Hann led such a party to north Queensland in 1872. The Reverend W. B. Clarke, who arrived in Australia in 1839 and is sometimes referred to as the Father of Australian geology, certainly made many expeditions in search of minerals, but he travelled largely over known paths even if lonely and difficult ones. Gold was found in areas to which the main routes, at least, had already been opened. Forrest and others rightly discerned that parts of Western Australia held promise of mineral wealth but this was incidental to their main purpose.

The historian, J. C. Beaglehole, points out that Joseph Banks had helped the British government create a precedent for men of science accompanying voyages of discovery when he and his large scientific party sailed with Cook.[4] Thus, on the early expeditions sent out under the auspices of the Colonial Office we find not only 'botanical gentlemen' (to use Flinders' phrase) but explicit instructions regarding the collection of information on the plants, animals and native inhabitants of New South Wales. Oxley took with him Allan Cunningham, who had been despatched to Australia in order to collect specimens for Banks' new botanical gardens at Kew. Ludwig Becker's carefully executed drawings are the only valuable legacy of the Burke and Wills saga. William Carron survived the ill-fated Kennedy expedition although his specimens did not. The ornithologist John Gilbert (who was one of John Gould's bird-collecting team) was killed by Aboriginals and the same fate was suffered by Richard Cunningham.

Leichhardt himself was a keen botanist with considerable geological knowledge, as his journal indicates. Stuart's party included the naturalist J. W. Waterhouse, and Sturt and Mitchell were both keen naturalists. One of Australia's most famous botanists, a promoter of exploration and the founder of Melbourne's Botanical Gardens, Dr Ferdinand von Mueller, travelled with A. C. Gregory's Northern Expedition in 1855.

Unlike exploration in Asia or Africa, commercial enterprise did not play

3. W. K. Hancock, *Australia*. Sydney, 1945.

4. J. C. Beaglehole (ed.), *The Endeavour Journal of Joseph Banks 1768–1771*. Sydney, 1962.

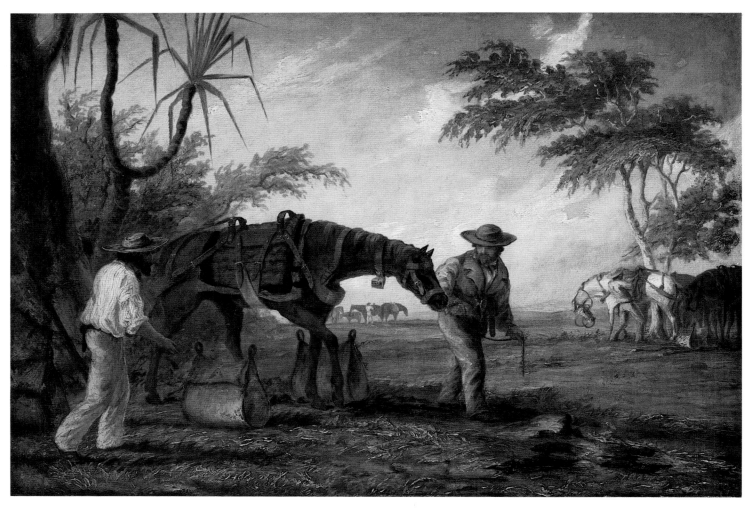

'Group of Explorers with Horses', by Thomas Baines, who accompanied A. C. Gregory on the Northern Expedition in 1855.

any part in Australian geographical discovery—there was nothing to exploit. Even the animal and plant life was of scientific interest rather than commercial value. Nor were there any Livingstones in the annals of Australian exploration. No religious orders set out to convert the native peoples and in so doing to open up new lands as had the Jesuits in Canada. Samuel Marsden soon forsook his attempts at conversion of the Australian Aboriginals to Christianity and departed for New Zealand, where as a result of his missionary activity amongst the Maoris he opened up extensive parts of the North Island.

One of the world's geographical myths concerned an Australian inland sea—or a variant on the same theme, the great northwest river. With so little real evidence to sustain it, why did this theory hold sway for more than twenty years? Imprisoned by the French on the island of Mauritius, Matthew Flinders reflected on the probability of a great river opening on to the west coast about which Dampier had originally speculated in 1699. 'But whether this opening,' wrote Flinders, 'were the entrance to a strait, separating Terra Australis into two or more islands, or led into a mediterranean sea, as some thought; or whether it were the entrance of a large river, there was, in either case, a great geographical question to be settled, relative to the parts behind Rosemary Island.'[5]

Oxley, a naval man who had also engaged in coastal surveying, did not mention Flinders' journal when he discussed the inland sea concept in the account of his 1818 expedition, although it is highly probable that he would have read Flinders' book by then. What is certain is, that after Oxley's suggestion that an inland sea might explain the disappearance of the Lachlan and Macquarie rivers into swamp, the idea hovered like a mirage on the Australian horizon tantalising explorers and settlers for nearly twenty years. It is interesting that the course of inland discovery followed an idea unleashed by the sea-

5. Matthew Flinders, A Voyage to Terra Australis. . . . London, 1814.

faring Dampier and later perpetuated by the navigators Flinders and P. P. King, and for a time by Lort Stokes. One must also remember that the circle of people discussing any Australian topic during these early years was necessarily small.

The great northern river concept also had its followers. Perhaps Australian explorers reflected on the possibility of finding a river such as the Nile or thought of the journeys of Lewis and Clarke on the Missouri or Pike on the Mississippi. Mitchell searched in vain for such a river on his northern expedition, deluding himself that he had found it in the Victoria River (later renamed the Barcoo by Kennedy). Earlier, Grey had fancied he had found a river comparable to the Murray when on the Glenelg in Western Australia. The expectation that somewhere on this arid continent more extensive water might yet be found was finally demolished in 1876 when Giles, crossing Aus-

Facsimile of a letter written by the navigator Matthew Flinders indicating his interest in land exploration in Australia. Flinders died in 1814 before he could return to Australia, but in the 1830s another sea captain, Lort Stokes, enjoyed inland discovery as well as marine surveying.

tralia from west to east, wrote: 'I was greatly disappointed to find that the Ashburton River did not exist to a greater distance eastwards . . .'.

The desert explorations of Forrest, Warburton and Giles had established the disappointing fact that more than half the continent was desert and sub-desert. But a visiting Frenchman, Conrad Malte-Brun, had speculated on just such a possibility as early as 1810:

On whatever side you land on this great island, or, if you like, this continent, you get the impression of a burning wind born in the centre of this vast land and blowing out in all directions. From this you'd be tempted to believe the interior of New Holland filled with sandy deserts like the African Sahara. Yet how do you reconcile this heat and aridity with the extreme height of the mountains which up til now have withstood all attempts by the English to climb them? It's a hard question to resolve.[6]

It was indeed, but had Australia been colonised by the French perhaps Malte-Brun's speculations rather than Dampier's would have held sway.

There were other motives influencing the pursuit of discovery but they are of less general significance. The emerging state patriotism of the ebullient colony of Victoria, jealous of South Australia's exploratory achievements, seems undoubtedly to be the reason behind the Burke and Wills fiasco, while Warburton affirms that he made his great desert journey for the sake of his family! Expectation of reward may have been an added spur to some explorers, although this would seem less of a motive than an appreciative compensation at the conclusion of arduous and frequently anguishing travel. The earlier explorers received land grants. Later there were public benefactions and many received the coveted awards of the august Royal Geographical Society of London, a body which itself did so much to encourage nineteenth century British exploration.

6. Conrad Malte-Brun, *Annales des Voyages, de la Géographie, et de l'Histoire. . . .* Paris, 1809–14.

The personal cost of geographical discovery was high. The journals contain endless harrowing stories of suffering—cruel thirst, wandering domestic animals, starvation, disease, attacks by the Aboriginals, terrible loneliness and the death of companions. Later Australian bushmen would learn something of the art of living off the land, but in arid areas, especially during drought periods, even the Aboriginal people found survival difficult. There are, however, some anomalies. One wonders why at times it seemed so difficult for the explorers to obtain animals and birds for food, when these seemed to be plentiful. Rowing back up the Murray River, Sturt rather surprisingly admits that his exhausted, hungry men did not fancy the fish! Mishaps sometimes occurred which possibly could have been avoided. Oxley left the spade in Bathurst; Warburton lost his only bucket when digging a well; in Central Australia Sturt found that the water-bags leaked. There appeared to be nothing amiss in the large and meticulously organised parties under Mitchell (or if there was he does not admit to it), but then he could afford to travel with every necessity. The explorers who went further inland had to make quick, light marches in order to survive, often being forced to eat their transport animals.

By 1872 the overland telegraph marked the beginning of a new era in which technology would largely replace the need for 'heroic deeds', but by then the explorers' work was almost finished. Their achievements had been based on initiative, courage and endurance without help from radio or rescuing helicopter. It is easy to appreciate the frequent calls made by them to divine Providence. There was no one else on whom to call.

There is considerable information in the journals regarding the explorers' first contacts with the Aboriginal people. Whatever crimes were committed towards the Aboriginals in Australia by some white settlers, the explorers for the most part endeavoured to establish friendship and to obey the Colonial Office instructions regarding the need to conciliate the native inhabitants. The spectacle of totally unfamiliar men and beasts advancing on their ancient territories must have been bewildering and terrifying to Australia's original people, so it is not surprising that conflict frequently occurred. Mitchell, encountering that hostility on the Darling, refers to the problem of control over all members of his party, some of whom were convicts. Kennedy's party would have been hard put to it not to retaliate as they trudged through dense, damp country, periodically pelted with spears. Sturt is famous for avoiding confrontation, through either skill or luck, or a combination of both.

In the sensitive and comprehensive account of the Aboriginal people

'Mallee Scrub, Murray River' by Nicholas Chevalier painted c.1871. By this time nearly all the major journeys of exploration had taken place.

within his journal, Eyre queried the Europeans' right as invaders of Australia, but most Englishmen of that time would have taken for granted the authority of a more advanced civilisation over a primitive one. The concept too of the 'noble savage', which has been observed in paintings, is also occasionally apparent in the journals. Leichhardt, near Port Essington, wrote that 'a fine native stepped out of the forrest with the ease and grace of an Apollo'. There were numerous instances of friendship and trust between both peoples and while a phrase such as 'our sable friends' sounds patronising today it also has a friendly tone, unlike the less respectful term 'blackfellows' used later.

 What does emerge from the explorers' writing is the unpredictability of relations with the Aboriginals. Behaviour towards the white men did not vary simply from place to place but from day to day within the same tribe. Aboriginals who appeared friendly one day would attack the next, sometimes motivated by cunning in order to steal or perhaps by a white man's unwitting infringement of Aboriginal law or custom. Even the explorers' trusted guides (often terrified of the myalls—the 'wild' Aboriginals) would become suddenly homesick for their own part of the country and disappear. Occasionally, deep human feeling bridges the wide gap between the two cultures, as when the Aboriginals at Cooper Creek realising that King's companions Burke and Wills, were both lying dead nearby, shed tears of compassion.

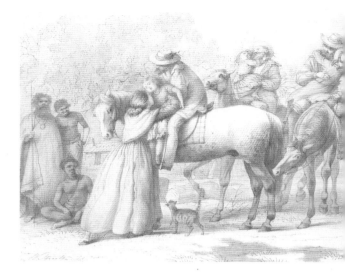

'Home at Last!', by the artist William Strutt. Such a sentiment on returning to the home station must have been common to all explorers.

This book does not attempt to tell the whole story and apologetically omits Tasmania; its exploration came about through many journeys, including those made by the employees of the Van Diemen's Land Company. Space has also prevented the inclusion of the practical account of the Jardine brothers of their journey to the tip of Cape York Peninsula in 1863–64.

 Many minor accounts, such as that of Sir John Jamison down the Warragamba in 1818 (published in 1834 in the *New South Wales Magazine*), are interesting but not of sufficient significance to warrant inclusion. The pages of the journals of the Royal Geographic Society of Australasia provide extensive material only some of which has been used. Governors' despatches, travellers' tales such as those of John Lhotsky, Mrs Meredith or Lady Franklin, or letters like those from George Moore on the Swan River to his sister in England, all contribute much information on the discovery of Australia. By 1888 several books on the subject had already been written.

 Much of the work of Australian exploration occurred in the course of settlement. The pioneering activities of pastoralists such as Patrick Leslie, the Russell brothers, the Duracks, the Hentys are well known but there is much that can never be told. As Ernest Favenc wrote in the year of Australia's first centenary:

That private individuals have done the bulk of the detail work there is no denying; but that work, although every whit as useful to the community as the more brilliant exploits that carried with them the publicity of Government patronage, has not found the same careful preservation . . . each countless subordinate river and tributary creek was the result of some extended research of the pioneer squatter . . .[7]

 George Evans in 1815 had written that he could see 'no end to travelling' and in 1875 Dr Ferdinand von Mueller pointed out in a letter to the Royal Geographical Society of London: 'We ought not to rest until all the wide inland tracts of Her Majesty's Australian territory are mapped'.[8] At that date there was considerable mapping and surveying still to be done, but the achievement had been immense. In a little over one hundred years since Cook resolved the uncertainty of *Terra Australis Incognita* the 'silent and sullen' inland had been forced to give up its mysteries and myths.

 What Blaxland wrote about the crossing of the Blue Mountains was true for the whole history of Australian geographical discovery: 'It . . . changed the aspect of the Colony, from a confined insulated tract of land, to a rich and extensive continent'.

7. Ernest Favenc, *The History of Australian Exploration From 1788 to 1888*. Sydney, 1888.

8. National Library of Australia. Exploration Box 4.

1

Beyond the Blue Mountains

Gregory Blaxland, settler and explorer.

1. W. C. Wentworth, *A Statistical, Historical and Political Description of The Colony of New South Wales and Its dependent Settlements in Van Diemen's Land: With a Particular Enumeration of the Advantages which these Colonies offer for Emigration and their Superiority in many Respects over those Possessed by the United States of America.* London, 1819.

William Lawson (1774–1850) arrived in Sydney in 1800 as a young officer in the New South Wales Corps. He became aide-de-camp to Major Johnston, who deposed Governor Bligh, although Lawson himself does not appear to have been an enthusiastic member of the rebellion.

By 1813 Lawson had established himself as a landowner and like others of his ilk was no doubt hungering for greener and more extensive pasture. His training as a surveyor must have been of considerable use to the more commercially oriented Blaxland and the politically minded Wentworth.

Lawson's subsequent success as a landowner illustrates the blessings which conquering the ranges brought to those early New South Welshmen cramped along the coast. He was rewarded (as were Blaxland and Wentworth) with 1000 acres (some 400 hectares) of the new land. He became the first commandant at Bathurst and explored land further west, helping to open up the district of Mudgee. Lawson became a man of substance, ultimately owning thousands of hectares. Between 1843 and 1848 he was a member of the Legislative Council. His journals, which have not been published, are held in the Mitchell Library, Sydney.

William Charles Wentworth (1790–1872) was born either in Australia or on board ship nearby. His father was a medical practitioner and his mother a convict. Both arrived in Sydney on board the *Neptune* in 1790 and soon after left for Norfolk Island. The young Wentworth was sent to England to be educated but by 1810 was back in Sydney. Soon after, Macquarie granted him land on the Nepean River.

Wentworth's crossing of the Blue Mountains with Blaxland and Lawson in 1813 was one of the first notable exploits in a long and active career passionately devoted to the development of Australia. He championed the cause of the emancipists and married, in 1829, a currency lass. He was ardent in the campaigns for self-government, trial by jury and freedom of the press, and was a leader of the movements to establish a national system of education in New South Wales and the University of Sydney.

Wentworth's treatise on New South Wales was the first book written by a native-born Australian to be published.[1] In it he made no mention of his own part in the crossing of the Blue Mountains but discussed the nature of the country to the west:

The herbage is sweeter and more nutritive, and there is an unlimited range for stock, without any danger of their committing trespass. There is besides, for the first two hundred miles, a constant succession of hill and dale, admirably suited for the pasture of sheep, the wool of which will without doubt eventually become the principal export of this colony, and may be conveyed across these mountains at an inconsiderable expense. . . .

The discovery of this vast and as yet imperfectly known tract of country, was made in the year 1814, and will doubtless be hereafter productive of the most important results. It has indeed already given a new aspect to the colony, and will form at some future day, a memorable era in its history. Nothing is now wanting to render this great western wilderness the seat of a powerful community, but the discovery of a navigable river communicating with the western coast. . . .

Gregory Blaxland (1778–1853) arrived in Sydney in 1806 as a free settler. Soon afterwards his brother John also arrived in the colony and the two joined forces in commercial enterprises. Gregory was at loggerheads with Governors Bligh and Macquarie, in 1808 signing the letter requesting Major Johnston to depose Bligh and later, in 1819, being amongst those who criticised Macquarie to Commissioner Bigge.

In 1813 Blaxland, in common with other settlers, found that his coastal land grants were insufficient to contain his growing flocks and herds. There had already been a number of attempts to push westward — William Dawes in

1789, Henry Hacking in 1794, George Bass in 1796, Francis Barrallier in 1802 and George Caley in 1804 — but none had succeeded in getting over the ranges.

The drought of 1812 emphasised the need for more land and the expedition of Blaxland, Lawson and Wentworth set off with the blessing of Macquarie. The story of their success is told here in extracts taken from Blaxland's journal, which he arranged for publication during a visit to London in 1822.[2] During this visit he won his first silver medal for the wine he had grown on his New South Wales farm.

Blaxland committed suicide at the beginning of 1853. By then, exploration and the settlement which had followed the crossing of the Blue Mountains was turning the Australian colonies towards nationhood.

Conquering the First Barrier

On Tuesday, May 11, 1813, Mr. Gregory Blaxland, Mr. William Wentworth, and Lieutenant Lawson, attended by four servants, with five dogs, and four horses laden with provisions, ammunition, and other necessaries, left Mr. Blaxland's farm at South Creek, for the purpose of endeavouring to effect a passage over the Blue Mountains, between the Western River and the River Grose. They crossed the Nepean, or Hawkesbury River, at the ford, on to Emu Island, at four o'clock p.m., and having proceeded, according to their calculation, two miles in a south-west direction, through forest land and good pasture, encamped at five o'clock at the foot of the first ridge. The distance travelled on this and on the subsequent days was computed by time, the rate being estimated at about two miles per hour. Thus far they were accompanied by two other gentlemen.

On the following morning, (May 12,) as soon as the heavy dew was off, which was about nine, a.m., they proceeded to ascend the ridge at the foot of which they had camped the preceding evening. Here they found a large lagoon of good water, full of very coarse rushes. The high land of Grose Head appeared before them at about seven miles distance, bearing north by east

After travelling about a mile on the third day, in a west and north west direction, they arrived at a large tract of forest land, rather hilly, the grass and timber tolerably good, extending, as they imagine, nearly to Grose Head, in the same direction nearly as the river. They computed it at two thousand acres. Here they found a track marked by a European, by cutting the bark of the trees. Several native huts presented themselves at different places. They had not proceeded above two miles, when they found themselves stopped by a brush-wood much thicker than they had hitherto met with. This induced them to alter their course, and to endeavour to find another passage to the westward; but every ridge which they explored, proved to terminate in a deep rocky precipice. . . .

On the next morning, leaving two men to take care of the horses and provisions, they proceeded to cut a path through the thick brush-wood, on which they considered as the main ridge of the mountain, between the Western River and the River Grose; keeping the heads of the gulleys, which were supposed to empty themselves into the Western River on their left hand, and into the River Grose on their right. As they ascended the mountain, these gulleys became much deeper and more rocky on each side. They now began to mark their track by cutting the bark of the trees on two sides. Having cut their way for about five miles, they returned in the evening to the spot on which they had encamped the night before. The fifth day was spent in prosecuting the same tedious operation; but, as much time was necessarily lost in walking twice over the track cleared the day before, they were unable to cut away more than two miles further. They found no food for the horses the whole way. An emu was heard on the other side of the gulley, calling continually in the night.

On Sunday they rested, and arranged their future plan. They had reason, however, to regret this suspension of their proceedings, as it gave the men leisure to ruminate on their danger; and it was for some time doubtful whether, on the next day, they could be persuaded to venture farther. . . .

On Wednesday, the 19th, the party moved forward along this path; bearing

2. Gregory Blaxland, *A Journal of a Tour of Discovery across the Blue Mountains in New South Wales*. London, 1823.

Blaxland, Wentworth and Lawson's route over the Blue Mountains.

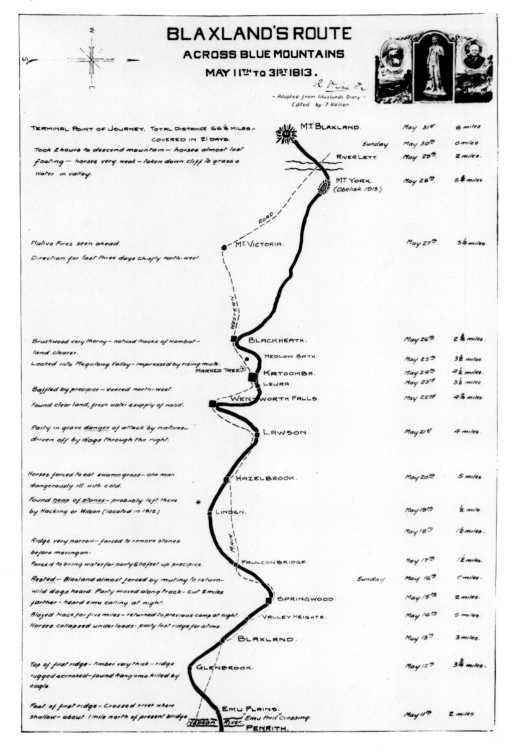

chiefly west, and west-south-west. . . . A little distance from the spot at which they began the ascent, they found a pyramidical heap of stones, the work, evidently, of some European, one side of which the natives had opened, probably in the expectation of finding some treasure deposited in it. This pile they concluded to be the one erected by Mr. Bass, to mark the end of his journey. . . . Here, therefore, the party had the satisfaction of believing that they had penetrated as far as any European had before them. . . .

On Saturday, the 22d instant, they proceeded in the track marked the preceding day rather more than three miles, in a south-westerly direction, when they reached the summit of the third and highest ridge of the mountains southward of Mount Banks. . . . From the summit, they had a fine view of all the settlements and country eastward, and of a great extent of country to the westward and south-west. But their progress in both the latter directions was stopped by an impassable barrier of rock, which appeared to divide the interior from the

coast, as with a stone wall, rising perpendicularly out of the side of the mountain.

In the afternoon, they left their little camp in the charge of three of the men, and made an attempt to descend the precipice, by following some of the streams of water, or by getting down at some of the projecting points where the rocks had fallen in; but they were baffled in every instance. . . .

On the 28th, they proceeded about five miles and three-quarters. Not being able to find water, they did not halt till five o'clock, when they took up their station on the edge of the precipice. To their great satisfaction, they discovered that what they had supposed to be sandy barren land below the mountain, was forest land, covered with good grass, and with timber of an inferior quality. In the evening, they contrived to get their horses down the mountain, by cutting a small trench with a hoe, which kept them from slipping, where they again tasted fresh grass for the first time since they left the forest land on the other side of the mountain. They were getting into miserable condition. Water was found about two miles below the foot of the mountain. The second camp of natives [they had seen a group of about thirty Aboriginals on 26 May] moved before them about three miles. In this day's route, little timber was observed fit for building.

On the 29th, having got up the horses, and laden them, they began to descend the mountain at seven o'clock, through a pass in the rock, about thirty feet wide, which they had discovered the day before, when the want of water put them on the alert. Part of the descent was so steep, that the horses could but just keep their footing without a load, so that, for some way, the party were obliged to carry the packages themselves. A cart road might, however, easily be made by cutting a slanting trench along the side of the mountain, which is here covered with earth. . . . [The first road to Bathurst was built, by convicts, along this track.]

The natives, as observed by the smoke of their fires, moved before them as yesterday. The dogs killed a kangaroo, which was very acceptable, as the

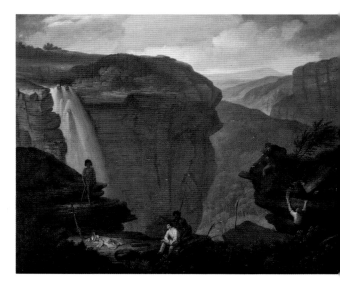

This painting by Augustus Earle of what is now known as Wentworth Falls illustrates the rugged nature of the Blue Mountains.

'Govett's Leap', the Blue Mountains, N.S.W. by Eugen von Guérard. Govett's Leap was named by T. L. Mitchell after one of his assistant surveyors, William Romaine Govett. Govett discovered this dramatic landscape when surveying the road to Bathurst in the late 1820s.

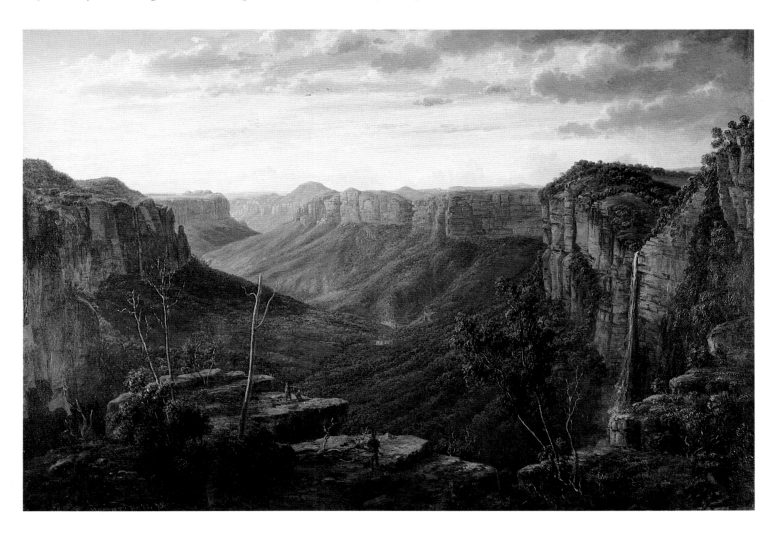

George William Evans, surveyor and explorer.

party had lived on salt meat since they caught the last. The timber seen this day, appeared rotten and unfit for building. . . .

On the Monday, they proceeded about six miles, south-west and west, through forest land, remarkably well watered, and several open meadows, clear of trees, and covered with high good grass. They crossed two fine streams of water. Traces of the natives presented themselves in the fires they had left the day before, and in the flowers of the honey-suckle tree scattered around, which had supplied them with food. These flowers, which were shaped like a bottle-brush, are very full of honey. The natives on this side of the mountains, appear to have no huts like those on the eastern side, nor do they strip the bark, or climb the trees. From the shavings and pieces of sharp stones which they had left, it was evident that they had been busily employed in sharpening their spears.

The party encamped by the side of a fine stream of water, at a short distance from a high hill, in the shape of a sugar loaf. In the afternoon they ascended its summit, from whence they descried all around, forest or grass land, sufficient in extent, in their opinion, to support the stock of the Colony for the next thirty years. This was the extreme point of their journey. The distance they had travelled, they computed about fifty-eight miles nearly north-west; that is, fifty miles through the mountain, (the greater part of which they had walked over three times,) and eight miles through the forest land beyond it, reckoning the descent of the mountain to be half-a-mile to the foot.

They now conceived that they had sufficiently accomplished the design of their undertaking, having surmounted all the difficulties which had hitherto prevented the interior of the country from being explored, and the Colony from being extended. . . . On Sunday, the 6th of June, they crossed the river after breakfast, and reached their homes, all in good health. The winter had not set in on this side of the mountain, nor had their been any frost.

The Explorations of Evans

G eorge William Evans (1775–1852) arrived in Australia in 1802. Between 1809 and 1825 he was employed in Van Diemen's Land as a deputy surveyor, but was several times recalled to Sydney by Macquarie to explore the country to the west, and later to act as second-in-command to Oxley. While Blaxland, Lawson and Wentworth had, by following the ridges, gone as far as present Mount Blaxland and observed the pleasing pastures beyond, they had not actually crossed the main range. This was the task Macquarie asked of Evans, and which was successfully accomplished as these extracts show.[3] The following accounts tell of this expedition in 1813–14 — and of a second one in which he discovered the Lachlan River.

Crossing the Great Divide

3. Evans' journals are to be found in *Historical Records of Australia*. Series 1, Volume VIII, Sydney, 1916.

Assistant-Surveyor Evans' Journal, 1813–1814

To His Excellency Governor Macquarie.

Friday, November 19th, 1813.
I DIRECTED the Provisions and other necessarys to be conveyed across the Nepean to the N.E. Point of Forest Land, commonly called Emu Island, which was done, and by the time every thing was arranged Evening approached.

Saturday, 20th.
The Night was most uncomfortable, and the Morning being wet prevented our departing so early as I meant; feeling anxious to proceed, I made up my mind to make the best of our way to the end of the Mountains, and on my return to measure the distance of Messrs. Blaxlands, Wentworths and Lawsons recent excursion; it appeared to me that while the Horses were fresh it was a plan likely to meet with your approbation, as I could then refresh them on good grass, and take my time in exploring to the Westward, which I conceived the object of the greatest importance; on returning should I not have sufficient provisions to subsist on to complete measuring the track of the above named Gentlemen, I could send in a Man and Horse to meet me with a small supply. . . .

John Lewin's watercolour of Emu Ford on the Nepean from which Governor Macquarie and his party set forth to travel across the first road through the Blue Mountains. Lewin was a member of the governor's party.

Sunday, 21st.

The Morning very much overcast, with a thick fog, however I had the Horses loaded, and travelled on mostly on Ridges overrun with Brush; at about 11 o'clock I passed the Pile of Stones alluded to by the former party; soon after we were on a very high hill, which was clear of Mist, but to my great disappointment the Country to the Eastward being covered with Vapour I could not be satisfied with the Prospect, which must have presented itself had the weather been clear; we made the best of our way on and halted at 2 o'Clock. . . .

Friday, 26th.

I stopped this evening near the foot of a very handsome Mount, which I take the liberty to call *Mount Blaxland*, also two Peaks rather North of it, and which the Riverlett separates *Wentworths and Lawsons Sugar Loaves*. I am at a loss to describe the pleasant appearance of this place, the Grass being quite green and good makes it look a pleasing scene, this is the termination of the excursion of the above named Gentlemen; be assured it was not without much labour, perseverance and fatigue that enabled them to reach thus far; I am certain that it is at least 50 Miles, and as the present track is, no person in the Colony on the Choicest Horse could reach this and return to the Nepean in four days; you may rely on what I say in this respect; the Mountains, being covered with sharp Granite, would be dangerous to put any Horse out of a walk, and impossible so to do through the Brushes; Kangaroos are numerous, we caught one this day altho' the dogs are so much hurt. . . .

Tuesday, 30th.

I have at length reached the Ridge I so much wished to do after walking about 2 Miles, where I had a prospect to the North for a great distance; A Mist arises from a part I suppose to be a River or a large Lagoon about 20 Miles off; the Country in this direction has a fine appearance, the Trees being thin and the hills covered with Grass; A ¼ of Mile farther along the Range, I came to a very high Mount, when I was much pleased with the sight Westward; I think I can see 40 Miles which had the look of an open country. To the South of me there are large hills much higher than the one I am on, with pasture to their tops; This Range is rather overrun with underwood and larger Timber growing thereon, but the sides are as green as possible; in descending for 2 Miles the verdure is good; the descent then becomes steep for a ¼ of a Mile, leading into a fine valley at the end I met a large Riverlett [the Fish River] arising from the Southern Hills. We shot Ducks and caught several trout weighing at least 5 or 6 Pounds each. distance, 5½ Miles. . . .

'View from the Summit of Mount York', by Augustus Earle. When Earle travelled over the mountains in the 1820s convict labour was still being used to improve Cox's original road.

Evans had at this point achieved what Blaxland and his friends had not — he had actually crossed the Great Dividing Range and was looking over the Bathurst Plains.

Saturday, 4th [December].

My Progress is through an exceeding good Track of Country; it is the handsomest I have yet seen with gentle rising hills and dales well watered; the distant hills, which are about 5 Miles South, appear as Grounds laid out divided into fields by edges; there are a few Trees on them and the Grass is quite green; I still keep the river [the Fish], and at times I walk a few Miles South or North as seems to me most requisite. The Dogs killed a Kangaroo and the river supplies us *with abundance of Fish.* . . .

Thursday, 9th.

I have called the Main Stream *"Macquarie River."* [He had discovered it on 7 December.] At 2½ Miles commences a most extensive Plain, the hills around are fine indeed; it requires a clever person to describe this Country properly, I never saw anything equal to it; the soil is good; I think the lower parts of the Plains are overflowed at times, but do not see marks to any height; the small Trees on the lower banks of the River stand straight, not laying down as you see them on the banks of the river and Creeks at Hawkesbury. The Grass here might be mowed it is so thick and long, particularly on the flat lands. [They were at present-day Bathurst.]

distance, 8¼ Miles.

Friday, 10th.

Emues are numerous; the Dogs will not give chase; I imagine they are bad ones; we have not been able to get a shot at any of the Geese, altho' plentiful, they are so shy; but frequently shoot Ducks. Nothing astonishes me more than the amazing large Fish that are caught; one is now brought me that weighs at

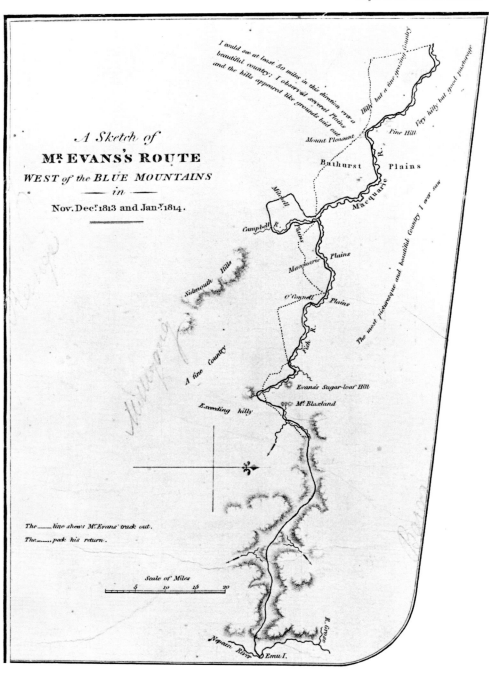

A sketch map of George Evans' route to the west of the Blue Mountains during his journey of exploration 1813–14.

least 15 *lb.*, they are all the same species. I call the Plains last passed over *"Bathurst Plains"*. . . . [They travelled along the Macquarie River until 17 December.]

Saturday, 18th.

We departed for our Journey homewards, keeping as far from the River as we conveniently could, and find the feed for Stock exceeding good; the farther back among these hills the better it is; the Valleys are beautiful, as also the intervening ridges that divide them, being thickly covered with herbage; Grazers may keep stock here to great advantage, particularly sheep, as they like dry healthy parts. . . .

By the end of December they were back at Mount Blaxland and Evans was busy surveying the route as he travelled back to Sydney.

Thursday, 30th.

We remained to prepare to ascend the Mountains early in the Morning, by hunting Kangaroo for their skins to secure our feet: Killed a very large one which will furnish us with pampoosers; hoping with what we have will enable us to reach home in safety. . . .

Monday, 3rd [January 1814].

The Mountains have been fired: had we been on them we could not have escaped; the Flames rage with violence through thick underwood, which they are covered with. Bad travelling the stick of the Bushes here are worse than if their leaves had not been consumed; they catch my Chain which makes the measuring very fatiguing; also tears our clothes to pieces, and makes us appear as Natives from black dust off them. The Marks in the Trees are burnt out; therefore am obliged to go over them again: Our Horses now want Grass. . . .

Thursday, 6th.

The Fires have been in my favor, otherwise it would be impossible to measure; the flames have consumed the foliage from the highest Trees. . . .

Saturday, 8th. . . .

The ascent from *Emu Island* is very regular and easy; *12 Men might clear a good Road in 3 months for a Cart to Travel over the Mountains* and make the descent of them so easy that it might be drove down in safety.

There are no hills on the Ridge that their ascent or descent is any way difficult; I beg to observe that it will be impossible to drive Cattle or attempt sending a Cart until a Road is made; for reasons that the stumps of the Brush and sharp Granite Rocks will run into their feet and lame them.

I have the honor to be with every respect,
Your very obedient Servant,
G. W. Evans.

Names of men that accompany'd me.

Richard Lewis ⎫
James Burns ⎬ Free Men
John Cooghan ⎫
John Grover ⎬ Prisoners
John Tygh ⎭

From Emu Island to the end of the Mountains............	46½ Miles	
From the end of the Mountains to the Riverlett..........	2	
From the end of the Mountains to Mount Blaxland.....	7¼	55¾
From Mount Blaxland to the end of my Journey.........	92½	
Up Campbell's River..	6	98½
Total		154

G. W. Evans

Governor Macquarie, who keenly supported exploration, took Evans' advice and by the middle of 1814 had arranged for William Cox to manage the building of the one hundred miles of road which engaged the labours of thirty convicts for six months. It was completed on 21 January 1815. Of this undertaking Cox wrote:[4]

The choice of the labourers to perform this work being left to myself, I informed the district constables what sort of men I wanted, and directed them to give notice to the convicts who were working with settlers in their districts that the number I wanted should be allowed to volunteer on the occasion, that they were to perform their work under my own direction, and if they behaved to my satisfaction they would be rewarded by emancipations from His Excellency the Governor.

As well as encouraging exploration Macquarie himself was a keen traveller.[5] In April 1815 the Governor and his lady travelled on Cox's road to the 'new discovered country'. As well as Cox, the party included John Oxley, James Meehan, George Evans, William Redfern, the artist John Lewin, and Captain H. C. Antill who also left an account of the excursion, of which the following is a brief extract:[6]

Sunday, May 7 [1815]. A thick foggy morning, which soon cleared away as the

4. *A Narrative of Proceedings of William Cox, Esq.— of Clarendon . . . in Constructing a Road from Capt. Woodriffe's farm on the Nepean River, opposite Emu Plains over the Blue Mountains, and from thence to Bathurst Plains, on the Banks of the Macquarie River in the years 1814 and 1815*, n.d., National Library of Australia Pamphlets, Vol. 9.

5. Lachlan Macquarie, *Journals of his Tours in New South Wales and Van Diemen's Land 1810–1822*. Sydney, 1956.

6. H. C. Antill, 'Journal of an excursion over the Blue or Western Mountains of New South Wales to visit a tract of newly discovered country, in company with His Excellency Governor and Mrs. Macquarie, and a party of Gentlemen', in *Records of the Education Society*. Sydney, 1914.

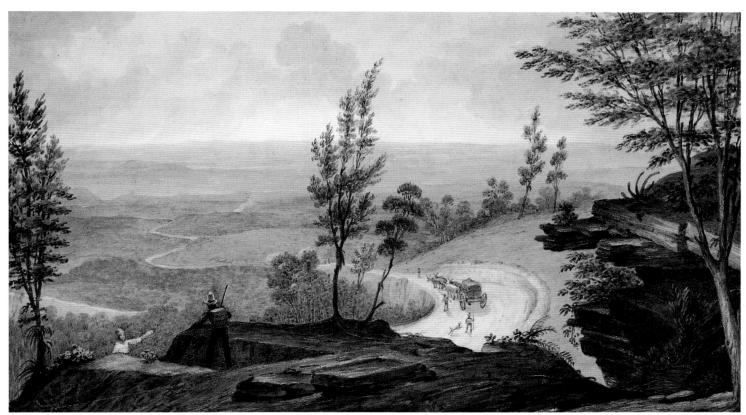

sun got a little power. A little after breakfast, assembled the whole of our inhabitants, civic, naval and military, 75 in number, and drawing them up in line, in front of the large tent, the British flag was displayed for the first time in this new country, the troops saluting it with three vollies, and the rest giving three cheers. The Governor then delivered a short speech to Mr. Cox and Mr. Evans as having through their exertions been brought to so fine a country, thanking the latter for having explored it with so much perseverance and success, and the former for having with considerable labour made so good a road for upwards of a hundred miles in so short a time and so difficult to perform. He then named the place and new town to be marked out, "Bathurst," and each drank a bumper, some in wine, and the rest in rum, to the King's health, and success to the town of Bathurst.

On his second journey Evans would have travelled along Cox's road to Bathurst — the road which was not made at the time of his first journey a year or so before.

To the Lachlan River

Saturday, May 13th, 1815.
I should have left Bathurst yesterday; when near ready to go, one of my Horses threw his Load, which damaged some of his tackling; repairs being necessary caused my delay until this Morning; my Course was S. 30°W or thereabouts along the fine flat, named Queen Charlotte Vale. . . .

Wednesday, 24th.
My Course was West for three Miles; it led me to the top of an high hill; the Water shewed itself about ½ Mile North of me; on the South is an extensive flat [the Lachlan Valley]. . . . The open Country and falling on the Water courses encouraged me so much that I made every exertion to push forward, besides being full of anxiety hoping soon to reach a River of some consequence. Every steep hill, between the Lime Rocks and Bathurst, may be avoided except two, and they are not worse than that at the Fish River. An handsomer and finer Country I never saw than what I have been over these last two Days; greatest part of the Land is good; Timber is its worst production; Kangaroos Emu and Wild Ducks are very numerous. distance 14½ Miles. . . .

'A Native chief of Bathurst' — an illustration in Oxley's journal from a painting by the naturalist John Lewin, who is best known for his paintings of birds and his simple watercolour representations of the Australian landscape.

Wednesday, 31st. . . .

[Evans was now following the course of the newly discovered Lachlan River.] We see Natives two or three times a day; I believe we are a great terror to them; a Woman with a young Child fell in our way this afternoon, to whom I gave a Tomahawk and other triffles; she was glad to depart; soon after we suddenly came upon a Man, who was much frightened; he run up a Tree in a moment, carrying with him his Spear and Crooked throwing Stick; he hallowed and cryed out so much and loud, that he might have been heard half a Mile; it was useless entreating him to come down, therefore stuck a Tomahawk in the Tree, and left him; the more I spoke, the more he cryed out. 7 Miles. . . .

Thursday, 1st June, 1815.

The River to-day is near West, and am clear of the points of hills; the Country is good indeed; these fine flats are flooded; there are rising Lands clear of it as I before stated, but no hill that will afford a prospect; to-morrow I am necessitated to return, and shall asscend a very high hill, I left on my right Hand early this Morning. I could leave no mark here more than cutting Trees; on one situated in an Angle of the River and a wet Creek, bearing up North, I have deeply carved "*Evans 1st June 1815.*" The Country continues good, and better than ever I expected to discover. I must defer making further remarks, until I have been upon the height I speak of. . . .

Friday, 2nd June

In travelling back, I left the River . . . I asscended the Height; no Country can possibly have a more interesting aspect; so much so that, if a further trace into the interior is required at a future period, I respectfully beg leave to offer myself for the Service. I see no end to travelling. . . .

The River [the Lachlan] I can distinctly discover to continue near due West, and rest confident that, when it is full, Boats may go down it in safety; my meaning of being full is its general height in moderate Seasons, which the banks shew, about Five feet above the presant level; it would then carry Boats over Trees and Narrows that now obstruct the Passage; no doubt the Stream connects with Macquarie or some other River further West; the Channel then sure is of great magnitude; I should think so to carry off the body of Water that must in time of Floods cover these very extensive flats. . . .

Monday, 5th June.

Left the River, which I have now called "*The River Lachlan.*" The Rain has fallen very heavy; we were completely washed up last Night; it extinguished our

Some visitors to Sydney wished to view the prosperous lands to the west and were prepared to ride or bump their way by coach over the road to Bathurst. This 'Vue de Cox-River' is by P. A. Marchais from a drawing by A. Pellion.

Fire, which made us still more uncomfortable, besides damaging my papers. I am fearful we shall experience the like this Evening, but have taken every precaution to prevent it. . . .

<div style="text-align:center">Monday, 12th June.</div>

Arrived at Bathurst, having experienced for these last six days extremely cold uncomfortable Weather, with Misty rain. My journal is short; but have endeavoured to state every thing, as it actually is, in as plain and correct a manner as I am capable of doing, that it sould be clearly understood by any person, who may hereafter follow my Track.

I assure your Excellency, I have lost no time in persevering to reach Westward so far as is herein represented, and do at all times with the utmost pleasure strive to fulfil to your satisfaction, any wish or Commands I have the honor to be entrusted with.

<div style="text-align:center">I remain, &c.,
G. W. Evans.</div>

P.S.—I beg leave to state that the undernamed Persons were very attentive and Obedient to my Orders:—

George Kane, alias Thos. Appledore; James Butler; Patk. Nurns; also John Tyghe, who accompanied me each journey previous to this.

<div style="text-align:center">G. W. Evans, Dy. Surveyor</div>

Oxley and the Western Rivers

As a young naval officer, John Joseph William Molesworth Oxley (1785?–1828) had been in and out of Sydney for some ten years when in 1812 he was appointed surveyor-general of New South Wales. He had already taken up land near Camden and by 1816 his herds were grazing at present-day Bowral. Oxley's elegantly written accounts of his two land explorations proved to be of exciting interest to a reading public in England, keen to know what lay within this vast southern continent; his supposition of the existence of an inland sea was to tempt future explorers onward.

Oxley also made several coastal explorations including the one to Port Curtis and Moreton Bay in 1823 when he charted 80 kilometres up the Brisbane River; he subsequently recommended the establishment of a penal settlement at Moreton Bay. It was here that Oxley's party found the castaway, Thomas Pamphlett, who, with his companions, had earlier discovered the Brisbane River and led Oxley to it.

It appears that Oxley found the work of an expanding survey office in Sydney arduous, but heavy business and public duties may also have weighed on him. Perhaps these factors as well as the rigours of exploration contributed to his early death in 1828.

The following extracts are taken from Oxley's journal[7] which tells the story of his journey up the Lachlan and Macquarie Rivers during the winter of 1817 and again to the Macquarie in 1818. From here he and his party moved northeast to discover the Castlereagh River and ultimately crossed the Great Dividing Range to Port Macquarie.

An appendix to the journal described the party:

1 John Oxley, Esq., chief of the expedition.
2 Mr. George William Evans, second in command.
3 Mr. Allan Cunningham, King's botanist.
4 Charles Fraser, colonial botanist.
5 William Parr, mineralogist.
6 George Hubbard, boat-builder.
7 James King, 1st boatman, and sailor.
8 James King, 2d horse-shoer.
9 William Meggs, butcher.
10 Patrick Byrne, guide and horse leader.
11 William Blake, harness-mender.
12 George Simpson, for chaining with surveyors.
13 William Warner, servant to Mr Oxley.

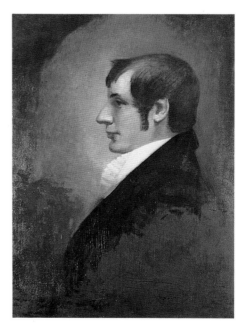

John Oxley, surveyor-general of New South Wales between 1812 and 1828.

7. John Oxley, *Journals of Two Expeditions into the Interior of New South Wales, undertaken by order of the British Government in the years 1817–18.* London, 1820.

To the Lachlan Marshes

On the twenty-fourth of March [1817] I received the instructions of his excellency the Governor to take charge of the expedition which had been fitted out for the purpose of ascertaining the course of the Lachlan River, and generally to prosecute the examination of the western interior of New South Wales. . . .

[Leaving Sydney on 6 April Oxley arrived at Bathurst eight days later.] Bathurst had assumed a very different appearance since I first visited it in the suite of his excellency the Governor in 1815. The industrious hand of man had been busy in improving the beautiful works of nature; a good substantial house for the superintendant had been erected, the government grounds fenced in, and the stackyards showed that the abundant produce of the last harvest had amply repaid the labour bestowed on its culture. The fine healthy appearance of the flocks and herds was a convincing proof how admirably adapted these extensive downs and thinly wooded hills are for grazing, more particularly of sheep. . . .

Sunday, April 20. Proceeded on our journey towards the Lachlan River. At two o'clock we arrived at the head of Queen Charlotte's Valley, passing through a fine open grazing country; the soil on the hills and in the vale a light clayey loam, occasionally intermixed with sand and gravel: the late rains had rendered the ground soft and boggy. The trees were small and stunted, and thinly scattered over the hills, which frequently closed in stony points on the valley. The rocks a coarse granite. . . .

April 25. . . . At two o'clock we saw the river which certainly did not disappoint me. . . .

April 29. Proceeded on our journey down the river, directing the boats to stop at the creek which terminated Mr. Evans's former journey [down the Lachlan in 1815]. . . .

May 6. Proceeded down the river. It is impossible to fancy a worse country than the one we were now travelling over, intersected by swamps and small lagoons in every direction; the soil a poor clay, and covered with stunted useless timber. . . . [They were between the present-day towns of Forbes and Condobolin.]

May 11. . . . If we had been so unfortunate as to have had a rainy season, it would have been utterly impossible to have come thus far by land. . . . Here we were so unfortunate as to find the barometer broken, the horse which carried the instruments having thrown his load in passing the swamps. . . .

May 12. The fine weather still continues to favour us. The river rose in the course of the night upwards of a foot. It is a probable supposition that the natives, warned by experience of these dangerous flats, rather choose to seek a more precarious, but more safe subsistence in the mountainous and rocky ridges which are occasionally to be met with. The river and lagoons abound with fish and fowl, and it is scarcely reasonable to suppose that the natives would not avail themselves of such store of food, if the danger of procuring it did not counterbalance the advantages they might otherwise derive from such abundance.

'Field Plains from Mount Amyot' — an etching from Oxley's journal. Field Plains were named after Barron Field, a judge of the Supreme Court of New South Wales who was keenly interested in geographical discovery. Neither of the above names are now used — but Oxley was referring to an area near the marshes of the Lachlan River, in the vicinity of present-day Forbes.

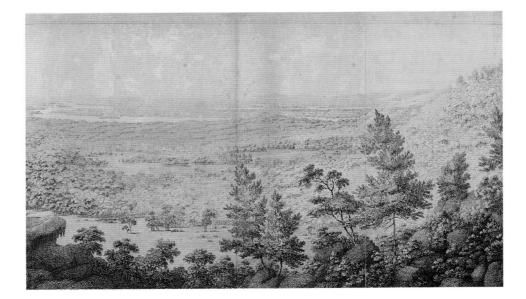

About three quarters of a mile farther westward we had to cross another small arm of the river, running to the northward, which although now full, is, I should think, dry when the river is at its usual level. It is probable that this and the one which we first crossed join each other a few miles farther to the westward, and then both united fall into the stream which gave them existence. We had scarcely proceeded a mile from the last branch, before it became evident that it would be impossible to advance farther in the direction in which we were travelling. The stream here overflowed both banks, and its course was lost among marshes: its channel not being distinguishable from the surrounding waters.

Observing an eminence about half a mile from the south side, we crossed over the horses and baggage at a place where the water was level with the banks, and which when within its usual channel did not exceed thirty or forty feet in width, its depth even now being only twelve feet.

We ascended the hill, and had the mortification to perceive the termination of our research, at least down this branch of the river: the whole country from the west north-west round to north was either a complete marsh or lay under water, and this for a distance of twenty-five or thirty miles, in those directions. . . .

May 13. Returned to the point whence the river separates into two branches. . . .

May 14. . . . Finding that it would be equally as impracticable to follow this branch as the other, I returned and commenced preparations for setting out for the coast. . . .

My present intention is to take a south-west direction for Cape Northumberland, since should any river be formed from these marshes, which is extremely probable, and fall into the sea between Spencer's Gulf and Cape Otway, this course will intersect it, and no river or stream can arise from these swamps without being discovered. . . .

May 18. [The boats were left on the Lachlan while the party moved off to the southwest.] At nine o'clock we commenced our journey towards the coast; at three stopped within four miles of Mount Maude, on a dry creek, with occasional pools of very indifferent water. . . .

May 20. . . . The country through which we passed being a perfect plain overrun with acacia scrubs, we could not see in any direction above a quarter of a mile; I therefore halted at two o-clock on purpose to gain time to find water before sun-set, as we had seen no other signs of any on our route than a few dry pits. It is impossible to imagine a more desolate region; and the uncertainty we are in, whilst traversing it, of finding water, adds to the melancholy feelings which the silence and solitude of such wastes is calculated to inspire. . . .

June 5. . . . Yesterday, being the King's birthday, Mr. Cunningham planted under Mount Brogden acorns, peach and apricot-stones, and quince-seeds, with the hope rather than the expectation that they would grow and serve to commemorate the day and situation, should these desolate plains be ever again visited by civilized man, of which, however, I think there is very little probability [they were in the vicinity of present-day Griffith]. . . .

June 18. . . . As if to add to our misfortunes, it was now first discovered that three of the casks, which had all along been taken for flour casks, were filled with pork. . . .

June 21. Fine mild weather: at eight o'clock set forward on our journey. The farther we proceed north-westerly, the more convinced I am that, for all the practical purposes of civilized man, the interior of this country westward of a certain meridian is uninhabitable, deprived as it is of wood, water, and grass. . . .

June 23. . . . After going eight miles and a quarter, we suddenly came upon the banks of the river; I call it the river, for it could certainly be no other than the Lachlan, which we had quitted nearly five weeks before. Our astonishment was extreme, since it was an incident little expected by any one. . . .

June 24. . . . At nine o'clock we set forward down the river; our course lay westerly, and by three o'clock we had gone nearly twelve miles in that direction; when we stopped for the night on the banks of the river near the termination

'The Grave of a Native of Australia'. This engraving in Oxley's journal was taken from a drawing by George Evans. Of one such grave Oxley wrote 'I hope I shall not be considered as either wantonly disturbing the remains of the dead, or needlessly violating the religious rites of an harmless people, in having caused the tomb to be opened, that we might examine its interior construction'

of Macquarie's Range, the north point of which I named Mount Porteous. . . .

Whilst the horses were coming up, I set off, accompanied by Mr. Cunningham, for the purpose of ascending Mount Porteous: the view from it by no means re-paid us for our trouble; the same everlasting flats met our eye in every direction westerly round nearly to north. . . .

June 28. . . . Our principal object being to keep as close to the stream as possible, with reference to the ability of the horses to travel over the ground. . . . The route taken by Mr. Evans and the horses led along the edge of extensive morrasses covered with water; we proceeded nine or ten miles, when the morrasses almost assumed the appearance of lakes; very extensive portions of them being free from timber, and being apparently deep water. South of the edge of the morass along which we travelled, the country was a barren scrub, and in places very soft; the horses falling repeatedly during the day. . . .

June 30. . . . There was not the least appearance of natives; nor was bird or animal of any description seen during the day, except a solitary native dog. Nothing can be more melancholy and irksome than travelling over wilds, which nature seems to have condemned to perpetual loneliness and desolation. We seemed indeed the sole living creatures in those vast deserts.

The plains last travelled over were named Molle's Plains, after the late lieutenant-governor of the territory; and those on the opposite side, Baird's Plains, after the general to whom he once acted as aide-de-camp, and whose glory he shared. The naming of places was often the only pleasure within our reach; but it was some relief from the desolation of these plains and hills to throw over them the associations of names dear to friendship, or sacred to genius. In the evening three or four small fish were caught. . . .

July 7. At eight o'clock, taking with me three men, I proceeded to follow the course of the stream; I attempted in the first instance to keep away from the banks, but was soon obliged to join them, as the morasses extended outwards and intersected my proposed course in almost every direction. . . .

'Two Kangaroos in a Landscape', by John Lewin, 1819.

Had there been any hill or even small eminence within thirty or forty miles of me they must now have been discovered, but there was not the least appearance of any such, and it was with infinite regret and pain that I was forced to come to the conclusion, that the interior of this vast country is a marsh and uninhabitable. . . . [The party had reached its westernmost point on the marshes of the Lachlan somewhere between the present towns of Booligal and Oxley, and only a few miles from the Murrumbidgee River.]

July 9. . . . At half-past eight we set out on our return eastward, every one feeling no little pleasure at quitting a region which had presented nothing to his exertions but disappointment and desolation. Under a tree near the tent, inscribed with the words "Dig under," we buried a bottle, containing a paper bearing the date of our arrival and departure, with our purposed course, and the names of each individual that composed the party. . . .

July 11. At nine, again set forward on our return up the river, and it was near four o'clock before we arrived at a convenient halting-place on its banks; the river presented a most singular phenomenon to our astonished view. That river which yesterday was so shallow that it could be walked across, and whose stream was scarcely perceptible, was now rolling along its agitated and muddy waters nearly on a level with the banks. . . .

July 29. . . . It was determined that as we had now ascertained the course of the Lachlan, from the depot to its termination, any farther trace of it, running as it did from the south-east, would take us materially out of our purposed course to Bathurst, without answering any good purpose, at the same time that we should entangle ourselves in the marshy grounds which had been seen both from Mount Cunningham, Farewell Hill, and our present station; and that therefore we should immediately proceed to construct a raft on which we might transport our provisions and baggage across the river, afterwards taking such a course as we deemed most likely to bring us to the Macquarie river, and so keep along its banks to Bathurst. . . .

August 6. . . . The range continued in short broken hills for upwards of three miles and a half, and led through such a country as distressed both men and horses exceedingly. . . .

Our search after water was not attended with success, but the ground being extremely boggy, we were in hopes of procuring a little by digging. Our spade, which had so unfortunately been left at Bathurst, would now have been of the most essential service, but the carpenter's adze proved a useful substitute. . . .

August 14. We had now come from the river Lachlan upwards of an hundred miles in a north-east direction, without being so fortunate as to fall in with the Macquarie. . . .

August 19. . . . A mile and a half brought us into the valley which we had seen on our first descending into the glen: imagination cannot fancy anything more beautifully picturesque than the scene which burst upon us. . . . In the centres of this charming valley ran a strong and beautiful stream, its bright transparent waters dashing over a gravelly bottom. . . .

Whilst we were waiting for the horses to come up we crossed the stream, and wishing to see as much of the country on its banks northerly, as possible, I proceeded down the stream, and had scarcely rode a mile when I was no less astonished than delighted to find that it joined a very fine river, coming from the east-south-east from among the chain of low grassy hills, bounding the east side of the valley in which we were. This then was certainly the long sought Macquarie, the sight of which amply repaid us for all our former disappointments. Different in every respect from the Lachlan, it here formed a river equal to the Hawkesbury at Windsor, and in many parts as wide as the Nepean at Emu Plains. . . .

August 29. At eight o'clock we proceeded towards Bathurst, hoping to reach it by the evening. . . .

The hospitable reception which we met with from Mr. Cox went far to banish all present care from our minds: relieved, as they were, by the knowledge that our friends were well, we almost forgot in the hilarity of the moment, that nineteen harassing weeks had elapsed since we last quitted it. . . . [They had travelled 1930 kilometres.]

From Bathurst to Port Macquarie

May 20, 1818. Having received his Excellency the Governor's instructions for the conduct of the expedition intended to examine the course of the Macquarie River, and every preparation having been made at the depot in Wellington Valley [near present-day Wellington] for that purpose, I quitted Sydney in company with Dr. Harris [John Harris] (late of the 102d foot), and after a pleasant journey arrived at Bathurst on the 25th. Our little arrangements having been completed by the 28th, we again set forward with the baggage horses and men that were to compose the expedition. . . .

We did not meet with the slightest interruption, and arrived at the depot on the 2d of June, where we found the boats &c. in perfect readiness for our immediate reception. . . .

June 4. Got all the horses and provisions over to the north side of the river, and made every preparation to pursue our journey on the morrow. The river rose about a foot during the day. The accident which had befallen our barometer during the former expedition not being repaired, we are of course deprived of means to make any observations on the height of the country above the sea, otherwise than by careful observation of the several falls or rapids. . . .

June 7. Proceeded on our journey, both boats and horses being very heavily laden with our stores and provisions. . . . The river had many fine reaches, extending in straight lines from one to three miles, and of a corresponding breadth. The rapids, although frequent, offered no material obstruction to the boats. . . .

June 20. The night cold, a sharp frost congealing some standing water by the river's side. . . . Having gone upwards of one hundred and twenty-five miles from Wellington Valley, I thought it advisable that the two men who accompanied us for that purpose should return to Sydney with an account of our proceedings, agreeably to the governor's instructions. . . .

June 21. The result of the observation this day gave for our situation lat. 31.49.60S., long. 147.52.15.E. . . .

June 23. Having despatched Thomas Thatcher and John Hall to Bathurst, with an account of our progress, the expedition set forward down the river. . . .

June 24. . . . The brushes were most numerous and perplexing in the neighbourhood of the river, a course we were obliged to keep, in order not to part company with the boats. The country two or three miles along the banks of the river was only partially flooded, the land being much lower at a greater distance from it; the most part of the soil was a rich, alluvial deposition from floods. Except on those clear plains which occasionally occurred on the sides of the river, we could seldom see beyond a quarter of a mile. Byrne, who was at the head of the hunting party, surprised an old native man and woman, the former digging for rats, or roots, the other lighting a fire: they did not perceive him till he was within a few yards of them, when the man threw his wooden spade at Byrne, which struck his horse; then taking his old woman by the hand, they set off with the utmost celerity, particularly when they saw the dogs, of which they seem to entertain great fears. In the evening, natives were heard on the opposite side of the river, but none came within view. . . .

June 30. . . . For all practical purposes, the nature of the country precluded me from indulging the hope, that even if the river should terminate in an inland sea, it could be of the smallest use to the colony. The knowledge of its actual termination, if at all attainable, was, however, a matter of deep importance, and would tend to throw some light on the obscurity in which the interior of this vast country is still involved. My ardent desire to investigate as far as possible this interesting question, determined me to take the large boat, with four volunteers to proceed down the river as long as it continued navigable. . . .

'A Map of New South Wales, from the best Authorities and from the Latest Discoveries 1825', by Joseph Lycett. Virtually all the exploratory routes shown in this map are those of Oxley's two expeditions into the interior of New South Wales.

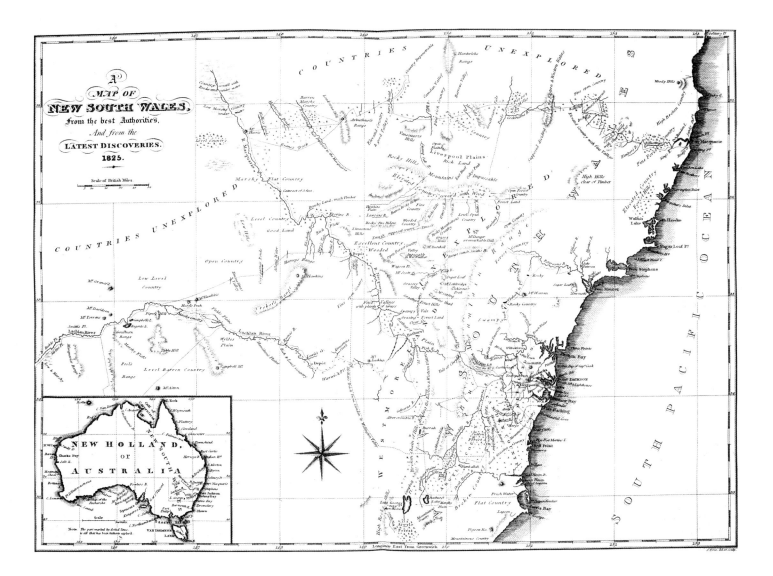

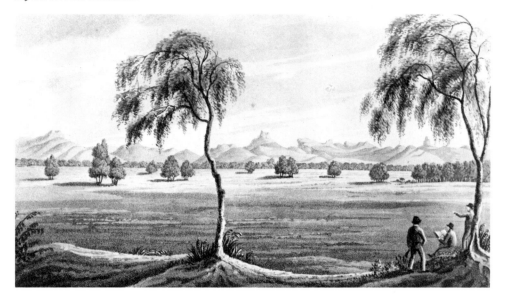

July 3. . . . After going about twenty miles, we lost the land and trees: the channel of the river, which lay through reeds, and was from one to three feet deep, ran northerly. This continued for three or four miles farther, when although there had been no previous change in the breadth, depth, and rapidity of the stream for several miles, and I was sanguine in my expectations of soon entering the long sought for Australian sea, it all at once eluded our farther pursuit by spreading on every point from north-west to north-east, among the ocean of reeds which surrounded us, still running with the same rapidity as before. There was no channel whatever among those reeds, and the depth varied from three to five feet [they were on the Macquarie Marshes]. . . . To assert positively that we were on the margin of the lake or sea into which this great body of water is discharged, might reasonably be deemed a conclusion which has nothing but conjecture for its basis; but if an opinion may be permitted to be hazarded from actual appearances, mine is decidedly in favour of our being in the immediate vicinity of an inland sea, or lake, most probably a shoal one, and gradually filling up by immense depositions from the higher lands, left by the waters which flow into it. It is most singular, that the high-lands on this continent seem to be confined to the sea-coast, or not to extend to any great distance from it. . . .

July 18. . . . We had a reason to congratulate ourselves on the change of our situation: a delay of a few days would have swept us from the face of the earth. On the 10th, the river began to rise rapidly, and on the 15th, in the evening it was at its height, laying the whole of the low country under water, and insulating us on the spot on which we were; the water approaching within a few yards of the tent. . . . By this morning the waters had retired as rapidly as they had risen, leaving us an outlet to the eastward, though I feared that to the north-east the waters would still remain. In the evening Mr. Evans returned, after an interesting though disagreeable journey. His horses were completely worn out by the difficulties of the country they had travelled over. His report, which I shall give at length [included in an appendix in Oxley's journal], decided me as to the steps that were now to be pursued; and I determined on making nearly an easterly course to the river which he had discovered, and which was now honoured with the name of Lord Castlereagh. This route would take us over a drier country, and the river being within a short distance of Arbuthnot's range [now known as the Warrumbungles] would enable me to examine from those elevated points the country to the north-east and east; and to decide how far it might be advisable to trace the river, which it is my present inclination to do as long as its course continues to the eastward of north. . . .

July 20. The morning was fine; and after much contrivance, we succeeded in taking with us whatever was essential to our future security, and the whole of the provisions except two casks of flour. The horses were, however, very heavily laden, carrying at least three hundred and fifty pounds each; a weight

which I was fearful the description of country we had to pass over would render still more burthensome. We had, however, relinquished everything that was not indispensable, and the saddle horses were equally laden with the others. Mount Harris, under which we had remained for the last fortnight, is in lat. 31.18.S. long. 147.31.E. and variation 7.48. On the summit of the hill we buried a bottle, containing a written scheme of our purposed route and intentions, with some silver coin. . . .

July 25. At nine o'clock we set forward with anxious hopes of reaching Castlereagh River in the course of the day; we struggled for nine miles through a line of country that baffles all description: we were literally up to the middle in water the whole way, and two of the horses were obliged to be unladen to get them over quicksand bogs. Finding a place sufficiently dry to pitch our tent on, though surrounded by water, we halted, both men and horses being too much exhausted to proceed farther. Mr. Evans thinking we could not be very far from the river, went forward a couple of miles, when he came upon its banks. This same river, which last Wednesday week had been crossed without any difficulty, was now nearly on a level with its first or inner bank. . . .

Owing most probably to the violent motion it experienced, my chronometer stopped: this accident was the more to be lamented, as the watch with which I was furnished by the crown had also stopped, and we had now nothing to regulate our time by. [Without a chronometer, it was almost impossible to make calculations of longitude.]

July 26. We passed a dreadful night; the elements seemed to be bursting asunder, and we were almost deluged with rain. . . . An inmate of an alarming description took up its lodging in our tent during the last night, probably washed out of its hole by the rain: a large diamond snake was discovered coiled up among the flour bags, four or five feet from the doctor's bed.

July 27. This morning the weather cleared up just in time to enable us to retreat to the river banks in safety, for we were washed out of the tent. The provisions and heavy baggage were carried by the people to a firmer spot of ground, at which place the horses being lightly laden, we got every thing transported to the river by one o'clock. Castlereagh River is certainly a stream of great magnitude. . . . This river doubtless discharges itself into that interior gulf, in which the waters of the Macquarie are merged. . . .

August 3. A dark cloudy morning. At nine o'clock proceeded on our eastern course towards Arbuthnot's Range. . . . The rain had rendered the ground so extremely soft and boggy, that we found it impossible to proceed above three-quarters of a mile on our eastern course. We therefore returned, resolving to keep close to the river's edge, until we should be enabled to sound the vein of quagmire, with which we appeared to be hemmed in. In this attempt we were equally unfortunate, the horses falling repeatedly: one rolled into the river, and it was with difficulty we saved him: my baggage was on him, and was entirely spoiled; the chartcase and charts were materially damaged, and our spare thermometer broken. . . .

August 26. While Mr. Evans proceeded with the horses on an eastern course for Mount Tetley, Dr. Harris and myself went towards the spacious valley at the foot of Whitwell Hill. . . . On ascending this hill, the view which was on all sides presented to our delighted eyes was of the most varied and exhilarating kind. Hills, dales, and plains of the richest description lay before us, bounded to the east by fine hills, beyond which were seen elevated mountains. . . . [Some of Oxley's names for geographical features are no longer used. The explorers had skirted the Nandewar Ranges and were looking out over the Liverpool Plains.]

September 1. We pursued our course to the east north-east, winding through rich valleys bounded by lofty forest hills for seven miles; when by a gentle descent we entered a rich and spacious vale, bounded on the east by very high hills, and on the west by others less elevated. . . .

September 2. Our expectations of finding a river to the eastward, were this day verified. . . . The river was named Peel's River in honour of the Right Hon. Robert Peel. . . . [They were in the vicinity of present-day Tamworth and about to cross the Great Dividing Range.]

September 12. We were obliged during the whole of this day's journey, to

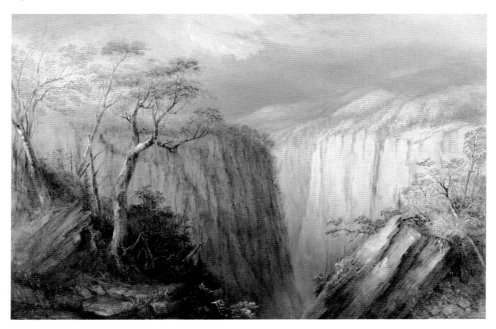

keep along the ridge bordering on the glen. It is impossible to form a correct idea of the wild magnificence of the scenery without the pencil of a Salvator. Such a painter would here find an ample field for the exercise of his genius. How dreadful must the convulsion have been that formed these glens! . . . The ridge along which we travelled was, as might be expected, very stony. It was otherwise open forest land, thickly timbered with large, stringy bark trees, casuarinae, and a large species of eucalyptus. Kangaroos abounded on it, and the tracks of emus were also seen. . . .

September 15. We first attempted the pass nearest to us, and which was reported to be practicable. The horses with tolerable ease descended the first ridge, which was about one third down; but it was impossible to proceed a step farther with them: indeed we had the utmost difficulty to get them back again. Three of them actually rolled over, and were saved only by the trees from being precipitated to the bottom. . . .

September 22. A dark tempestuous morning. . . . The rain ceasing, was succeeded about nine o'clock by one of the severest storms of wind I ever remember to have witnessed; and for the first time perhaps during the journey, we were alarmed for our personal safety. The howling of the wind down the sides of the mountain, the violent agitation of the trees, and the crash of falling branches, made us every instant fear that we should be buried under the ruins of some of the stupendous trees which surrounded us.

September 23. Towards midnight the storm abated, and allowed us to pass the remainder of the night in comparative comfort. The morning broke fair, and as the state of the horses would not permit us to attempt ascending the mountain with the baggage today, I contented myself with despatching them for the provisions left last night at the foot of the precipice, and to get up if possible the two remaining horses, whilst Mr. Evans and myself should explore the range, and endeavour to find out a somewhat more practicable route. We proceeded to ascend the mountain, the summit of which was near two miles distant and in many places extremely difficult and abrupt. We however remarked on our road seven native huts, which increased our hopes that these mountains would lead by a comparatively easy descent to the coast line of country. Bilboa's ecstacy at the first sight of the South Sea could not have been greater than ours, when on gaining the summit of this mountain [now Mount Seaview], we beheld Old Ocean at our feet; it inspired us with new life: every difficulty vanished, and in imagination we were already at home. . . .

September 24. At eight o'clock the horses began to ascend the mountain . . . a distance of scarcely two miles. How the horses descended, I scarcely know; and the bare recollections of the imminent dangers which they escaped, makes me tremble. . . .

September 26. We proceeded between four and five miles down the river, which was named Hastings River, in honour of the Governor General of India; the vale gradually opening into a greater width between steep and lofty hills, the soil on which was very stony, but rich, and covered with fine grass two or three feet high. At the place where we stopped, small rich flats began to extend on either side, and confirmed our hopes that we should find a more regular country as we approached the sea. . . .

October 4. We could distinctly hear, during the night, the murmurs of the surf on the beach, and the sound was most grateful to our ears, as the welcome harbinger of the point to which eighteen weeks of anxious pilgrimage had been directed. . . .

October 8. . . . [We] passed over an excellent and rich country; alternately thick brush and clear forest, with small streams of water for near four miles more, when, to our great joy and satisfaction, we arrived on the sea-shore about half a mile from the entrance of what we saw (with no small pleasure), formed a port to the river which we had been tracing from Sea View Mount. Thus, after twelve weeks travelling over a country exceeding three hundred and fifty miles, in a direct line from the Macquarie River, without a single serious fatality, we had the gratification to find that neither our time nor our exertions had been uselessly bestowed; and we trusted that the limited examination, which our means would allow us to make of the entrance of this port, would ultimately throw open the whole interior to the Macquarie River, for the benefit of British settlers. . . .

October 11. . . . I named this inlet, Port Macquarie, in honor of His Excellency the Governor, the original promoter of these expeditions.

October 12. . . . We quitted Port Macquarie at an early hour on our course homewards with all those feelings which that word even in the wilds of Australia can inspire. . . .

After travelling along the coast, at times through swampy country, the explorers arrived at Port Stephens. Evans and three others crossed in the party's own boat to Newcastle where the commandant, Captain Wallis of the 46th Regiment, sent a vessel large enough to convey them to Sydney.

The convict artist, Joseph Lycett painted this view of Port Macquarie two or three years after the first settlement there in 1821.

'Corroboree', by Captain James Wallis, who was the commandant at Newcastle when Oxley's party arrived at Port Macquarie.

2

The Inland Pathfinders

Hamilton Hume (1797–1873) was a native-born Australian who took to exploring as a young man. With Dr Charles Throsby and surveyor James Meehan he explored the country to the south of Sydney, he and Meehan penetrating as far as the Goulburn Plains by 1818. In 1821 he discovered the Yass Plains and soon took up land there. Meanwhile Throsby had established his estate Throsby Park at Moss Vale, and in 1820 his convict overseer Joseph Wild found a new lake south of Goulburn. Of this Throsby wrote:

The lake is called by the natives Warrewaa [Lake George], and is stated by them to empty its waters in a southerly direction . . . by a river they call Murrumbid-gee.[1]

In March 1821 Throsby explored the country around what is now Canberra:

I met with vast quantities of limestone . . . the country in the neighbourhood appeared to me likely to afford a great source of amusement, if not profit to the minerologist. . . . I also saw a large number of fish swimming with their noses just above the water. . . .[2]

Cattlemen quickly made good use of Throsby's discovery of the Limestone Plains and were keen to find further pasture. In 1823 Captain Mark Currie left Throsby's farm, in company with Captain John Ovens and Joseph Wild, to explore the land south of Lake George. They found the South Fish (Queanbeyan) River and met an Aboriginal tribe who informed them 'that the clear country before us was called Monaroo'.[3]

By 1824 settlement had spread as far south as Yass towards what is now the Australian Capital Territory, and other adventurers were nudging their way inland from the coast. One of these was Alexander Berry who, with Hume and others, rowed up the Clyde River from Batemans Bay, followed by 'a journey of four days into the interior' towards present-day Braidwood.[4] Such journeying had resulted in Hume becoming, by 1824, an experienced bushman and now the time was ripe for the opening of a land route south from Sydney, parts of which would subsequently become known as the 'Hume Highway'. Later Hume was to serve as a very competent second-in-command on Sturt's 1828 expedition.

William Hovell (1786–1875) came to Australia in 1813 and after several years commanding trading vessels for the merchant Simeon Lord took up land

Lake George, near present-day Canberra, was discovered in 1820 and was soon visited by many travellers including Governor Macquarie. Joseph Lycett included this picture amongst his Views in Australia, *published in London in 1824–25.*

1. 'Discovery of Lake Warrewaa', National Library of Australia Pamphlets, Vol. 297.

2. Charles Throsby's letter recounting his excursion south of Lake George is in *The Australian Magazine; or Compendium of Religious, Literary, and Miscellaneous Intelligence.* Sydney, 1821.

3. Mark John Currie, 'Journal of an Excursion to the Southward of Lake George in New South Wales', in Barron Field, *Geographical Memoirs on New South Wales; by Various Hands.* . . . London, 1825.

4. Alexander Berry, 'On the Geology of part of the Coast of New South Wales', in Barron Field, *Geographical Memoirs.*

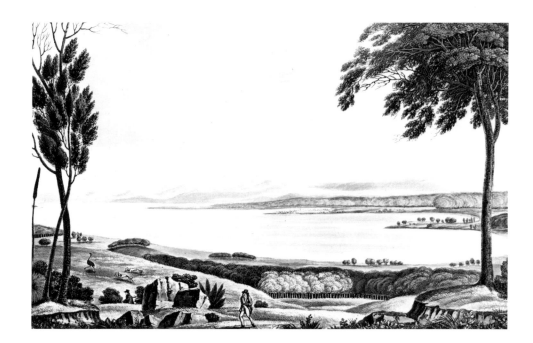

at Narellan, in New South Wales. He had already made some short explora-
tory journeys before he joined forces with Hume. Of the two, Hovell was
better able to calculate position, although this unfortunately did not prevent
them from thinking they had arrived at Westernport when in fact they had
reached Corio Bay at Port Phillip. Hovell realised the mistake when, a year
after their return to Sydney, he joined a party which travelled to Westernport
by sea.

In later years there was an unfortunate public disagreement between
Hume and Hovell regarding this incident and their relative importance as
explorers. It was from Hovell's prosaic diary that William Bland, in 1831,
substantially compiled his account of Hume and Hovell's journey from which
the following extracts are taken.[5] In his preface to the journal Dr Bland apolo-
gised for the lateness of the publication, due partly to a shortage of paper in
the colony.

S aturday, October 2, 1824. Messrs. Hovell and Hume having met, as it lay
in their route, at Mr. Hume's house, commenced their journey from Appin, in
the County of Cumberland, accompanied by six men, a couple of carts, contain-
ing their supplies, drawn by four bullocks, and two horses, having also one spare
horse, and a spare bullock; and each of the men as well as themselves provided
either with a musket or fowling-piece. At seven, they halt for the night, opposite
to a point of land called Bird's-eye corner, on the Cowpasture, or Nepean,
River. . . .

Wednesday, October 6. Arrive at the watering place in the Mittigong
range, by ten o'clock in the forenoon; here halt. The weather sultry. At two in
the afternoon, again move forward; cross the Bong-Bong river by five o'clock,
and rest on its banks for the night. The distance from Meehan's forest to
Mittigong, seven miles and a half, thence to the river, six and a half; the total
distance travelled today, fourteen miles. . . .

Sunday, October 10. Mr. Hovell goes to Dr. Reid's house, and thence to
Mr. Surveyor Harper's tent, at Jocqua, that he may compare their own
compasses with those of Mr. Harper. On his return finds Mr. Hume and Mr.
Barber, at Dr. Reid's house. The latter part of the day cloudy and attended with
rain; and during the night heavy and continued rain, accompanied at intervals
with squalls from the eastward. . . .

Thursday, October 14. Messrs. Hume and Hovell, with two of the men,
proceed to Lake George, in order to ascertain the bearings and distance of the
Lake from Mr. Hume's station. . . . The Lake . . . is distant from Mr. Hume's
station about twelve miles. . . .

Sunday, October 17. Leave Mr. Hume's station (the last which is settled
or occupied by the colonists) without a guide; travel twelve miles S. 60 W.
(through a country affording good pastureage for cattle, thinly wooded and well
watered) then rest for the night. The soil, near the spot where they halt, is
composed principally of coarse schistus and granite. . . .

Tuesday, Oct 19. Resume their journey. . . . Yarrh, Yass, or McDougall's
Plains . . . consist for the most part, of clear land generally level. The soil dry
and good. . . . At three o'clock this afternoon, they found themselves on the
banks of the Murrumbidgee river. . . . The river, however, is so swollen by the
late rains, that it appears utterly impassable, and it is evidently rising. . . .

Friday, October 22. . . . One of the carts is made to supply the place of
a punt or boat, and the end of a tow-rope, having been conveyed across the
river, in the course of four or five hours, the whole of the supplies, including
the second cart is landed, without loss or injury, on the left bank of the Murrum-
bidgee. The horses and bullocks are now conducted separately across the stream,
though not without much difficulty, and considerable risk, by means of the tow-
rope. By five o'clock, every thing had been readjusted; and they rest for the night
on the banks of the stream, a short distance from the place at which they had
crossed. The weather during the earlier part of the day, cloudy and showery;
towards evening, squalls, accompanied at intervals with heavy rain.

Monday, November 1st. Thermometer at sunrise, 50; at noon 89 in the

Overland to Port Phillip

William Hilton Hovell.

5. W. Bland (ed.), *Journey of Discovery to Port
Phillip, New South Wales, by Messrs. W. H. Hovel,
and Hamilton Hume: in 1824 and 1825.* Sydney,
1831.

Andrew Hamilton Hume.

tent. As there was here sufficient and good feed for the cattle, which had had but scanty fare, and were much fatigued by the last three days journey, they resolve to halt for the day, intending to employ themselves in making preparations for a good journey on the morrow. A large kangaroo was killed, and a lobster was caught in the river, twelve or thirteen inches long, and of an excellent flavour. They sow some clover seed, and a few peach stones, a practice which they had observed at every place at which they had stopped since the 19th of the last month. . . .

Wednesday, November 3. Weather cloudy; indications of rain. They start at sunrise; proceed towards the river, and after having travelled three miles in the direction about S. 20 deg. W. arrive on its banks. This stream, which they name the "Medway" [Tumut River], proves to be about 100 feet wide, has a strong current, and is of various depths. . . .

Thursday, November 4. . . . During the last four days and nights, they have been tormented by swarms of little flies; these by day, and a large species of musquito by night, were found extremely distressing. . . .

Friday, November 5. At sunrise, having proceeded along the causeway, or ridge, they commence ascending the mountain [they were crossing the Bago Range], to which the extremity of it is attached; when having arrived about a furlong from the summit they find it necessary to unload the cattle, and for the men to carry up the loads, the ascent having become so steep, that the cattle are at every moment in danger of slipping or falling, in which event they would be precipitated down this steep descent, and be inevitably dashed to pieces: the mountain, part of which rises at an angle of 50 deg. and much of it at that of 45 deg. being at least a mile in extent, in a direct line from the foot to the summit. . . .

Saturday, November 6. . . . They now descended the table range pursuing the zig-zag course of one of the little tributaries of the stream which they had observed in the valley, taking its rise in these mountains, not far below the spot at which they commence making their descent. . . . In effecting the descent from these mountains, they had nearly lost one of the party, as well as a bullock; the animal had fallen when it had reached about two-thirds down the mountain, in consequence of the slipping of a stone from under its feet, and in its fall, it had forced down with it, the man who was leading it. But their fall was intercepted by a large tree, and the man, as well as the animal, was thus prevented from being dashed to pieces. The man, however, unfortunately, was much hurt.

Map of Australia from Moreton Bay to the New Colonies in Australia Felix, showing routes followed by Hovell and Hume, and Mitchell.

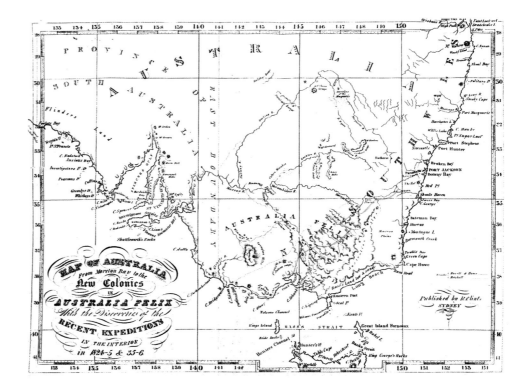

Never was the superiority of bullocks to horses ... for journeys of this description, more observable than in the progress of this dangerous and difficult descent. . . .

Monday, November 8 [near present-day Tumbarumba]. . . . Messrs. Hovell and Hume having ascended, close to the stream, with some difficulty, about half the height of this range, in order to be the better enabled to decide as to their future operations, were suddenly surprised by a sight, to the utmost degree magnificent. Mountains, of a conoidal form, and of an apparently immense height, and some of them covered about one fourth of their height with snow, were now seen extending semicircularly from the S.E. to S.S.W. at the supposed distance of about twenty miles. The sun was bright (it was about ten or eleven in the forenoon), and gave them an appearace the most brilliant.

The mountains which they had hitherto seen, compared with these stupendous elevations were no more than hillocks; from which, also their form, as well as their other general characters, rendered them not the less dissimilar.

The men no sooner heard of this unexpected and interesting scene than, catching the enthusiasm, they ran to the spot where the travellers were standing, and were not less than themselves surprised and delighted at this pre-eminently grand and beautiful spectacle. . . .

Thursday, November 11th. . . . During the entire period that they have been among the mountains, the cattle have been . . . totally unable to feed during the day, and but little at night, from the incessant and almost equally tormenting attacks of the musquitoes. . . .

Friday, November 12th. They travel to-day thirteen miles to the southward and westward. . . . Here, on their left, the country consisted of the terminations of the collateral branches of those mountainous or hilly regions over which they had hitherto been travelling. . . .

Tuesday, November 16. Soon after sunrise they re-commence their journey, and having proceeded three miles and a half S. (the land gradually sloping as they advanced), arrive suddenly on the banks of a fine river. This was named "The Hume" [Sturt subsequently renamed it the Murray River]. . . .

Friday, November 19. . . . The general appearance of the country, together with that of the soil, is rich and beautiful. . . . On both sides of the river, the "bell-birds" are "ringing merrily", a treat hitherto unusual, this being only the second time, that they have met with this delightful bird since their departure from the Cowpastures. . . .

Saturday, November 20. Weather fine, and extremely pleasant; this morning they cross the river: this they effect by means of a temporary boat, hastily constructed (of wicker, covered with the tarpauling) for the occasion, and by four in the afternoon, every thing, including the cattle, had been landed on the opposite bank. . . . [They were near present-day Albury.]

Tuesday, November 23. . . . As they approach the mountains, as usual on these occasions, the flies and musquitoes are again becoming troublesome; to escape from which they are glad to submit to a state of half suffocation from smoke. The horses too are literally crippled from want of shoes. The thermometer, at sunset, 62 deg.; at noon, 72 deg. Killed two snakes, both of a dark brown colour.

Wednesday, November 24. . . . Four miles and a quarter from the spot from which they had last started, they arrive at the north or right bank of another (the 8th) river. . . . The river comes from the eastern chain of mountains, and very probably joins the Hume, though perhaps at a considerable distance to the westward. They name this river the "Ovens," after the deceased Major Ovens, the late Governor, Sir Thomas Brisbane's Private Secretary. . . .

Thursday, November 25. . . . Four miles and a half from the "Ovens" they reach the summits of a range, whence they obtain a view of that river, coming from East by North, and evidently deriving its waters, from part of the "Alpine Chain." One of these snow-capped mountains, is now in sight, bearing South East, distant about twenty miles, there is also a singularly formed mountain, in the same direction, but much nearer, which from its shape, they name "Mount Buffalo". . . . All the country in their line af [sic] route to-day, had been burned, and a little to the Westward of this line, the grass was still blazing to a consider-

'View on the Upper Mitta Mitta', by the landscape artist Eugen von Guérard, painted some fifty years after Hume and Hovell travelled through this area.

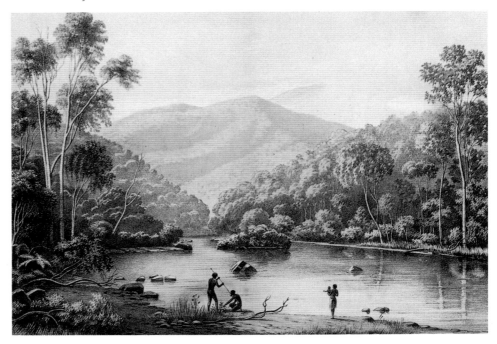

able height. At noon having travelled seven miles, they rest near some water holes, on a small plot of good grass, which had most fortunately escaped the ravages of the flames. . . . The crossing of these ranges was dreadfully distressing to the cattle. A little before sunset they pitched their tent near some water holes. The grass good. The natives evidently numerous. . . .

Friday, December 3. Proceeding S.W. in the course of the creek twelve or thirteen miles, they arrive, as they had expected, on the banks of another river. . . . The river they cross, as on a former occasion, by means of a large tree which lay extended from bank to bank. . . . [They were on what is now Eildon Reservoir and the river was named Goulburn after the colonial secretary. It was later changed to the Hovell, but is now again called the Goulburn River.]

Tuesday, December 7th. . . . They now ascend a very high stony range, lying in about the directions N.W. and S.E. a most toilsome task for the cattle. By nine they arrive on its summits, when they find to their great disappointment that they have to descend its S.W. aspect, there being no connecting range, between this and another range, which is of yet greater height, running parralel with it, in their advance. They descend accordingly and having rested about two hours, commence climbing the next range, when after two hours toil, they arrive on the summits of this also. Here, however, they find themselves completely at a stand, without clue or guide as to the direction in which they are to proceed; the brush wood so thick that it was impossible to see before them in any direction ten yards. They proceed therefore a mile and a quarter by guess, with two men ahead, cutting a route through the brush for the cattle. During this operation they were overtaken by night, and compelled to halt, utterly unable to proceed one step further: here, without water or grass, or a spot on which to rest (from the stony and rugged character of the surface,) men and cattle have to pass the night. . . . On the range they found the land-leech. This animal bites with an avidity equal to that of the water-leech. The flies and musquitoes are again extremely troublesome, and in addition the tic.

Wednesday, December 8. . . . Messrs. Hovell and Hume now propose to themselves the following plan: to make a fresh attempt on foot to cross the range in a south westerly direction. . . . The hoofs of the horses are sadly broken, and the feet of the cattle are so swollen, that they are at present unfit for travelling, particularly their finest bullock, the leader.

The natives here are in the habit of extracting grubs from the trees (a practice of which they had seen no trace since their leaving the Murrumbidgee). This had in one instance been done with an iron tomahowk. . . .

Thursday, December 9th. . . . Uncertain of their route, fatigued, themselves lacerated and their clothes torn at every step, it had at length become

literally impracticable to proceed, they now therefore return towards the tent, and remain the night near a small spring, after having succeeded in penetrating four miles into this dreadful scrub, and advanced fourteen from their station in the morning. In this scrub they found the turtine the fern, and sassafras tree. The mountain leech was common, and the tic; which burying itself in the flesh, becomes destructive to the lower classes of animals. Pheasants they had heard, but had not seen any. The timber as they advanced to the southward, is observed to be gradually of a finer appearance, but that which they met with on the mountain, a species of black butted-gum infinitely surpasses all that they had seen hitherto.

Friday, December 10th. They start at sunrise, and at nine o'clock reach their tent, the shelter of which after their late excessive fatigues was highly acceptable. At two the whole party again proceed on their journey, and . . . pass along the plain of which they had taken the bearings the day before yesterday.

Sunday, December 12. Desirous during the absence of the breeze, which they expected would return at sunrise, of passing over the scrub and grass, which were still on fire in the direction of their proposed route, they were moving this morning before five o'clock. . . .

Thursday, December 16. . . . They now proceeded S. and at four o'clock, had the gratification satisfactorily to determine that the appearance which had just now created so much doubt, was that of water; and which, leaving the river a short distance, and directing their march from S.W. to S.S.W. they soon ascertain to be part of the sea, — the so long and ardently desired object of their labours. . . . [After three months arduous travel they were gazing upon the waters of Port Phillip Bay.]

The water near the shore was covered with water-fowl, of various descriptions, some of which were new to them. — And by the time they had halted for the night, they had procured an ample supply of black swans and ducks. They stopped for the night at seven o'clock, in a small wood about a mile from the beach, but where there was no fresh water; having travelled to-day, upwards of twenty miles.

Friday, December 17th. . . . This morning, one of the men, James Fitzpatrick, having proceeded a short distance up the creek, to shoot wild fowl, was suddenly surprised by a couple of natives who were lurking behind some reeds; the man no sooner perceived them, than he began to retreat, and they to advance, throwing off their cloaks, and with their arms in their hands; perceiving this, he turned and snapped his piece at one of them; but as it missed fire, he had no resource left, except flight, and which also would have been unavailing, had not his shouts for assistance, brought him timely aid. . . .

Messrs. Hovell and Hume, had been desirous of taking their horses in the direction of what they supposed to be Port Phillip, but the conduct of these people, and the numerous fires which were being made around them, apparently as signals among the natives, made them conclude, that it would be unsafe for the party to separate. . . .

The natives here, in their form and features, very much resemble those about Sydney, their manners and customs appeared very similar, and they have the same kind of weapons. . . .

The harbour or bay consisted of an immense sheet of water, its greatest length extending E. and W. with land which seemed to them an island, to the southward, lying across its mouth, but which, in fact, is a peninsula, with a very low isthmus connecting it to the western shore. Hence the mistaking of this spot, Port Phillip, for Western Port, a bay about fifteen miles to the eastward of the latter. This error has been since satisfactorily rectified by Mr. Hovell, in his examination of Western Port, and its vicinities, on the occasion of the late settlement of that place. . . . [In 1826 Hovell was one of a party which Governor Brisbane sent by sea to Westernport.]

Saturday, December 18. This morning they commence their return keeping between two and three miles to the southward and eastward of their outward route. . . .

Saturday, January 8 [1825]. To-day was served out the last of their provisions, viz. six pounds of flour to each man, and some tea, while they had a

journey before them of at least a hundred and fifty miles to the nearest stock station, over a mountainous and difficult country, and with cattle so fatigued and crippled, that they were able to make only short stages. . . .

Saturday, January 15. To-day they rejoin their old track of the 28th of October, at the upper part of Limestone Valley, after a mountain journey, which for fatigue and intricacy, and even danger to the cattle, it would be impossible adequately to describe. . . . The whole of their flour was expended today. . . .

Sunday, January 16th. Messrs. Hume and Hovell, with two men, hurry onwards to the carts, which they had left with part of their supplies on the 26th of October, enjoining the rest of the party to follow slowly with the bullocks, while they themselves would be occupied in conveying the carts across the stream. . . . The following day, (17th,) they ford the Murrumbidgee at the same spot, at which they had before crossed it with so much difficulty. . . .

On the . . . (18th,) they arrived in safety at Mr. Hume's station, near Lake George, from which they had taken their departure, when on their outward journey, the 17th of last October, having had the good fortune to complete in the fullest sense their arduous attempt, and to accomplish all its various objects to their utmost extent, within the short period of sixteen weeks. . . .

The results of this important undertaking, were the discovery of a vast range of country, invaluable for every purpose of grazing, and of agriculture — watered by numerous fine streams and rivers, and presenting an easy inland intercourse, extending from Port Phillip, and Western Port, to the settled districts of Bathurst — thus refuting the previously adopted opinion, by which this same line of country, had been denounced as "uninhabitable and useless for all the purposes of civilization," while, further, when taken in connection with the later discoveries of Captain Sturt, they gave access to regions of an amplitude and capabilities fully adequate to receive, at the lowest estimate, the entire *supposed* present surplus population of the Mother Country.

The following appendix from Hovell's Journey provides a list of what the explorers carried with them on this journey:

The supplies were as follow: — Seven pack saddles, one riding saddle, eight stand of arms, six pounds of gunpowder, sixty rounds of ball cartridge, six suits of slops, and six blankets for the men, two tarpaulins, one tent made of coarse Colonial woollen cloth, twelve hundred pounds of flour, three hundred and fifty pounds of pork, one hundred and seventy pounds of sugar, thirty-eight pounds of tea and coffee, eight pounds of tobacco for the men, sixteen pounds of soap, twenty pounds of salt, cooking utensils, one false horizon, one sextant, three pocket compasses, and one perambulator, exclusive of Messrs. Hovell and Hume's own personal clothes and bedding; the latter consisting, like that of the men, of a blanket only. Six of the pack saddles, the slops, and blankets for the men, with six of the muskets, and the ball-cartridges, tent, and tarpaulin, were liberally furnished by the Government; and of which, the muskets only, the other articles having become destroyed or worn out in the course of the journey, were returned. . . .

Allan Cunningham (1791–1839) became interested in geographic discovery through his professional work as a botanist. Arriving in Sydney in 1816, he was shortly to go off with Oxley up the Lachlan. Between 1817 and 1822 he accompanied Captain Phillip Parker King on his surveys of the Australian coast, contributing a 'botanical' chapter to King's own journal of that voyage.[6] In the early 1820s Cunningham made a number of excursions in New South Wales.

The descriptions of his travels are those of the scientific man. They contain none of the flamboyancy of style in which nineteenth century travellers sometimes indulged to impress an Empire-loving reading public in England. His account of his discovery of a route between Bathurst and the Liverpool Plains in 1823 is a careful factual description of a short but demanding journey.[7] Other portions of his manuscripts, which are at the Mitchell

The Road North

6. Phillip P. King, *Narrative of a Survey of the Intertropical and Western Coasts of Australia. Performed Between the Years 1818 and 1822.* London, 1827.

7. Allan Cunningham, 'Journal of a Route from Liverpool Plains, in New South Wales', in Barron Field, *Geographical Memoirs*.

Library, Sydney, and at Kew Gardens, London, have since been published.[8]

In 1832 Cunningham prepared a paper for the Royal Geographical Society in London, from which the following extracts are taken.[9] They tell the story of his major contribution to exploration — the discovery of the Darling Downs in 1827.

With the exception of my examination of the western and northern sides of Liverpool Plains in the month of May, 1825, which enabled me to furnish something more than what had been previously known of those extensive levels, our stock of geographical knowledge received no accession during either that or the following year. [Cunningham had briefly explored the country north of Pandora's Pass.] The year 1827, however, a new scene opened to the colonists; for a journey which the late Mr. Oxley had himself at one period contemplated, was determined on, viz., to explore the entirely unknown country, lying on the western side of the dividing range, between Hunter's River in latitude 32° and Moreton Bay in latitude 27°S. For this purpose a well appointed expedition, equipped fully for an absence of five months, was placed by the Colonial Government under my direction.

On the 30th of April of that year, (1827,) having provided myself with the necessary instruments, and with an escort of six servants and eleven horses, I took my departure from a station [Segenhoe] on an upper branch of the Hunter's River, and upon crossing the dividing range to the westward, at a mean elevation above the level of the sea of three thousand and eighty feet, I pursued my journey northerly, through an uninteresting forest country, skirting Liverpool Plains on their eastern side. . . .

On the 11th of May, we crossed (in latitude 31°2') Mr. Oxley's track easterly towards Port Macquarie in 1818, and from that point the labours of the expedition commenced on ground previously untrodden by civilized man. It was my original design to have taken a fresh departure to the northward, from the point at which the late Surveyor-General [Oxley] had passed the river named by him the 'Peel', upon our reaching the above-mentioned parallel, and which bore from a spot on which we had encamped, due east about twelve miles: however, the intermediate country, although Mr. Oxley had passed it, proved too elevated and rocky for my heavily-burdened horses. . . . Thus we continued our journey to the north through barren, but densely-timbered country of frequently brushy character, and altogether very indifferently watered. . . . Through these gloomy woods, with scarcely a trace of either Indian or kangaroo, we patiently pursued our way until the 19th of May, when, upon passing the parallel of 30°, we descended from some stony hills to the head of a beautiful well-watered valley, affording abundance of the richest pasturage, and bounded, on either side, by a bold and elevated rocky range. This grassy vale we followed northerly about sixteen miles to its termination at the left bank of a large river, which, in seasons less unfavourable to vegetation, appeared evidently a stream of considerable magnitude. This was the Peel [actually the Gwydir] of Mr. Oxley. . . . Our course led us through a variety of country; for, on quitting the river, we traversed a barren, brushy tract, which extended more or less for fourteen miles; beyond, however, the land materially improved, and as it was less encumbered with small timber and more open to the action of the atmosphere, a considerable growth of grass was produced. . . . In this stage of our journey we crossed the parallel of 29°, in about the meridian of 150°40'; and having very little expectation of meeting with water, in any state, in so arid a region, we were most agreeably surprised to find the channel of a river from eighty to one hundred yards in width, winding its course to the westward. This stream, which received the name of Dumaresq's River, although greatly reduced by drought, presented, nevertheless, a handsome piece of water, half a mile in length, about thirty yards in width, and evidently very deep. . . .

At length, on the 5th of June, having gained an elevation of about nine hundred feet above the bed of Dumaresq's River, we reached the confines of a superior country. It was exceedingly cheering to my people, after they had traversed a waste oftentimes of the most forbiddingly arid character, for a space, more or less, of eighty miles, and had borne, with no ordinary patience, a degree

Allan Cunningham, botanist and explorer.

8. Ida Lee, (ed.) *Early Explorers in Australia. From the Log-books and Journals; including the Diary of Allan Cunningham, Botanist, from March 1 , 1817, to November 19, 1818.* London, 1925.

9. Allan Cunningham, 'Brief View of the Progress of the Interior Discovery in New South Wales', in *The Journal of the Royal Geographical Society of London*. 1832.

Gowrie Station, Darling Downs. Despite Cunningham's discovery of the Darling Downs in 1827 it was not until the Leslie brothers moved into the area in the 1840s that settlement commenced.

of privation to which I had well nigh sacrificed the weaker of my horses — to observe, from a ridge which lay in our course, that they were within a day's march of open downs of unknown extent, which stretched, easterly, to the base of a lofty range of mountains, distant, apparently, about twenty-five miles. On the 6th and following day, we travelled throughout the whole extent of these plains, to the foot of the mountains extending along their eastern side, and the following is the substance of my observations on their extent, soil, and capability.

These extensive tracts of clear pastoral country, which were subsequently named Darling Downs, in honour of his Excellency the Governor, are situated in, or about, the mean parallel of 28°S., along which they stretch east, eighteen statute miles to the meridian of 152°. Deep ponds, supported by streams from the highlands, immediately to the eastward, extend along their central lower flats; and these, when united, in a wet season, become an auxiliary to Condamine's River — a stream which winds its course along their south-western margin. . . .

Large patches of land, perfectly clear of trees, lying to the north of Darling Downs, were named Peel's Plains, whilst others, bearing to the south and south-east, and which presented an undulated surface with a few scattered trees, were called after the late Mr. Canning. . . .

In a valley which led to the immediate base of the mountain-barrier, I fixed my northernmost encampment [near present-day Warwick], determining, as I had not the means of advancing further in consequence of the state of my provisions and the low condition of my horses, to employ a short period in a partial examination of the principal range, to the western base of which we had penetrated from the southward, through a considerable portion of barren interior. In exploring the mountains immediately above our tents, with a view more especially of ascertaining how far a passage could be effected over them to the shores of Moreton Bay, a remarkably excavated part of the main range was discovered, which appeared likely to prove a very practicable pass [later named Cunningham's Gap] through these mountains from the eastward. . . .

Circumstances now urged me to commence my journey homewards, and this I determined to prosecute with as much despatch as the condition of my horses and the nature of the country would admit of. I had also resolved to pursue my course to the southward, under the meridian of our encampment, as that would lead us through a tract of perfectly unknown country, lying nearly

equidistant between our outward-bound track and the coast-line.

On the 16th of June, therefore, I again put my people in motion, and quitting the vale in which we had rested, (and which I had named after the late Captain Logan, at that period commandant of Moreton Bay,) I shaped my course to the southward; and after passing through a fine, open, forest tract, abounding in excellent pasturage, in nine miles gained north-eastern skirts of Canning Downs, of which I had had a view from a station on the hills which we had left. . . .

Governor Darling's despatch[10] to the Colonial Office relating to this expedition of Cunningham's concluded with the following comments:

I would observe that Mr. Cunningham appears desirous to render the result of his Expedition confirmatory of a favorite hypothesis, the existence of an Inland Sea. This opinion has lately become so general from reports of the Natives, that I propose, as soon as the Season permits, to endeavour to ascertain the fact. But the more immediate and practical advantages, which have resulted from Mr. Cunningham's Expedition, are,

1st. The Knowledge, which it has furnished of a very considerable extent of the Interior, which was previously unknown and

2nd. The discovery of a rich and fertile Country, which will be of immediate advantage, when the Settlement at Moreton Bay is thrown open.

I cannot conclude without bearing testimony to Mr. Cunningham's Zeal on

'Tomb of Allan Cunningham, Esqr. at Sydney', by Phillip Parker King. Cunningham had travelled with King on the latter's surveys of the Australian coast. Both men were dedicated to the furtherance of knowledge about Australia. Cunningham died in Sydney in 1839.

10. *Historical Records of Australia.* Series 1, Volume XIII, Sydney, 1920.

all occasions; and I have much pleasure in bringing under Your Lordship's Notice the judgment and enterprise he has evinced in the Conduct of this Expedition. It is due to this Gentlemen to observe that it has been performed without any claim on his part, or any expectation having been held out to him of remuneration, for the Services he has rendered.

I have, &c.,
RA. DARLING

The Riddle of the Western Rivers

Charles Sturt.

Discovery of the Darling River

Charles Sturt (1795–1869) arrived in Sydney in 1827 in charge of a detachment of the 39th Regiment on board a convict ship. He soon became military secretary to Governor Darling. To the chagrin of Thomas Mitchell, who had become surveyor general after Oxley's death, Darling agreed that Sturt should lead an expedition to the interior. The following passages are taken from the journal accounts of his first two expeditions which he prepared for publication from his own field books.[11]

Sturt wrote well but, like the early painters of the Australian landscape, he observed the local scene with the eyes of a European. Nevertheless, during these years he developed a deep love of Australia which never left him.

Sturt's first expedition in 1828–29 had two important results. Firstly, it succeeded in its prime purpose of tracing the course of the Macquarie River. In a dry season Sturt was able to get through the marshes from which Oxley had been forced to retreat in 1818. Secondly, the Darling River was discovered. On this journey Sturt wisely chose Hamilton Hume, already an experienced explorer, as his second-in-command.

During his second expedition of 1829–30 Sturt and his party travelled by whaleboat down the Murrumbidgee River from just below its junction with the Lachlan, into the Murray River and on to Lake Alexandrina. These were significant journeys as they solved some of the current geographical complexities regarding the westward flowing rivers of New South Wales.

In an introduction to his account of his first expedition Sturt discussed the then current speculation regarding the topography of the interior:

Mr. Cunningham, who, independently of his individual excursions, had not only circumnavigated the Australian Continent with Capt. King, but had formed also one of the party with Mr. Oxley, in the journeys before noticed, had adopted this gentleman's opinion with regard to the swampy and inhospitable character of the distant interior. Its depressed appearance from the high ground on which Mr. Cunningham subsequently moved, tended to confirm this opinion, which was moreover daily gaining strength from the reports of the natives, who became more frequent in their intercourse with the whites, and who reported that there were large waters to the westward, on which the natives had canoes, and in which there were fish of great size.

It became, therefore, a current opinion, that the western interior of New Holland comprehended an extensive basin, of which the ocean of reeds which had proved so formidable to Mr. Oxley, formed most probably the outskirts; and it was generally thought that an expedition proceeding into the interior, would encounter marshes of vast extent, which would be extremely difficult to turn, and no less dangerous to enter.

It remained to be proved, however, whether these conjectures were founded in fact. . . .

The year 1826 was remarkable for the commencement of one of those fearful droughts to which we have reason to believe the climate of New South Wales is periodically subject. It continued during the two following years with unabated severity. The surface of the earth became so parched up that minor vegetation ceased upon it. Culinary herbs were raised with difficulty, and crops failed even in the most favourable situations. Settlers drove their flocks and herds to distant tracts for pasture and water, neither remaining for them in the located districts. . . . It almost appeared as if the Australian sky were never again to be traversed by a cloud.

11. Charles Sturt, *Two Expeditions into the Interior of Southern Australia, during the years 1828, 1829, 1830, and 1831: with Observations on the Soil, Climate, and General Resources of the Colony of New South Wales.* London, 1833.

Note.— Mr Arrowsmith has prepared a detailed Map of Captⁿ Sturt's late Routes into the Interior, in 2 Sheets, which may be had in a cover.— Price 7ˢ

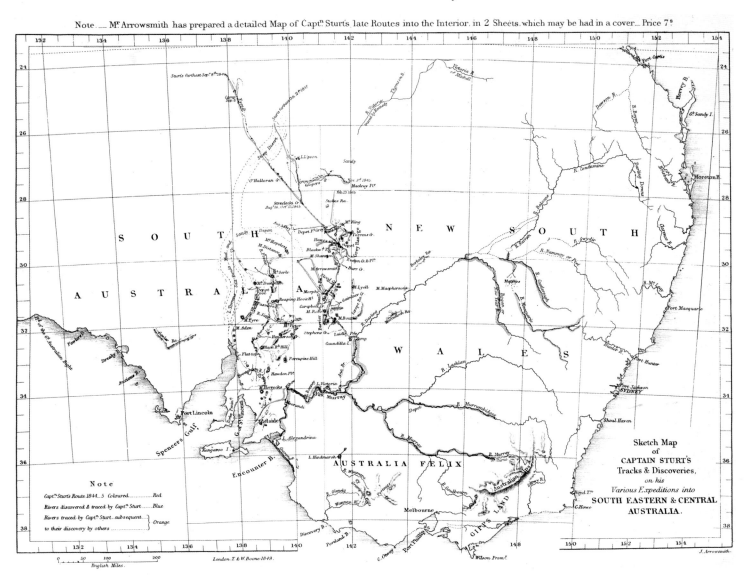

Sketch map of country covered by Sturt in his exploration of south-eastern and central Australia.

But, however severe for the colony the seasons had proved, or were likely to prove, it was borne in mind at this critical moment, that the wet and swampy state of the interior had alone prevented Mr. Oxley from penetrating further into it, in 1818. Each successive report from Wellington Valley, the most distant settlement to the N.W., confirmed the news of the unusually dry state of the lowlands, and of the exhausted appearance of the streams falling into them. It was, consequently, hoped than an expedition, pursuing the line of the Macquarie, would have a greater chance of success than the late Surveyor General had; and that the difficulties he had to contend against would be found to be greatly diminished, if not altogether removed. The immediate fitting out of an expedition was therefore decided upon, for the express purpose of ascertaining the nature and extent of that basin into which the Macquarie was supposed to fall, and whether any connection existed between it and the streams falling westerly. As I had early taken a great interest in the geography of New South Wales, the Governor was pleased to appoint me to the command of this expedition.

In the month of September, 1828, I received his Excellency's commands to prepare for my journey; and by the commencement of November, had organized my party, and completed the necessary arrangements. On the 9th of that month, I waited on the Governor, at Parramatta, to receive his definitive instructions. As the establishments at Sydney had been unable to supply me with the necessary number of horses and oxen, instructions had been forwarded to Mr. Maxwell, the superintendent of Wellington Valley, to train a certain number for my use; and I was now directed to push for that settlement without loss of time. I

Wellington Valley (now the New South Wales town of Wellington) in 1826–27. Oxley discovered this valley in 1817 and by 1823 a convict settlement was established there. The watercolour, by Earle, portrays the scene as it would have appeared to Sturt in 1828.

returned to Sydney in the afternoon of the 9th, and on the 10th took leave of my brother officers, to commence a journey of very dubious issue; and, in company with my friend, Staff-surgeon M'Leod, who had obtained permission to accompany me to the limits of the colony, followed my men along the great western road. We moved leisurely over the level country, between the coast and the Nepean River, and availed ourselves of the kind hospitality of those of our friends whose property lay along that line of road, to secure more comfortable places of rest than the inns would have afforded.

We reached Sheane, the residence of Dr. Harris, on the 11th [November], and were received by him with the characteristic kindness with which friends or strangers are ever welcomed by that gentleman. He had accompanied Mr. Oxley as a volunteer in 1818, and his name was then given to the mount which formed the extreme point to which the main body of the first expedition down the banks of the Macquarie penetrated, in a westerly direction. . . .

In his description of Wellington Valley [which Sturt's party reached by the end of November], Mr. Oxley has not done it more than justice. It is certainly a beautiful and fertile spot, and it was now abundant in pasturage, notwithstanding the unfavourable season that had passed over it.

The settlement stands upon the right bank of the Bell, about two miles above the junction of that stream with the Macquarie. Its whitewashed buildings bore outward testimony to the cleanliness and regularity of the inhabitants; and the respectful conduct of the prisoners under his charge, shewed that Mr. Maxwell had maintained that discipline by which alone he could have secured respect to himself and success to his exertions, at such a distance from the seat of government.

The weather was so exceedingly hot, during our stay, that it was impossible to take exercise at noon; but in the evening, or at an early hour in the morning, we were enabled to make short excursions in the neighbourhood.

Mr. Maxwell informed me that there were three stations below the settlement, the first of which, called Gobawlin, belonging to Mr. Wylde, was not more than five miles from it; the other two, occupied by Mr. Palmer, were at a greater distance, one being nineteen, the other thirty-four miles below the junction of the Bell. He was good enough to send for the stockman (or chief herdsman), in charge of the last, to give me such information of the nature of the country below him, as he could furnish from personal knowledge or from the accounts of the natives.

Mr. Maxwell pointed out to me the spot on which Mr. Oxley's boats had

been built, close upon the bank of the Macquarie; and I could not but reflect with some degree of apprehension on the singularly diminished state of the river from what it must then have been to allow a boat to pass down it. Instead of a broad stream and a rapid current, the stream was confined to a narrow space in the centre of the channel, and it ran so feebly amidst frequent shallows that it was often scarcely perceptible. . . .

On the 5th [December], our preparations being wholly completed, and the loads arranged, the party was mustered, and was found to consist of myself and Mr. Hume, two soldiers and eight prisoners of the crown, two of whom were to return with dispatches. Our animals numbered two riding, and seven pack, horses, two draft, and eight pack, bullocks, exclusive of two horses of my own, and two for the men to be sent back.

The morning of the 7th December, the day upon which we were to leave the valley, was ushered in by a cloudless sky, and that heated appearance in the atmosphere which foretels an oppressively sultry day. I therefore put off the moment of our departure to the evening, and determined to proceed no further than Gobawlin. . . . [8 December] Mr. Hume rode with me to the summit of a limestone elevation, from which I thought it probable we might have obtained such a view as would have enabled us to form some idea of the country into which we were about to descend. But in following the river line, the eye wandered over a dark and unbroken forest alone. . . .

With the help of Aboriginal guides, the explorers left Mr Palmer's second station and pushed on to the cataract of the Macquarie River.

The views upon the river were really beautiful, and varied at every turn; nor is it possible for any tree to exceed the casuarina in the graceful manner in which it bends over the stream, or clings to some solitary rock in its centre. . . .

If there had been other proof wanting, of the lamentably parched and exhausted state of the interior, we had on this occasion ample evidence of it and of the fearful severity of the drought under which the country was suffering. As soon as the sun dipped under the horizon, hundreds of birds came crowding to the border of the lake to quench the thirst they had been unable to allay in the forest. Some were gasping, others almost too weak to avoid us, and all were indifferent to the reports of our guns. . . .

So little force was there in the current, that I began to entertain doubts how long it would continue, more especially when I reflected on the level character of the country we had entered, and the fact of the Macquarie not receiving any tributary between this point and the marshes. I was in consequence led to infer that result, which, though not immediately, eventually took place.

As they were treated with kindness, the natives who accompanied us soon threw off all reserve, and in the afternoon assembled at the pool below the fall to take fish. . . .

We pitched our tents as soon as we had effected the passage of the river [it was now 16 December]; after which, the men went to bathe, and blacks and whites were mingled promiscuously in the stream. . . . They are certainly a merry people, and sit up laughing and talking more than half the night.

During the removal of the stores my barometer was unfortunately broken, and I had often, in the subsequent stages of the journey, occasion to regret the accident. . . . I fear that barometers as at present constructed, will seldom be carried with safety in overland expeditions. . . . [Barometers were used for calculating height.]

The cattle found such poor feed around the camp that they strayed away in search of better during the night. On such an occasion Botheri and his fraternity would have been of real service; but he had decamped at an early hour, and had carried off an axe, a tomahawk, and some bacon, although I had made him several presents. I was not at all surprised at this piece of roguery, since cunning is the natural attribute of a savage; but I was provoked at their running away at a moment when I so much required their assistance.

Left to ourselves, I found Mr. Hume of the most essential service in tracking the animals, and to his perseverance we were indebted for their speedy

recovery. They had managed to find tolerable feed near a serpentine sheet of water, which Mr. Hume thought it would be adviseable to examine. . . .

The heat, which had been excessive at Wellington Valley, increased upon us as we advanced into the interior. The thermometer was seldom under 114° at noon, and rose still higher at 2 p.m. We had no dews at night, and consequently the range of the instrument was trifling in the twenty-four hours. The country looked bare and scorched, and the plains over which we journeyed [they were halfway between the present-day towns of Coonamble and Nyngan] had large fissures traversing them, so that the earth may literally be said to have gasped for moisture. . . .

Nearly ten years had elapsed since Mr. Oxley pitched his tents under the smallest of the two hills into which Mount Harris is broken. There was no difficulty in hitting upon his position. . . . On the summit of the greater eminence, which we ascended, there remained the half-burnt planks of a boat, some clenched and rusty nails, and an old trunk; but my search for the bottle Mr. Oxley had left was unsuccessful.

A reflection naturally arose to my mind on examining these decaying vestiges of a former expedition, whether I should be more fortunate than the leader of it, and how far I should be enabled to penetrate beyond the point which had conquered his perseverance. Only a week before I left Sydney I had followed Mr. Oxley to the tomb. . . . My eye instinctively turned to the North-West, and the view extended over an apparently endless forest. I could trace the river line of trees by their superior height; but saw no appearance of reeds, save the few that grew on the banks of the stream. . . .

On our return to the camp, I was vexed to find two of the men, Henwood and Williams, with increased inflamation of the eyes, of which they had previously been complaining, and I thought it advisable to bleed the latter. . . .

We moved leisurely towards Mount Foster, on the 22nd, and arrived opposite to it a little before sunset. . . . [Mount Foster — still marked on current maps — is on the opposite side of the Macquarie River from Mount Harris, which is no longer marked on our maps.]

Considering our situation in its different bearings, it struck me that the men who were to return to Wellington Valley with an account of our proceedings for the Governor's information, had been brought as far as prudence warranted. There was no fear of their going astray, as long as they had the river to guide them. . . . I determined, therefore, not to risk their safety, but to prepare my dispatches for Sydney, and I hoped most anxiously, that ere they were closed, all symptoms of disease would have terminated. . . .

On the morning of the 26th, the men were sufficiently recovered to pursue their journey. Riley and Spencer left us at an early hour; and about 7 a.m. we pursued a N.N.W. course along the great plain I have noticed, starting numberless quails, and many wild turkeys, by the way. . . .

The soil was yielding, blistered, and uneven; and the claws of cray-fish, together with numerous small shells, were everywhere collected in the hollows made by the subsiding of the waters, between broad belts of reeds and scrubs of polygonum.

On gaining the point of the wood, we found an absolute check put to our further progress. We had been moving directly on the great body of the marsh, and from the wood it spread in boundless extent before us. It was evidently lower than the ground on which we stood; we had, therefore, a complete view over the whole expanse; and there was a dreariness and desolation pervading the scene that strengthened as we gazed upon it. Under existing circumstances, it only remained for us either to skirt the reeds to the northward, or to turn in again upon the river; and as I considered it important to ascertain the direction of the Macquarie at so critical and interesting a point, I thought it better to adopt the latter measure. We, accordingly, made for the river, and pitched our tents, as at the last station, in the midst of reeds.

There were two points, at this time, upon which I was extremely anxious. The first was as to the course of the river; the second, as to the extent of the marshes by which we had been checked, and the practicability of the country to the northward.

PALŒORNIS MELANURA
BLACK TAILED PAROQUET.

In advising with Mr. Hume, I proposed launching the boat, as the surest means of ascertaining the former, and he, on his part, most readily volunteered to examine the marshes, in any direction I should point out. It was, therefore, arranged, that I should take two men, and a week's provision with me in the boat down the river; and that he should proceed with a like number of men on an excursion to the northward. . . .

We found it unsufferably hot and suffocating in the reeds, and were tormented by myriads of mosquitoes, but the waters were perfectly sweet to the taste, nor did the slightest smell, as of stagnation, proceed from them. I may add that the birds, whose sanctuary we had invaded, as the bittern and various tribes of the galinule, together with the frogs, made incessant noises around us. There were, however, but few waterfowl on the river; which was an additional proof to me that we were not near any very extensive lake.

Mr. Hume had returned before me to the camp, and had succeeded in finding a serpentine sheet of water, about twelve miles to the northward; which he did not doubt to be the channel of the river. He had pushed on after this success, in the hope of gaining a further knowledge of the country; but another still more extensive marsh checked him, and obliged him to retrace his steps. . . .

For some days Sturt and Hume continued their wanderings in the marshes of the Macquarie, Sturt concluding that they were not connected with the Lachlan Marshes.

We left our position at the head of the plain early on the 13th of January, and, ere the sun dipped, had entered a very different country from that in which we had been labouring for the last three weeks. . . .

As we were travelling through a forest we surprised a hunting party of natives. Mr. Hume and I were considerably in front of our party at the time, and he only had his gun with him. . . . As soon as they saw us, four of them ran away; but the fifth, who wore a cap of emu feathers, stood for a moment looking at us, and then very deliberately dropped out of the tree to the ground. I then advanced towards him, but before I got round a bush that intervened, he had darted away. I was fearful that he was gone to collect his tribe, and, under this impression, rode quickly back for my gun to support Mr. Hume. On my arrival I found the native was before me. He stood about twenty paces from Mr. Hume, who was endeavouring to explain what he was; but seeing me approach he immediately poised his spear at him, as being the nearest. Mr. Hume then

(above) 'The Rose Cockatoo' — an illustration from Sturt's journal. Referring to his exploration along the Macquarie River, Sturt wrote: 'We had likewise procured some of the rose-coloured and grey parrots, mentioned by Mr Oxley . . . but there was less variety in the feathered race than I expected to find . . .'

(above left) 'Black Tailed Paroquet', an illustration from Sturt's journal. On the journey up the Murray River Sturt's party shot at the 'paroquets perched in the lofty trees' — an act which attracted hostile and unwelcome attention from the Aboriginals.

unslung his carbine, and presented it; but, as it was evident my reappearance had startled the savage, I pulled up; and he immediately lowered his weapon. His coolness and courage surprised me, and increased my desire to communicate with him. He had evidently taken both man and horse for one animal, and as long as Mr. Hume kept his seat, the native remained upon his guard; but when he saw him dismount, after the first astonishment had subsided, he stuck his spear into the ground, and walked fearlessly up to him. We easily made him comprehend that we were in search of water; when he pointed to the west, as indicating that we should supply our wants there. He gave his information in a frank and manly way, without the least embarrassment, and when the party passed, he stepped back to avoid the animals, without the smallest confusion. I am sure he was a very brave man; and I left him with the most favourable impressions, and not without hope that he would follow us. . . .

We struck upon a creek late in the afternoon, at which we stopped; New Year's Range bearing nearly due west at about four miles' distance. Had we struck upon my track, the question about which we were so anxious would still have been undecided; but the circumstances of our having crossed Mr. Hume's, which, from its direction, could not be mistaken, convinced me of the fate of the Macquarie, and I felt assured that, whatever channels it might have for the distribution of its waters, to the north of our line of route, the equality of surface of the interior would never permit it again to form a river; and that it only required an examination of the lower parts of the marshes to confirm the theory of the ultimate evaporation and absorption of its waters, instead of their contributing to the permanence of an inland sea, as Mr. Oxley had supposed. . . .

Our camp [of 19 January] was infested by the kangaroo fly, which settled upon us in thousands. They appeared to rise from the ground, and as fast as they were swept off were succeeded by fresh numbers. It was utterly impossible to avoid their persecution, penetrating as they did into the very tents.

The men were obliged to put handkerchiefs over their faces, and stockings upon their hands; but they bit through every thing. It was to no purpose that I myself shifted from place to place; they still followed, or were equally numerous everywhere. To add to our discomfort, the animals were driven almost to madness, and galloped to and fro in so furious a manner that I was apprehensive some of them would have been lost. I never experienced such a day of torment; and only when the sun set, did these little creatures cease from their attacks. . . .

Nothing could exceed in dreariness the appearance of the tracks through which we journeyed, on this and the two following days. . . . We passed hollow after hollow that had successively dried up, although originally of considerable depth; and, when we at length found water, it was doubtful how far we could make use of it. Sometimes in boiling it left a sediment nearly equal to half its body; at other times it was so bitter as to be quite unpalatable. That on which we subsisted was scraped up from small puddles, heated by the sun's rays; and so uncertain were we of finding water at the end of the day's journey, that we were obliged to carry a supply on one of the bullocks. There was scarcely a living creature, even of the feathered race, to be seen to break the stillness of the forest. The native dogs alone wandered about, though they had scarcely strength to avoid us; and their melancholy howl, breaking in upon the ear at the dead of the night, only served to impress more fully on the mind the absolute loneliness of the desert. . . .

On 31 January 1829 the explorers encamped in a dry creek bed. Water was found and then the party pushed on to the west.

The circumstances of there having been natives in the neighbourhood, of whom we had seen so few traces of late, assured me that water was at hand. . . . As the path we observed was leading northerly we took up that course, and had not proceeded more than a mile upon it, when we suddenly found ourselves on the banks of a noble river. . . . The party drew up upon a bank that was from forty to forty-five feet above the level of the stream. . . .

Its banks were too precipitous to allow of our watering the cattle, but the men eagerly descended to quench their thirst, which a powerful sun had con-

tributed to increase; nor shall I ever forget the cry of amazement that followed their doing so, or the looks of terror and disappointment with which they called out to inform me that the water was so salt as to be unfit to drink! This was indeed, too true: on tasting it, I found it extremely nauseous, and strongly impregnated with salt, being apparently a mixture of sea and fresh water. Whence this arose, whether from local causes, or from a communication with some inland sea, I knew not, but the discovery was certainly a blow for which I was not prepared. . . . Mr. Hume, with his usual perseverance, walked out when the camp was formed. . . . he found a small pond of fresh water on a tongue of land, and immediately afterwards returned to acquaint me with the welcome tidings. . . . [Sturt named the river the Darling, as 'a lasting memorial of the respect I bear the governor'.]

The natives of the Darling are a clean-limbed, well-conditioned race, generally speaking. . . . It was evident their population had been thinned. . . . Whether these people have an idea of a superintending Providence I doubt, but they evidently dread evil agency. On the whole I should say they are a people, at present, at the very bottom of the scale of humanity.

We struck the Darling River in lat. 29°37'S. and in E. long 145°33', and traced it down for about sixty-six miles in a direct line to the S.W. . . . it is incumbent on me to state that the country, through which it flows, holds out but little prospect of advantage. . . . there is a singular want of vegetable decay in the interior of New Holland, and that powerfully argues its recent origin.

The party I found awaiting our arrival at Mount Harris [to which Sturt returned on 23 February] consisted of one soldier, Riley, who had the charge of the supplies, and a drayman. . . .

My dispatches stated, that additional supplies had been forwarded for my use, together with horses and bullocks, in the event of my requiring them. On examination, the former were found to be in excellent order; and, as it would take some time to carry any changes I might contemplate, or find it necessary to make, into effect, I determined to give the men who had been with me a week's rest. . . .

I had a temporary awning erected near the river, and was for three or four days busily employed writing an account of our journey for the Governor's information.

Having closed my despatches, and answered the numerous friendly letters I had received, my attention was next turned to the changes that had taken place at Mount Harris during our absence. The Macquarie, I found, had wholly ceased to flow, and now consisted of a chain of ponds. Such of the minor vegetation as had escaped the fires of the natives, had perished under the extreme heat of the season. . . . We . . . determined to make for the Castlereagh, agreeably to our instructions. . . .

[10 March] We reached the Castlereagh about 4 p.m. and although its channel could not have been less than 130 yards in breadth, there was apparently not a drop of water in it. . . . The Castlereagh as I rode down it, diminished in size considerably, and became quite choked up with rushes and brambles. . . . The wretched appearance of the country as we penetrated into it, damped our spirits. . . .

We still, however, continued to travel over a dead level, nor was a height or break visible from the loftiest trees we ascended. A little before we stopped at the creek, we surprised a party of natives. . . . In the afternoon one of the men came to inform me that the tribe was coming down upon us. Mr. Hume and I, therefore, went to meet them. . . . When the natives saw us advance, they stopped, and we did the same. Mr. Hume then walked to a tree, and broke off a short branch. It is singular that this should, even with these rude people, be a token of peace. As soon as they saw the branch, the natives laid aside their spears. . . . Mr. Hume then went forward and sat down, when the two natives again advanced and seated themselves close to him. [Sturt would not permit his men to remove any of the Aboriginals' weapons.]

Now it is evident that a little insight into the customs of every people is necessary to insure a kindly communication; this, joined with patience and kindness, will seldom fail with the natives of the interior. It is not to avoid alarming

their natural timidity that a gradual approach is so necessary. They preserve the same ceremony among themselves. These men, who were eighteen in number, came with us to the tents, and received such presents as we had for them. They conducted themselves very quietly, and, after a short time, left us with every token of friendship. . . .

In the hope that we should fall on some detached pond, we pursued our journey on the 29th [March]. The Castlereagh gave singular proofs of its violence, as if its waters, confined in the valley, had a difficulty in escaping from it. We had not travelled two miles, when in crossing, as we imagined, one of its bights, we found ourselves checked by a broad river. A single glimpse of it was sufficient to tell us it was the Darling. At a distance of more than ninety miles nearer its source, this singular river still preserved its character, so strikingly, that it was impossible not to have recognised it in a moment. . . . I rode to the junction of the Castlereagh with the Darling, accompanied by Mr. Hume, a distance of about half a mile. . . .

Although the natives had shewn so good a disposition, as they were numerous, I thought it as well since I was about to leave the camp, to shew them that I had a power they little dreamt of about me. I therefore called for my gun and fired a ball into a tree. The effect of the report upon the natives, was truly ridiculous. Some stood and stared at me, others fell down, and others ran away; and it was with some difficulty we collected them again. . . .

It is impossible for me to describe the nature of the country over which we passed. . . . [We] had left all traces of the natives far behind us; and this seemed a desert they never entered — that not even a bird inhabited. I could not encourage a hope of success, and, therefore, gave up the point. . . . During the short interval I had been out, I had seen rivers cease to flow before me, and sheets of water disappear; and had it not been for a merciful Providence, should, ere reaching the Darling, have been overwhelmed by misfortune.

I am giving no false picture of the reality. . . . The emus, with outstretched necks, gasping for breath, searched the channels of the rivers for water, in vain. . . . We arrived in camp at a late hour, and having nothing to detain us longer, prepared for our retreat in the morning. . . .

It was now early April and the party had been encamped for some days near a minor waterway, which was also explored.

The result of our journey up the creek was particularly satisfactory, both to myself and Mr. Hume; since it cleared up every doubt that might have existed regarding the actual termination of the Macquarie, and enabled us to connect the flow of waters at so interesting and particular a point. . . .

It would be presumptuous to hazard any opinion as to the nature of the interior to the westward of that remarkable river. Its course is involved in equal mystery, and it is a matter of equal doubt whether it makes its way to the south coast, or ultimately exhausts itself in feeding a succession of swamps, or falls into a large reservoir in the centre of the island.

We reached Mount Harris on the 7th of the month, and moving leisurely up the banks of the Macquarie, gained Mr. Palmer's first station on the 14th, and Wellington Valley on the 21st, having been absent from that settlement four months and two weeks. . . .

Whether the discoveries that had been made during this expedition, will ultimately prove of advantage to the colony of New South Wales, is a question that time alone can answer. We have in the meanwhile to regret that no beneficial consequences will immediately follow them. The further knowledge that has been gained of the interior is but as a gleam of sunshine over an extensive landscape. A stronger light has fallen upon the nearer ground, but the distant horizon is still enveloped in clouds. The veil has only as it were been withdrawn from the marshes of the Macquarie, to be spread over the channel of the Darling. . . .

The discovery of the Darling River was a major breakthrough and on his return to Sydney, Sturt was anxious to be off again to dispel its mysteries.

The fitting out of another expedition was accordingly determined upon; and about the end of September 1829, I received the Governor's instructions to make the necessary preparations for a second descent into the interior, for the purpose of tracing the Morumbidgee [Murrumbidgee], or such rivers as it might prove to be connected with, as far as practicable. In the event of failure in this object, it was hoped that an attempt to regain the banks of the Darling on a N.W. course from the point at which the expedition might be thwarted in its primary views, would not be unattended with success. Under any circumstances, however, by pursuing these measures, an important part of the colony would necessarily be traversed, of which the features were as yet altogether unknown. . . .

Mr. Hume declined accompanying me, as the harvest was at hand. Mr. George M'Leay therefore supplied his place, rather as a companion than as an assistant; and of those who accompanied me down the banks of the Macquarie, I again selected Harris (my body servant), Hopkinson, and Fraser. . . .

The High Road to the South Coast

The expedition which traversed the marshes of the Macquarie, left Sydney on the 10th day of Nov. 1828. That destined to follow the waters of the Morumbidgee, took its departure from the same capital on the 3d of the same month in the ensuing year. Rain had fallen in the interval, but not in such quantities as to lead to the apprehension that it had either influenced or swollen the western streams. . . . The Governor had watched over my preparations with a degree of anxiety that evidenced the interest he felt in the expedition, and his arrangements to ensure, as far as practicable, our being met on our return, in the event of our being in distress, were equally provident and satisfactory. It was not, however, to the providing for our wants in the interior alone that His Excellency's views were directed, but orders were given to hold a vessel in readiness, to be dispatched at a given time to St. Vincent's Gulf, in case we should ultimately succeed in making the south coast in its neighbourhood.

The morning on which I left Sydney a second time, under such doubtful circumstances, was perfectly serene and clear. I found myself at 5 a.m. of that delightful morning leading my horses through the gates of those barracks [in George Street] whose precincts I might never again enter, and whose inmates I might never again behold assembled in military array. Yet, although the chance of misfortune flashed across my mind, I was never lighter at heart, or more joyous in spirit. . . .

I proceeded direct to the house of my friend Mr. J. Deas Thomson, who had agreed to accompany me to Brownlow Hill, a property belonging to Mr. M'Leay, the Colonial Secretary, where his son, Mr. George M'Leay, was to join the expedition. . . . My servant Harris, who had shared my wanderings and had continued in my service for eighteen years, led the advance, with his companion Hopkinson. Nearly abreast of them the eccentric Fraser stalked along wholly lost in thought. The two former had laid aside their military habits, and had substituted the broad brimmed hat and the bushman's dress in their place, but it was impossible to guess how Fraser intended to protect himself from the heat or the damp, so little were his habiliments suited for the occasion. . . . Some dogs Mr. Maxwell had kindly sent me followed close at his heels. . . . At some distance in the rear the drays moved slowly along, on one of which rode the black boy . . . and behind them followed the pack animals. . . .

About 1 p.m. [on 18 November 1829] we passed Mr. Hume's station, with whom I remained for a short time. He had fixed his establishments on the banks of the Lorn, a small river, issuing from the broken country near Lake George, and now ascertained to be one of the largest branches of the Lachlan River. We had descended a barren pass of stringy bark scrub, on sandstone rock, a little before we reached Mr. Hume's station, but around it the same open forest tract again prevailed. . . .

One of the drays was upset in its progress down a broken pass, where the road had been altogether neglected, and it was difficult to avoid accidents. . . . Mr. O'Brien, an enterprising settler, who had pushed his flocks to the banks of the Morumbidgee, and who was proceeding to visit his several stations, overtook us in the midst of our troubles. We had already passed each other frequently

on the road, but he now preceded me to his establishment at Yass; at which I proposed remaining for a day. . . .

Yharr or Yass Plains were discovered by Mr. Hovel, and Mr. Hume, the companion of my journey down the Macquarie, in 1828. . . . I have no doubt that Yass Plains will ere long be wholly taken up as sheep-walks. . . .

We left Mr. O'Brien's station on the morning of the 21st. . . . We had already recrossed the Yass River, and passed Mr. Barber's station, to that of Mr. Hume's father, at which we stopped for a short time. . . . We unavoidably lost a day but left our position on the 23d, for Underaliga, a station occupied by Doctor Harris. . . .

A short time before we reached the Morumbidgee, we forded a creek. . . . In the distance there was a small hill, and on its top a bark hut. . . . I went to the hut to ascertain where I could conveniently stop for the night but the residents were absent. I could not but admire the position they had taken up.

We were now far beyond the acknowledged limits of the located parts of the colony, and Mr. Whaby's station was the last at which we could expect even the casual supply of milk or other trifling relief. . . .

The Dumot river, another mountain stream, joins the Morumbidgee opposite to Mr. Whaby's residence [near present-day Gundagai]. . . . It rises amidst the snowy ranges to the S.E. . . . [It was now the end of November.]

The Morumbidgee from Tuggiong to our present encampment had held a general S.S.W. course. . . .

Some natives had joined us in the morning, and acted as our guides. . . . The blacks suffered beyond what I could have imagined, from cold, and seemed as incapable of enduring it as if they had experienced the rigour of a northern snow storm. . . . [The party proceeded along the Murrumbidgee, travelling between 19 and 24 kilometres per day. On 9 December they met another party of Aboriginals.]

The natives left us at sunset, but returned early in the morning with an extremely facetious and good-humoured old man, who volunteered to act as our guide without the least hesitation. . . . The old black informed me that there was another large river flowing to the southward of west, to which the Morumbidgee was as a creek, and that we could gain it in four days. . . .

[13 December] We fell in with another tribe of blacks during the journey, to whom we were literally consigned by those who had been previously with us, and who now turned back, while our new friends took the lead of the drays. . . . One of these young men, however, clearly stated that he had seen the tracks of bullocks and horses, a long time ago to the N.N.W. in the direction of some detached hills, that were visible from 20 to 25 miles distant. He remembered them, he said, as a boy, and added that the white men were without water. It was, therefore, clear that he alluded to Mr. Oxley's excursion, southerly from the Lachlan. . . .

We found this part of the Morumbidgee much more populous than its upper branches. When we halted, we had no fewer than forty-one natives with us, of whom the young men were the least numerous. They allowed us to choose a place for ourselves before they formed their own camp, and studiously avoided encroaching on our ground so as to appear troublesome. Their manners were those of a quiet and inoffensive people, and their appearance in some measure prepossessing. The old men had lofty foreheads, and stood exceedingly erect. The young men were cleaner in their persons, and were better featured than any we had seen, some of them having smooth hair and an almost Asiatic cast of countenance. On the other hand, the women and children were disgusting objects. The latter were much subject to diseases, and were dreadfully emaciated. It is evident that numbers of them die in their infancy for want of care and nourishment. . . . The sunken eye and overhanging eyebrow, the high cheek-bone and thick lip, distended nostrils, the nose either short or acquiline, together with a stout bust and slender extremities, and both curled and smooth hair, marked the native of the Morumbidgee as well as those of the Darling. They were evidently sprung from one common stock, the savage and scattered inhabitants of a rude and inhospitable land. . . .

We journeyed due west over plains of great extent. . . . Nothing could

'View of the Morumbidgee' — *a pencil drawing of the Murrumbidgee River by Sturt.*

exceed the apparent barrenness of these plains, or the cheerlessness of the land-scape. . . . The lofty gum-trees on the river followed its windings, and, as we opened the points, they appeared, from the peculiar effect of a mirage, as bold promontories jutting into the ocean, having literally the blue tint of distance. This mirage floated in a light tremulous vapour on the ground, and not only deceived us with regard to the extent of the plains, and the appearance of objects, but hid the trees, in fact, from our view altogether. . . .

The cattle about this time began to suffer, and, anxious as I was to push on, I was obliged to shorten my journeys, according to circumstances. Amidst the desolation around us, the river kept alive our hopes. . . . Neither beast nor bird inhabited these lonely and inhospitable regions, over which the silence of the grave seemed to reign. . . .

[24 December] Two or three natives made their appearance at some dis-tance from the party, but would not approach it until after we had halted. They then came to the tents, seven in number, and it was evident from their manner, that their chief or only object was to pilfer anything they could. . . . Probably from seeing that we were aware of their intentions, they left us early, and point-ing somewhat to the eastward of north, said they were going to the Colare, and on being asked how far it was, they signified that they should sleep there. I had on a former occasion recollected the term having been made use of by a black on the Macquarie, when speaking to me of the Lachlan. . . . I suggested to M'Leay to ride in that direction, while the party should be at rest, with some good feed for the cattle that fortune had pointed out to us. . . . [Sturt and M'Leay made this short excursion together] We had undoubtedly struck below to the westward of the Colare or Lachlan, and the creek was the channel of communi-cation between it and the Morumbidgee. . . . [They started off again down the river on 26 December, the wheels of the drays sinking into the mud. To Sturt the country resembled that of the Macquarie Marshes. After a sleepless night he decided that a boat should be built, by which some of the party should proceed

down the river, while the remainder should turn back with the drays.]

The attention both of M'Leay, and myself, was turned to the hasty building of the whale-boat. A shed was erected, and every necessary preparation made. . . . Thus, in seven days we had put together a boat, twenty-seven feet in length, had felled a tree from the forest, with which we had built a second of half the size, had painted both, and had them at a temporary wharf ready for loading. . . . In the intervals between the hours of work, I prepared my despatches for the Governor, and when they were closed, it only remained for me to select six hands, the number I intended should accompany me down the river, and to load the boats, ere we should once more proceed in the further obedience of our instructions. . . . I then gave the rest over in charge to Harris. . . .

The camp was a scene of bustle and confusion long before day-light. . . . At a little after seven, however, the weather cleared up, the morning mists blew over our heads, and the sun struck upon us with his usual fervour. As soon as the minor things were stowed away, we bade adieu to Harris and his party; and, shortly after, embarked on the bosom of that stream [the Murrumbidgee] along the banks of which we had journeyed for so many miles. [It was January 1830.]

Notwithstanding that we only used two oars, our progress down the river was rapid. Hopkinson had arranged the loads so well, that all the party could sit at their ease, and Fraser was posted in the bow of the boat, with gun in hand, to fire at any new bird or beast that we might surprise in our silent progress. The little boat, which I shall henceforward call the skiff, was fastened by a painter to our stern. . . .

The second day of our journey from the depôt was marked by an accident that had well nigh obliged us to abandon the further pursuit of the river . . . , the skiff struck upon a sunken log, and immediately filling went down in about twelve feet of water. . . . [After a laborious afternoon's work the skiff and most of its contents were recovered from the bottom of the river and the next morning the all-important still head was also found.]

Leaving this unlucky spot, we made good about sixteen miles in the afternoon. The river maintained its breadth and depth nor were the reeds continuous upon its banks. . . . Having taken the precaution of shortening the painter of the skiff, we found less difficulty in steering her clear of obstacles, and made rapid progress down the Morumbidgee during the first cool and refreshing hours of the morning. . . . On the 10th, reeds lined the banks of the river on both sides, without any break, and waved like gloomy streamers over its turbid waters. . . .

[14 January] We rose in the morning with feelings of apprehension, and uncertainty; and, indeed, with great doubts on our minds whether we were not thus early destined to witness the wreck, and the defeat of the expedition. The men got slowly and cautiously into the boat, and placed themselves so as to leave no part of her undefended. Hopkinson stood at the bow, ready with poles to turn her head from anything upon which she might be drifting. Thus prepared, we allowed her to go with the stream. . . . Hopkinson in particular exerted himself, and more than once leapt from the boat upon apparently rotten logs of wood, that I should not have judged capable of bearing his weight, the more effectually to save the boat. . . . On a sudden, the river took a general southern direction, but, in its tortuous course, swept round to every point of the compass with the greatest irregularity. We were carried at a fearful rate down its gloomy and contracted banks. . . . At 3 p.m., Hopkinson called out that we were approaching a junction, and in less than a minute afterwards, we were hurried into a broad and noble river. . . . [It was 14 January and they were on the river already discovered by Hume and Hovell and which Sturt would later name the Murray].

We had got on the high road, as it were, either to the south coast, or to some important outlet; and the appearance of the river itself was such as to justify our most sanguine expectations. I could not doubt its being the great channel of the streams from the S.E. angle of the island. Mr. Hume had mentioned to me that he crossed three very considerable streams, when employed with Mr. Hovell in 1823 in penetrating towards Port Phillips, to which the names of the Goulburn, the Hume and the Ovens, had been given; and as I was 300

miles from the track these gentlemen had pursued, I considered it more than probable that those rivers must already have formed a junction above me, more especially when I reflected that the convexity of the mountains to the S.E. would necessarily direct the waters falling inwards from them to a common centre. . . .

On the 19th [January], as we were about to conclude our journey for the day, we saw a large body of natives before us. On approaching them, they shewed every disposition for combat, and ran along the bank with spears in rests, as if only waiting for the opportunity to throw them at us. . . . I held a long pantomimical dialogue with them, across the water, and held out the olive branch in token of amity. They at length laid aside their spears, and a long consultation took place among them, which ended in two or three wading into the river, contrary, as it appeared, to the earnest remonstrances of the majority, who, finding that their entreaties had no effect, wept aloud, and followed them with a determination, I am sure, of sharing their fate, whatever it might have been. As soon as they landed, M'Leay and I retired to a little distance from the bank, and sat down; that being the usual way among the natives of the interior, to invite to an interview. . . . I observed that few of them had either lost their front teeth or lacerated their bodies, as the more westerly tribes do. The most loathsome diseases prevailed among them. Several were disabled by leprosy, or some similar disorder, and two or three had entirely lost their sight. They are, undoubtedly, a brave and a confiding people, and are by no means wanting in natural affection. . . .

The old men slept very soundly by the fire, and were the last to get up in the morning. M'Leay's extreme good humour had made a most favourable impression upon them, and I can picture him, even now, joining in their wild song. Whether it was from his entering so readily into their mirth, or from anything peculiar that struck them, the impression upon the whole of us was, that they took him to have been originally a black, in consequence of which they gave him the name of Rundi. . . .

After breakfast [on 23 January], we proceeded onwards as usual. The river had increased so much in width that, the wind being fair, I hoisted sail for the first time, to save the strength of my men as much as possible. . . . As we sailed down the reach, we observed a vast concourse of natives under them, and on a nearer approach, we not only heard their war-song, if it might so be called, but remarked that they were painted and armed, as they generally are, prior to their engaging in deadly conflict. . . . As we neared the sand-bank, I stood up and made signs to the natives to desist; but without success. I took up my gun, therefore, and cocking it, had already brought it down to a level. A few seconds more would have closed the life of the nearest of the savages. . . . But at the very moment, when my hand was on the trigger, and my eye was along the barrel, my purpose was checked by M'Leay, who called to me that another party of blacks had made their appearance upon the left bank of the river. Turning round, I observed four men at the top of their speed. The foremost of them as soon as he got a head of the boat, threw himself from a considerable height into the water. He struggled across the channel to the sand-bank, and in an incredibly short space of time stood in front of the savage, against whom my aim had been directed. Seizing him by the throat, he pushed him backwards, and forcing all who were in the water upon the bank, he trod its margin with a vehemence and an agitation that were exceedingly striking. . . . For my own part I was over-whelmed with astonishment, and in truth stunned and confused; so singular, so unexpected, and so strikingly providential, had been our escape.

We were again roused to action by the boat suddenly striking upon a shoal, which reached from one side of the river to the other. To jump out and push here into deeper water was but the work of a moment with the men, and it was just as she floated again that our attention was withdrawn to a new and beautiful stream [the Darling], coming apparently from the north. . . .

As soon as we got above the entrance of the new river, we found easier pulling, and proceeded up it for some miles, accompanied by the once more noisy multitude. . . . An irresistible conviction impressed me that we were now sailing on the bosom of that very stream from whose banks I had been twice forced to retire. I directed the Union Jack to be hoisted, and giving way to our

River Murray bark canoe, basketry and tools, by George French Angas, who left meticulous drawings of Aboriginal artefacts.

satisfaction, we all stood up in the boat, and gave three distinct cheers. . . . The eye of every native had been fixed upon that noble flag, at all times a beautiful object, and to them a novel one, as it waved over us in the heart of a desert [near present-day Wentworth]. . . .

Arrived once more at the junction of the two rivers, and unmolested in our occupations, we had leisure to examine it more closely. Not having as yet given a name to our first discovery, when we re-entered its capacious channel on this occasion, I laid it down as the Murray River, in compliment to the distinguished officer, Sir George Murray, who then presided over the colonial department, not only in compliance with the known wishes of his Excellency General Darling, but also in accordance with my own feelings as a soldier. . . .

Our intercourse with the natives had now been constant. We had found the interior more populous than we had any reason to expect; yet as we advanced into it, the population appeared to increase. . . . The most loathsome of diseases prevailed throughout the tribes, nor were the youngest infants exempt from them. . . . Syphilis raged amongst them with fearful violence. . . .

I was particularly careful not to do anything that would alarm them, or to permit any liberty to be taken with their women. Our reserve in this respect seemed to excite their surprise, for they asked sundry questions, by signs and expressions, as to whether we had any women, and where they were. The whole tribe generally assembled to receive us, and all, without exception, were in a complete state of nudity, and really the loathsome condition and hideous countenances of the women would, I should imagine, have been a complete antidote to the sexual passion. . . .

The river continued to flow to the southward, a circumstance that gave me much satisfaction, for I now began to feel some anxiety about the men. They had borne their fatigues and trials so cheerfully, and had behaved so well, that I could not but regret the scanty provision that remained for them. The salt meat being spoiled [this refers to the earlier overturning of the skiff], it had fallen to the share of the dogs, so that we had little else than flour to eat. Fish no one would touch, and of wild fowl there were none to be seen. The men complained of sore eyes, from the perspiration constantly running into them, and it was obvious to me that they were much reduced. . . .

Among the natives who followed us from the last tribe, there was an old man, who took an uncommon fancy or attachment to Hopkinson, and who promised, when we separated, to join us again in the course of the day. . . . It was evident this old man had been upon the coast, and we were therefore highly delighted at the prospect thus held out to us of reaching it. . . .

[9 February] We had, at length, arrived at the termination of the Murray.

'Junction of the Supposed Darling with the Murray', where Sturt and McLeay landed amongst hundreds of Aboriginals, whose anger then changed to curiosity. This illustration is a lithograph from Sturt's journal after one of his own sketches.

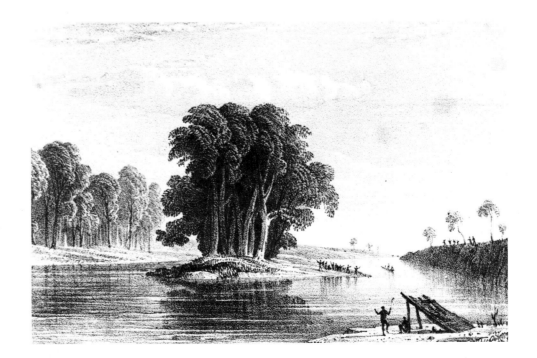

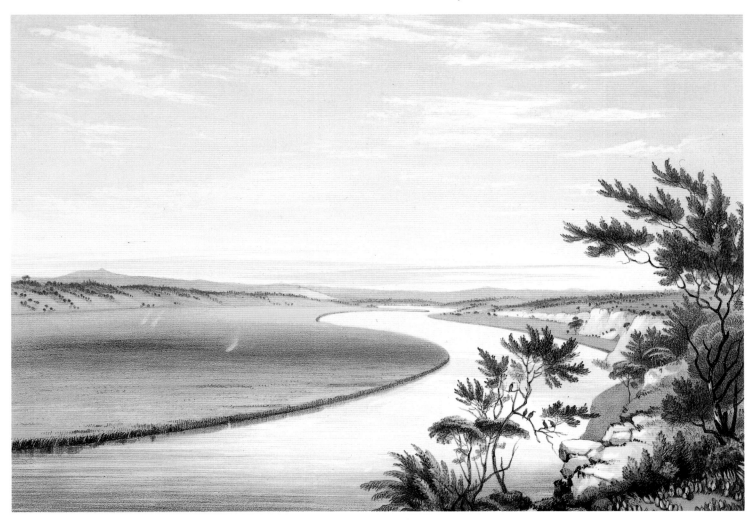

Immediately below me was a beautiful lake, which appeared to be a fitting reservoir for the noble stream that had led us to it; and which was now ruffled by the breeze that swept over it. . . . Thirty-three days had now passed over our heads since we left the depôt upon the Morumbidgee, twenty-six of which had been passed upon the Murray. We had, at length, arrived at the grand reservoir of those waters whose course and fate had previously been involved in such obscurity. . . . [They were on Lake Alexandrina.]

It is difficult to give a just description of our passage across the lake. The boisterous weather we had had seemed to have blown over. A cool and refreshing breeze was carrying us on at between four and five knots an hour, and the heavens above us were without a cloud. . . .

As soon as we had well opened the point, we had a full view of the splendid bay [Encounter Bay] that, commencing at the western-most of the central points, swept in a beautiful curve under the ranges. . . .

As we were standing across from one shore to the other, our attention was drawn to a most singular object. It started suddenly up, as above the waters to the south, and strikingly resembled an isolated castle. Behind it, a dense column of smoke rose into the sky, and the effect was most remarkable. On a nearer approach, the phantom disappeared, and a clear and open sea again presented itself to our view. The fact was, that the refractive power upon the coast had elevated the sand hillocks above their true position, since we satisfactorily ascertained that they alone separated the lake from the ocean, and that they alone could have produced the semblance we noticed. It is a singular fact, that this very hillock was the one which Capt. Barker ascended whilst carrying on the survey of the south coast, and immediately previous to his tragical death. . . . [Barker was speared to death when swimming across the mouth of the Murray on 30 April 1831.]

We had approached to within twelve miles of the ranges, but had not

'The River Murray near Lake Alexandrina' as depicted by George French Angas some years after Sturt's epic boat trip to this point.

gained their southern extremity. . . . The sound of the surf came gratefully to our ears, for it told us we were near the goal for which we had so anxiously pushed, and we all of us promised ourselves a view of the boundless ocean on the morrow. . . .

A little before high water we again embarked. A seal had been observed playing about, and we augured well from such an omen. The blacks had been watching us from the opposite shore, and as soon as we moved, rose to keep abreast of us. With all our efforts we could not avoid the shoals. We walked up to our knees in mud and water, to find the least variation in the depth of the water so as to facilitate our exertions, but it was to no purpose. We were ultimately obliged to drag the boat over the flats; there were some of them a quarter of a mile in breadth, knee-deep in mud; but at length got her into deep water again. The turn of the channel was now before us, and we had a good run for about four or five miles. . . . Shoals again closed in upon us on every side. We dragged the boat over several, and at last got amongst quicksands. I, therefore, directed our efforts to hauling the boat over to the south side of the channel, as that on which we could most satisfactorily ascertain our position. After great labour we succeeded, and, as evening had closed in, lost no time in pitching the tents.

While the men were thus employed, I took Fraser with me, and, accompanied by M'Leay, crossed the sand-hummocks behind us, and descended to the sea-shore. I found that we had struck the south coast deep in the bight of Encounter Bay. We had no time for examination, but returned immediately to the camp, as I intended to give the men an opportunity to go to the beach. They accordingly went and bathed, and returned not only highly delighted at this little act of good nature on my part, but loaded with cockles, a bed of which they had managed to find among the sand. . . .

While the men were enjoying their cockles, a large kettle of which they had boiled, M'Leay and I were anxiously employed in examining the state of our provisions, and in ascertaining what still remained. Flour and tea were the only articles we had left so the task was not a difficult one. . . . In the deep bight in which we were, I could not hope that any vessel would approach sufficiently near to been seen by us. Our only chance of attracting notice would have been by crossing the Ranges to the Gulf St. Vincent, but the men had not strength to walk, and I hesitated to divide my party in the presence of a determined and numerous enemy, who closely watched our motions. . . .

Further exertion on the part of the men being out of the question, I determined to remain no longer on the coast than to enable me to trace the channel to its actual junction with the sea, and to ascertain the features of the coast at that important point. . . . I at length arranged that M'Leay, I, and Fraser, should start on this excursion, at the earliest dawn. . . .

At the time we arrived at the end of the channel, the tide had turned, and was again setting in. The entrance appeared to me to be somewhat less than a quarter of a mile in breadth. Under the sand-hill on the off side, the water is deep and the current strong. No doubt, at high tide, a part of the low beach we had traversed is covered. The mouth of the channel is defended by a double line of breakers, amidst which, it would be dangerous to venture, except in calm and summer weather; and the line of foam is unbroken from one end of Encounter Bay to the other. Thus were our fears of the impracticability and inutility of the channel of communication between the lake and the ocean confirmed. . . .

It will be borne in mind that our difficulties were just about to commence . . . we had now to contend against the united waters of the eastern ranges, with diminished strength, and, in some measure, with disappointed feelings. . . . We re-entered the river on the 13th [February] under as fair prospects as we could have desired. . . .

Having left the sea breezes behind us, the weather had become oppressive; and as the current was stronger, and rapids more numerous, our labour was proportionably increased. We perspired to an astonishing degree, and gave up our oars after our turn at them, with shirts and clothes as wet as if we had been in the water. Indeed Mulholland and Hopkinson, who worked hard, poured a considerable quantity of perspiration from their shoes after their task. The evil

of this was that we were always chilled after rowing, and, of course, suffered more than we should otherwise have done.

On the 25th [February] we passed the last of the cliffs composing the great fossil bed through which the Murray flows, and entered that low country already described as being immediately above it. . . .

I have omitted to mention one remarkable trait of the good disposition of all the men while on the coast. Our sugar had held out to that point; but it appeared, when we examined the stores, that six pounds alone remained in the cask. This the men positively refused to touch. They said that, divided, it would benefit nobody; that they hoped M'Leay and I would use it, that it would last us for some time, and that they were better able to submit to privations than we were. The feeling did them infinite credit, and the circumstance is not forgotten by me. . . . [They continued rowing homewards up the Murray, frequently watched by Aboriginals on the banks. On the night of 15 March some 150 Aboriginals slept close to the explorers' tents.]

We had been drawing nearer the Morumbidgee every day. . . . Our feelings were almost as strong when we re-entered it, as they had been when we were launched from it into that river, on whose waters we had continued for upwards of fifty-five days; during which period, including the sweeps and bends it made, we could not have travelled less than 1500 miles.

Our provisions were now running very short; we had, however, "broken the neck of our journey," as the men said, and we looked anxiously to gaining the depôt; for we were not without hopes that Robert Harris would have pushed forward to it with his supplies. . . .

We had found the intricate navigation of the Morumbidgee infinitely more distressing than the hard pulling up the open reaches of the Murray, for we were obliged to haul the boat up between numberless trunks of trees, an operation that exhausted the men much more than rowing. . . . I became captious, and found fault where there was no occasion, and lost the equilibrium of my temper in contemplating the condition of my companions. No murmur, however, escaped them, nor did a complaint reach me, that was intended to indicate that they had done all they could do. . . .

Amidst these distresses, M'Leay preserved his good humour, and endeavoured to lighten the task, and to cheer the men as much as possible. . . .

On the 8th and 9th of April we had heavy rain, but there was no respite for us. Our provisions were nearly consumed, and would have been wholly exhausted, if we had not been so fortunate as to kill several swans. On the 11th, we gained our camp opposite to Hamilton's Plains, after a day of severe exertion. Our tents were pitched upon the old ground, and the marks of our cattle were around us. . . . The men were completely sunk. We were still between eighty and ninety miles from Pontebadgery, in a direct line, and nearly treble that distance by water. The task was greater than we could perform, and our provisions were insufficient. In this extremity I thought it best to save the men the mortification of yielding, by abandoning the boat; and on further consideration I determined on sending Hopkinson and Mulholland, whose devotion, intelligence, and indefatigable spirits, I well knew, forward to the plain. . . .

[Six days later Mulholland and Hopkinson returned.] They were both of them in a state that beggars description. Their knees and ancles were dreadfully swollen, and their limbs so painful, that as soon as they arrived in the camp they sunk under their efforts, but they met us with smiling countenances, and expressed their satisfaction at having arrived so seasonably to our relief. They had, as I had foreseen, found Robert Harris on the plain, which they reached on the evening of the third day. They had started early the next morning on their return with such supplies as they thought we might immediately want. . . .

In my depatches to the Governor, from the depôt, I had suggested the policy of distributing some blankets and other presents to the natives on the Morumbidgee, in order to reward those who had been useful to our party, and in the hope of proving beneficial to settlers in that distant part of the colony. His Excellency was kind enough to accede to my request, and I found ample means for these purposes among the stores that Harris brought from Sydney.

We left Pondebadgery Plain early on the 5th of May, and reached Guise's

Station late in the afternoon. We gained Yass Plains on the 12th, having struck through the mountain passes by a direct line, instead of returning by our old route near Underaliga. As the party was crossing the plains I rode to see Mr. O'Brien, but did not find him at home. . . .

We left Yass Plains on the 14th of May [1830], and reached Sydney by easy stages on the 25th, after an absence of nearly six months.

The last chapter of Sturt's journal tells of his recommendation to Governor Darling that there should be a more thorough examination of the coast from Encounter Bay to the head of Gulf St Vincent. Darling subsequently instructed Captain Collet Barker to do this, on his way back to Sydney from King George Sound, Western Australia. Barker disappeared after swimming across a channel at Lake Alexandrina; it appears that he was killed by Aboriginals. Sturt felt some measure of responsibility for Barker's untimely end, which explains the inclusion of this story in Sturt's own journal and perhaps also the fact that the title of the journal includes the date of 1831 as relating to Sturt's expedition, which, in fact, ended in May 1830.

The Swan River Colony

While Sturt was exploring the river systems of what a later generation of Western Australians was to call the 'Eastern States', the Swan River colony, its select settlers as yet untarnished by convict labour, was expanding south and east. A small book, published in London in 1833, tells some of the early story of Western Australian exploration 'in the simple and original language of the hardy adventurers'.[12] These adventurers included Lieutenant Preston, R.N., Lieutenant Erskine of the 63rd Regiment, Surgeon A. Collie, pioneer John Bussell, Captain Bannister and Ensign Richard Dale.

In December 1830 Captain Bannister left Perth for King George Sound. The following is the conclusion of his report to the surveyor general of Western Australia, J. S. Roe.

Perth to King George Sound

On the 4th of February [1831] we arrived here [King George's Sound]. I have not words to convey to his Excellency the great kindness and friendship (of which we stood in the greatest need) with which we were received by Captain Barker (the commandant,) [later killed by Aboriginals in South Australia] and officers of the settlement, Dr. Davies, of the 39th, and Mr. Kent, of the Commissariat; and, under the care of Dr. Davies, the party, I trust, will soon recover its strength. From what I have written, it will be concluded, and justly so, that there is a body of available land, with certain extensive tracts of the richest description, fit for the plough, sheep, or cattle, or indeed any cultivation in the interior commencing about twenty-five or thirty miles from King George's Sound, which, under a judicious system of colonization, the main roads being

Sketch Map of Swan River Settlement 1829 by John Septimus Roe.

12. *Journals of Several Expeditions made in Western Australia, during the years 1829, 1830, 1831, and 1832; under the sanction of the Governor, Sir James Stirling, containing the latest authentic information relative to that country, Accompanied by a Map.* London, 1833.

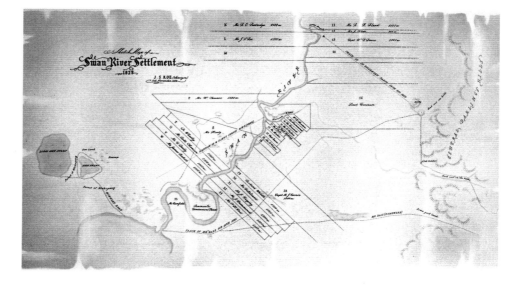

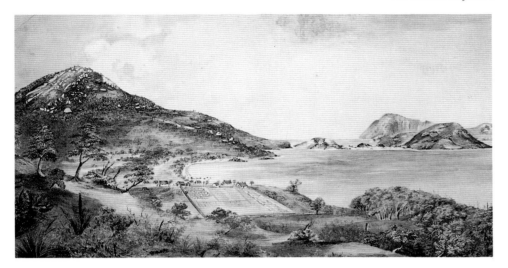

The settlement at King George's Sound about 1828, as painted by Isaac Scott Nind.

made in the first instance by forced labour, would, in the course of a few years, become inhabited by thousands of industrious men, sent out by the parishes of England, Scotland, or Ireland, or brought out by individuals bettering their condition, as well as relieving their country. I have been induced to make this remark, from the conviction that we can do nothing without the powerful aid of Government, in our infancy. Like every young community we must be nursed at first, which, though perhaps a little costly, will give rise to a good feeling towards our country, in those who follow us, which will last for ages.

Another hardy adventurer was Ensign Dale. Journeys such as his had little of the epic quality of the early discoveries of New South Wales, but encouraged by government and assisted by pasture-seeking pioneers, he and others like him opened the country for further settlement and quietly revealed its geography.

East of the Darling Range

Having provided a sufficient supply of provisions for three weeks, and prepared whatever was necessary for my expedition, I left Perth in the morning of the 31st of July, and in the morning reached Messrs. Thompson and Trimmer's, on the Swan River, a distance of about seven miles. On the following morning, I proceeded to Mr. Brockman's, four miles higher up, who proposed accompanying me on my intended expedition. I was obliged to await there the arrival of the boat I had despatched from Perth with my provisions, and then succeeded in swimming our horses over the river, after experiencing some danger in the attempt, owing to the Swan, from late heavy rains, having overflowed its banks to a considerable height.

On the 2nd of August, having arranged our different packages, and reduced them as much as possible, I proceeded with my party, consisting of Mr. Brockman, one soldier, and a store-keeper, the two latter each leading a packhorse to carry our baggage across the plain, which extends from the left bank of the Swan to the base of the Darling range, until we reached, in a course varying from north to east, the foot of those hills, the ascent of which we commenced up a narrow defile, through which a stream was running to the westward. . . .

In the course of this expedition we collected several specimens of the mineralogy of the country traversed. Among these there are some varieties of granite, rock-crystal, and limestone. Some of them appear to be metalliferous, but as they have been placed in the hands of a competent gentleman for the purpose of being analyzed, whose report is shortly expected, it is unnecessary at present to hazard an opinion as to their specific qualities. We estimated the distance from Mr. Brockman's house to the river which washes the base of the Dyott Hills, and which formed the extreme point or termination of our journey, to be forty miles in due easterly course, and to which there is no obstacle of sufficient importance to prevent a good communication from being opened.

3

Consolidating the Interior

Major Thomas Livingstone Mitchell (1792–1855) arrived in Sydney as assistant surveyor general in 1827 — the same year as his rival for the glories and rewards of exploration, Captain Charles Sturt. Like Sturt, he, too, was a military man who had served in the Napoleonic Wars. By 1828 Oxley had died and Mitchell was surveyor general — not an enviable position due to a heavy workload with insufficient facilities and instruments to cope with it.

Mitchell vigorously set about establishing better roads and bridges, including a new route over the Blue Mountains and a road to Goulburn. Soon, however, there was serious conflict between Mitchell and Governor Darling, due in part to Mitchell's annoying habit of by-passing the governor and dealing directly with the Imperial government. Happily for Mitchell a change of government in England led to Darling's recall and before a new governor reached the colony, the surveyor general was off, eager to satisfy his aspirations for geographical discovery.

Acting Governor Lindesay's despatch to the Imperial government admitted that the possibility 'of a large interior river, flowing towards the North West', as well as Mr Oxley's 'Theory of an immense inland Marsh', had been 'somewhat Shaken in 1830 by Captain Sturt's Discovery of So large a river as the Darling pursuing a S.W. Course', but had been 'recently revived by the report of a runaway prisoner'.[1] It was this report which provided Mitchell with a reason for setting out on his first journey of discovery — the search for a great northwest waterway, an idea to which he would turn again later on. While he did not find such a river, he did explore the country between the Castlereagh and Gwydir Rivers. This was the first of the three expeditions which Mitchell undertook in the 1830s, expeditions which would consolidate and extend the geographical discoveries of Oxley, Cunningham and Sturt. The following extracts commence with the recital of the events which preceded the search for the imaginary 'Kindur'[2].

In Search of the Kindur

The journey northward in 1831, originated in one of those fabulous tales, which occasionally become current in the colony of New South Wales, respecting the interior country, still unexplored.

A runaway convict, named George Clarke, alias "the Barber," had, for a length of time, escaped the vigilance of the police, by disguising himself as an aboriginal native. . . .

After this man was taken into custody, he gave a circumstantial detail of his travels to the north-west, along the bank of a large river, named, as he said, the *"Kindur;"* by following which in a south-west direction, he had twice reached the sea shore. . . . Vague accounts of "a great river beyond Liverpool plains,"

A watercolour of Victoria Pass by Mitchell, who was responsible for the successful road-building programme in New South Wales, which included a new route to Bathurst.

1. *Historical Records of Australia.* Series 1, Vol. XVI, Sydney, 1923.

2. T. L. Mitchell, *Three Expeditions into the Interior of Eastern Australia; with descriptions of the recently explored region of Australia Felix, and of the present colony of New South Wales.* London, 1839.

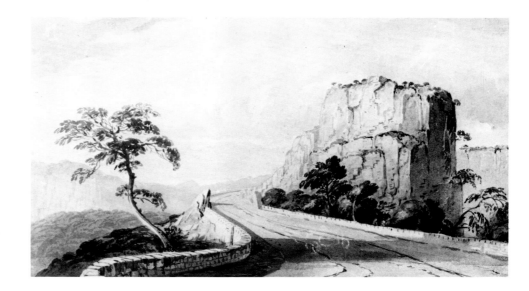

flowing north-west, were current, about the time General Darling embarked for England. . . .

There are few undertakings more attractive to the votaries of fame or lovers of adventure, than the exploration of unknown regions; but Sir Patrick Lindesay, with due regard to the responsibility which my office seemed to impose upon me, as successor to Mr. Oxley, at once accepted my proffered services to conduct a party into the interior. . . .

Various rivers were known to arise on that side of the Coast Range; the streams from Liverpool plains flowing northward; the Peel, the Gwydir, and the Dumaresq, arising in the Coast Range, and falling, as had been represented, to the north-westward. I proposed, therefore, to proceed northward, or to pursue such a direction as well as the nature of the country permitted, so that I might arrive, on the most northern of these streams, and then, keeping in view whatever high land might be visible near its northern banks, to trace the river's course downwards, and thus to arrive at the "large river," or common channel of all these waters. . . .

From the known level character of the interior, I considered that the light drays or carts used by the surveyors might easily pass, and I, therefore, preferred them to pack horses, being also a more convenient means of conveyance; I availed myself likewise of such men, carts, bullocks, and horses, as were disposable in the survey department at the time. The new Governor was expected in the course of a few months, and I was, therefore, desirous to set out as soon as possible, that I might return before his arrival. . . .

In the correspondence with the office at Sydney, which amounted annually to about 2000 letters, none remained unanswered; and my last cares were to leave, in the hands of an engraver, a map of the colony, that the past labours of the department might be permanently secured to the public, whatever might be our fate in the interior.

Little time remained for me to look at the sextants, theodolite, and other instruments necessary for the exploratory journey; I collected in haste a few articles of personal equipment, and having as well as I could, under the circumstances, set my house in order, I bade adieu to my family, and left Sydney at noon, on Thursday, the 24th day of November, 1831, being accompanied for some miles by my friend Colonel Snodgrass. . . .

My first day's journey, terminated near Parramatta, at the residence of Mr. John Macarthur. I was received by that gentleman with his usual hospitality, and although not in the enjoyment of the best health, he insisted on accompanying me over his extensive and beautiful garden, where he pointed out to my attention, the first olive-tree ever planted in Australia. . . .

At an early hour on the following morning, I took leave of my kind host, and also of my friend Mr. Dunlop, to whose scientific assistance in preparing for this journey, I feel much indebted. Mr. James Macarthur accompanied me a few miles on the road, when we parted with regret; and I set forth on my journey

Thomas Livingstone Mitchell, surveyor-general of New South Wales from 1828 until his death in 1855.

'Craig End' — an oil painting of Mitchell's Sydney residence by G. E. Peacock, c. 1849. Mitchell was born at Craigend in Scotland.

Outward bound on his first journey of exploration Mitchell enjoyed the hospitality of John Macarthur at Parramatta. Lycett completed this etching (hand coloured) of Macarthur's residence c. 1820 for his Views in Australia.

in the direction of the Hawkesbury, along the road leading to the ferry, across that river at Wiseman's. I should here observe, that I had previously arranged that the exploring party, which, being slower in its movements, had been dispatched two weeks before, should await my arrival on Foy Brook, beyond the River Hunter, where I expected to meet Mr. White also, the assistant surveyor, whom I had selected to accompany me on this expedition.

My ride, on that day, was along a ridge, which extended upwards of fifty miles, through a succession of deep ravines, where no objects met the eye except barren sandstone rocks, and stunted trees. . . . The horizon is flat, affording no relief to the eye from the dreary and inhospitable scene, which these solitudes present; and which extends over a great portion of the country, uninhabitable even by the aborigines. Yet here the patient labours of the surveyor have opened a road. . . . [Mitchell was referring to himself.]

Nov. 28. We left the hospitable station of Mr. Blaxland at an early hour and proceeded on our way to join the party. We found the country across which we rode, very much parched from the want of rain. The grass was every where yellow, or burnt up, and in many parts on fire, so that the smoke which arose from it obscured the sun, and added sensibly to the heat of the atmosphere.

We lost ourselves, and, consequently, a good portion of the day, from having rode too carelessly through the forest country, while engaged in conversation respecting the intended journey. We, nevertheless, reached the place of rendezvous on Foy Brook long before night, and I encamped on a spot, where the whole party was to join me in the morning.

Nov. 30. At length I had the satisfaction to see my party move forward in exploring order; it consisted of the following persons, viz.: —

Alexander Burnett, Robert Whiting,	}	Carpenters.
William Woods, John Palmer, Thomas Jones, William Worthington,	}	Sailors.
James Souter,	•	Medical Assistant.
Robert Muirhead, Daniel Delaney, James Foreham,	}	Bullock-Drivers.
Joseph Jones,	•	Groom.
Stephen Bombelli,	•	Blacksmith.
Timothy Cussack,	•	Surveyor's Man.
Anthony Brown,	•	Servant to me.
Henry Dawkins,	•	Servant to Mr. White.

These were the best men I could find. All were ready to face fire or water, in hopes of regaining by desperate exploits, a portion, at least, of that liberty which had been forfeited to the laws of their country. This was always a favourite service with the best disposed of the convict prisoners, for in the event of their meriting, by their good conduct, a favourable report on my return, the government was likely to grant them some indulgence. . . . [Mitchell was also accompanied by Surveyor Finch and Assistant Surveyor White.]

After travelling six hours, we encamped beside a small watercourse near Muscle Brook [Muswellbrook]. . . .

Dec. 11. The weather cleared up at about six A. M.: and we travelled across a good soil, throughout the whole of this day's journey. The country appeared

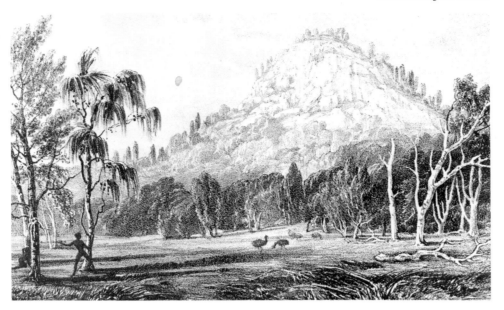

'The Pic of Tangulda' by T. L. Mitchell. Mitchell's journals are well illustrated with lithographs from his own drawings.

but thinly wooded, and without any hill or water-course. After a journey of thirteen miles, we reached the bank of the Peel at Wallamoul [near present-day Tamworth], the lowest cattle station upon this river. . . . I met, at this place, with some intelligent natives, from whom I learnt, that the spot where Mr. Oxley crossed the Peel on his journey, was about two miles lower down. . . .

Dec. 13. . . . We advanced with feelings of intense interest into the country before us, and impressed with the responsibility of commencing the first chapter of its history. All was still new and nameless, but by this beginning, we were to open a way for the many other beginnings of civilized man, and thus extend his dominion over some of the last holds of barbarism. . . . [On 16 December they camped on the Namoi River, near the farthest point reached by Cunningham in 1827.]

Dec. 17. Leaving the ground at an early hour, the party travelled for about two miles along the river bank. . . . We next reached a very large stock-yard, which the natives said belonged to "George the Barber," meaning the bushranger. . . . The whole country was on fire; but although our guide frequently drew our attention to recent footmarks, we could not discover a single native. . . . We encamped near this stock-yard, beside a lagoon of still water. . . . The pic of Tangùlda lay due north of our camp, distant about two miles; and, in the afternoon, I set out on foot to ascend it, accompanied by Mr. White and the carpenter. . . .

Dec. 20. . . . We had now tried the course pointed out by the bushranger, and, having found that it was wholly impracticable, I determined upon returning to Tangùlda, and by pursuing the Nammoy, to endeavour to turn this range, and so enter the region beyond it. . . .

Dec. 22. I set out before the party moved off, in order to mark the line of route for the carts, and to fix on a spot for the camp. I rode over firm and level ground, on a bearing of 295°, which I knew would bring me to the little hill observed from Tangùlda, where the Nammoy passes to the lower country beyond. . . . Lofty blue gum-trees grew on the margin of the stream, and the place [near Boggabri], upon the whole, seemed favourable for the formation of a depôt, where I might leave the cattle to refresh, while I proceeded down the Nammoy in the canvass boats, with the materials for constructing which, we were provided. . . . The country smoked around us on all sides; and the invisible blacks, the Barber's allies, were not well disposed towards us, but in a position like this our depôt would be secure. I accordingly made preparations for constructing our boats and launching them on the Nammoy as soon as possible. With four adjoining trees cut off at equal height, we formed a saw-pit, and a small recess which had been worked in the bank by the floods, served as a dock in which to set up and float the boats. . . .

Dec. 28. This day I sent off one of the men (Stephen Bombelli) with a

despatch for the government at Sydney, giving an account of our journey thus far, and stating my intention of descending the Nammoy in the boats. . . .

Dec. 29. We launched the second boat, and having loaded both, I left two men in charge of the carts, bullocks and horses, at Bullabalakit, and embarked, at last, on the waters of the Nammoy, on a voyage of discovery. . . . The evenness of the banks and reaches, and the depth and stillness of the waters were such, that I might have traced the river downwards . . . had our boats been of a stronger material than canvass. But dead trees lay almost invisible under water, and at the end of a short reach where I awaited the reappearance of the second boat, we heard suddenly, confused shouts, and . . . running to the spot, I found that the boat had run foul of a sunken tree—and had filled almost immediately. . . . By this disaster our whole stock of tea, sugar and tobacco, with part of our flour and pork, were immersed in the water, but fortunately all the gunpowder had been stowed in the first boat. . . .

Jan. 7 [1832]. The night had been unusually hot. . . . Few of the men had slept. Thus even night, which had previously afforded some protection from our great enemy, the heat, no longer relieved us from its effects; and this incessant high temperature which weakened the cattle, dried up the waters, destroyed our wheels, and nourished the fires that covered the country with smoke,—made humidity appear to us the very essence of existence, and water almost an object of adoration. . . .

Jan. 9. . . . We next crossed some slightly rising ground, and high in the branches of the trees, I perceived, to my astonishment, dry tufts of grass, old logs,and other drift matter! I felt confident that we were at length approaching something new, perhaps the "large river," the "Kindur," of the Bushranger. . . . I galloped over . . . and beheld a broad silvery expanse shaded by steep banks and lofty trees. . . . Nevertheless this was not the "Kindur," as described by the Barber, but evidently the Gwydir of Cunningham, as seen by him at a higher part of its course. We were exactly in the latitude of the Gwydir. . . . [Mitchell was near present-day Moree.]

Part of a map showing the limits of New South Wales from T. L. Mitchell's Three Expeditions into the Interior of Eastern Australia. *Mitchell's journeys are outlined in orange.*

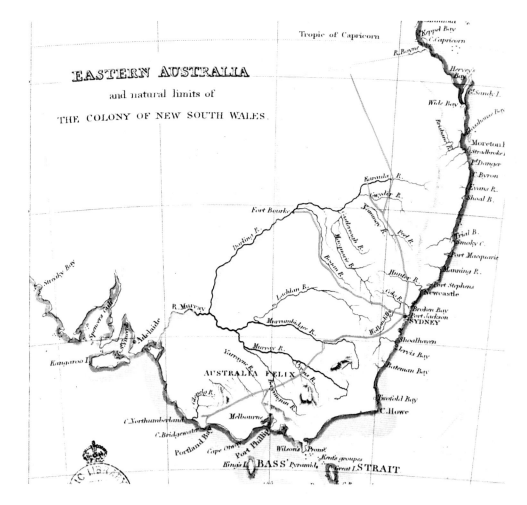

CERNUA BIDYANA (or Bidyan Ruffe)

Jan. 10. This morning it rained heavily; but we left the encampment at six, to pursue the course of the Gwydir. . . .

Jan. 14. . . . I had now on my map the Nundawàr range [Nandewar Range], with the courses of the Nammoy on one side, and the Gwydir on the other. . . .

Jan. 23. After crossing the line of ponds and a slight elevation beyond them, we came upon a channel of considerable breadth. . . . There was abundance of rich grass along the banks of this river; and here our horses at length enjoyed some days of rest. [They had come to a tributary of the Darling, now known as the Macintyre River. Mitchell and some of his party were riding ahead.]

Jan. 24. Early this morning, I sent back a party of the men, with the freshest of the bullocks, to Mr. White, to whom I also enclosed a letter for Mr. Finch, which I requested might be concealed in a tree with certain marks. I hoped, however, that by that time Mr. Finch might have overtaken Mr. White's party. Four men remained with me, viz. two carpenters, a sawyer's man, and my own servant. . . .

Jan. 28. Mr. White arrived with the carts and the depôt party, including Souter, "the doctor," who had wandered from our camp in search of water on the 21st instant. His story was, that on going about six miles from the camp, he lost his way, and fell in with the blacks, who detained him one day and two nights, but having at length effected his escape, while they were asleep . . . he had made the best of his way toward the Gwydir, and thus reached the depôt camp. . . .

Feb. 2. I left the camp with six men and four pack-animals, carrying nine days' rations, and proceeded along the left bank of the newly-discovered river. I found the course much more to the southward than I had expected or wished. . . .

Feb. 4. At length . . . at the distance of about four miles from where we had slept, we made the Gwydir. . . . This stream could not, therefore, contribute much to that I was tracing, and in search of which I now turned westward. On this course, the windings of the Gwydir often came in my way, so that I turned to north 25° east, in which direction, I at length reached the large river, which had been the object of our excursion. Here it was, indeed, a noble sheet of water, and I regretted much, that this had not been our first view of it, that we might have realized, at least for a day or two, all that we had imagined of *"the Kindur."* I now overlooked, from a bank seventy feet high, a river as broad as the Thames at Putney; and on which the goodly waves, perfectly free from fallen timber, danced in full liberty. . . .

Thus terminated our excursion, to explore this last discovered stream . . . as I could not suppose that it was any other than the Darling. [They were at the junction of the Macintyre and the Gwydir.]

Feb. 6. We reached the camp, by nine A.M. and, I learnt, that the natives had visited it, during my absence. . . . They were much disposed to steal. Mr. White observed one to purloin a tea-cup from his canteen, and conceal it very cleverly in his kangaroo cloak. . . .

The boat was already in the water, and every thing packed up, for the

(above left) 'Cernua Bidyana', by T. L. Mitchell. Explorers were often naturalists as well as artists.

(above) Mitchell named this 'very curious and rare little quadruped' after himself — Dipus Mitchellii.

'A thirsty crow as seen through a glass', a line drawing by Mitchell.

A kangaroo in long grass, by Mitchell.

'The Palti Dance', by George French Angas. Mitchell devoted several pages of his journal to a description of Aboriginal culture remarking that 'the quickness of apprehension of those in the interior was very remarkable'.

purpose of crossing the river, when Mr. Finch approached the camp [bringing up further supplies], and I hastened to congratulate him on his opportune arrival. But he told a dismal tale — two of his men having been killed, and all the supplies, cattle and equipment, having fallen into the hands of the natives. This catastrophe occurred at the ponds of "Gorolei," beyond Mount Frazer, which Mr. Finch had reached, after having been distressed, even more than our party had been in the same place, for want of water. This privation had first occasioned the loss of his horse and several other animals, so that his party had been able to convey the supplies to these ponds, by carrying forward from the dry camp, only a portion at a time, on the two remaining bullocks. Mr. Finch at length succeeded in thus lodging all the stores at the ponds, but being unable to move them further without the assistance of my cattle, he left them there, and proceeded forward on foot along our track with one man, in expectation of falling in with my party, at no great distance in advance. After ascertaining that we were not so near as he hoped, and having reached the Gwydir, and traced our route along its banks, until he again recognised Mount Frazer; he returned at the end of the second day, when he found neither his tents nor his men to receive him, but a heap of various articles, such as bags, trunks, harness, tea and sugar canisters, &c. piled over the dead bodies of his men, whose legs he, at length, perceived projecting. The tents had been cut in pieces; tobacco and other articles lay about; and most of the flour had been carried off, although some bags still remained on the cart. The two bullocks continued feeding near. This spectacle must have appeared most appalling to Mr. Finch, uncertain, as he must have been, whether the eyes of the natives were not then upon him, while neither he nor his man, possessed any means of defence! Taking a piece of pork and some flour in a havresack, he hastened from the dismal scene; and by travelling all day, and passing the nights without fire, he most providentially escaped the natives, and, had at length, reached our camp.

Thus terminated my hopes of exploring the country beyond the Karaula [the Aboriginal name for what Mitchell considered the Darling and which was, as already mentioned, a tributary, now known as the Macintyre], and I could not but feel thankful for the providential circumstance of Mr. Finch's arrival, at the very moment, I was about to proceed on that undertaking, trusting that I should find, in returning to this depôt, the supplies which I expected him to bring. We had now, on the contrary, an additional demand on our much exhausted stock of provisions. The season, when rain might be expected, was approaching, and we had behind us two hundred miles of country subject to inundation, without a hill to which we could in such a case repair. The soil was likely to become impassable after two days rain, and our cart wheels were represented by the carpenters to be almost unserviceable. These considerations, and the hostile

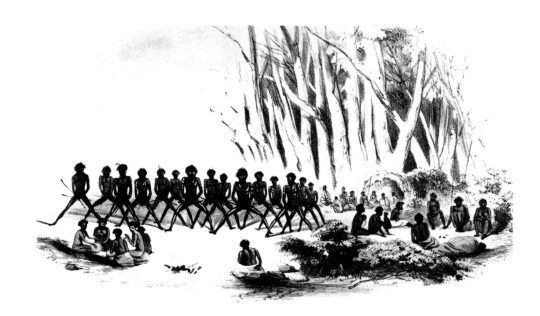

disposition of the natives in our rear, not only deterred me from crossing the Karaula, but seemed to require my particular attention to the journey homewards. We had at least accomplished the main object of the expedition, by ascertaining that there was no truth in the bushranger's report, respecting the great river. . . .

The party commenced their retreat on the following day, stopping at a point between present-day Narrabri and Moree to bury the two men who had been killed. Afflicted with scurvy the explorers pushed on homewards and by late February had once again reached 'the christian world'.

Still determined to discover more of the course of the Darling, Mitchell undertook a second expedition in which he followed the Bogan River to its junction with the Darling. A large party, similar to that of his first expedition, departed from Parramatta on 9 March 1835. The boats were carried in a specially constructed boat-carriage. The pace was slow, so it was not necessary for Mitchell, travelling on a lively mount, to leave Sydney until 31 March. He caught up with the main party on 5 April and by the middle of the month they were approaching the Bogan River in the vicinity of the present town of Narromine.

The extracts below include the account of the tragedy which befell Allan Cunningham's brother Richard, who was the botanist on this journey. Richard had been appointed colonial botanist in 1832.

The River Darling

April 17. We moved off at 8 o'clock and at the distance of 3¼ miles we came upon some curious rocks of red sandstone, forming the tops of a ridge which extended N. N. E.

It is called Bèny by the natives, and in a deep crevice, there is a well, the water of which, although at times apparently deep, had the previous night, been drained nearly to the bottom by a party of some tribe, whose fires still were burning.

The natives who accompanied us, examined the traces of those who had fled, with considerable interest, and then fell behind our party and disappeared. . . .

Being . . . anxious about finding water for the cattle, I galloped forward three miles, in search of the Bogan, but without reaching it.

The sun of this very hot day, was near setting by the time I met our party, to whom I had hastened back. They had travelled two miles beyond the dry creek, which it was my intention now to trace downwards as fast as possible, followed by all our animals, in hopes that it would lead to water. While the men were unyoking the teams, I was informed, that Mr. Cunningham was missing. [They were in the vicinity of present-day Narromine.] The occasional absence of this gentleman was not uncommon, but, as he had left the party early in the day, in order to join me, it was evident, from his not having done so, that he had gone astray. At that moment, I felt less anxiety on the subject, little doubting that he would gain our camp, before I returned from the forlorn search, I was about to make for water. Leaving Mr. Larmer [the assistant surveyor] with the rest of the party to encamp there, I proceeded eastwards towards the dry creek, whose course I soon intercepted, and I hurried the bullock-drivers along its bed downwards, until, after crossing many a hopeful but dry hole, they begged, that the cattle might be allowed to rest. Leaving them, therefore, I continued my search with the horses, still following the channel, until I had the happiness of seeing the stars of heaven reflected from a spacious pool. We had, in fact, reached the junction of the creek with the Bogan. Having filled our kettles and leathern bottles, we hastened back, to where we had left the bullocks. Leaving them to go forward, and refresh, I set off at a venture, on the bearing of southwest by south, in search of our camp. After an hour's riding, the moon rose, and at length our cooy was answered. I had previously observed, by the moon's light, the track left by my horse that morning in the long dry grass, and verified it by some of my marks on the trees. Would that Mr. Cunningham had been as

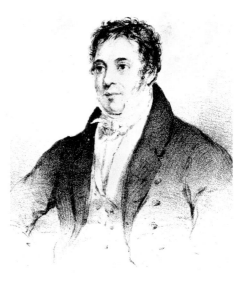

Richard Cunningham, colonial botanist 1833–1835.

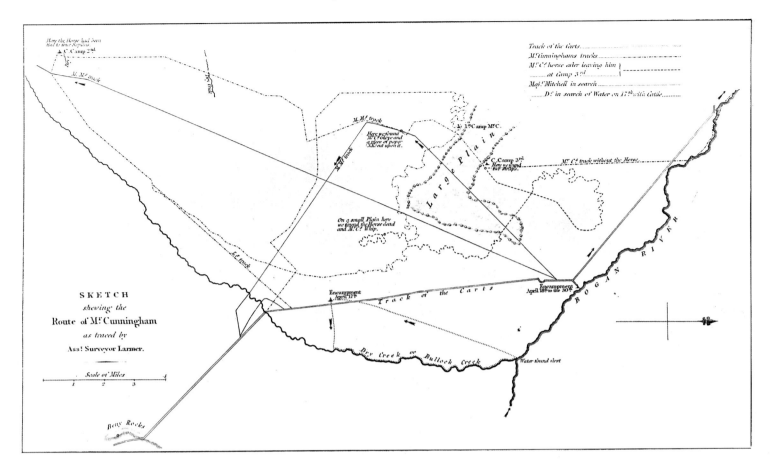

Sketch map showing the Route of Mr
Cunningham as traced by Asst. Surveyor Larmer.

fortunate! At that time I did not doubt, that I should find him at the camp; especially as we heard no guns, it being a practice in the bush to fire shots, when persons are missing, that they may hear the report, and so find the party. I then made sure of a pleasant night's rest, as I was relieved from my anxiety respecting the cattle.

I had the pain to learn, however, on reaching the camp about eleven o'clock, that Mr. Cunningham was still absent; and, what was worse, in all probability suffering from want of water. I had repeatedly cautioned this gentleman, about the danger of losing sight of the party in such a country; yet his carelessness in this respect was quite surprising. The line of route, after being traversed by our carts, looked like a road that had been used for years, and it was almost impossible to doubt, then, that he would fall in with it next morning.

April 18. We continued to fire shots and sound the bugle till eleven o'clock. Our cattle were then ready to drink again, and as Mr. Cunningham was probably a-head of us, to proceed on our route to the Bogan without further delay was indispensable, in order that we might, in case of need, make such extensive search for him, as was only possible from a camp where we could continue stationary.

We accordingly proceeded towards the Bogan, anxiously hoping, that Mr. Cunningham would fall in with our line, and rejoin the party in the course of the day. After proceeding due north eight miles, we came upon the bed of this river; but, before I could find water in it, I had to trace its course some way up and down. We at length encamped near a pond, and night advanced, but poor Mr. Cunningham came not!

April 19. After an almost sleepless night, I rose early, and could relieve my anxiety only by organising a search, to be made in different directions, and getting into movement as soon as possible. The darkness of a second night of dreary solitude, had passed over our fellow-traveller, under the accumulated horrors of thirst, hunger, and despair! . . .

I seldom saw to less distance, about me, than from one to two miles, or at least as far as that in some one direction. We continued to cooy frequently,

and the two men were ordered to look on the ground for a horse's track.

In the centre of a small plain, where I changed my direction to the south-east, I set up a small stick with a piece of paper fixed in it, containing the following words,

> "Dear Cunningham,
> "These are my horse's tracks, follow them backwards, they will lead you to our camp, which is N. E. of you.
> <div align="right">"T. L. MITCHELL."</div>

Returning, we continued the search, and particularly to the westward of Bullock creek, where the direction of our route had been changed; but I was disappointed in all our endeavours to find any traces of him there, although I enjoyed, for some time, a gleam of hope, on seeing the track of a horse near the bed of the creek, but it returned to our line, and was afterwards ascertained to have been made by the horse of Mr. Larmer.

Although scarcely able to walk myself, from a sprain, (my horse having fallen in a hole that day, and rolled on my foot), I shall never forget with what anxiety, I limped along that track, which seemed to promise so well; yet we were so unsuccessful that evening, on the very ground where, afterwards, Mr. Cunningham's true track was found, that I could no longer imagine, that our unfortunate fellow-traveller could be to the westward. . . .

April 20. After another night of painful anxiety, the dawn of the *third* day of Mr. Cunningham's absence, brought some relief, as daylight renewed the chance of finding him. . . .

April 21. I proceeded in a south-south-west direction, (or S. 17° W. by compass), or on an intermediate line between our route and the north-west line, by which I had explored that country on the nineteenth, the men cooying as before.

We explored every open space; and we looked into many bushes, but in vain. . . .

May 2. Five natives were brought to me by Whiting and Tom Jones, on suspicion; one of them having a silk pocket-handkerchief, which they thought might have belonged to Mr. Cunningham. . . .

While the men were pitching their tents, at this place, I rode with the natives, at their request, towards some ponds lower down. There, by their cooys and their looks, they seemed to be very anxious about somebody in the bush, beyond the Bogan. I expected to see their chief; at all events, from these silent woods something was to emerge, in which my guides were evidently much interested, as they kept me waiting nearly an hour for

"Th' unseen genius of the wood."

'First Meeting with the Chief of the Bogan', by T. L. Mitchell.

At length a man of mild but pensive countenance, athletic form, and apparently about fifty years of age, came forth, leading a very fine boy, so dressed with green boughs, that only his head and legs remained uncovered; a few emu-feathers being mixed with the wild locks of his hair. I received him in this appropriate costume, as a personification of the green bough, or emblem of peace.

One large feather decked the brow of the chief; which with his nose, was tinged with yellow ochre. Having presented the boy to me, he next advanced with much formality towards the camp, having "Tackijally" on his right, the boy walking between and rather in advance of both, each having a hand on his shoulder. . . .

To this personage, all the others paid the greatest deference, and it is worthy of remark, that they always refused to tell his name, or that of several others, while those of some of the tribe were "familiar in our mouths as household words." The boy, who was called Talàmbe Nadóo, was not his son; but he took particular care of him. This tribe gloried in the name of "Myall," which the natives nearer to the colony apply in terror and abhorrence to the "wild blackfellows," to whom they usually attribute the most savage propensities. . . .

May 5. . . . The tidings brought by the men sent after Mr. Cunningham's footsteps, were still most unsatisfactory. They had followed the river bed back for the first twelve miles from our camp, without finding in it a single pond. They had traced the continuation of his track to where it disappeared near some recent fires, where many natives had been encamped. Near one of these fires, they found a portion of the skirt or selvage of Mr. Cunningham's coat; numerous small fragments of his map of the colony; and, in the hollow of a tree, some yellow printed paper, in which he used to carry the map. The men examined the ground for half a mile all around without finding more of his footsteps, or any traces of him, besides those mentioned. It was possible, and indeed, as I then thought, probable, that having been deprived by the natives of his coat, he might have escaped from them by going northward, towards some of the various cattle stations on the Macquarie. I learnt that when the men returned with these vestiges of poor Cunningham, there was great alarm amongst the natives, and movements by night, when the greater part of the tribe decamped, and amongst them the fellow with the handkerchief, who never again appeared. The chief, or *king* (as our people called him), continued with us, and seemed quite unconscious of anything wrong. This tribe seemed too far from the place, where the native camp had been, to be suspected of any participation in the ill treatment with which we had too much reason to fear, Mr. Cunningham had met. As we had no language to explain, even that one of our party was missing, I could only hope, that, by treating these savages kindly, they might be more disposed, should they ever see or hear of Mr. Cunningham, to assist him to rejoin us. To delay the party longer was obviously unnecessary; and, indeed, the loss of more time must have defeated the object of the expedition, considering our limited stock of provisions.

I, therefore, determined on proceeding by short journeys along the Bogan, accompanied by these natives, not altogether without the hope, that Mr. Cunningham might still be brought to us, by some of them. . . . [Cunningham's

Mitchell's drawing of his boat carriage. Both Sturt and Mitchell made provision for having boats in the interior in case a great waterway or inland sea was discovered.

remains were discovered later that year by a search party led by Lieutenant Zouch of the Mounted Police. It appeared from the story told by the Aboriginals that they had befriended him, but when he wandered at night they had become frightened and killed him. Mitchell and his party continued their northwest trek and by 25 May had reached the Darling River.]

May 27. During the night the wind blew, and rain fell, for the first time, since the party left the colony. As we had been travelling for the last month on ground, which must have become impassable after two days of wet weather, it may be imagined what satisfaction our high position gave me, when I heard the rain patter. The morning being fair, I reconnoitered the course of the river, and the environs of our camp, and at once selected the spot, on which our tents then stood, for a place of defence, and a station in which the party should be left with the cattle. The boats were immediately lowered from the carriage, and although they had been brought 500 miles across mountain ranges, and through trackless forests, we found them in as perfect a state as when they left the dock-yard at Sydney.

Our first care was to erect a strong stockade of rough logs, that we might be secure under any circumstances; for we had not asked permission to come there from the inhabitants, who had been reported to be numerous. . . . As the position was, in every respect, a good one, either for its present purpose, or, hereafter perhaps, for a township . . . I named it Fort Bourke [near present-day Bourke], after His Excellency the present Governor, the better to mark the progress of interior discovery. . . .

Mitchell's problems in coping with the Aboriginals, who were at times friendly and helpful and at others savage and cunning, were often compounded by the apprehensive actions of his own men, as the following passages indicate. It was now over a month since Cunningham's disappearance.

June 27. About nine o'clock this morning, Joseph Jones came in to report, that a native had pointed a spear at him when he was on the river bank with the sheep; and that this native, accompanied by a boy, kept his ground in a position which placed the sheep entirely in his power, and prevented Jones from driving them back. He added, that on his holding out a green bough, the man had also taken a bough, spit upon it, and then thrust it into the fire. On hastening to the spot with three men, I found the native still there, no way daunted, and on my advancing towards him with a twig, he shook another twig at me, quite in a new style, waving it over his head, and at the same time intimating with it, that we must go back. He and the boy then threw up dust at us, in a clever way, with their toes. . . .

About half-past four in the afternoon, a party of the tribe made their appearance in the same quarter. . . . They used the most violent and expressive gestures, apparently to induce us to go back, whence we had come; and as I felt, that we were rather unceremonious invaders of their country, it was certainly my duty to conciliate them by every possible means. . . . The difference in disposition between tribes not very remote from each other was often striking. We had left, at only three days' journey behind us, natives as kind and civil as any I had met with; and I was rather at a loss now to understand, how they could exist so near fiends like these. . . .

June 28. The natives did not appear in the morning, as we had expected, but at three in the afternoon, their voices were again heard in the woods. . . . At length, I prevailed on an old man to sit down by me, and gave him a clasp-knife in order to check the search, he was disposed to make through my pockets. Meanwhile, the others came around the forge, and immediately began to pilfer, whatever they could lay either hand or foot upon. While one was detected making off with a file, another seized something else, until the poor blacksmith could no longer proceed with his work. . . . The best of this part of the scene was, that they did not mind being observed by any one, except the blacksmith, supposing that they were robbing him only. . . .

July 9th. . . . We continued over a firm clay surface . . . until we came on the Darling. The same natives, whom we had seen, but accompanied by another

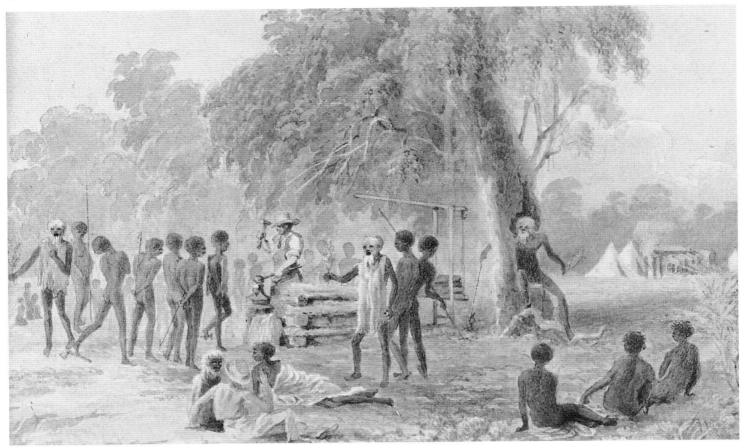

'Robbing the blacksmith' — *A watercolour by Mitchell, which also appears as a lithograph in his journal.*

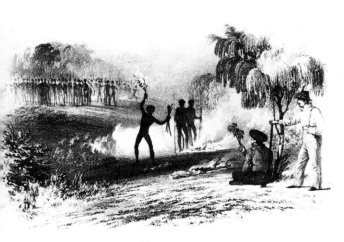

'Scene near the Darling', by Mitchell.

tribe, as it seemed, overtook the carts on the road, and now accompanied us. They were so covetous, that the progress of the carts was impeded for some time, by the care necessary on the part of the drivers, to prevent these people from stealing. Every thing, no matter what, they were equally disposed to carry off. . . .

July 10th. Early this morning, the blacks came up in increased numbers. . . .

July 11. Soon after sunrise this morning, some natives, I think twelve or thirteen in number, were seen approaching our tents at a kind of run, carrying spears and green boughs. As soon as they arrived within a short distance, three came forward, stuck their spears in the ground, and seemed to beckon me to approach; but as I was advancing towards them, they violently shook their boughs at me, and having set them on fire, dashed them to the ground, calling out "Nangry," (sit down.) I accordingly obeyed the mandate; but seeing that they stood, and continued their unfriendly gestures, I arose and called to my party, on which the natives immediately turned, and ran away.

I took forward some men, huzzaing after them for a short distance, and we fired one shot over their heads, as they ran stumbling to the other side of an intervening clear flat, towards the tribe, who were assembling, as lookers-on. There they made a fire, and seeming disposed to stop, I ordered four men with muskets to advance and make them quit that spot; but the men had scarcely left the camp when the natives withdrew, and joined the tribe beyond, amid much laughter and noise. . . . I became now apprehensive, that the party could not be safely separated under such circumstances, and when I ascertained, as I did just then, that a small stream joined the Darling from the west, and that a range was visible in the same direction beyond it, I discontinued the preparations I had been making for exploring the river further with pack animals, and determined to return. The identity of this river with that which had been seen to enter the Murray, now admitted of little doubt, and the continuation of the survey to that point, was scarcely an object worth the peril likely to attend it. I had traced its course upwards of 300 miles, through a country which did not supply a single stream, all the torrents which might descend from the sharp and naked hills, being absorbed by the thirsty earth. . . .

Scarce an hour had elapsed, after I had communicated my determination to the party, when a shot was heard on the river. This was soon followed by several others, which were more plainly audible, because the wind was fortunately from the north-west; and as five of the bullock-drivers and two men, sent for water, were at that time there, and also the tribe of king Peter, it was evident that a collision had taken place between them. . . . As soon as the firing was heard, several men rushed forward as volunteers to support the party on the river, and take them more ammunition. Those, whose services I accepted, were William Woods, Charles King, and John Johnston (the blacksmith), who all ran through the polygonum bushes with a speed, that seemed to astonish, even the two natives, still sitting before our camp. In the mean time we made every possible preparation for defence. Robert Whiting, who was very ill and weak, crawled to a wheel; and he said that though unable to stand, he had yet strength enough to load and fire. The shots at the river seemed renewed almost as soon as the reinforcement left us, but we were obliged to remain in ignorance of the nature and result of the attack, for at least an hour, after the firing had ceased. . . .

It now turned out, that the tea-kettle which Jones carried, had been the sole cause of the quarrel. As he was ascending the river bank with the water, Thomas Jones (the sailor) being stationed on the bank, covering the other with his pistol, as was usual and necessary on this journey; king Peter, who had come along the bank with several other natives, met him when half way up, and smilingly took hold of the pot, as if meaning to assist him in carrying it up; but on reaching the top of the bank, he, in the same jocose way, held it fast, until a gin said something to him, upon which he relinquished the pot and seized the kettle with his left hand, and at the same time grasping his waddy or club in his right, he immediately struck Joseph Jones senseless to the ground, by a violent blow on the forehead. On seeing this, the sailor Jones fired, and wounded, in the thigh or groin, king Peter, who thereupon dropped his club, reeled over the bank, swam across the river, and scrambled up the opposite side. This delay gave Jones time to reload for defence against the tribe, who were now advancing towards him. One man who stood covered by a tree, quivered his spear ready to throw, and Jones on firing at him, missed him. His next shot was discharged amongst the mob, and most unfortunately wounded the gin already mentioned; who, with a child fastened to her back, slid down the bank, and lay, apparently dying, with her legs in the water. . . .

A death-like silence now prevailed along the banks of the river, no far-heard voices of natives at their fires broke, as before, the stillness of the night—while a painful sympathy for the child bereft of its parent, and anticipations of the probable consequences to us, cast a melancholy gloom over the scene. The waning moon at length arose, and I was anxiously occupied with the observations, which were most important at this point of my journey, when a mournful song, strongly expressive of the wailing of women, came from beyond the Darling, on the fitful breeze which still blew from the north-west. It was then that I regretted most bitterly the inconsiderate conduct of some of the men. I was, indeed, liable to pay dear for geographical discovery, when my honour and character were delivered over to convicts, on whom, although I might confide as to courage, I could not always rely for humanity. . . .

July 12. . . . We broke up the camp at ten A.M. and turned our faces homewards. . . . [Mitchell's party had gone as far as Lindley's Ponds, a series of lakes now known by individual names, near present-day Menindie. They had not succeeded in tracing the Darling to its junction with the Murray.]

In March 1836 the *Beagle* was sailing out of King George Sound, homeward bound after an historic voyage. Charles Darwin wrote in his journal: 'Farewell, Australia! you are a rising infant and doubtless some day will reign a great princess in the south: but you are too great and ambitious for affection, yet not great enough for respect. I leave your shores without sorrow or regret'.[3]

At the same time Mitchell was on his travels once more. This third expedition to the rivers Darling and Murray was to greatly accelerate the

List of the Party proceeding to the Darling in March 1836.

Australia Felix

3. Charles Darwin, *Journal of Researches into the Geology and Natural History of the Various Countries visited by H.M.S. Beagle, under the command of Captain Fitzroy, R. N. from 1832 to 1836.* London, 1839.

Cockatoo from the interior of Australia

Mitchell's drawings and descriptions indicate his interest in Australia's varied wildlife. On the Lachlan River he noted that a 'flight of the cockatoo of the interior with scarlet and yellow top-knot, passed over our heads from the north-west'.

opening up of western Victoria, which would in turn do so much to increase the prosperity of Darwin's 'princess'.

Towards the end of the year 1835, I was apprised, that the governor of New South Wales was desirous of having the survey of the Darling completed with the least possible delay. His excellency proposed, that I should return for this purpose to the extreme point on the Darling, where my last journey terminated, and that, after having traced the Darling into the Murray, I should embark on the latter river, and, passing the carts and oxen to the left bank, at the first convenient opportunity, proceed upwards by water, as far as practicable, and regain the colony somewhere about Yass Plains. . . .

In consequence of a long continued drought, serviceable horses and bullocks were at that time scarce, and could only be obtained at high prices; but no expense was spared by the government in providing the animals required. . . .

March 30. I ascertained accidentally this morning, that we were abreast of the spot, where Mr. Oxley left the Lachlan and proceeded southward. [They were in the vicinity of present-day Condobolin.] This, I learnt from a marked tree, which a native pointed out to me, distant about 250 yards south from our camp, on the opposite side of a branch of the river. On this tree were still legible the names of Mr. Oxley and Mr. Evans; and although the inscription had been there nineteen years, the tree seemed still in full vigour. . . .

April 21. . . . I considered it necessary now to ascertain, if possible, and before the heavy part of our equipment moved further, whether the Lachlan actually joined the Murrumbidgee near the point, where Mr. Oxley saw its waters covering the country; or whether it pursued a course, so much more to the westward, as to have been taken for the Darling by Captain Sturt. Near the Lachlan, at this place, the *anthericum bulbosum* occurred in abundance, and the cattle seemed to eat it with avidity.

On the bank of the river, a new species of roselle appeared amongst the birds, and several were shot and preserved as specimens.

April 22. I proceeded westward, accompanied by five men and an aboriginal guide, all mounted on horseback. . . .

April 23. . . . Late in the night, as we lay burning with thirst and dreaming of water, a species of duck flew over our heads, which from its particular note, I knew I had previously heard on the Darling. . . .

May 5. The ground being very heavy, the cattle in the carts proceeded but slowly along the plains to the northwards of the Lachlan. . . . Our female guide, who appeared to be about thirty years of age, remembered the visit of the white men; and she this day shewed me the spot, where Mr. Oxley's tent stood, and the root with some remains of the branches of a tree near it, which had been burnt down very recently, and on which she said some marks were cut. . . . [This was Oxley's last camp before he turned back in 1817.]

May 11. . . . Although anxious to see the junction of the Lachlan and the Murrumbidgee, curiosity irresistible led me to the rising ground; while Mr. Stapylton traced the supposed line of the Lachlan, and the overseer conducted the carts and party westward. . . . On the top of this ridge, I ate a russet apple, which had grown in my garden at Sydney, and I planted the seeds in a spot of rich earth, likely to be saturated with water as often as it fell from the heavens. Southward I could see no trace of the Lachlan, and I hastened towards the highest trees where I thought it turned in that direction. I thus met the track of the carts at right angles and galloped after them, as they were driving through scrubs and over heaths away to the westward. . . .

May 12. It had rained heavily during the night, so that water was no longer scarce. . . . On passing the scrubs, we crossed a plain of the same kind which we had so often met. It sloped towards a belt of large trees in a flat, where we also saw reeds, the ground there being very soft and heavy for the draught animals. Passing this flat, we again reached firm ground with stately yarra trees; and charming vistas through miles of open forest scenery, had, indeed, nearly drawn me away from the bearing which was otherwise most likely to hit the river. I, however, continued to follow it, and in the midst of such scenery, without being at all aware that I was approaching a river, I suddenly saw the

water before me, and stood at last on the banks of the Murrumbidgee. . . . After thirsting so long amongst the muddy holes of the Lachlan, I witnessed, with no slight degree of satisfaction, the jaded cattle drinking at this full and flowing stream, resembling a thing of life, in its deep and rippling waters. . . .

May 14. . . . So far from terminating in a lagoon or uninhabitable marsh, the banks of the Lachlan, at fifty miles below the spot, where Mr. Oxley supposed he saw its termination as a river, are backed on both sides by rising ground, until the course turns southward into the Murrumbidgee. . . .

May 16. We commenced our journey down the Murrumbidgee. Our route passed occasionally through reeds, as we cut off the bends of the river; but they formed no serious impediment, although they stood so high, that we occasionally experienced some difficulty in following each other through them. . . .

May 22. This morning the bullock-drivers gave so favourable an account of the pasture, that I determined to leave a depôt there [Lake Stapylton, near the junction of the Murrumbidgee and Murray Rivers], and to set out next morning, with the rest of the party, for the Darling. . . .

May 23. . . . Mr. Stapylton and I then separated, with a mutual and most sincere wish, that we should meet again as soon as possible. . . . [Stapylton remained at the depot with eight of the men, while Mitchell and the remaining fifteen of the party departed for the Darling.] At 7½ miles, we crossed ground of a more open character than any we had seen for some days; and it appeared to belong to the river margin, as it was marked by some yarra trees. On approaching this river I judged, from the breadth of its channel, that we were already on the banks of the Murray. . . .

May 24. It was quite impossible to say on what part of the Murray, as laid down by Captain Sturt, we had arrived; and we were therefore obliged to feel our way, just as cautiously, as if we had been upon a river unexplored. . . .

The alarm of our arrival was then resounding among the natives, whom I saw in great numbers along its western shores. . . . It will, however, be readily understood with what caution we followed these natives, when we discovered, almost as soon as we fell in with them, that they were actually our old enemies from the Darling! I had certainly heard, when still far up on the Lachlan, that these people were coming down to fight us; but I little expected, they were to be the first natives we should meet with on the Murray, at a distance of nearly two hundred miles from the scene of our former encounter. . . .

In the group before me, were pointed out two daughters of the gin which had been killed, also a little boy, a son. The girls exactly resembled each other, and reminded me of the mother. The youngest was the handsomest female, I had ever seen amongst the natives. She was so far from black, that the red colour was very apparent in her cheeks. She sat before me in a corner of the group, nearly in the attitude of Mr. Bailey's fine statue of Eve at the fountain; and apparently equally unconscious that she was naked. As I looked upon her for a moment, while deeply regretting the fate of her mother, the chief who stood by, and whose hand had more than once been laid upon my cap, as if to feel whether it were proof against the blow of a waddy, begged me to accept of her in exchange for a tomahawk! . . .

Night had closed in, and these groups hung still about us, having also lighted up five large fires, which formed a cordon around our camp. Still I did not interfere with them, relying chiefly on the sagacity and vigilance of Piper [Mitchell's Aboriginal guide], whom I directed to be particularly on the alert. At length Burnett came to inform me, that they had sent away all their gins, that there was no keeping them from the carts, and that they seemed bent on mischief. Piper also took the alarm, and came to me, inquiring, apparently with a thoughtful sense of responsibility, what the Governor had said to me, about shooting blackfellows. "These," he continued, "are only Myalls," (*wild natives*). His gin had overheard them arranging, that three should seize and strip him, while others attacked the tents. I told him the Governor had said positively, that I was not to shoot blackfellows, unless our own lives were in danger. I then went out—it was about eight o'clock,—and I saw one fellow who had always been very forward, posted behind our carts, and speaking to Piper's wife. I ordered him away, then drew up the men in line, and when, as preconcerted, I sent up

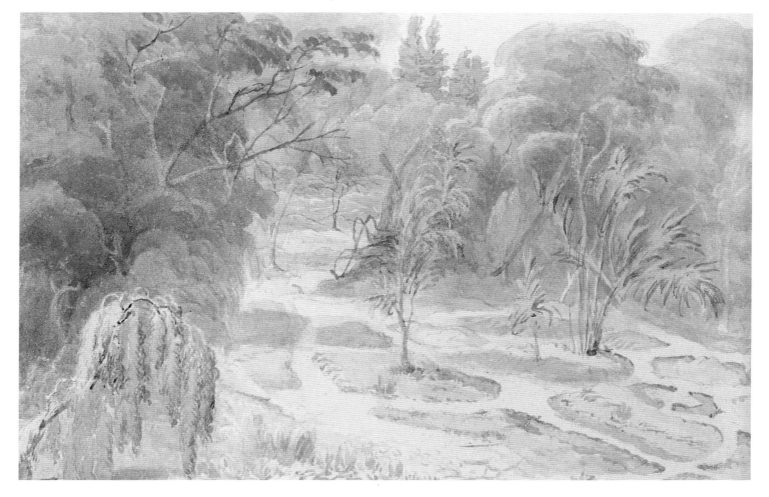

A watercolour by Mitchell of a native burial ground.

a rocket, and the men gave three cheers, all the blacks ran off, with the exception of one old man, who lingered behind a tree. They hailed us afterwards from the wood at a little distance, where they made fires, saying they were preparing to corrobory, and inviting us to be present. . . .

May 25. . . . It was most painfully alarming to discover, that the knowledge these savages had acquired of the nature of our arms, by the loss of several lives last year, did not deter them from following us now with the most hostile intentions. . . .

May 27. . . . We proceeded on our journey as usual, but had not gone far, when we heard the voices of a vast body of blacks following our track, shouting prodigiously, and raising war cries. . . . We were travelling along the *berg* or outer bank of the river, a feature which not only afforded the best defensive position, but also guided me in tracing the river's course. . . . The natives however having immediately discovered our ambuscade, by the howling of one of their dogs, halted, and poised their spears; but a man of our party (King) inconsiderately discharging his carabine, they fled, as usual, to their citadel, the river, pursued and fired upon by the party from the scrub. The firing had no sooner commenced, than I perceived from the top of the hill, which I ascended, some of the blacks, who appeared to be a very numerous tribe, swimming across the Murray. I was not then aware what accidental provocation had brought on this attack, without my orders, but it was not the time to inquire; for the men, who were with me, as soon as they heard the shots of their comrades, and saw me ascend the hill, ran furiously down the steep bank to the river, not a man remaining with the carts. . . . The sound of so much firing must have been terrible to them, and it was not without effect, if we may credit the information of Piper, who was afterwards informed that seven had been shot in crossing the river, and among them the fellow in the cloak, who at Benanee appeared to be the chief. Much as I regretted the necessity for firing upon these savages, and little as the men might have been justifiable under other circumstances, for firing upon any body of men without orders, I could not blame them much on this

occasion; for the result was the permanent deliverance of the party from imminent danger. . . .

I gave to the little hill which witnessed this overthrow of our enemies, and was to us the harbinger of peace and tranquillity, the name of Mount Dispersion. [They were about halfway between the present-day towns of Mildura and Robinvale. This incident caused Mitchell some embarrassment when the Executive Council later conducted an inquiry into the affair.]

May 31. I now ventured to take a north-west course, in expectation of falling in with the supposed Darling. . . .

June 1. . . . We continued our journey, and soon found all the usual features of the Darling; the hills of soft red sand near the river, covered with the same kind of shrubs seen so much higher up. The graves had no longer any resemblance to those on the Murrumbidgee and Murray, but were precisely similar to the places of interment we had seen on the Darling, being mounds surrounded by, and covered with, dead branches and pieces of wood. . . .

At length, I reached an angle of the river, and encamped on a small flat beside a sand-hill. Here the Darling was only a chain of ponds, and I walked across its channel dry shod, the bed consisting of coarse sand, and angular fragments of ferruginous sandstone. . . . While I stood on the adverse side or the right bank of this hopeless river, I began to think, I had pursued its course far enough. The identity was no longer a question. . . . My anxiety about the safety of the depôt, brought me more speedily to this determination. . . .

June 3. . . . A bank of sand extended further, and on standing upon this and looking back, I recognised the view given in Captain Sturt's work and the adjacent localities described by him. . . .

June 10. We started early, and by crossing a small plain, cut off half a mile of our former route. When within a few miles of the camp of Mr. Stapylton, we heard a shot, and soon discovered that it was fired by one of the men (Webb), rather a "*mauvais sujet*," who had been transgressing rules by firing at a duck. We learnt from him, however, the agreeable news that the depôt had not been disturbed. . . . Mr. Stapylton and his party were well. . . . We had now got through the most unpromising part of our task. We had penetrated the Australian Hesperides—although the golden fruit was still to be sought. . . . and to trace the Murray upwards and explore the unknown regions beyond it, was a charming undertaking, when we had at length bid adieu, for ever, to the dreary banks of the Darling. . . .

June 16. We left our encampment, and commenced our travels up the left bank of the Murray, over ground which seemed much better than any we had seen on the right bank. . . . [Mitchell had now put aside his instructions from Governor Bourke regarding tracing the unexplored stretch of the Darling between its junction with the Murray and present-day Menindee.]

June 19. Piper, although so far from his country, could still point directly to it, but he had grown so homesick, that he begged Burnett not to mention Bathurst. . . .

June 21. Among the reeds on the point of ground between the two rivers [the Murray and what was later called the Loddon River], was a shallow lagoon, where swans and other wild fowl so abounded that, although half a mile from our camp, their noise disturbed us through the night. I, therefore, named this somewhat remarkable and isolated feature, Swan-hill. . . .

At this camp, where we lay shivering for want of fire, the different habits of the aborigines and us, strangers from the north, were strongly contrasted. On that freezing night, the natives, according to their usual custom, stript off all their clothes, previous to lying down to sleep in the open air, their bodies being doubled up around a few burning reeds. We could not understand how they could lay thus naked, when the earth was white with hoar frost. . . .

June 28. . . . The country which I had seen this day beyond Mount Hope, was too inviting to be left behind us unexplored; and, I therefore, determined to turn into it without further delay. . . . [Mitchell then departed from the Murray—and, again, from the governor's instructions, which had been to pursue the river as far as possible.]

June 30. Having seen the party on the way, and directed it to proceed on

a bearing of 215° from N., I ascended the rocky pyramidic hill [near the Victorian town of Pyramid Hill], which I found arose to the height of 300 feet above the plain. Its apex consisted of a single block of granite, and the view was exceedingly beautiful over the surrounding plains, shining fresh and green in the light of a fine morning. The scene was different from anything I had ever before witnessed, either in New South Wales or elsewhere. A land so inviting, and still without inhabitants! As I stood, the first European intruder on the sublime solitude of these verdant plains, as yet untouched by flocks or herds; I felt conscious of being the harbinger of mighty changes; and that our steps would soon be followed by the men and the animals for which it seemed to have been prepared. . . .

July 13. We had at length discovered a country ready for the immediate reception of civilized man; and destined perhaps to become eventually a portion of a great empire. . . . [On his map and towards the end of this journal Mitchell refers to this area as 'Australia Felix'. It would become the rich farming area of western Victoria.]

July 14. . . . [Mitchell and six of the party went off to explore a nearby mountain range—the Grampians.] We had not come prepared in any way to pass the night on such a wild and desolate spot, for we had neither clothing, nor food, nor was there any shelter; but I was willing to suffer any privations, for the attainment of the object of our ascent. One man, Richardson, an old traveller, had most wisely brought his day's provisions in his havresack, and these I divided equally among *five*. . . . The thermometer stood at 29°, and we strove to make a fire to protect us from the piercing cold; but the green twigs, encrusted with icicles, could not by our united efforts be blown into a flame sufficient to warm us. There was abundance of good wood *at the foot of the cliffs*. . . .

July 15. At six o'clock, the sky became clear . . . and as soon as it was day, I mounted the frozen rock. . . . I could distinguish only a pool of water, apparently near the foot of the mountain. This water . . . I afterwards found to be a lake eight miles distant, and in my map I have named it Lake Lonsdale [near Stawell], in honour of the Commandant then, or soon after, appointed at Port Phillip. . . . That night on the mountain materially injured the health of two of my best men, and who had been with me on all three of my expeditions. . . .

In adding this noble range of mountains to my map, I felt some difficulty in deciding on a name. . . . The capes on the coast, I was then approaching, were chiefly distinguished with the names of naval heroes; and as such capes were but subordinate points of the primitive range, I ventured to connect this summit [Mount William] with the name of the sovereign in whose reign the extensive, valuable, and interesting region below was first explored; and, I confess, it was not without some pride, as a Briton, that I, "more majorum", gave the name of the Grampians, to these extreme summits of the southern hemisphere. . . .

July 18. We continued for five miles along good firm ground, on which there was an open forest of box and gum-trees; and part of the bold outline of the Grampians appeared to our left. At 9 miles we fell in with a flowing stream, the water being deep and nearly as high as the banks I did not doubt, that this was the channel of the waters from the north-side of these mountains, and, I was convinced, that it contained the water of all the streams we had crossed on our way to Mount William, with the exception of Richardson's creek, already crossed by the party, where it was flowing to the north-west. The richness of the soil, and the verdure near the river, as well as the natural beauty of the scenery, could scarcely be surpassed in any country. The banks were in some places open and grassy, and shaded by lofty yarra trees, in others mimosa-bushes nodded over the eddying stream. . . .

Some natives being heard on the opposite bank, Piper advanced towards them as cautiously as possible; but he could not prevail on them to come over, although he ascertained, that the name of the river was the "Wimmera". . . .

July 31. We now moved merrily over hill and dale, but were soon, however, brought to a full-stop by a fine river. . . . The banks of this stream were thickly overhung with bushes of the mimosa, which were festooned in a very picturesque manner with the wild vine. . . .

Aug. 15. Two bullocks were still missing, and I had recourse to compulsory

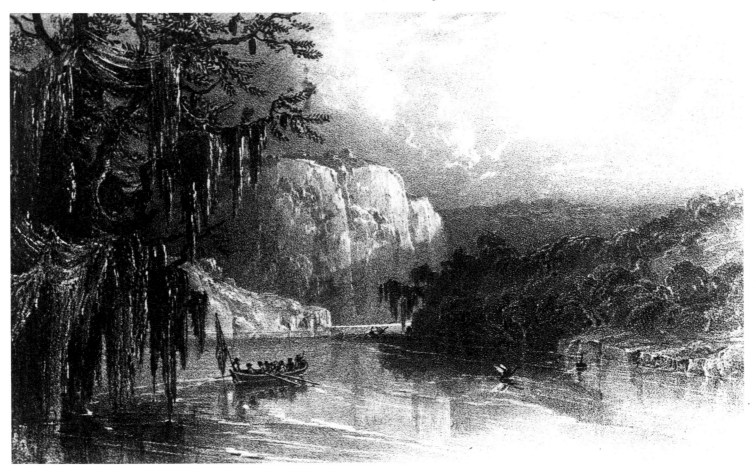

measures with Piper and the man who lost them, in order to find them again:
I declared that unless they were found, Piper should have no provisions for a
week; and I condemned the man who lost them to be kept every second night
on watch, during the remainder of the journey. . . . We found the country
beyond very intricate, being so intersected with swamps, draining off in all
directions, and so divided by stringy bark forests, that it was next to impossible
to avoid the soft swampy ground, or reach the river bank again. . . . At length
I approached a ravine . . . but I soon perceived through the trees on my right,
a still greater opening, and there I at last found the valley of the Glenelg. . . .

Aug. 16. This morning it rained heavily, and there was a balmy and refresh-
ing mildness in the air, probably owing to the vicinity of the sea. . . .

Aug. 18. . . . I embarked on the river [the Glenelg] with sixteen men, in two
boats, leaving eight with Mr. Stapylton in the depôt. . . .

Aug. 19. I arose at three in order to determine the latitude more exactly,
by the altitude of various stars then approaching the meridian. . . .

Aug. 20. . . . We pulled on through the silent waters, awakening the slum-
bering echoes with many a shot at the numerous swans or ducks. . . . In the two
basins we had seen, there was scarcely sufficent water to float the boats, and thus
our hopes of finding a port at the mouth of this fine river were at once at an
end. The sea broke on a sandy beach outside, and on ascending one of the sand
hills near it, I perceived Cape Northumberland. . . . Mount Gambier bore 23°40'
N. of W. and a height which seemed near the extreme point of the coast to the
eastward, and which I therefore took for Cape Bridgewater, bore 52°E. of S.
These points seemed distant from each other about forty miles; the line of coast
between forming one grand curve or bay, which received this river at the
deepest part, and which I now named Discovery Bay. . . . I was too intent on
the completion of my survey, to indulge much in contemplating the welcome
sight of old ocean; but when a plank was picked up by the men on that desolate
shore, and we found the initials, I. W. B., and the year 1832, carved on wood
which had probably grown in old England, the sea really seemed like home to
us. . . .

*'Rowing up the Glenelg River' by Mitchell —
from his journal.*

This sketch by the surveyor John Helder Wedge indicates how the Henty establishment at Portland Bay would have appeared when Mitchell arrived there in August 1836. Wedge himself was an explorer in both Van Diemen's Land and around Port Phillip and was one of the founders of Melbourne.

Aug. 29. . . . [After further struggles through boggy country they had reached Portland Bay.] Proceeding round the bay with the intention of examining the head of an inlet and continuing along shore as far as Cape Bridgewater, I was struck with the resemblance to houses, that some supposed grey rocks under the grassy cliffs presented; and while I directed my glass towards them, my servant Brown said he saw a brig at anchor; a fact of which I was soon convinced, and also that the grey rocks were in reality wooden houses. . . .

We ascended these cliffs near the wooden houses, which proved to be some deserted sheds of the whalers. One shot was heard as we drew near them, and another on our ascending the rocks. I then became somewhat apprehensive that the parties might either be, or suppose us to be, bushrangers, and to prevent if possible some such awkward mistake, I ordered a man to fire a gun and the bugle to be sounded; but on reaching the higher ground, we discovered not only a beaten path, but the track of two carts, and while we were following the latter, a man came towards us from the face of the cliffs. He informed me in answer to my questions, that the vessel at anchor was the "Elizabeth of Launceston;" and that just round the point there was a considerable farming establishment, belonging to Messrs. Henty, who were then at the house. It then occurred to me, that I might there procure a small additional supply of provisions, especially of flour, as my men were on very reduced rations. I, therefore, approached the house, and was kindly received and entertained by the Messrs. Henty, who as I learnt had been established there during upwards of two years. It was very obvious indeed from the magnitude and extent of the buildings, and the substantial fencing erected, that both time and labour had been expended in their construction. A good garden stocked with abundance of vegetables, already smiled on Portland Bay; the soil was very rich on the overhanging cliffs, and the potatoes and turnips produced there, surpassed in magnitude and quality any I had ever seen elsewhere. I learnt that the bay was much resorted to by vessels engaged in the whale fishery, and that upwards of 700 tons of oil had been shipped that season. I was likewise informed that only a few days before my arrival, five vessels lay at anchor together in that bay, and that a communication was regularly kept up with Van Diemen's Land by means of vessels from Launceston. Messrs. Henty were importing sheep and cattle as fast as vessels could be found to bring them over, and the numerous whalers touching at or fishing on the coast, were found to be good customers for farm produce and whatever else could be spared from the establishment. . . .

Aug. 30. . . . I was accommodated with a small supply of flour by Messrs. Henty, who having been themselves on short allowance, were awaiting the arrival of a vessel then due two weeks. They also supplied us with as many vegetables, as the men could carry away on their horses. Just as I was about to leave the place, "a whale" was announced, and instantly three boats well manned, were seen cutting through the water, a harpooneer standing up at the stern of each with oar in hand, and assisting the rowers by a forward movement at each stroke. It was not the least interesting scene in these my Australian travels, thus to witness from a verandah on a beautiful afternoon at Portland Bay, the humours of the whale fishery, and all those wondrous perils of harpooneers and whale boats, of which I had delighted to read as scenes of "the stormy north". . . .

Sept. 2. We travelled as much in a north-east direction as the ground permitted, but although I should most willingly have followed the connecting features whatever their directions, I could not avoid the passage of various swamps or boggy soft hollows, in which the carts, and more especially the boat-carriage, notwithstanding the greatest exertions on the part of the men, again sank up to the axles. . . .

Sept. 10. . . . Smoke arose from many parts of the lower country, and showed that the inhabitants were very generally scattered over its surface. We could now look on such fires with indifference, so harmless were these natives, compared with those on the Darling. . . .

Sept. 17. This day the rest of the party came up, but the cattle seemed quite exhausted. They had at length become so weak, from the continued heavy dragging through mud, that it was obvious they could not proceed much further until after they had enjoyed at least some weeks of repose. But our provisions

did not admit of this delay, as the time had arrived, when I ought to have been at Sydney, although still so far from it. After mature deliberation, we hit upon a plan, which might, as I thought, enable us to escape. The arrangement proposed was, that I should go forward with some of the freshest of the cattle drawing the light carts and boat, with a month's provisions, and taking with me as many men as would enable me to leave with those who should remain, provisions for two months. That the cattle should rest at the present camp two weeks [in the vicinity of present-day Hamilton] and then proceed, while I, by travelling so far before them with so light a party, could send back a supply of provisions, and also the boat, to meet this second party following in my track, on the banks of the Murray. . . .

Sept. 20. Our wheels now rolled lightly over fine grassy downs, and our faces were turned towards distant home. . . . [They were travelling in a north-easterly direction.]

Sept. 27. I was surprised to hear the voice of a Scotch-woman in the camp, this morning . . . and I called to inquire who the stranger was, when I ascertained that it was only Tommy Come-last [an aboriginal member of the party], who was imitating a Scotch female, who, as I then learnt, was at Portland Bay, and had been very kind to Tommy. . . .

Sept. 30. Compelled . . . to await the repair of the boat-carriage, I determined to make an excursion to the lofty mountain mass, which appeared about thirty miles to the southward, in order that I might connect my survey with Port Phillip, which I hoped to see thence. . . . I at length recognized Port Phillip. . . . At that vast distance, I could trace no signs of life about this harbour. No stockyards, cattle, nor even smoke, although at the highest northern point of the bay, I saw a mass of white objects which might have been either tents or vessels. . . . Thus the mountain on which I stood, became an important point in my survey, and I gave it the name of Mount Macedon, with reference to that of Port Phillip. . . .

By mid October Mitchell had re-crossed the Murray River. Near the end of his journal he comments on the country over which he had travelled.

The land is . . . open and available in its present state, for all the purposes of civilized man. We traversed it in two directions with heavy carts, meeting no other obstruction than the softness of the rich soil; and, in returning, over flowery plains and green hills, fanned by the breezes of early spring, I named this region Australia Felix, the better to distinguish it from the parched deserts of the interior country, where we had wandered so unprofitably, and so long. . . .

'Deputy Collector of Customs, and Surveyor's Camp on arrival at Port Phillip, Dec 1836' by Robert Russell, the first surveyor of Port Phillip.

As Mitchell's journal shows he was not the first to exult over Australia Felix, although his discoveries and maps opened routes and greatly hastened Victorian settlement. The Hentys were at Portland Bay when he arrived there in 1836, while J. P. Fawkner and John Batman were on the Yarra. Pioneers were opening new lands, C. H. Ebden, for example, was already south of the Murray.

Towards the close of 1836 Mitchell was back in Sydney and the overlander Joseph Hawdon was setting out from the Murrumbidgee to the 'new settlement of Port Phillip' taking, as he later wrote, 'a herd of upwards of three hundred head of cattle, being the first expedition of the kind ever performed between that Settlement and the parent Colony'.[4]

Gippsland Discovered

Angus McMillan, the discoverer of Gippsland. Had his discovery been recognised earlier the name which he bestowed on this district — 'Caledonia Australis' — might have remained.

Angus McMillan (1810–1865) arrived in Sydney from Scotland in 1838 and by the following year was manager of a cattle station in the Monaro district of New South Wales. From here he moved south to discover in 1839 the part of Victoria which he named 'Caledonia Australis', but which ironically came to be known as Gippsland, the name given to it by 'Count' Strzelecki. (In fact McMillan preceded Strzelecki into the district but Strzelecki's report appeared first.) From this time on McMillan's life was spent as a pioneer, pastoralist and keen supporter of the district. He was also concerned with the welfare of Aboriginals. He died in 1865 while engaged in opening up new tracks in Gippsland. The story of his major discovery—and his comments on Strzelecki—are found in the following 'memorandum' of his trip from the 'Maneroo' district in 1839.[5]

Start from Maneroo. On the 20th of May 1839, I left Currawang, a station of James McFarlane, Esq., J.P., of the Maneroo district, having heard from the natives of that district that a fine country existed near the sea-coast, to the south-west of Maneroo.

Accompanied by one Black only. I was accompanied in my expedition by Jemmy Gibber, the chief of the Maneroo tribe. After five days' journey towards the south-west, I obtained a view of the sea from the top of a mountain, near a hill known as the Haystack, in the Buchan district, and also of the low country towards Wilson's Promontory.

On the sixth day after Currawang the blackfellow who accompanied me became so frightened of the Warrigals, or wild blacks, that he tried to leave me, and refused to proceed any further towards the new country. We pressed on until the evening when we camped, and about twelve o'clock at night I woke up, and found Jemmy Gibber in the act of raising his waddy or club to strike me, as he fancied that, if he succeeded in killing me, he would then be able to get back to Maneroo. I presented a pistol at him, and he begged me not to shoot him, and excused himself by saying that he had dreamt that another blackfellow was taking away his gin, and that he did not mean to kill me.

Omeo. Next morning we started for Omeo, where we arrived after four days' journey over very broken country. There were three settlers at Omeo at this time, viz., Pender, McFarlane, and Hyland.

Numbla-Munjee. On the 16th September 1839 I formed a cattle station at a place called Numbla-Munjee [or Ensay], on the River Tambo, 50 miles to the south of Omeo, for Lachlan Macalister, Esq., J.P. A Mr. Buckley had, previous to my arrival here, formed a station ten miles higher up the River Tambo from Numbie-Munjee.

On the 26th December 1839 I formed a party, consisting of Mr. Cameron, Mr. Matthew Macalister, Edward Bath, a stockman, and myself, with the view of proceeding towards and exploring the low country I had formerly obtained a view of from the mountain in the Buchan district alluded to in my first trip from Maneroo. After travelling for three days over a hilly and broken country, one of our horses met with a serious accident, tumbling down the side of the steep ranges, and staked itself in four or five places. In consequence of this accident we were compelled to return to Numbla-Munjee.

On the 11th of January 1840, the same party as before, with the addition

4. Joseph Hawdon, *The Journal of a Journey from New South Wales to Adelaide.* Melbourne, 1952.

5. 'Memorandum of Trip by A. McMillan, from Maneroo District, in the year 1839, to the South-West of that District, towards the Sea-coast, in Search of New Country', in Thomas Francis Bride, *Letters from Victorian Pioneers. A Series of Papers on the early Occupation of the Colony, the Aborigines, etc.* Melbourne, 1898.

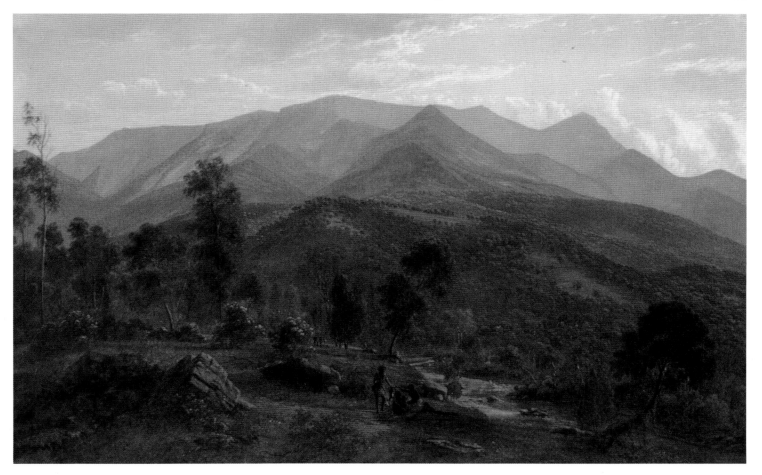

of two Omeo blacks—Cobbon Johnny and Boy Friday—started once more with the same object in view, namely, that of reaching the new country to the south-west, and if possible, to penetrate as far as Corner Inlet, where I was led to believe there existed an excellent harbour.

Meet with the Aborigines. After a fearful journey of four days, over some of the worst description of country I ever saw, we succeeded in crossing the coast range leading down into the low country. This day we were met by a tribe of the wild blacks who came up quite close to us, and stared at us while on horse-back, but the moment I dismounted they commenced yelling out, and took to their heels, running away as fast as possible; and from the astonishment displayed at the circumstance of my dismounting from the horse, I fancied they took both man and horse to constitute one animal.

Lake Victoria. On Wednesday, the 15th of January, our little party encamped on the River Tambo, running towards the sea in a south-easterly direction. On the morning of the 16th we started down the Tambo, in order, if possible, to get sight of a lake we had previously seen when descending the ranges to the low country and which I was certain must be in our immediate vicinity. The country passed through to-day consisted of open forest, well-grassed, the timber consisting chiefly of red and white gum, box, he-and she-oak, and occasionally wattle. At six p.m. we made the lake, to which I gave the name Lake Victoria. From the appearance of this beautiful sheet of water, I should say that it is fully 20 miles in length and about 8 miles in width. On the north side of this lake the country consists of beautiful open forest, and the grass was up to our stirrup-irons as we rode along, and was absolutely swarming with kangaroos and emus. The lake was covered with wild ducks, swans, and pelicans. We used some of the lake water for tea, but found it quite brackish. We remained on the margin of the lake all night. The River Tambo was about one mile north-east of our camp. The River Tambo, where we first made it, appears to be very deep and from 20 to 30 yards wide. The water is brackish for the distance of about five miles from its mouth, where it empties itself into Lake Victoria.

Nicholson River. On the 17th January, started from the camp, and proceeded

This mountain landscape by Eugen von Guérard depicts the type of country explored by Strzelecki and his party.

'Panoramic view of Mr. Angus McMillan's Station' by Eugen von Guérard, 1861.

in a south-westerly direction. At ten a.m. came upon another river, to which I gave the name Nicholson, after Dr. Nicholson, of Sydney. . . .

River Mitchell. 18th January. Started again upon our usual course (south-west), and, after travelling about seven miles, came upon a large river, which I named the Mitchell, after Sir Thomas Mitchell, Surveyor-General of New South Wales. . . .

General View of Country from a Hill. . . . [We] again proceeded on our journey for three miles, when we came once more upon the Mitchell River higher up, and encamped for the night, the country improving at every step. In the evening I ascended a hill near the camp, from the top of which I obtained a good view of the low country still before us, of the high mountains to the north-west, and the lakes stretching towards the sea-coast in a south and south-easterly direction; and, from the general view of the country as I then stood, it put me more in mind of the scenery of Scotland than any other country I had hitherto seen, and therefore I named it at the moment "Caledonia Australis". . . .

The River Avon. 21st January. Started upon our usual course (south-west), and, after travelling about four miles, came upon a river flowing through a fine, open forest, with high banks, to which I gave the name of the Avon. We followed this river up all day, and crossed it about twenty miles from the foot of the mountains. It appears to be a mountain stream, generally not very deep, and runs over a bed of shingle. The country around and beyond the place where we crossed the Avon consists of beautiful, rich, open plains, and appeared, as far as I could judge at the time, to extend as far as the mountains. We encamped upon these plains for the night. From our encampment we had a splendid view of the mountains, the highest of which I named Mount Wellington, and also I named several others, which appear in the Government maps (published) of Gippsland.

22nd January. Left the encampment on the plains, and proceeded on our usual course of south-west, and travelled over a beautiful country, consisting of

fine, open plains, intersected by occasional narrow belts of open forest, extending as far as the lakes to the eastward and stretching away west and north-west as far as the foot of the mountains.

Macalister River. After travelling about ten miles we encamped in the evening on a large stream, which I named the Macalister. This river appears deep and rapid, and is about 40 yards wide. Here we saw an immense number of fires of the natives.

23rd January. Started early in the morning, and tried to cross the river, but could not succeed, and followed the River Macalister down to its junction with another very large river called the La Trobe, which river is bounded on both sides by large morasses. . . .

On the morning of the 24th January, the provisions having become very short, and as some of the party were unwilling to prosecute the journey upon small allowance, I determined upon returning to the station and bringing down stock to the district. We then returned to Numbla-Munjee, which place we made in seven days from the 24th, and were the last two days without any provisions at all.

I may add that I was the first person who discovered Gippsland, and when I started to explore that district I had no guide but my pocket compass and a chart of Captain Flinders. We had not even a tent, but used to camp out and made rough gunyahs wherever we remained for the night.

On the 27th March 1840, Count Strzelecki and party left our station at Numbla-Munjee for Caledonia Australis. He was supplied with some provisions and a camp kettle, and Mr. Matthew Macalister, who was one of my party in January of the same year, accompanied them one day's journey, and, after explaining the situation and nature of the country, about the different crossing-places, left them upon my tracks on the coast range leading to Gippsland, and which tracks Charley, the Sydney blackfellow, who accompanied Count Strzelecki, said he could easily follow.

On my return to Numbla-Munjee on the 31st January, after having discovered the country of Gippsland as far as the La Trobe River, I proceeded immediately to Maneroo, and reported my discovery to Mr. Macalister, who did not publish my report at the time. I had also written another letter to a friend of mine in Sydney, containing a description of my expedition; at the same time I wrote to Mr. Macalister, but it unfortunately miscarried. In October 1840 I arrived in Gippsland with 500 head of cattle, and formed a station on the Avon River, after having been six weeks engaged in clearing a road over the mountains.

After four attempts I succeeded in discovering the present shipping place at Port Albert, and marked a road from thence to Numbla-Munjee, a distance of 130 miles.

Mount Kosciusko

Sir Paul Edmund Strzelecki.

Sir Paul Edmond de Strzelecki (1797–1873), who was born in Poland, arrived in Sydney in 1839 and early the following year carried out an exploratory journey across the Australian Alps to Melbourne. He remained in Australia only three years, although in 1845 he published a book in London entitled *Physical Description of New South Wales and Van Diemen's Land.* While there appears to be little justification for his use of the title 'Count', Strzelecki's aspirations towards entering the ranks of the nobility were rewarded when the British Government conferred a knighthood upon him in 1869.

As we have seen, Strzelecki did not discover Gippsland, although the name he chose for McMillan's 'Caledonia Australis' has remained. Nor was he the first to explore the Snowy Mountains. This had been done in 1834 by another scientifically minded Pole, John Lhotsky, who wrote an interesting account of his travels from Sydney to these mountainous regions via 'Kembery' (now present-day Canberra).[6] During Strzelecki's arduous and exhausting trek over the Alps in 1840, he collected considerable geological information although he is probably best remembered for his naming of Australia's highest mountain—Kosciusko. The following extracts are taken from his official report to Governor Gipps.[7]

From the Murrumbidgee ... there still remained for me to wind my course through a country unsurveyed, uninhabited, in a great measure unknown, untrodden even by the foot of a white man. A survey became, therefore, indispensable to the main object in view, and it is that survey of the predominant characteristic features of the country, partly trigonometrically, partly astronomically ascertained and laid down on the chart, together with such barometrical, meteorological and mineralogical observations as seemed naturally to belong to it, that I take the liberty to lay before the colonial government of New South Wales, confident that my great devotion, and the obligation every Pole finds himself under to the English nation, will serve to excuse and render legitimate my somewhat uncalled for communication. . . .

I followed the windings of that valley for about 70 miles to the foot of the highest protuberance of the Australian Alps, which it was my object to ascend and examine. The steepness of the numberless ridges, intersected by gullies and torrents, rendered this ascent a matter of no small difficulty, which was not a little increased by the weight of the instruments, which for safety I carried on my back. Once on the crest of the range, the remainder of the ascent to its highest pinnacle was accomplished with comparative ease. On the 15th February, about noon, I found myself on an elevation of 6,510 feet above the level of the sea, seated on perpetual snow, a lucid sky above me, and below an uninterrupted view over more than 7,000 square miles. This pinnacle, rocky and naked, predominant over several others, elevations of the same mountain, was, and always will be, chosen for an important point of trigonometrical survey; clear and standing by itself, it affords a most advantageous position for overlooking the intricacies of the mountain country around. The eye wanders to the Three Brothers, or Tintern, thence to the sources of the Dumut and the Murrumbidgee, discovers with ease the windings of the Murray, the course of the dividing range, the summits of Mounts Aberdeen and Buller, and is seduced

6. John Lhotsky, *A Journey from Sydney to the Australian Alps, undertaken in the months of January, February, and March, 1834. Being an account of the geographical & natural relation of the country traversed, its aborigines &c. together with some general information respecting the colony of New South Wales.* Sydney, 1835.

7. 'Report by Count Streleski', in 'Copy of a Despatch from Sir G. Gipps, Governor of New South Wales, to the Secretary of State for the Colonies, transmitting a report of the progressive Discovery and Occupation of that Colony during the Period of Administration of the Government'. *House of Commons Papers*, Volume XVII, 1841.

even beyond the required limits of a survey. The particular configuration of this eminence struck me so forcibly, by the similarity it bears to a tumulus elevated in Krakow over the tomb of the patriot Kosciusko, that, although in a foreign country, on foreign ground, but amongst a free people, who appreciate freedom and its votaries, I could not refrain from giving it the name of Mount Kosciusko. . . .

At 17 miles from Omeo to the S.S.E., and at the crossing of the dividing range, begins the third division, which the meridian 148° limits from the N.E.; the sea-coast and the dividing range from E. and W.; Corner Inlet and Western Port from the S. and S.W.—a division which, on account of its extensive riches as a pastoral country, its open forest, its inland navigation, rivers, timber, climate, proximity to the sea-coast, probable outlets, and more than probable boat and small craft harbours, its easy land communication, the neighbourhood of Corner Inlet and Western Port, the gradual elevation, more hilly than mountainous, and finally, on account of the cheering prospects to future settlers which this country holds out, and which it was my lot to discover, I took the liberty of naming, in honour of his Excellency the Governor, Gipps' Land. . . .

The direct course which necessity obliged us to pursue led us, during 22 days of almost complete starvation, through a scrubby and, for exhausted men, a trying country, which, however, for its valuable timber of blue gum and black butt has no parallel in the colony. The ascent of the dividing range was gradual, the descent towards Western Port easy; all the great protuberances which characterize that range elsewhere, either in elevation, or windings, or bold features among the spurs and ramifications, began to cease. Some minor spurs on the western side of that range formed an extensive valley to the N.W. of my route, almost opposite to that watered by the River La Trobe on the eastern side of the range. Some others, which, on ulterior examination, proved to be divisions of creeks running in the direction of Cape Liptrap and Western Port, were the sole elevations composing the rest of the fine undulating country through which I passed. . . .

That which, however, is already open to industry, ready to reward the toil and perseverance of the unwearied and greatly thriving settlers of Australia, is the country itself, considered as an agricultural and pastoral one; scarcely any spot I know, either within or without the boundaries of New South Wales, on a large or small scale, can boast more advantages than Gipps' Land. . . .

Mount Kosciusko was discovered by Strzelecki and painted by von Guérard.

4

Northwest Coasts and Rivers

'Swan River — the Bivouac of Capt. Stirling in the Exploring Party, March 1827' by John William Huggins.

In Search of an Inland Waterway

Soon after the founding of South Australia in 1836, Lieutenant George Grey (1812–98), a young and ambitious army officer, requested the British government's permission to explore the northwest of Western Australia in order to solve the question as to whether a large river or inland sea opened out on to the northwest coast. Within four years Grey, later Sir George Grey, was to become governor of this most recent Australian colony. The Colonial Office consented to Grey's proposal and in July 1837 he and his party embarked on the HMS *Beagle*, which was again sailing for Australia, this time to spend several years surveying the coast.

The Admiralty's instructions to Captain Wickham of the *Beagle* were explicit:

As this question, whether there are or are not any rivers of magnitude on the western coast is one of the principal objects of the expedition, you will leave no likely opening unexplored, nor desist from its examination till fully satisfied. . . .[1]

Grey too was left in no doubt for he wrote:

After due examination of the country about Prince Regent's River, we were instructed to take such a course as would lead us in the direction of the great opening behind Dampier's Land.

This idea was not new. In 1699 the *Roebuck* lay off what is now known as the Dampier Archipelago and her buccaneering commander, Captain William Dampier, wrote:

I had a strong suspicion that there might be a kind of *Archipelago* of Islands; and a Passage possibly to the S. of N. Holland and N. Guinea into the great S. Sea Eastward. . . . But I would not attempt it at this time, because we wanted Water, and could not depend upon finding it there.[2]

And in 1823 after surveying the Western Australian coast Captain Phillip Parker King, who had almost certainly read Dampier's journal, made a similar comment:

. . . it is not at all improbable that there may be a communication at this part with the interior for a considerable distance from the coast.[3]

Now came the young Grey, curious and courageous, ready to explore the

1. J. Lort Stokes, *Discoveries in Australia; with an account of the coasts and rivers explored and surveyed during the voyage of the H.M.S. Beagle, in the years 1837-38-39-40-41-42-43. By command of the Lords Commissioners of the Admiralty. Also a narrative of Captain Owen Stanley's visits to the Arafúa Sea.* London, 1846.

2. William Dampier, *A Voyage to New-Holland, &. In the Year, 1699.* London, 1709.

3. Phillip P. King, *Narrative of a Survey of the Intertropical and Western Coasts of Australia. Performed Between the Years 1818 and 1822.* London, 1826.

treacherous northwest coast in an open boat or venture bravely into the 'interior'. Oxley, Sturt and Mitchell had all believed in the possibility of an inland sea or rolling river. Sturt had discovered the Murray and so satisfied the quest for a great waterway in southern Australia. But what of the centre, the north and the northwest?

The following extracts from Grey's journal include passages which tell of his attempts to penetrate into this unknown part of Australia, to search along the coast for the supposed great river and finally of his terrible walk to Perth—an endurance test of the highest order.[4]

Sir George Grey — explorer, governor, politician.

All our preparations being completed, there embarked in the Beagle, besides myself and Mr. Lushington, Mr Walker, a surgeon and naturalist, and Corporals Coles and Auger, Royal Sappers and Miners, who had volunteered their services; and we sailed from Plymouth on the 5th July, 1837. . . .

September 21. We came in sight of land yesterday evening, and spent the greater part of the day in beating up False Bay to Simon's Town, where we arrived about half-past six, P.M. I instantly landed in a shore-boat with Lieutenant Lushington and Mr. Walker; and having first hurried to Admiral Sir P. Campbell with some letters I had to him, we forthwith started to ride to Cape Town. Finding that a vessel for our expedition could be procured here more readily and economically than at Swan River, I determined on making this my point of departure, and after diligent enquiry I finally hired the Lynher, a schooner of about 140 tons, Henry Browne, master, and subsequently found every reason to be satisfied, both with the little vessel and her commander.

My time was now wholly occupied in completing the preparations for our future proceedings. I increased my party by a few additional hands of good character, and thought myself fortunate in engaging amongst them Thomas Ruston, a seaman who had already served on the Australian coast under Captain King. On the 12th October I with great difficulty got my affairs at Cape Town so arranged, as to be able to embark in the evening, and on the morning of the 13th we hove anchor and made sail.

The party now embarked consisted of:—

Lieut. Grey.	
Lieut. Lushington.	
Mr. Walker,	*our Surgeon.*
Mr. Powell	*Surgeon.*
Corporal R. Auger,	
Corporal John Coles,	*of the Corps of Sappers and Miners.*
Private Mustard,	
J. C. Cox,	*a Stock Keeper.*
Thomas Ruston,	*A sailor who had been on the coast of Australia, in the Mermaid, with Captain King.*
Evan Edwards,	*a Sailor.*
Henry Williams,	*Shoemakers.*
R. Inglesby,	

There were besides on board, a captain, a mate, seven men and a boy.

The live stock I took from the Cape consisted altogether of thirty-one sheep, nineteen goats, and six dogs. The dogs were as follows: one greyhound; one dog bred between a greyhound and a foxhound; one between a greyhound and a sheep dog; a bull terrier; a Cape wolf dog; and a useful nondescript mongrel.

The plan that I had finally resolved on adopting was:—

To proceed in the first instance to Hanover Bay, there to select a good spot on which to form a temporary encampment; and having landed the stock, to despatch Lieutenant Lushington, with Cox, and Williams in the vessel to Timor for ponies. . . . [The *Lynher* arrived at Hanover Bay at the beginning of December.]

December 2. . . . At the first streak of dawn, I leant over the vessel's side, to gaze upon those shores I had so longed to see. I had not anticipated that they

4. George Grey, *Journals of Two Expeditions of Discovery in North-west and Western Australia, during the years 1837, 38, and 39, under the authority of Her Majesty's Government describing many newly discovered, important, and fertile districts, with observations on the moral and physical condition of the aboriginal inhabitants, &c. &c.* London, 1841.

'Native of Western Australia', one of Grey's own illustrations

would present any appearance of inviting fertility; but I was not altogether prepared to behold so arid and barren a surface, as that which now met my view. . . .

The shore for which we pulled was not more than half a mile distant, and we soon gained the edge of a sandy beach, on which I sprang, eagerly followed by the rest; every eye beaming with delight and hope, unconscious as we were, how soon our trials were to commence.

I soon found that we had landed under very unfavourable circumstances. . . .

A feeling of thirst and lassitude, such as I had never before experienced, soon began to overcome all of us; for such a state of things we had unfortunately landed quite unprepared, having only two pints of water with us, a portion of which it was necessary to give to the dogs; who apparently suffered from the heat, in an equal degree with ourselves.

December 9. This day we pitched our tents, disembarked the sheep and goats, and some of the stores. . . . We here hoisted the British flag and went through the ceremony of taking possession of the territory in the name of Her Majesty and her heirs for ever. . . .

December 11. . . . As Mr. Lushington was to accompany the schooner to Timor, and I was anxious to ascertain which would be the best direction for us to move off in on his return, I determined to commence my exploring trips as soon as possible. . . . [Within a week Grey, accompanied by two of his party, set off to the south on the first of his exploratory excursions.]

Sunday, December 17. . . . We soon erected a little hut of bark, then kindled a fire and cooked our supper, consisting of tea and two white pigeons. . . . My companions laid down to sleep: I remained up for a short time, to think alone in the wilderness, and then followed their example. . . .

December 21. We all to-day began to feel the want of food . . . as the heavy rain had materially interrupted our cooking. . . . The large bird which was the most abundant here was the *Cuculus Phasianus* or Pheasant Cuckoo. . . . I never enjoyed a better day's pheasant shooting in any preserve in England; and I may here remark, that North-Western Australia is as good a country for sport in the shooting way, as I am acquainted with; whilst for every kind of sport, except wild fowl shooting, the southern part of Australia is the worst country in the world. My bag being full, and my companions very hungry, I had no excuse for staying longer away from them, and therefore returned, although very loth to leave such beautiful scenery and such excellent sport. . . .

The following day, after a wet and uncomfortable night, the party was attacked by Aboriginals. They returned to the base camp at Hanover Bay.

Since the sailing of the Lynher, the party had been actively engaged in building a shed for the stores. This labour was still continued, after my arrival, and completed on Christmas eve. On Christmas day we all dined together in a little booth made of boughs, which we dressed up as gaily as we could. I could not but feel considerable pleasure in seeing the happy countenances of the men ranged round the rough plank that formed our table. We sat down, — a little band of nine, bound upon an adventure of which the issue to any, and all of us, was very uncertain: yet no forebodings appeared to damp the pleasure of the present moment; and, as I anxiously looked round, I could not detect the slightest trace of a gloomy thought in any of the cheerful faces that surrounded me. After dinner we drank the Queen's health, — the first time such a toast had been given in these regions; and then, Mr. Walker and myself retiring to talk alone, left the rest to their own amusements. . . .

During the absence of the schooner, we had our attention fully engaged in forming a garden, collecting specimens, and building sheds for the stores. So difficult and rocky was the country we were in, that I was employed for several days in finding a route by which unloaded horses could travel from the beach in Hanover Bay to the point where we were encamped, for the landing-place at the end of the ravine was so rocky, as to be impracticable for that purpose. Mr. Walker at length discovered a pass in the cliffs, and by constructing a winding

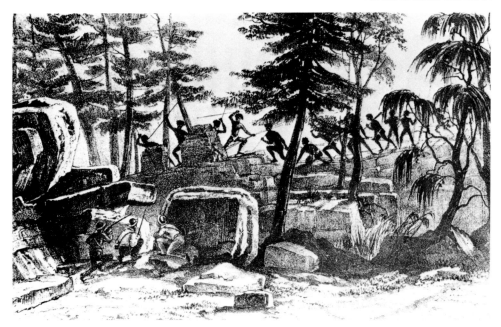

path in this, he thought that we should be able to get loaded horses out of the valley. . . .

It was now early January, 1838. Soon the *Lynher* returned with twenty-six small, wild ponies and by the end of the month the expedition inland was ready to begin.

On the 29th, we began in the afternoon to load our horses. Mr. Walker's pathway . . . led directly up the face of cliffs which were almost precipitous, and 180 feet in height. . . .

February 10 [1838]. We moved off at daybreak, and having reached the ravine, set to work to form a pathway down the descent, and up the ascent on the other side, under the additional disadvantage of heavy rain. The sudden transition from the rays of a burning sun to this cold bath made my teeth chatter as if I had a tertian ague. When half our work was completed, we breakfasted in the beautiful ravine, amidst the dark luxuriant vegetation of the tropics, formed by the pandanus, bamboo, and palm. . . . [The party was now on its way towards the Glenelg River when a further encounter with the Aboriginals contributed to its soon having to turn back. Grey described what happened with his usual graphic turn of phrase.]

February 11. . . . It was the duty of the Cape man who accompanied me, to mark a tree every here and there by chipping the bark . . . upon looking back I now perceived that he had neglected a very remarkable tree. . . . I desired him to go back. . . .

Finding that the man remained absent longer than I had expected, I called loudly to him. . . . Suddenly I saw him close to me breathless, and speechless with terror, and a native with his spear fixed in a throwing-stick, in full pursuit of him. . . .

A moment before, the most solemn silence pervaded these woods . . . and now they rang with savage and ferocious yells, and fierce armed men crowded round us on every side, bent on our destruction. . . .

I saw now that but one thing could be done to save our lives, so I gave Coles my gun to complete the reloading, and took the rifle which he had not yet disengaged from the cover. I tore it off, and stepping out from behind our parapet, advanced to the rock which covered my light coloured opponent. I had not made two steps in advance when three spears struck me nearly at the same moment, one of which was thrown by him. I felt severely wounded in the hip, but knew not exactly where the others had struck me. The force of all knocked me down, and made me very giddy and faint, but as I fell, I heard the savage yells of the natives' delight and triumph; these recalled me to myself, and, roused

by momentary rage and indignation, I made a strong effort, rallied, and in a
moment was on my legs; the spear was wrenched from my wound, and my
havresack drawn closely over it, that neither my own party nor the natives might
see it, and I advanced again steadily to the rock. The man became alarmed, and
threatened me with his club, yelling most furiously; but as I neared the rock,
behind which all but his head and arm was covered, he fled towards an adjoining
one, dodging dexterously, according to the native manner of confusing an assail-
ant and avoiding the cast of his spear; but he was scarcely uncovered in his flight,
when my rifle ball pierced him through the back, between the shoulders, and
he fell heavily on his face with a deep groan.

The effect was electrical. The tumult of the combat had ceased: not
another spear was thrown, not another yell was uttered. Native after native
dropped away, and noiselessly disappeared. . . .

My wound began, by degrees, to get very stiff and painful, and I was,
moreover, excessively weak and faint from loss of blood; indeed, I grew so dizzy
that I could scarcely see, and neither of the others were capable of leading the
party back to the tents; yet I was afraid to halt and rest, for I imagined that if
I allowed my wound to grow cold and benumbed I should then be unable to
move; leaning, therefore, on Coles's arm I walked on as rapidly as I could,
directing the men which way to go. Unfortunately, however, we lost our track,
and after walking for nearly two hours, I found that we were far from the
encampment, whilst my sight and strength were momentarily failing. . . . Coles,
with his usual courage and devotion to me, volunteered to go on alone to the
party, and send assistance; the other man was to remain with me, and keep a
look-out for the natives, and had they again attacked us, I should still have had
strength enough to have shot two of them, and thus have sold my life dearly. . . .
Mr. Lushington soon arrived with a pony. . . . I was placed upon the pony, and,
supported by my comrades, moved onwards to the tent.

I cared but little for the want of comforts I must now be subject to. . . but
one thing made the night very wretched, for then through the woods came the
piercing shrieks of wailing women and the mournful cries of native men, sorrow-
ing over him who had that day fallen by my hand. . . .

A very serious change had taken place in our resources in one respect, for
only fourteen ponies now remained alive out of twenty-six. . . .

This reduction in the number of our beasts of burden, prevented me from
entertaining further hope of being able to proceed for any great distance parallel
to the coast in a southerly direction. I therefore formed a depot at our present
encampment, burying all such stores as the remaining ponies were unable to
carry on. My intentions being merely to proceed as far as the supply of pro-
visions we could carry with us would last, then to return to our position, and
from thence to the schooner.

On the morning of the 27th of February, I was, in pursuance of this plan
of operations, lifted on my horse, and we moved on in a S.W. direction, across
sandy plains covered with scrub, and a species of stringy bark. . . .

March 2. . . . We passed numerous streams, and the country generally con-
tinued of a very rich and fertile character: at last, from the top of one of these
ridges, there burst upon the sight a noble river, running through a beautiful
country, and where we saw it, at least three or four miles across, and studded
with numerous verdant islands. I have since seen many Australian rivers, but
none to equal this either in magnitude or beauty.

I at once named it Glenelg, in compliment to the Right Hon. Lord Glenelg,
to whom we were all under great obligations. . . .

March 14. . . . I have since visited many of the most noted Australian
streams, and found this distinguished by many peculiar characteristics; nor
would I hesitate to say, that, with the exception perhaps of the Murray, it will
be found the most important on that continent. . . .

March 26. . . . Finding that it would be useless to lose more time in search-
ing for a route through this country, I proceeded to rejoin the party once more;
but whilst returning to them, my attention was drawn to the numerous remains
of native fires and encampments . . . till at last, on looking over some bushes,
at the sandstone rocks which were above us, I suddenly saw from one of them

'Sandstone Cave with Paintings near Glenelg River', by George Grey.

Grey's illustrations of the aboriginal cave paintings which he discovered in north-west Australia are to be found in his journal.

a most extraordinary large figure peering down upon me. Upon examination this proved to be a drawing at the entrance to a cave, which, on entering, I found to contain, besides, many remarkable paintings. . . . [These were the Wandjina rock paintings, now considered fine examples of ancient Aboriginal art.]

March 31. . . . Mr. Walker [the surgeon] . . . came to me to-day, and said, he felt it his duty to recommend me without delay to return to the vessel. . . . To this opinion I felt constrained to yield, and Mr. Walker having, at my desire, repeated it in a letter this afternoon, I arranged my plans accordingly. . . .

April. 14 We this day started on our march homewards. . . .

Sunday, April 15. . . . As I proceeded nearly in a direct line to Hanover Bay, we encountered some difficulty from the broken character of the ground, but about eleven o'clock had gained the hilly country at the back of the beach, from whence, however, we could not obtain a view of the spot where the vessel lay. On emerging from the mangroves upon the beach, we saw painted upon the sandstone cliffs, in very large letters, — "Beagle Observatory, letters S.E. 52 paces". . . . [The *Beagle* and the *Lynher* were both anchored in Port George the Fourth. The *Beagle* had arrived at the Swan River the previous November and was now charting the northwest coast.]

As Mr. Stokes was hourly expected to return [from a short excursion], and I was very anxious to know if he had discovered the mouth of the Glenelg, I remained on board the Beagle, and as all had much to hear, and much to communicate, the evening wore rapidly away. The next day Mr. Stokes arrived, having seen nothing of the mouth of the river. . . .

Stokes, in his journal, described the physical condition of his exploring friend: 'Poor fellow! gaunt misery had worn him to the bone; and I believe, that in any other part of the world, not myself alone, but Lieutenant Grey's most intimate friends, would have stared at him without the least approach to recognition. Badly wounded, and half starved, he did, indeed, present a melancholy contrast to the vigorous and determined enthusiast we had parted from a few months before at the Cape, to whom danger seemed to have a charm, distant from success'.[5]

Grey concluded his account of his first Australian expedition with the following comment:

Our whole residence in this country had been marked by toils and sufferings. Heat, wounds, hunger, thirst, and many other things had combined to harass us. Under these circumstances, it might have been imagined that we left these shores without a single regret; but such was far from being the case: when the ponies had wandered off, when all the remaining stores had been removed, and the only marks of our residence in this valley were a few shattered bark huts, young cocoa-nut plants, a bread-fruit, and some other useful trees and plants, I felt very loath to leave the spot. . . .

We then weighed and sailed for the Isle of France, where we arrived on the 17th May [1838], without having met with any circumstance on our voyage worthy of record.

At Mauritius Grey recovered his strength and reconsidered plans for his return to Australia.

Overland to Perth

The rivers Fitzroy and Glenelg, simultaneously discovered by Captain Wickham and myself, although of considerable magnitude, were only sufficient to account for the drainage of a small portion of the vast continent of Australia, and this interesting question, far from being placed in a clearer point of view by our expeditions, was if possible involved in deeper obscurity than ever. I was therefore anxious to return to the north-west coast, and solve the mystery that still hung over those regions. . . .

I accordingly embarked my party, and the stores in my possession, at Port Louis [Mauritius], on the 21st August, 1838, and arrived on the 18th September at Swan River, where I lost no time in communicating my views to Sir James

5. J. Lort Stokes, *Discoveries in Australia.*

Stirling, who concurred in the plan for returning to the north-west. . . .

It was not however until the month of December following that the Colonial schooner became disposable, and then new impediments arose from her being found so much in want of repair as to be, in Sir James Stirling's opinion, scarcely in a condition to proceed on such a voyage as we contemplated, whilst the repairs required were of a nature which could not be effected in the Colony. [While awaiting the fitting out of a vessel, Grey made several excursions into the country around Perth.]

At length, in the middle of February, after a mortifying delay of nearly five months, an opportunity occurred which held out every prospect of enabling me to complete the examination of the most interesting portion of the north coast, together with the country lying behind it.

Three whale-boats having been procured, an engagement was made with Captain Long, of the American whaler Russel, of New Bedford, to convey my party and the boats to some point to the northward of Sharks Bay, and there land us, together with a supply of provisions sufficient for five months. . . .

I had taken three whale boats in order to have a spare one should any accident reduce the number; and every thing being arranged, I sailed in the Russel from Freemantle, on Sunday, February the 17th, 1839, at 3 P.M. with the following party: —

Mr. Walker,	*the Surgeon of the former expedition.*
Mr. Frederick Smith,	*the young gentleman who had accompanied me on a former tour.*

'Sketch of the Coasts of Australia and of the supposed Entrance of the Great River' — an imaginary map based on wishful thinking.

Corporal Auger,	}	
Corporal Coles,	}	*Sappers and Miners.*
Thomas Ruston,		*Sailor*

The last three, together with Mr. Walker, had been with me on the first expedition, and to these were added—

H. Wood,	}	
C. Wood,	}	*Seamen*
—Clotworthy,	}	
—Stiles,	}	*taken as volunteers at Swan*
—Hackney,	}	*River. And lastly,*

Kaiber, *an intelligent native of the Swan. . . .*

February 25 [1839]. Soon after day break we made the north-western part of Bernier Island, and . . . stood into Sharks Bay. . . . Captain Long, of the Russel. . . . had scarcely left us . . . when we found that our keg of tobacco had been left on board; the vessel was soon out of sight, and this article so necessary in hardships where men are deprived of every other luxury, was lost to us.

February 26. Early this morning we had finished burying our stores. . . . My own party, as well as the crews of the boats which came off from the whaler, had during the hurry and confusion incident on landing, made very free with our supply of water, and as . . . I felt very doubtful whether we should find any more, I put all hands on an allowance of two pints and a half a-day, and then employed the men thus:—One party, under the direction of Mr. Walker, worked at constructing a still, by means of which we might obtain fresh water from salt; another made various attempts to sink a well; whilst the native, another man, and myself, traversed the island in search of a supply from the surface. [The only result of this activity was that if the still were kept working constantly it would provide just enough water to keep the party alive. Grey and Walker then attempted to launch the boats, but Walker's boat was smashed by the surf.]

February 28. About ten A.M. the wind moderated so much that we ventured to launch our remaining boat, now become the second, and in a few minutes both were riding alongside one another in the little cove. . . .

It was nearly three P.M. when we reached the north-eastern extremity of Dorre Island, and found a most convenient little boat harbour, sheltered by a reef from all winds. . . .

'View of Fremantle, Western Australia' by John Buckler, 1832.

Sunday, March 3. The men had slept but little during the night, for they were oppressed with thirst; and when I rose in the morning, I saw evident symptoms of the coming of another roasting day. They were busy at the boats as soon as they could see to work, whilst Mr. Smith and myself ascended the cliffs to get a view towards the main. When I looked down upon the calm and glassy sea, I could scarcely believe it was the same element, which within so short a period had worked us such serious damage. . . .

March 5. . . . [Grey was still searching for openings on the coast.] We had not proceeded more than a few hundred yards, when we unexpectedly came upon another mouth of the river, as large as that upon which we stood, and which ran off nearly west, the river itself appeared to come from the N.E., and we saw salt water still further up than where we were. . . .

I now turned off w. by s., quitting the bed of the river, which I named the Gascoyne, in compliment to my friend, Captain Gascoyne, and found that we were in a very fertile district, being one of those splendid exceptions to the general sterility of Australia which are only occasionally met with. . . . I however felt conscious that within a few years of the moment at which I stood there, a British population, rich in civilization, and the means of transforming an unoc-cupied country to one teeming with inhabitants and produce, would have fol-lowed my steps, and be eagerly and anxiously examining my charts; and this reflection imparted a high degree of interest and importance to our present position and operations. . . . Poor Mr. Smith was very unwell to-night, with a feverish attack. Mr. Walker had proscribed for him, and ordered him to be kept quiet. . . .

March 7. I went off with a party before dawn, to explore the country to the northward of the Gascoyne. . . .

[The following day Grey climbed a high sandhill and saw in the distance a fine sheet of water.] The lake had a glassy and fairy-like appearance, and I sat down alone . . . to contemplate this great water which the eye of European now for the first time rested on. . . . As we continued to advance, the water however constantly retreated before us, and at last surrounded us. I now found that we had been deceived by mirage. . . . the plains themselves I named the Plains of Kolaina (Deceit). [A number of the party were now ill, food supplies were short and the Aboriginals hostile. The weather was tempestuous and it was some days before it was possible to launch the boats.]

March 20. When we pulled out of the Gascoyne this morning, the first streak of dawn had not lit up the eastern horizon, we however managed by creeping along the southern shore, to get out to sea. . . .

Bernier Island at last rose in sight, and amidst the giant waves we occasion-ally caught a peep of its rocky shores. . . .

At length we reached the spot where the depot had been made: so changed was it, that both Mr. Smith and Coles persisted it was not the place; but on going to the shore, there were some very remarkable rocks, on the top of which lay a flour cask more than half empty, with the head knocked out, but not otherwise injured; this also was washed up at least twenty feet of perpendicular elevation beyond high water mark. The dreadful certainty now flashed upon the minds of Mr. Smith and Coles, and I waited to see what effect it would have upon them. Coles did not bear the surprise so well as I had expected; he dashed the spade upon the ground with almost ferocious violence, and looking up to me, he said—"All lost, Sir! we are all lost, Sir!" Mr. Smith stood utterly calm and unmoved; I had not calculated wrongly upon his courage and firmness. His answer to Coles was—"Nonsense, Coles, we shall do very well yet; why, there is a cask of salt provisions, and half a cask of flour still left". . . . [The provisions which they had buried at Bernier Island had been removed by Aboriginals.]

It would be useless to detail the different reasons which induced me to adopt the plan of endeavouring to make Swan River in the whale boats; this was, however, the course I resolved to pursue. . . .

March 22. This day at two P.M. all our preparations having been completed, and the wind somewhat moderated, we stood across the bay, and soon after nightfall made the main, about twelve miles to the north of the northern mouth of the Gascoyne. . . .

*'Baie des Chiens Marins' by a member of the
expedition of the French navigator de Freycinet in
1818. It was from Shark Bay that Grey set out
on his second attempt to explore the north-west
coast, which resulted in his overland trek to Perth.*

March 29. The weather this morning being very foul, I occupied myself in making a survey of a portion of Dirk Hartog's island, which is of a very barren nature, though rather better than either Bernier or Dorre islands, but for many years to come it must be utterly useless. It looks exactly like a Scottish heath. . . .

March 30. . . . The attempt to get along this coast appeared, indeed, to be so hazardous that even the old sailors, who were with me, begged me not to risk it, but rather to allow them to endeavour to walk overland to Perth. . . .

March 31. This day we continued our course, tracing out the shore. . . . The men being now completely worn out by want of rest, incessant exertion, and the mental anxiety they had undergone in the last fifty-six hours, during the whole of which time they had been in actual danger, I determined to attempt a landing in Gantheaume Bay. . . . We were swept along at a terrific rate, and yet it appeared as if each following wave must engulph us, so lofty were they, and so rapidly did they pour on. . . . For one second the boat hung upon the top of the wave; in the next, I felt the sensation of falling rapidly, then a tremendous shock and crash, which jerked me away amongst rocks and breakers, and for the few following seconds I heard nothing but the din of waves, whilst I was rolling about amongst men, and a torn boat, oars, and water-kegs, in such a manner that I could not collect my senses. . . . [The other whale-boat coming in behind them was also wrecked.]

No resource was now left to us but to endeavour to reach Perth by walking; yet when I looked at the sickly faces of some of the party, and saw their wasted forms, I much doubted if they retained strength to execute such a task; but they themselves were in high spirits, and talked of the undertaking as a mere trifle. . . . On reaching the valley I have before-mentioned we found a small stream, and following this to the northward for about a mile, came out upon one of the most romantic and picturesque-looking estuaries [Murchison River] I had yet seen. . . .

April 2. . . . We were now all ready to commence our toilsome journey; the provisions had been shared out; twenty pounds of flour and one pound of salt provisions per man, being all that was left. . . . The party, however, were in high spirits; they talked of a walk of three hundred miles in a direct line through the

country (without taking hills, valleys, and necessary deviations into account), as a trifle and in imagination were already feasting at home, and taking their ease after the toils they had undergone. . . .

April 3. . . . I now entreated the men to disencumber themselves of a portion of the loads which they were attempting to carry. Urged by a miscalculating desire of gain, when the boats were abandoned they had laid hands upon canvass and what else they thought would sell at Perth, and some of them appeared to be resolved rather to risk their lives than the booty they were bending under. The more tractable threw away the articles I told them to get rid of; but neither entreaties nor menaces prevailed with the others. . . .

April 5. . . . I knew our latitude and position this night exactly, as I had seen Mount Naturaliste of the French in the course of the day. . . . I named the river and estuary now discovered, the Hutt, after William Hutt, Esq., M.P., brother of His Excellency, the Governor of Western Australia. . . .

April 6. . . . Although we had walked very slowly, many of the party were completely exhausted, and one or two of the discontented ones pretended to be dreadfully in want of water, notwithstanding they carried canteens, and had only walked eight miles since leaving the bank of a river; I was therefore obliged to halt, and could not get them to move for three hours. I am sorry to say some who should have known much better endeavoured to instil into the minds of the men, that it was preferable only to walk a few miles a day, and not to waste their strength by long marches; utterly forgetting that most of the party had now only seven or eight pounds of fermented flour left, and that if they did not make play whilst they had strength, their eventually reaching Perth was quite hopeless. . . . One man of the name of Stiles, who was a stout supporter of the new theory, made us stop for him nearly every five minutes. . . .

April 7. . . . Whilst I stretched my weary length along under the pleasant shade, I saw in fancy busy crowds throng the scenes I was then amongst. I pictured to myself the bleating sheep and lowing herds, wandering over these fertile hills; and I chose the very spot on which my house should stand, surrounded with as fine an amphitheatre of verdant land as the eye of man has ever gazed on. The view was backed by the Victoria Range, whilst seaward you looked out through a romantic glen upon the great Indian Ocean. . . .

Mr. Walker now came up with the remainder of the party, and reported that Stiles was missing. . . .

April 8. . . . For the next two and a half miles we wound along low, grassy, swampy plains, thinly wooded with clumps of Acacias, and then entered upon low scrubby plains, bounding the sea-shore. I here caught sight of Stiles, just a-head of us, and coming in from the eastward: he was very glad once more to find himself in safety; and his comrades seemed pleased to see him again, although many a suppressed murmur had met my ears during our morning's walk, at the trouble I was taking to look for him. . . .

April 9. . . . I felt sure that if the men persisted in their resolution of moving slowly, a lingering and dreadful death awaited us all; yet my opinion was a solitary one. Mr. Walker had in many instances plainly and publicly shewn, that he on this point differed with me; and he was a medical man, and one who certainly never shrank from any danger or toil, which he thought it his duty to encounter. . . .

April 10 We were about one hundred and ninety miles from Perth, in a direct line measured through the air. None of the party had more than six or seven pounds of flour left; whilst I had myself but one pound and a half, and half a pound of arrow-root; the native had nothing left, and was wholly dependant on me for his subsistence. Now, we had been seven days on our route, and had made but little more than seventy miles, and as the men were much weaker than when they first started, it appeared to me to be extremely problematical whether we should ever reach Perth, unless some plan different from what we had hitherto pursued, was adopted. . . .

Being fully aware of the danger which threatened them, it remained for me to act with that decision which circumstances appeared to require, and to proceed by rapid and forced marches to Perth, whence assistance could be sent out to the remainder. . . .

The party I left, and who were not required to proceed by forced marches, consisted of—

> Mr. Walker,
> Mr. Smith,
> Thomas Ruston,
> C. Woods,
> T. Stiles,
> A. Clotworthy.

Before parting with Mr. Walker and Mr. Smith, I again urged them to push steadily onwards, and never to idle for an instant; but I do not think that either of them were fully aware of the dangers they had to contend with. Poor Smith, as he squeezed my hand, begged me to send out a horse for him, if one could be procured, and also some tobacco; he said the only thing he dreaded was want of water.

April 11. . . . Our route lay along a series of undulating sandy hills, which sloped down to a fertile plain. . . . We found the walking along these hills very difficult on account of the prickly scrub with which they were covered, and the general appearance of the country to the eastward was barren and unpromising. . . .

April 12. Before dawn this morning our native neighbours, who doubtless were not pleased at our sleeping so near them, began to *koo-ee* to each other, which is their usual signal for collecting their forces; and as our safety depended upon none of the party being incapacitated by a wound or other cause, from proceeding with the utmost rapidity, I at once roused the men, and we resumed our way. . . .

April 13. On waking up this morning, I found that in the night a rat had gnawed a hole in the canvass bag, in which my little damper was placed, and had eaten more than half of it. . . .

We halted at noon for about two hours, during which time I made my breakfast with Kaiber, sharing my remaining portion of damper between us. It was almost a satisfaction to me when it was gone, for, tormented by the pangs of hunger, as I had now been for many days, I found that nearly the whole of my time was passed in struggling with myself, as to whether I should eat at once all the provisions I had left, or refrain till a future hour. Having completed this last morsel, I occupied myself for a little with my journal, then read a few chapters in the New Testament, and having fulfilled these duties, I felt myself as contented and cheerful, as I had ever been in the most fortunate moments of my life. . . .

Soon after the fires had been lighted, I was sitting alone by mine, as the shadows of night were just falling over the wild hilly scenery with which we were surrounded. . . . I heard Hackney propose to Woods to offer me a share of their little store of food:—"No," said Woods; "every one for himself under these circumstances; let Mr. Grey do as well as he can, and I will do the same."—"Well, then, I shall give him some of mine at all events," said Hackney; and a few minutes afterwards he came up to my fire, and pressed me to accept a morsel of damper, about the size of a walnut. . . .

I was much affected by the kindness of Hackney, who was a young American; and I regret to add that I felt more hurt than I ought to have done at the remark of Woods. . . .

April 16. . . . The men had now been already one night and two days without tasting a single drop of water, or food of any kind whatever, for as the only provisions they had left was a spoonful or two of flour each, it was impossible for them to cook this without water; indeed only two of them had even this small supply of flour left, and the rest were wholly destitute. . . .

I personally suffered far less than any of the others, with the exception of the native, and this for several reasons. In the first place I had been accustomed to subsist on a very small quantity of water, and secondly I had always kept my mind occupied and amused, instead of giving way to desponding or gloomy thoughts. . . .

April 17. . . . When I halted, the sun was intensely powerful; the groans and exclamations of some of the men were painful in the extreme; but my feelings

were still more agonized when I saw the poor creatures driven, by the want of water, to drink their own—the last sad and revolting resource of thirst! Unable to bear these distressing scenes any longer, I ordered Kaiber to accompany me, and notwithstanding the heat and my own weariness, I left the others lying down in such slight shade as the stunted Banksias afforded, and throwing aside all my ammunition, papers, &c. started with him in search of water, carrying nothing but my double-barrelled gun. We proceeded towards the sea. . . . The same arid barren country seemed spread on every side; and when, at length, I began occasionally to stumble and fall from weakness, hope abandoned me, and I determined to return direct to my comrades, and get them to make one more effort to proceed and search for it in a southerly direction.

I, therefore, told Kaiber that such was my intention, and directed him to guide me to the party. With apparent alacrity, he obeyed my orders; but after leading me about for some time in an extraordinary manner, he told me that he had lost his way, and could not find them. . . . I remained seated on the ground for a few minutes, still hearing no answer to my shot, till the conviction gradually forced itself on my mind, that the native had been leading me astray. . . .

"Do you see the sun, Kaiber, and where it now stands?" I replied to him. "Yes," was his answer. "Then if you have not led me to the party before that sun falls behind the hills, I will shoot you; as it begins to sink you die". . . . He made a few protestations as to the folly of my conduct . . . and led me straight back to the party in about an hour. . . .

They were all reduced to the last degree of weakness and want; indeed, I myself was at this period suffering from the most distressing symptoms of thirst; not only was my mouth parched, burning, and devoid of moisture, but the senses of sight and hearing became much affected. . . . My intention, I told them, was to proceed slowly but steadily to the southward, and never once to halt until I dropped, or reached water. . . .

We had marched for about an hour and a quarter, and in this time had only made two miles, when we suddenly arrived upon the edge of a dried-up bed of a sedgy swamp. . . . We soon discovered several native wells dug in the bed of the swamp; but these were all dry, and I began again to fear that I was disappointed, when Kaiber suddenly started up from a thick bed of reeds, and made me a sign which was unobserved by the others, as was evidently his intention. I hurried up, and found him with head buried in a small hole of moist mud,—for I can call it nothing else. I very deliberately raised Kaiber by the hair, as all expostulations to him were useless, and then called up the others. . . .

I now felt assured that my life was saved, and rendering thanks to God for his many mercies, I laid down by the fire to watch for the first appearance of dawn. . . .

April 18. . . . I nearly expired from cold and pain during this inclement night; the rheumatism in the hip in which I had been wounded was dreadful, and I lost the power of moving my extremities from cold. . . .

April 19. . . . Pale, wasted, and weak, we still crawled onwards in the straight line for Perth, which I assured them they would reach on Saturday night or Sunday morning. . . .

April 20. . . . We, however, walked on as well as we could until near noon, at which time, from excessive weakness, we had not made more than eight miles, or about a mile and a quarter an hour, when we suddenly came out on the bed of a dried up swamp, now looking like a desert of white sand studded with reeds. The forms of natives were seen wandering about this, one mile from us, who were searching for frogs. . . .

Presently Kaiber called out to me, "Mr. Grey, Mr. Grey, nadjoo watto,—nginnee yalga nginnow,"—"Mr. Grey, Mr. Grey, I am going to them; you sit here a little;"—and he then, with his long thin ungainly legs, bounded by me like a deer. "Imbat, friend," I heard him cry out, as a young man came running up to him. I grew giddy; I knew Imbat by name, and felt assured that at all events the lives of a great portion of my party were safe. . . . My name was well known amongst them as a tried friend, although indeed my common denomination was "Wokeley brudder," or Oakley's brother; for, from my giving them flour, they concluded that I was a relation of the baker of that name at

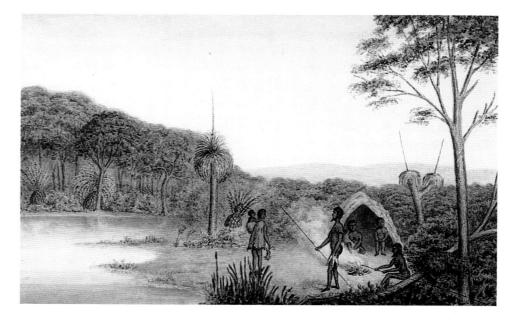

Perth. . . .

My intentions in going on were to have everything prepared for the men, on their arrival at the hut; but, when I reached it I found it deserted, the owner having returned to Perth. . . . [The hut belonged to a kangaroo hunter called Porley.]

April 21. . . . [Starting early, the party reached an outlying cottage in time for breakfast.] I could obtain no conveyance to take us on to Perth, and therefore started to walk in with Imbat, leaving the others to complete their breakfast; but I soon found myself dreadfully ill, from having eaten too profusely; still I pushed on as well as I could and in about an hour and a half, reached the house of my friend, L. Samson, Esq. He could not believe it was me whom he beheld, but having convinced himself of the fact, he made me swallow about a tea-spoonful of brandy, and, recruited by this, I was sufficiently recovered to wait upon His Excellency the Governor [Hutt], in order to have immediate steps taken to send off a party in search of my missing comrades. . . .

Accordingly, on the 23rd of April, Lieutenant Mortimer, of the 21st regiment, and Mr. Spofforth, with four soldiers, left Perth, and arrived on the Moore River in two days. . . . At length . . . the seaman, Charles Woods, one of my party, was found by Mr. Spofforth, lying on the beach, wrapped in his blanket, and fast asleep. He soon awoke, and was not a little delighted to recognise Mr. Spofforth, whom he had seen before at Freemantle. By the account Woods gave, it appears that from the period of my departure much disorder and discontent at the direction of their course prevailed among the men. They frequently left the beach and wandered inland to procure water and food, not sufficiently exerting themselves to advance southward. . . .

May 1. This day the party separated into two portions, and did not meet again until the 2nd, on which day Mr. Walker left them by agreement, he being the strongest of the party. His object was to proceed as expeditiously as he could to Freemantle, and send from thence a boat and fresh water for the relief of the rest. . . .

For two days after Mr. Walker left them, it appears they wandered about to look for water, and then fished. They fortunately fell in with a cask of water, washed up on the beach, from which they filled their canteens, roasted the fish and started on again, but made no distance. . . . Mr. Smith now gradually became exhausted, and, at last, one evening sat down on a bank, and said he could not go on. . . . Mr. Smith seems to have crawled up into the bush, a little on one side of their route, and there died. Four days after, the rest were picked up by Mr. Roe's party. . . .

The last chapters of Grey's journal are devoted to the Aboriginals—their language, laws, traditions, customs and ceremonies, their songs and poetry, as

well as a plan for promoting their civilisation. Grey considered the Aboriginals 'as apt and intelligent as any other race of men I am acquainted with', but was anxious that their 'barbarous customs' should be brought under British law 'so that any native who is suffering under their own customs may have the power of appeal to those of Great Britain'.

Later, in 1839, and while he was resident magistrate at King George Sound, Grey published his *Vocabulary of the Dialects spoken by Aboriginal Races of South-Western Australia.*

Grey was lieutenant governor of South Australia between 1841 and 1845. After disagreement with the Legislative Council he was removed by the Colonial Office to become governor of New Zealand. He ultimately spent twenty years in the New Zealand House of Representatives, two of them as premier.

John Lort Stokes (1812–85) is best known for his outstanding work as a marine surveyor, especially on board the famous sloop HMS *Beagle*, which he joined as a midshipman in 1825 and on which he served continuously for eighteen years. The *Beagle* was first in Australian waters in 1836, towards the end of her famous round-the-world voyage on which Charles Darwin was the naturalist. The following year she was back again—this time to remain for six years charting the coasts. Captain J. S. Wickham was in command, but in 1841 he became ill and Lort Stokes took his place.

Stokes, able hydrographer that he was, also had a fancy for land exploration and made several forays into the 'Interior'. The passages which follow tell of his discovery of the Victoria River in 1839, and later, in 1841, of his trips down the Flinders and Albert Rivers.[6]

Stokes and the 'Beagle'

The Victoria River

Early on the morning of the 4th of September, 1839, the Beagle was once more slipping out of Port Essington [on Cobourg Peninsula] before a light land wind. . . . I confess that the theory of an inland sea has long since vanished from my mind, though I base my opinion on reasons different from those of Mr. Eyre. . . .

Before quitting this subject it may be as well to mention that my own impression, which the most recent information bears out, is that instead of an inland sea, there is in the centre of Australia a vast desert, the head of which, near Lake Torrens, is not more than three hundred feet above the level of the sea. The coast being surrounded by hilly ranges, the great falls of rain that must occasionally occur in the interior, may convert a vast extent of the central and lowest portion, towards the north side of the continent, into a great morass, or lake, which, from the northerly dip, must discharge its waters slowly into the

HMS Beagle.

6. J. Lort Stokes, *Discoveries in Australia.*

John Lort Stokes, the marine surveyor who also turned his energy and interest to land exploration.

Gulf of Carpentaria, without possessing sufficient stability to mark either its bed or boundaries. . . .

September 12. We moved the ship into Port Darwin [named by Stokes because of his association with Charles Darwin], anchoring just within the eastern cliffy head which, to commemorate Lieut. Emery's success in finding water by digging, we named after him. All the surveying force was now put in instant requisition; Captain Wickham went to examine an opening in the coast mentioned by Captain King, lying about twelve miles to the westward, whilst the other boats explored the openings at the head of the harbour. . . .

Another opening of far greater magnitude, and promising in all probability to lead far into the interior now lay before us, at a distance of 140 miles further on the coast to the south-west. By the evening we had lost sight of the land near Port Patterson, and were steering towards the opening that promised so much. A gap in the coast line, 28 miles wide, with a strong tide passing to and fro, failed not to give birth to endless speculation as we approached the spot. I had always looked forward to the examination of this unexplored portion of the North-west coast, as one of the most interesting parts of our survey.

In consequence of light north-west and westerly winds, our approach was tantalizingly slow, and we did not enter the opening until the evening of the 9th, when we passed four miles from the north point, called by Captain King, Point Pearce. His visit to this part of the coast was in September 1819, and under very adverse circumstances. . . .

October 10. We were naturally very anxious to proceed, and as soon as there was sufficient light to read the division of the bearing compass, the ship was gently stealing onward in the direction of the bluff, and furthest land seen last evening to the S. E. . . . We proceeded cautiously, feeling our way with the boats a-head. . . .

A remarkable change here occurred in the character of the country, the hills being now composed of a white, and very compact kind of sandstone. . . . The appearance presented was precisely similar to that of a new road, after it had undergone the improving process invented by Mr M'Adam, in whose honour, therefore, we named this M'Adam Range. . . .

Crossing the flat on returning to the boat, I was much struck by one particular spot on the border of a creek. . . . Several flights of large curlews were seen passing over the boat, and resting on the flats in its neighbourhood. . . . I had stripped to swim across a creek, and with gun in hand was stealthily crawling to the outer edge of the flat where my intended victims were, when an alligator rose close by, bringing his unpleasant countenance much nearer than was agreeable. . . . My only chance of escaping the monster was to hasten back to the boat, and to cross the last creek before the alligator, who appeared fully aware of my intentions. It was now, therefore, a mere matter of speed between us, and the race began. I started off with the utmost rapidity, the alligator keeping pace with me in the water. After a sharp and anxious race, I reached the last creek, which was now much swollen; while the difficulty of crossing was aggravated by my desire to save my gun. Plunging in I reached the opposite shore just in time to see the huge jaws of the alligator extended close above the spot where I had quitted the water. My deliverance was providential, and I could not refrain from shuddering as I sat gaining breath upon the bank after my escape, and watching the disappointed alligator lurking about as if still in hopes of making his supper upon me. . . .

October 13. . . . [They were now in Joseph Bonaparte Gulf, about to explore the Victoria River.] It was soon arranged that Captain Wickham and myself, should at once dispell all doubts, and that next morning, Messrs. Fitzmaurice and Keys should start to explore the river-like opening, under the south end of M'Adam Range, to which we have above alluded.

Our preparations were rapidly made, a few days provisions were stowed away in the boat, and as the western sky glowed red in the expiring light of day, the gig was running before a north-west breeze, for the chasm in the distant high land, bearing S. 20° E., twelve miles from the ship. . . . Still we ran on keeping close to the eastern low land, and just as we found that the course we held no longer appeared to follow the direction of the channel, out burst the moon above

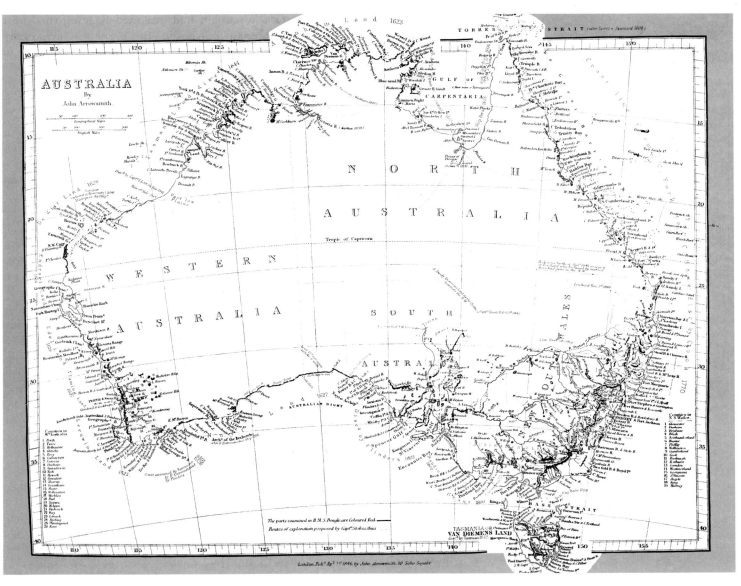

the hills in all its glory, shedding a silvery stream of light upon the water, and revealing to our anxious eyes the long looked for river, rippling and swelling, as it forced its way between high rocky ranges. . . . "This is indeed a noble river!" burst from several lips at the same moment; "and worthy," continued I, "of being honoured with the name of her most gracious majesty the Queen:"—which Captain Wickham fully concurred in, by at once bestowing upon it the name of Victoria River. . . . [They returned to the ship, which Stokes then navigated upstream.]

October 27. . . . The Beagle was now nearly fifty miles up the Victoria. . . .

The expedition, consisting of the two large boats and gig, with Captain Wickham, who was to shew them the watering place, left the ship early on the morning of the 31st of October. I was to follow in one of the whale boats, and explore the upper parts in company with Captain Wickham; and after completing the survey near the ship, I was at last fairly off to explore the Victoria with the first glimmer of light the morning following, once more to revel in scenes where all was new. How amply is the explorer repaid by such sights for all his toils! To ascend a hill and say you are the first civilized man that has ever trod on this spot; to gaze around from its summit and behold a prospect over which no European eye has ever before wandered; to descry new mountains; to dart your eager glance down unexplored valleys, and unvisited glens; to trace the course of rivers whose waters no white man's boat has ever cleaved, and which tempt you onwards into the bosom of unknown lands:—these are the charms of an explorer's life. . . .

November 8. Our little band left the boats before daylight, the morning being

Map of Australia by John Arrowsmith in Stokes' Discoveries in Australia.

agreeably cool (temp. 85°). Captain Wickham had intended heading this most interesting expedition himself, but feeling indisposed, the party was eventually placed under my command. . . . Besides provisions for six days, and arms, we had with us the following instruments: large sextant, small sextant, artificial horizon, chronometer, two compasses, spy glass, watch, lantern, and measuring tape. . . .

November 10. . . . Our route now lay across a barren stony plain, of which the vegetation it might once have boasted had been burnt off: the blackened ground, heated by the fierce rays of the sun, seemed still to us on fire. In crossing a creek which lay in our path, and which we managed to do by means of a fallen tree, Mr. Forsyth shewed symptoms of being struck with the sun, but a little water, which I was happy enough to get from the creek, revived him. Several others of the party also complained of the trying effects of the great heat; after a short rest, I therefore determined on making for the river, which we arrived at in half an hour, near a bed of dry rocks, but with the reaches on either side wide and deep, and shut in by steep banks. By this time one of the men was seriously indisposed; all hopes, therefore, of proceeding much further upon this most interesting expedition I was compelled, though very reluctantly, to abandon. . . .

Scarcely had we disposed of our invalid as comfortably as circumstances would admit, under a bank overshadowed by acacias and gum-trees, when we heard the shrill voices of an evidently large body of natives. . . . What they thought of us, strange intruders as we must have appeared to them, it is not possible fully even to imagine; at any rate they seemed impressed with some sort of respect either for our appearance, jaded as we were, or our position, and forbore any nearer approach. I was of course very glad that no appeal to force was necessary: in the first place I should very reluctantly have resorted to it against those to whom we appeared in the character of invaders of a peaceful country. . . .

Our last regretful view of this part of the Victoria—for every member of our little band seemed to feel an equal interest in the subject—was taken from a position in lat.15° 36′ and long. 130° 52′ E.; 140 miles distant from the sea: but still 500 miles from the centre of Australia. . . .

November 14. . . . We learnt from the party at the boat that a large body of the natives had been down watching their movements, and apparently intending if possible to surprise them. . . . Little did they imagine, as they gazed upon our small party and its solitary boat, that they had seen the harbingers of an approaching revolution in the fortunes of their country!. . .

December 3. . . . That the Beagle was once more anchored outside all the banks— to have touched on any of which, with the great strength of the tides that hurried us along would have been fatal—was a great relief to all of us, especially to me, in whom Captain Wickham has placed so much confidence as to trust the ship to my guidance. . . .

December 7. I left the ship in the morning to make some observations at Point Pearce for the errors of the chronometers. I was accompanied to the shore by Mr. Bynoe, who was going on a shooting excursion. . . .

I had just turned my head round to look after my followers when I was suddenly staggered by a violent and piercing blow about the left shoulder. . . . One glance sufficed to shew me the cliffs, so lately the abode of silence and solitude, swarming with the dusky forms of the natives, now indulging in all the exuberant action with which the Australian testifies his delight. One tall bushy-headed fellow led the group, and was evidently my successful assailant. I drew out the spear, which had entered the cavity of the chest, and retreated, with all the swiftness I could command, in the hope of reaching those who were coming up from the boat, and were then about half way. . . . I had fallen twice: each disaster being announced by a shout of vindictive triumph, from the blood-hounds behind. To add to my distress, I now saw, with utter dismay, that Mr. Tarrant, and the man with the instruments, unconscious of the fact that I had been speared, and therefore believing that I could make good my escape, were moving off towards the boat. . . . At that moment the attention of the retreating party was aroused by a boat approaching hastily from the ship; the first long, loud, wild shriek of the natives having most providentially apprised those on

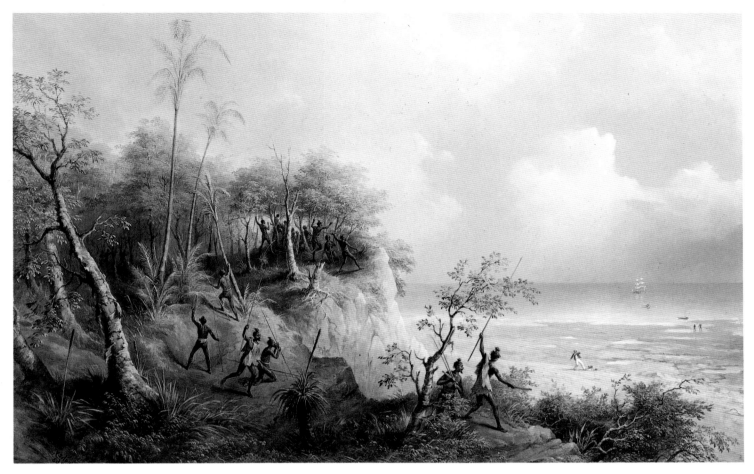

Some years after the event the artist R. B. Beechey recorded the spearing of Stokes which occurred during his discovery of the Victoria River in 1839.

board of our danger. They turned and perceived that I was completely exhausted. I spent the last struggling energy I possessed to join them. . . .

I was soon got down to the boat, lifted over the ship's side, and stretched on the poop cabin table, under the care of Mr. Bynoe, who on probing the wound gave me a cheering hope of its not proving fatal. The anxiety with which I watched his countenance, and listened to the words of life or death, the reader may imagine, but I cannot attempt to describe. . . .

December 12. By this day Mr. Bynoe thought I was sufficiently recovered to be able to bear the motion of the ship at sea, and we accordingly sailed in the morning for Swan River. . . .

In the Gulf of Carpentaria

During 1840 the *Beagle* was engaged in navigational surveys along the Western Australian coast. By June 1841, with Lort Stokes now in command, she had sailed from Sydney for the Gulf of Carpentaria, on the last lap of an important voyage.

July 7 [1841]. . . . The Investigator's old well was discovered half a mile eastward of the point, to which I gave the name of Point Inscription [Sweers Island], from a very interesting discovery we made of the name of Flinders' ship cut on a tree near the well, and still perfectly legible, although nearly forty years old, as the reader will perceive from the wood-cut annexed. On the opposite side of the trunk the Beagle's name and the date of our visit were cut.

It was thus our good fortune to find at last some traces of the Investigator's voyage. . . . I forthwith determined accordingly that the first river we discovered in the Gulf should be named the Flinders. . . .

The Flinders River was subsequently discovered, and explored by boat for forty-eight kilometres. On his return to the *Beagle*, Stokes and three others left immediately to explore another opening on the mainland twenty-four kilometres to the south.

August 1. As time and tide wait for no man we were obliged to move off at one in the morning. The earth's shadow having passed over the moon, the pale light of her full orb fell in a silvery stream on the tortuous reaches, as the waters swelled in silence between the growth of mangroves fringing the banks. . . .

There could be little difficulty in finding a name for our new discovery. We had already called two rivers, explored by the Beagle's officers, the Victoria and the Adelaide; we were glad of such an opportunity of again showing our loyalty to Her Majesty, by conferring the name of her noble consort upon this important stream; it was accordingly christened The Albert. . . .

August 4. . . . It was now quite clear that all hopes of water carriage towards the interior were at an end. The boats were at this time above fifty miles from the entrance, and our provisions only admitting of the remainder of this day being spent in land exploration, a party was immediately selected for this service. . . .

Time being, as I have before said, very precious, we moved off in a S.S.E. direction, at the rate of almost four miles an hour, in spite of the long coarse grass lying on the ground and entangling our legs. The soil was still a light-coloured mould of great depth, and according to one so well qualified to judge as Sir W. Hooker, who kindly examined some that I brought to England, is of a rich quality, confirming the opinion I entertained of it , which suggested for this part of the continent, the name of "The Plains of Promise."

The feelings of delight which are naturally aroused in those whose feet for the first time press a new and rich country, and which I have so often before endeavoured in vain to express, burst forth on this occasion with renewed intensity.

We soon gained almost another two miles, when I availed myself of the opportunity to satisfy a second time my ambition of outstripping my companions in approaching towards that land of mystery, Central Australia. . . .

My position was in lat. 17° 58½' S. long. 7° 12½' E. of Port Essington, or 139° 25' E. of Greenwich; and within four hundred miles from the centre of the continent. What an admirable point of departure for exploring the interior! A few camels, with skins for conveying water, would be the means of effecting this great end in a very short time. In one month these ships of the desert, as they have been appropriately called, might accomplish, at a trifling expense, that which has been attempted in vain by the outlay of so much money. When we consider that Australia is our own continent, and that now, after sixty years of occupation, we are in total ignorance of the interior, though thousands are annually spent in geographical research, it seems not unreasonable to expect that so important a question should at length be set at rest.

In the whole continent there exists no point of departure to be compared with the head of the Albert. The expedition should, as I have before remarked, go to Investigator Road [between Sweers and Bentinck Islands], fulfilling my prediction of the ultimate importance of that port, which lies only twenty-seven miles N. N. W. from the entrance. Here the flat-bottomed boats, taken out in frame, for the purpose of carrying up the camels, should be put together, and towed from thence to the river. . . .

Thus terminated our exploration of the southern shores of the Gulf of Carpentaria, nearly two hundred miles of which had been minutely examined in the boats. Twenty-six inlets had been discovered, of which two proved to be rivers, whilst three more were nearly as promising. That all the others may contain fresh water in the rainy season there is every reason for supposing, from the fact of deep channels being found in their banks. . . .

The *Beagle* was back at Port Essington on 20 August 1841, where Stokes was happy to meet another British navigator, Captain Owen Stanley. The *Beagle* continued on her voyages charting the western and southern coasts in 1842. On several occasions Stokes, who was obviously intrigued by land exploration, referred to the work of Sturt, Eyre or Mitchell. The discovery of the 'interior' of this great continent must have been an important topic of conversation at the various ports at which the vessel called. Finally the Admiralty ordered Stokes and his company home.

'Burial Reach, Flinders River July 29, 1840' a painting by G. Gore, also reproduced in the journal of Lort Stokes.

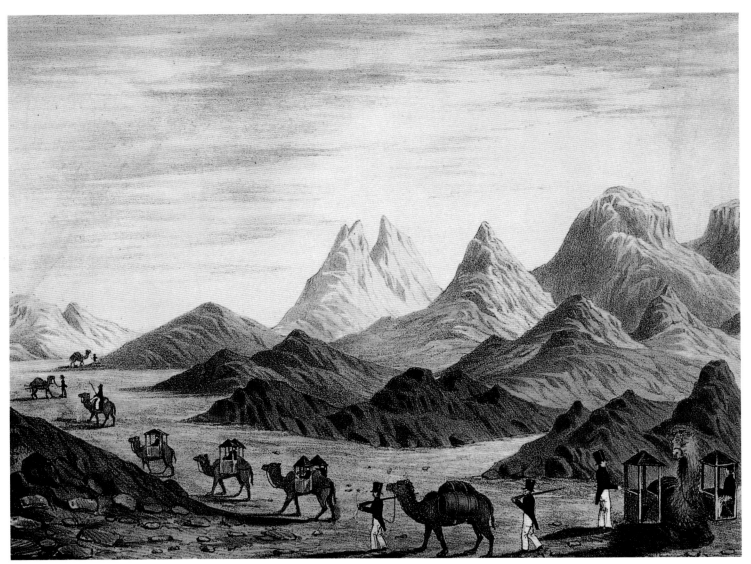

We left Swan River on the evening of the 6th of May, 1843, running out with a moderate N.E. breeze. . . .

Ere the last vestige of day had passed, the coast of Australia had faded from our sight, though not from our memory; for, however much thoughts of the land to which we were returning crowded on our minds, they could not as yet entirely obliterate the recollection of that we were quitting. The Swan River colony — its history, its state, its prospects — naturally occupied much of our mind. What a change had come over it even since our visit! From a happy little family, if I may use the expression, it had grown into a populous colony, in which all the passions, the rivalries, the loves and the hates of the mother country were in some sort represented. And yet there remained still much of that old English hospitality, which rendered our first stay so pleasant, and which almost made us desire to prolong our last. The alteration that had taken place was rather to be referred to the increasing number of settlers, which rendered inevitable the formation of circles more or less exclusive, and which, with the forms of European society, promised to introduce many of its defects.

But our thoughts wandered, from time to time, over the whole of this extraordinary continent, which we saw for the first time in November 1837, at the point from which we took our departure, in May, 1843. The strange contrasts to the rest of the world which it affords were enumerated and commented upon — its cherries with their stones growing outside — its trees, which shed their bark instead of their leaves — its strange animals — its still stranger population — its mushroom cities — and, finally, the fact that the approach to human habitations is not announced by the *barking* of dogs, but by the *barking* of trees!

This illustration is taken from a book published c. 1836 entitled The Friend of Australia or a plan for Exploring the Interior and for carrying on a Survey of the Whole Continent of Australia. *Lort Stokes may have read or heard of this book whilst making his own plans for inland exploration. Obviously inland exploration was a subject of considerable interest in colonial conversation.*

5

The First East-West Crossing

North to Lake Torrens

Edward John Eyre (1815–1901) arrived in Sydney in 1833. The following year he took up land on the Molonglo Plains, near present-day Canberra, and soon joined with Robert Campbell in overlanding sheep from Liverpool Plains to the Molonglo. Two years later he joined forces with Charles Sturt in droving stock to Port Phillip. In January 1838 Eyre set out with his new overseer, John Baxter, in the hope of finding a direct route between Sydney and Adelaide. He followed Mitchell's tracks to the Wimmera but was foiled in his attempts to cut across to the Murray by lack of water. He ultimately reached Adelaide by keeping close to Joseph Hawdon's newly made path by the Murray.

After settling in South Australia Eyre carried out two explorations between 1839 and 1841 — the first north of Mount Arden to within sight of Lake Torrens, and the second westward from Port Lincoln to Streaky Bay and back to the head of Spencer Gulf. Then followed that extraordinary journey for which he is justly famous and which the following passages from his journal describe.[1]

Upon returning, about the middle of May 1840, from a visit to King George's Sound and Swan River, I found public attention in Adelaide considerably engrossed with the subject of an overland communication between Southern and Western Australia. Captain Grey, now [at the time Eyre was writing] the Governor of South Australia, had called at Adelaide on his way to England from King George's Sound, and by furnishing a great deal of interesting information relative to Western Australia, and pointing out the facilities that existed on its eastern frontier, as far as it was then known, for the entrance of stock from the Eastward, had called the attention of the flock-masters of the Colony to the importance of opening communication between the two places, with a view to the extension of their pastoral interests. . . .

Now, from my previous examination of the country to the westward of the located parts of South Australia, I had in 1839 fully satisfied myself, not only of the difficulty, but of the utter impracticability of opening an overland route for stock in that direction, and I at once stated my opinion to that effect, and endeavoured to turn the general attention from the Westward to the North, as being the more promising opening, either for the discovery of good country, or of an available route across the continent. . . .

On the 27th [May] I dined with His Excellency the Governor [Gawler, whom Grey was soon to replace], and had a long conversation with him on the

This lithograph entitled 'Crossing Cattle over the Murray near Lake Alexandrina' is taken from a chapter on the overlanders in Grey's journal. Grey wrote that the overlanders were 'nearly all men in the prime of youth' and 'generally descended from good families'. Eyre fitted Grey's description.

1. Edward John Eyre, *Journals of Expeditions of Discovery into Central Australia, and Overland from Adelaide to King George's Sound, in the Years 1840–1.* London, 1845.

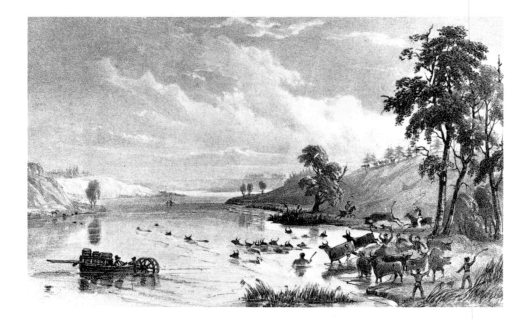

subject of the proposed Western Expedition, and on the exploration of the Northern Interior. With his usual anxiety to promote any object which he thought likely to benefit the colony, and advance the cause of science, His Excellency expressed great interest in the examination of the Northern Interior, and a desire that an attempt should be made to penetrate its recesses during the ensuing season. . . .

Meetings of the colonists interested in the undertaking were again held on the 2nd and 5th of June, at which subscriptions were entered into for carrying out the object of the expedition; and a brief outline of my plans was given by the Chairman, Captain Sturt. . . .

June 18. [1840] Calling my party up early, I ordered the horses to be harnessed, and yoked to the drays, at half past nine the whole party, (except the overseer who was at a station up the country) proceeded to Government House, where the drays were halted for the men to partake of a breakfast kindly provided for them by His Excellency and Mrs. Gawler, whilst myself and Mr. Scott joined the very large party invited to meet us in the drawing room. . . .

Leaving Government House under the hearty cheers of the very large concourse assembled to witness our departure outside the grounds; Mr. Scott, myself, and two native boys (the drays having previously gone on) proceeded on horseback on our route, accompanied by a large body of gentlemen on horseback, and ladies in carriages, desirous of paying us the last kind tribute of friendship by a farewell escort of a few miles. . . .

June 23. . . . My overseer and another man were now added to the party, making up our complement in number . . . and the party and equipment stood thus:—

> Mr. Eyre.
> Mr. Scott, *my assistant and companion.*
> John Baxter, *Overseer.*
> Corporal Coles, R.S. & M.
> John Houston, *driving a three horse dray.*
> R. M'Robert, *driving a three horse dray.*
> Neramberein ⎱ *Aboriginal boys, to drive the*
> Cootachah ⎰ *sheep, track, &c. . . .*

July 3. . . . At dark we arrived at my former depôt near Mount Arden. . . . [Eyre had established this base on his first journey of exploration the previous year, when he had discovered and named Lake Torrens.]

July 6. Being anxious to pursue my explorations, and unwilling to lose another day solely for the purpose of receiving my letters, I sent down my overseer to arrange about getting our stores up from the vessel [the *Waterwitch*], which was about fourteen miles away [in Spencer Gulf], and to request the master to await my return from the north, and in the interval employ himself

Edward John Eyre,

Routes of John Eyre's travels in central Australia and overland from Adelaide to King George's Sound. Drawn by John Arrowsmith.

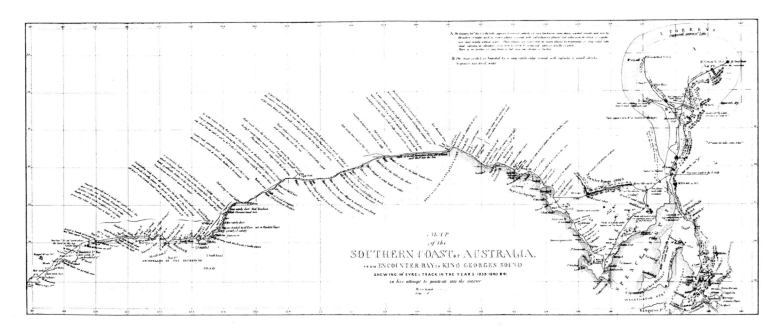

Salt Lake to the North of Spencer's Gulf by S. T. Gill. Eyre's assumption that Lake Torrens was a large continuous horse-shoe shape persisted for nearly twenty years.

in surveying and sounding some salt water inlets, we had seen on the eastern shores of the gulf in our route up under Flinders range. . . .

July 8. . . . [Eyre was in familiar territory, but he was anxious to know more of the country to the north.] I found Lake Torrens completely girded by a steep sandy ridge, exactly like the sandy ridges bounding the sea shore, no rocks or stones were visible any where, but many saline coasts peeped out in the outer ridge, and upon descending westerly to its basin, I found the dry bed of the lake coated completely over with a crust of salt, forming one unbroken sheet of pure white, and glittering brilliantly in the sun. On stepping upon this I found that it yielded to the foot, and that below the surface the bed of the lake consisted of a soft mud, and the further we advanced to the westward the more boggy it got, so that at last it became quite impossible to proceed. . . .

My only chance of success now lay in the non-termination of Flinders range, and in the prospect it held out to me, that by continuing our course along it we might be able to procure grass and water in its recesses, until we were either taken beyond Lake Torrens, or led to some practicable opening to the north. . . .

July 13. . . . About two o'clock, P.M. we passed a little grass, and as the day appeared likely to become rainy, I halted for the night. Leaving the native boy to hobble the horses, I took my gun and ascended one of the hills near me for a view. Lake Torrens was visible to the west, and Mount Deception to the N.W. but higher hills near me, shut out the view in every other direction. In descending, I followed a little rocky gully leading to the main watercourse, and to my surprise and joy, discovered a small but deep pool of water in a hole of the rock: upon sounding the depth, I found it would last us some time, and that I might safely bring on my party thus far, until I could look for some other point for a depôt still farther north; the little channel where the water was, I named Depôt Pool [about twenty-eight kilometres east of Beltana]. . . .

July 21. I pushed on as rapidly as I could . . . and arrived at the Depôt under Mount Arden, late in the day, having been absent sixteen days. . . .

July 25. . . . From the 25th to the evening of the 30th, we were engaged in travelling from Mount Arden to Depôt Pool. . . .

July 31. . . . I decided upon leaving the party in camp at Depôt Pool until I could reconnoitre further north and return. . . .

August 6. . . . following down the Mount Deception Range . . . I examined all the watercourses . . . in one, which I named The Scott, after my young friend and fellow-traveller, I found a large hole of rain water among the rocks. . . . [Eyre returned to Depôt Pool and conducted his party on to the Scott. Then, with two others, he pushed north again.]

August 14. . . . I was now upwards of 100 miles away from my party in a desert, without grass or water, nor could I expect to obtain either until my return to the creek, where I had left the twelve gallons, and this was about fifty miles away. The main basin of Lake Torrens was still four or five miles distant, and I could not expect to gain any thing by going down to its shores. . . .

August 21. . . . Our party being once more all together, it became necessary to decide upon our future movements, the water in the hole at the Depôt being nearly all used, and what was left being very muddy and unpalatable. Before I abandoned our present position, however, I was anxious to make a journey to the shores of Lake Torrens to the westward; I had already visited its basin at points fully 150 miles apart, viz. in about 29°10′S. latitude, and in 31°30′S. I had also traced its course from various heights in Flinders range, from which it was distinctly visible, and in my mind, had not the slightest doubt that it was one continuous and connected basin. . . .

August 23. . . . I penetrated into the basin of the lake for about six miles, and found it so far without surface water. . . . From the extraordinary and deceptive appearances, caused by mirage and refraction, however, it was impossible to tell what to make of sensible objects, or what to believe on the evidence of vision. . . . The whole scene partook more of enchantment than reality, and as the eye wandered over the smooth and unbroken crust of pure white salt which glazed the basin of the lake, and which was lit up by the dazzling rays of a noonday sun, the effect was glittering, and brilliant beyond conception.

August 27. . . . At ten miles from our camp, we came to a large watercourse, emanating from the Mount Serle range on the south side, and running close under its western aspect, with an abundance of excellent clear water in it. This I named the Frome, after the Surveyor-general of the colony, to whose kindness I was so much indebted in preparing my outfit and for the loan of instruments for the use of the expedition.

Having watered our horses we tied them up to some trees, and commenced the ascent of Mount Serle on foot. The day was exceedingly hot, and we found our task a much harder one than we had anticipated, being compelled to wind up and down several steep and rugged ridges before we could reach the main one.

At length, however, having overcome all difficulties we stood upon the summit of the mountain. Our view was then extensive and final. At one glance I saw the realization of my worst forebodings; and the termination of the expedition of which I had the command. Lake Torrens now faced us to the east, whilst on every side we were hemmed in by a barrier that we could never hope to pass. . . .

Upon returning to the depot at the Burr, I decided upon making an excursion to the north-east, to ascertain the actual temination of Flinders range, and the nature of the prospect beyond it. . . . [The Burr River was a tributary of the Scott River discovered earlier. It is marked on present maps as Burr Creek.]

September 2. At thirty-five miles we reached the little elevation I had been steering for, and ascended Mount Hopeless, and cheerless and hopeless indeed was the prospect before us. . . . The appearances from the ranges were similar; the trend of all the watercourses was to the same basin, and undoubtedly that basin, if traced far enough, must be of nearly the same level on the eastern, as on the western side of the ranges. I had completely ascertained that Flinders range had terminated to the eastward, the north-east, and the north; that there were no hills or elevations connected with it beyond, in any of these directions, and that the horizon every where was one low uninterrupted level. . . .

I was now more than a hundred miles away from my party; and having sent them orders to move back towards Mount Arden, I had no time to lose in following them. . . .

September 13. . . . Steering to the south-west we came at twelve miles to the

head of Spencer's Gulf, and crossed the channel connecting it with Lake Torrens. . . .

September 16. Remained in camp to-day to rest the horses and prepare for dividing the party, as from the great abundance of rain that had fallen, I no longer apprehended a scarcity of water on the route to Streaky Bay, and therefore decided upon sending my overseer across with the party, whilst I myself took a dray down direct to Port Lincoln, on the west side of Spencer's Gulf, to obtain additional supplies, with the intention of joining them again at Streaky Bay. . . .

October 3. Leaving our horses to enjoy the good quarters we had selected for them, and a respite from their labours, Mr. Scott and I walked across the range into Port Lincoln, not a little surprising the good people there, who had not heard of our coming, and who imagined us to be many hundreds of miles away to the north. Calling upon Dr. Harvey, the only Government officer then at the settlement, I learnt with regret that it was quite impossible for me to procure the supplies I required in the town, whilst there were no vessels in the port, except foreign whalers, who were neither likely to have, nor be willing to part with the things I should require. . . .

October 6. In the course of the afternoon I learnt that a little boy about twelve years old, a son of Mr. Hawson's, had been speared on the previous day by the natives, at a station about a mile and a half from my tent. . . . [Eyre devoted the next ten pages of his journal to sympathetic comment regarding the Aboriginals' resistance to European intrusion.]

The 7th was spent in preparing my despatches for Adelaide. On the 8th I sent a dray to Port Lincoln, with Mr. Scott's luggage, and those things that were

Most of the second volume of Eyre's journal was devoted to providing information on the culture and life of the Australian Aboriginals and comments on how to promote their well-being. These illustrations are from this section.

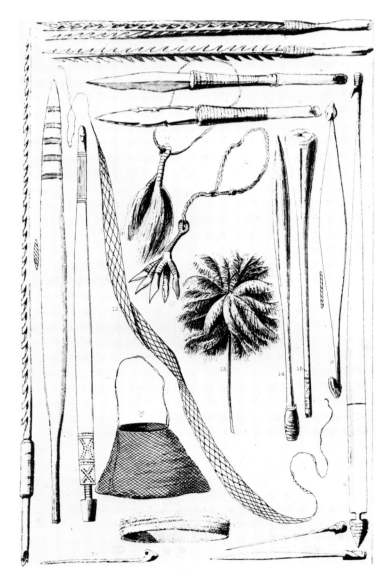

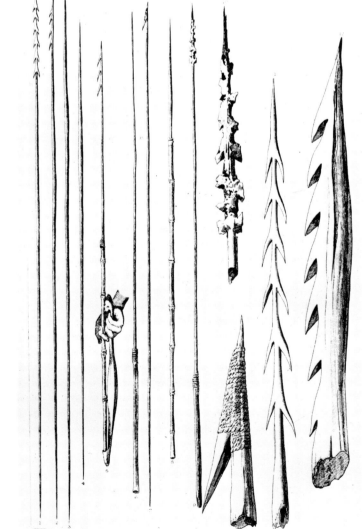

to be sent to Adelaide, comprising all the specimens of geology and botany we had collected, a rough chart of our route, and the despatches and letters I had written. The boat was not ready at the time appointed, and Mr. Scott returned to the tents. In the evening, however, he again went to the settlement, and about ten P.M., he, and the man who was to manage the boat, went on board to sail for Adelaide. . . .

On the 22nd, upon going into the settlement, I found the Government cutter Waterwitch at anchor in the harbour, having Mr. Scott on board, and a most abundant supply of stores and provisions, liberally sent to us by his Excellency the Governor, who had most kindly placed the cutter at my disposal, to accompany and co-operate with me along the coast to the westward.

Mr. Scott had managed every thing confided to him most admirably; and I felt very greatly indebted to him for the ready and enterprising manner in which he had volunteered, to undertake a voyage from Port Lincoln to Adelaide in a small open boat, and the successful manner in which he had accomplished it. Among other commissions, I had requested him to bring me another man . . . also to bring for me a native, named Wylie, an aborigine, from King George's Sound. . . . the boy was in the country when he reached Adelaide, and there was not time to get him down before the Waterwitch sailed. . . .

October 24. Having struck the tent, and loaded the dray, Mr. Scott and I rode into town to breakfast with Dr. Harvey, and take leave of our Port Lincoln friends. . . .

November 3. After seeing the party ready to move on, I left Mr. Scott to conduct the dray, whilst I rode forward in advance to the depôt near Streaky Bay, where I arrived early in the afternoon, and was delighted to find the party all well. . . . The Waterwitch had arrived on the 29th of October. . . .

The great delay caused by my having been obliged to send over from Port Lincoln to Adelaide for supplies, had thrown us very late in the season; the summer was rapidly advancing. . . . Our sending to Adelaide had, however, obtained for us the valuable services of the Waterwitch to assist us in tracing round the desert line of coast to the north-west. . . . We were now amply furnished with conveniences of every kind; and both men and horses were in good plight and ready to enter upon the task before them. . . .

In his despatches to the Governor from Port Lincoln, Eyre wrote of the only plans which appeared feasible to him after he had been forced to retreat from the barren sea around Lake Torrens: 'First — To move my party to the southward . . . and then by crossing to the Darling, to trace the river up until I found high land leading to the north-west. Secondly — To cross over to Streaky Bay . . . and then follow the line of the coast to the westward, until I met with a tract of country practicable to the north'.

Eyre informed the Governor that he had decided to adopt the second of these plans and that he hoped it would meet with the approbation of the Northern Expedition committee which had helped to raise the funds for this venture.

Across the Nullarbor

During the time that I had been occupied in conducting my division of the party from Baxter's Range to Port Lincoln, the overseer [Baxter] had been engaged in guiding the other portion across to Streaky Bay, upon my former track from thence to Mount Arden, in September 1839. . . .

The skill, judgment, and success with which the overseer conducted the task assigned to him, fully justified the confidence I reposed in him; and upon my rejoining the party at Streaky Bay, after an absence of seven weeks, I was much gratified to find that neither the men, animals, or equipment, were in the least degree the worse for their passage through the desert. . . .

November 4. To-day the party were occupied in sorting and packing stores, which I intended to send on board the Waterwitch to Fowler's Bay, that by lightening the loads upon the drays, we might the more easily force a passage through the dense scrub which I knew we had to pass before we reached that point. . . .

'The aboriginal inhabitants . . . of Port Lincoln'
by Angas.

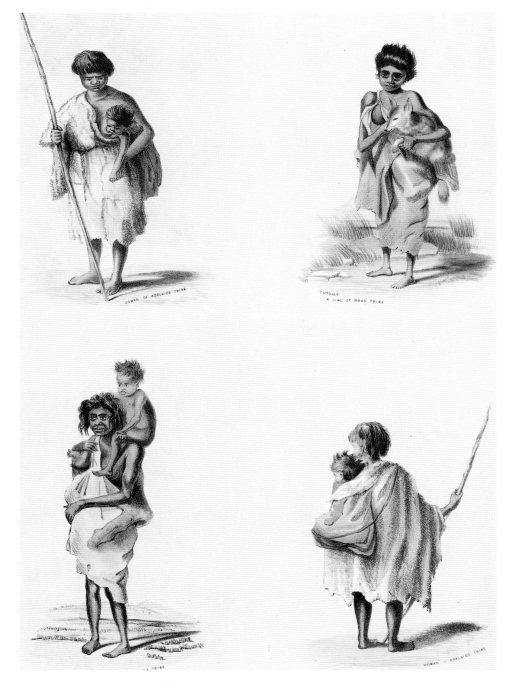

November 10. . . . Our road to-day was through a heavy sandy country, covered for the most part densely with eucalyptus and tea-tree. About eleven we struck the south-east corner of Denial Bay [near present-day Ceduna] and proceeded on to the north-east, where I had appointed the cutter to meet me. . . .

November 17. Moving on early, we were guided by the natives for about twelve miles, round the head of Fowler's Bay, crossing through a very sandy, scrubby, and hilly country, and encamping at a waterhole, dug between the sandy ridges, about two o'clock in the day. I had ridden a little in advance of the party, and arriving at the water first, surprised some women and children encamped there, and very busily engaged in roasting snakes and lizards over a fire. . . . These few women were the first we had seen for some time, as the men appeared to keep them studiously out of our way, and it struck me that this might be in consequence of the conduct of the whalers or sealers with whom they might have come in contact on the coast. . . .

November 19. . . . Upon walking round the shores of Fowler's Bay, I found them literally strewed in all directions with the bones and carcases of whales, which had been taken here by the American ship I saw at Port Lincoln, and had been washed on shore by the waves. . . .

November 20. The wind being favourable for the boats landing to-day, I sent the overseer with pack-horses to the west side of Fowler's Bay, to bring up some flour and other stores for the use of the party; at the same time I wrote to the master of the cutter, to know whether he considered his anchorage, at Fowler's Bay, perfectly safe. His reply was, that the anchorage was good and secure if he had been provided with a proper cable; but that as he was not, he could not depend upon the vessel being safe, should a heavy swell set in from the south-east. Upon this report, I decided upon landing all the stores from the cutter; and sending her to lay at a secure place on the west side of Denial Bay, until I returned from exploring the country, near the head of the Great Bight. . . . [Eyre's attempts to get round the head of the Bight met with no success, nor could he find water ahead.]

December 17. Having now maturely considered the serious position I was in, the difficult nature of the country, the reduced condition and diminished number of my horses, and the very unfavourable season of the year, I decided upon taking advantage of a considerate clause in the Governor's letter, authorizing me "to send back the Waterwitch to Adelaide for assistance, if required."

From the experience I had already had, and from the knowledge I had thus acquired of the character of the country to the westward and to the north, it was evident that I could never hope to take my whole party, small as it was, with me in either direction. I had already lost three horses in an attempt to get round the head of the Bight, and I had also found that my three best horses now remaining, when strong and fresh after a long period of rest at the depôt, had with difficulty been able to move along with an empty dray in the heavy sandy country to the north-west; how could I expect, then, to take drays when loaded with provisions and other stores? . . . Fowler's Bay being the last place of refuge where a vessel could take shelter for many hundred miles, whilst the fearful nature of the coast and the strong current setting into the Bight, made it very dangerous for a vessel to approach the land at all. . . . It appeared to me that if I sent two of my men back to Adelaide in the Waterwitch, a single dray would carry every necessary for the reduced party remaining, and that by obtaining a supply of oats and bran for the horses, and giving them a long rest, they might so far recover strength and spirits as to afford me reasonable grounds of hope that we might succeed in forcing a passage through the country to the westward, bad as it evidently was. . . .

December 18. . . . After the departure of the cutter, our mode of life was for some time very monotonous, and our camp bore a gloomy and melancholy aspect. . . .

Christmas day came, and made a slight though temporary break in the daily monotony of our life. . . . [Eyre determined to make one more attempt to get round the head of the Bight.]

January 7. [1841] . . . We once more moved on to the north-west, through the same barren region of heavy sandy ridges, entirely destitute of grass or timber. After travelling through this for ten miles, we came upon a native pathway, and following it under the hummocks of the coast for eight miles, lost it at some bare sand-drifts, close to the head of the Great Bight, where we had at last arrived, after our many former ineffectual attempts. . . .

January 16. After breakfast, in returning from the water, we had a feast upon some berries, growing on the briary bushes behind the sand-hills. . . . About eight o'clock we set off for the depôt, and arrived there at two, glad to reach our temporary home once more, after eighteen days absence, and heartily welcomed by Mr. Scott, who complained bitterly of having been left alone so long. . . .

January 17. Spent the day in writing, and in meditating upon my future plans and prospects. I had now been forty-five miles beyond the head of the Great Bight. . . . The account of the natives fully satisfied me that there was no possibility of getting inland, and my own experience told me that I could never hope to take a loaded dray through the dreadful country I had already traversed on horseback. . . .

On the 26th, I went down myself to Fowler's Bay to look for the cutter, which we now daily expected. Just as I arrived at the beach she came rounding

into the bay. . . . On board the Hero [a replacement for *Waterwitch*] I was pleased to find the native from King George's Sound, named Wylie, whom I had sent for, and who was almost wild with delight at meeting us, having been much disappointed at being out of the way when I sent for him from Port Lincoln. . . . Among other presents I received a fine and valuable kangaroo-dog from my friend, Captain Sturt, and which had fortunately arrived safely, and in excellent condition. . . .

From his Excellency the Governor I received a kind and friendly letter, acquainting me that the Hero was entirely at my disposal *within* the limits of South Australia. . . .

In the instructions I received relative to the cutter, I have mentioned that I was restricted to employing her within the limits of the colony of South Australia, and thus, the plan I had formed of sending our drays and heavy stores in her to Cape Arid, whilst we proceeded overland ourselves with pack-horses, was completely overturned, and it became now a matter of very serious consideration to decide what I should do under the circumstances. It was impossible for me to take my whole party and the drays overland through the dreadful country verging upon the Great Bight; whilst if I took the party, and left the drays, it was equally hopeless that I could carry upon pack-horses a sufficiency of provisions to last us to King George's Sound. There remained, then, but two alternatives, either to break through the instructions I had received with regard to the Hero, or to reduce my party still further, and attempt to force a passage almost alone. The first I did not, for many reasons, think myself justified in doing — the second, therefore, became my *dernier resort*, and I reluctantly decided upon adopting it.

It now became my duty to determine without delay who were to be my companions in the perilous attempt before me. The first and most painful necessity impressed upon me by the step I contemplated, was that of parting with my young friend, Mr. Scott. . . . I had no right to lead a young enthusiastic friend into a peril from which escape seemed to be all but hopeless. . . .

Our future movements being now arranged, and the division of the party decided upon, it remained only for me to put my plans into execution. The prospect of the approaching separation, had cast a gloom over the whole party, and now that all was finally determined, I felt that the sooner it was over the better. I lost no time, therefore, in getting up all the bran and oats from the cutter, and in putting on board of her our drays, and such stores as we did not require, directing the master to hold himself in readiness to return to Adelaide immediately.

By the 31st January, every thing was ready; my farewell letters were written to the kind friends in Adelaide, to whom I owed so much. . . .

In the evening the man and Mr. Scott went on board the cutter, taking with them our three kangaroo dogs, which the arid nature of the country rendered it impossible for me to keep. I regretted exceedingly being compelled to part with the dogs, but it would have been certain destruction to them to have attempted to take them with me. . . .

We were now alone, myself, my overseer [John Baxter], and three native boys, with a fearful task before us, the bridge was broken down behind us, and we must succeed in reaching King George's Sound, or perish; no middle course remained. . . . [They had 1370 kilometres to go before they would reach King George Sound.]

February 24. This being the day I had appointed to enter upon the arduous task before me, I had the party up at a very early hour. Our loads were all arranged for each of the horses; our blankets and coats were all packed up, and we were in the act of burying in a hole under ground the few stores we could not take with us, when to our surprise a shot was heard in the direction of Fowler's Bay, and shortly after a second; we then observed two people in the distance following up the dray tracks leading to the depôt. . . .

As the parties we had seen gradually approached nearer I recognised one of them with the telescope as being Mr. Germain, the master of the Hero; the other I could not make out at first from his being enveloped in heavy pilot clothes; a little time however enabled me to distinguish under this guise my

'Portrait of Wylie', the Aboriginal boy from King George Sound who accompanied Eyre on his desert trek.

young friend Mr. Scott, and I went anxiously to meet him, and learn what had brought him back. Our greeting over, he informed me that the Governor had sent him back with letters to me, and desired me to return in the Hero to Adelaide. . . . after giving my best and serious attention to the arguments of my friends, and carefully reconsidering the subject now, I saw nothing to induce me to change the opinion I had . . . arrived at. . . .

February 25. . . . About two we loaded the pack animals, and wishing Mr. Scott a final adieu, set off upon our route. . . .

March 2. A hot day, with the wind north-east. Between eleven and twelve we arrived at the first water, at the head of the Bight, and had a long and arduous task to get the sheep and horses watered. . . .

March 10. . . . Still we kept moving onwards and still the cliffs continued. . . . We had now been four days without a drop of water for our horses, and we had no longer any for ourselves. . . .

March 11. Early this morning we moved on, leading slowly our jaded animals through the scrub. . . . After a little while, we again came to a well beaten native pathway. . . . The road now led us down a very rocky steep part of the cliffs . . . following along by the water's edge, we felt cooled and refreshed by the sea air, and in one mile and a half from where we had descended the cliffs, we reached the white sand-drifts. Upon turning into these to search for water, we were fortunate enough to strike the very place where the natives had dug little wells; and thus on the fifth day of our sufferings, we were again blessed with abundance of water. . . . [At this stage, Eyre and his party were near present-day Eucla, on the border of South Australia and Western Australia.]

March 28. . . . Our route lay along the beach, as the dense scrub inland prevented us from following any other course. . . . Our horses were nearly all exhausted, and I dreaded that when we next moved on many of them would be unable to proceed far, and that, one by one, they would all perish, overcome by sufferings which those, who have not witnessed such scenes, can have no conception of. We should then have been entirely dependent upon our own strength and exertions, nearly midway between Adelaide and King George's Sound, with a fearful country on either side of us, with a very small supply of provisions, and without water. . . .

We were now pushing on for some sand-hills, marked down in Captain Flinders' chart at about 126½° of east longitude; I did not expect to procure water until we reached these, but I felt sure we should obtain it on our arrival there. After this point was passed, there appeared to be one more long push without any likelihood of procuring water, as the cliffs again became the boundary of the ocean; but beyond Cape Arid, the change in the character and appearance of the country, as described by Flinders, indicated the existence of a better and more practicable line of country than we had yet fallen in with.

My overseer, however, was now unfortunately beginning to take up an opposite opinion, and though he still went through the duty devolving upon him with assiduity and cheerfulness, it was evident that his mind was ill at ease, and that he had many gloomy anticipations of the future. . . .

March 30. . . . Leaving the overseer to search for those [horses] that had strayed, I took a sponge, and went to collect some of the dew which was hanging in spangles upon the grass and shrubs; brushing these with the sponge, I squeezed it, when saturated, into a quart pot, which, in an hour's time, I filled with water. . . . As we progressed, it was evident that the country was undergoing a considerable change; the sea shore dunes and the ridges immediately behind them were now of a pure white sand, and steep, whilst those further back were very high and covered with low bushes. . . . The horses were, however, becoming exhausted. . . . Leaving the boys to attend to the animals, I took the overseer up one of the ridges to reconnoitre the country for the purpose of ascertaining whether there was no place near us where water might be procured by digging. After a careful examination a hollow was selected between the two front ridges of white sand, where the overseer thought it likely we might be successful [near the now abandoned Eyre Telegraph Office]. The boys were called up to assist in digging, and the work was anxiously commenced; our suspense increasing every moment as the well was deepened. At about five feet the sand was

observed to be quite moist, and upon its being tasted was pronounced quite free from any saline qualities. . . . That gracious God, without whose assistance all hope of safety had been in vain, had heard our earnest prayers for his aid, and I trust that in our deliverance we recognized and acknowledged with sincerity and thankfulness his guiding and protecting hand. . . .

April 7. Another sleepless night from the intense cold. . . . The day being very clear, I ascended the highest sand-hill to obtain a view of what had appeared to us to be a long point of land, stretching to the south-west. It was now clearly recognizable as the high level line of cliffs forming the western boundary of the Great Bight, and I at once knew, that when we left our present position, we could hope for no water for at least 140 or 150 miles beyond. . . .

[Eyre's overseer, Baxter, was now convinced that their only hope was to return to Fowler's Bay.] Finding that I made little progress in removing his doubts on the question of our advance, I resolved to pursue the subject no further, until the time for decision came, hoping that in the interim, his opinions and feelings might in some degree be modified, and that he might then accompany me cheerfully. . . .

April 28. . . . The night was cold, and the wind blowing hard from the south-west, whilst scud and nimbus were passing very rapidly by the moon. The horses fed tolerably well, but rambled a good deal, threading in and out among the many belts of scrub which intersected the grassy openings, until at last I hardly knew exactly where our camp was, the fires having apparently expired some time ago. It was now half past ten, and I headed the horses back, in the direction in which I thought the camp lay, that I might be ready to call the overseer to relieve me at eleven. Whilst thus engaged, and looking steadfastly around among the scrub, to see if I could anywhere detect the embers of our fires, I was startled by a sudden flash, followed by the report of a gun, not a quarter of a mile away from me. . . . Upon reaching the encampment, which I did in about five minutes after the shot was fired, I was horror-struck to find my poor overseer lying on the ground, weltering in his blood, and in the last agonies of death. . . .

Glancing hastily around the camp I found it deserted by the two younger native boys, whilst the scattered fragments of our baggage, which I left carefully piled under the oilskin, lay thrown about in wild disorder, and at once revealed the cause of the harrowing scene before me. . . . At the dead hour of night, in the wildest and most inhospitable wastes of Australia, with the fierce wind raging in unison with the scene of violence before me, I was left, with a single native [Wylie], whose fidelity I could not rely upon, and who for aught I knew might be in league with the other two, who perhaps were even now, lurking about with a view of taking away my life as they had done that of the overseer. . . .

After obtaining possession of all the remaining arms, useless as they were at the moment, with some ammunition, I made no further examination then, but hurried away from the fearful scene, accompanied by the King George's Sound native, to search for the horses, knowing that if they got away now, no chance whatever would remain of saving our lives. . . . With an aching heart, and in most painful reflections, I passed this dreadful night. . . .

April 30. At last, by God's blessing, daylight dawned once more, but sad and heart-rending was the scene it presented my view, upon driving the horses to what had been our last night's camp. The corpse of my poor companion lay extended on the ground, with the eyes open, but cold and glazed in death. . . .

One vast unbroken surface of sheet rock extended for miles in every direction, and rendered it impossible to make a grave. . . . I could only, therefore, wrap a blanket around the body of the overseer, and leaving it enshrouded where he fell, escape from the melancholy scene, accompanied by Wylie, under the influence of feelings which neither time nor circumstances will ever obliterate. . . .

For some time we travelled slowly and silently onwards. . . .

My own impression was, that Wylie had agreed with the other two to rob the camp and leave us . . . but that when, upon the eve of their departure, the overseer had unexpectedly awoke and been murdered, he was shocked and frightened at the deed, and instead of accompanying them, had run down to meet

me. . . .

We remained in camp until four o'clock, and were again preparing to advance, when my attention was called by Wylie to two white objects among the scrub, at no great distance from us, and I at once recognized the native boys, covered with their blankets only, and advancing towards us. . . . Although they had taken fully one-third of the whole stock of our provisions, their appetites were so ravenous, and their habits so improvident, that this would soon be consumed, and then they must either starve or plunder us; for they had already tried to subsist themselves in the bush, and had failed. . . .

As soon as the two natives saw us moving on, and found Wylie did not join them, they set up a wild and plaintive cry, still following along the brush parallel to our line of route, and never ceasing in their importunities to Wylie, until the denseness of the scrub, and the closing in of night, concealed us from each other. . . .

Moving on again on the 1st of May, as the sun was above the horizon, we passed through a continuation of the same kind of country, for sixteen miles, and then halted for a few hours during the heat of the day. . . .

One circumstance in our route to-day cheered me greatly, and led me shortly to expect some important and decisive change in the character and formation of the country. It was the appearance for the first time of the Banksia, a shrub which I had never before found to the westward of Spencer's Gulf, but which I knew to abound in the vicinity of King George's Sound, and that description of country generally. . . .

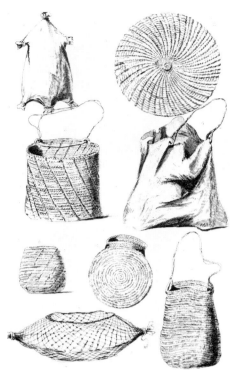

Another drawing from Eyre's journal, showing Aboriginal artefacts.

May 3. . . . Having at last got fairly beyond all the cliffs bounding the Great Bight, I fully trusted that we had now overcome the greatest difficulties of the undertaking, and confidently hoped that there would be no more of those fearful long journeys through the desert without water, but that the character of the country would be changed, and so far improved as to enable us to procure it, once at least every thirty or forty miles, if not more frequently. . . .

May 15. . . . After proceeding eleven miles along the coast, I halted, and Wylie came up a little before dark, bringing the hobbles with him. We were both very hungry; and as we had suffered so much lately from eating the horse flesh, we indulged to-night in a piece of bread, and a spoonful of flour boiled into a paste, an extravagance which I knew we should have to make up for by and bye. . . .

May 17. . . . Added to all other evils, the nature of the country behind the sea-coast was as yet so sandy and scrubby that we were still compelled to follow the beach, frequently travelling on loose heavy sands, that rendered our stages doubly fatiguing. . . . On our march we felt generally weak and languid — it was an effort to put one foot before the other. . . . I felt, on such occasions, that I could have sat quiet and contentedly, and let the glass of life glide away to its last sand. . . .

May 19. The morning set in very cold and showery, with the wind from the southward, making us shiver terribly as we went along. . . .

May 26. . . . The high bluff and craggy hills, whose tops we had formerly seen, stood out now in bold relief. . . . I named these lofty and abrupt mountain masses the "Russell Range," after the Right Honourable the Secretary of State for the Colonies — Lord John Russell. . . .

June 2. . . . Being now near Thistle Cove, where I intended to halt for some time, and kill the little foal for food, whilst the other horses were recruiting, and as I hoped to get there early this afternoon, I was anxious to husband our little stock of flour in the hope, that at the little fresh-water lake described by Flinders, as existing there, we should find abundance of the flag-reed for our support. Keeping a little behind the shore for the first hour, we crossed over the sandy ridge bounding it, and upon looking towards the sea, I thought I discovered a boat sailing in the bay. . . . We now anxiously scanned the horizon in every direction, and at last were delighted beyond measure to perceive to the westward the masts of a large ship, peeping above the rocky island which had heretofore concealed her from our view.

Poor Wylie's joy now knew no bounds, and he leapt and skipped about with delight as he congratulated me once more upon the prospect of getting

The French whaling ship that rescued Eyre and Wylie near present-day Esperance would have been one of many whalers cruising off the southern Australian coast at this time.

plenty to eat. . . . I now made a smoke on the rock where I was, and hailed the vessel, upon which a boat instantly put off, and in a few moments I had the inexpressible pleasure of being again among civilized beings, and of shaking hands with a fellow-countryman in the person of Captain Rossiter, commanding the French Whaler "Mississippi".

Early in the evening the whalers retired to rest, and I had a comfortable berth provided for me in the cabin, but could not sleep. . . .

June 5. . . . Every thing that I wished for, was given to me with a kindness and liberality beyond what I could have expected; and it gives me unfeigned pleasure, to have it now in my power to record thus publicly the obligations I was under to Captain Rossiter. . . .

June 15. . . . Having received a few letters to be posted at Albany for France, I asked the Captain if there was anything else I could do for him, but he said there was not. The only subject upon which he was at all anxious, was to ascertain whether a war had broken out between France and England or not. In the event of this being the case, he wished me not to mention having seen a French vessel upon the coast, and I promised to comply with his request.

After wishing my kind host good bye, and directing Wylie to lead one of the horses in advance, I brought up the rear, driving the others before me. Once again we had a long and arduous journey before us, and were wending our lonely way through the unknown and untrodden wilds. . . .

June 25. We commenced our journey early, but had not gone far before the rain began to fall, and continued until ten o'clock. Occasionally the showers came down in perfect torrents, rendering us very cold and miserable, and giving the whole country the appearance of a large puddle. . . .

June 30. . . . In the evening we obtained a view of some high rugged and distant ranges, which I at once recognised as being the mountains immediately behind King George's Sound. . . .

July 6. [At King's River Eyre and Wylie spent two hours in the water and mud, helping the horses to cross the stream.] The morning still very wet and miserably cold. . . . For three days and nights, we had never had our clothes dry, and for the greater part of this time, we had been enduring in full violence the pitiless storm — whilst wading so constantly through the cold torrents in the depth of the winter season, and latterly being detained in the water so long a time at King's river, had rendered us rheumatic, and painfully sensitive to either cold or wet. I hoped to have reached Albany this evening, and should have done so, as it was only six miles distant, if it had not been for the unlucky attempt to cross King's river. Now we had another night's misery before us, for we had hardly lain down before the rain began to fall again in torrents. . . .

July 7. . . . The rain still continued falling heavily as we ascended to the brow of the hill immediately overlooking the town of Albany — not a soul was to be seen — not an animal of any kind — the place looked deserted and uninhabited, so completely had the inclemency of the weather driven both man and beast to seek shelter from the storm. . . .

Whilst standing thus upon the brow overlooking the town, and buried in reflection, I was startled by the loud shrill cry of the native we had met on the road, and who still kept with us. . . . For an instant there was a silence still almost as death — then a single repetition of that wild joyous cry, a confused hum of many voices, a hurrying to and fro of human feet, and the streets which had appeared so shortly before gloomy and untenanted, were now alive with natives — men, women and children, old and young, rushing rapidly up the hill, to welcome the wanderer on his return, and to receive their lost one almost from the grave. . . .

I feel great pleasure in the opportunity now afforded me of recording the grateful feelings I entertain towards the residents at Albany for the kindness I experienced upon this occasion. Wet as the day was, I had hardly been two hours at Mr. Sherrats before I was honoured by a visit from Lady Spencer, from the Government-resident, Mr. Phillips, and from almost all the other residents and visitors at the settlement, — all vying with each other in their kind attentions and congratulations, and in every offer of assistance or accommodation which it was in their power to render. . . .

On the 13th July I wished my friends good bye, and in the afternoon went on board the Truelove to sail for Adelaide. . . .

More than half of Volume II of Eyre's journal is devoted to a section entitled: *Manners and Customs of the Aborigines of Australia*, much of the information from these pages having been gathered between 1841–44 when he was resident magistrate at Moorundie on the Murray. Here he disassociated himself from the unfavourable views then current regarding the character of the Australian native which he considered was constantly misrepresented. 'I do not imagine', he wrote, 'that his vices would usually be found greater, or his passions more malignant than those of a very large proportion of men ordinarily denominated civilised.'

In view of what appears to be an enlightened attitude for his time, his career on leaving Australia seems difficult to understand. While governor of Jamaica he was accused in 1865 of quashing a native mutiny with too much severity. He was recalled to England to face protracted legal proceedings and an intense public debate on his actions but was acquitted, the British government finally paying his legal costs.

Part of a panorama of King George Sound by Robert Dale in 1831. It would appear to be something like the scene which greeted the bedraggled Eyre and Wylie as they approached the southern port of Albany in the winter of 1841.

6

Inland Routes to the North

Journey to the Centre

A watercolour by S. T. Gill of a drove of cattle in the bush. Cattlemen were often just behind, and indeed sometimes ahead of the explorers. Sturt himself had been a drover.

After a sojourn in England writing the account of his journey down the Murray River in 1829–30 and recovering his health, Charles Sturt returned in 1835 to New South Wales where as a reward for his services to exploration he had been granted land at Ginninderra — now part of Canberra. Sturt settled at Mittagong, but by 1838 was droving cattle to South Australia to which colony he moved early the following year, expecting to take up the position of surveyor general offered him by Governor Gawler. This was not to be, however, for Edward Frome's appointment had already been made in London.

Frustrated by setbacks and at loggerheads with the new governor, George Grey, Sturt turned once more to exploration. Leaving Adelaide in August 1844 he and his party moved along the Murray and Darling Rivers, pushing on into the interior until they were well north of present-day Broken Hill and, eventually, near where Birdsville now stands. For Sturt, it was a disappointing expedition — there was no inland sea, nor was there country which would tempt even the most intrepid cattlemen to follow his tracks, nor did he even achieve his aim of reaching the geographical centre of the continent. Nevertheless, as the following extracts[1] show, this was another epic journey, no less significant because it revealed not lush pastures, but the harsh realities of inland Australia.

Sturt's desire to enter colonial politics was ultimately fulfilled when he became colonial secretary of South Australia in 1849, but two years later he was forced to retire due to poor eyesight. Sturt died in England, but to the end of his life, he retained his affection for Australia.

More than sixteen years had elapsed from the period when I undertook the exploration of the Murray River, to that at which I commenced my preparations for an attempt to penetrate Central Australia. . . .

It was still a matter of conjecture what the real character of Central Australia really was, for its depths had been but superficially explored before my recent attempt. My own opinion, when I commenced my last expedition, inclined me to the belief, and perhaps this opinion was fostered by the hope that such would prove to be the case, as well as by the reports of the distant natives, which invariably went to confirm it, that the interior was occupied by a sea of

1. Charles Sturt, *Narrative of an Expedition into Central Australia, performed under the Authority of Her Majesty's Government, during the years 1844, 5, and 6 together with a Notice of the Province of South Australia, in 1847.* London, 1849.

greater or less extent, and very probably by large tracts of desert country.

With such a conviction I commenced my recent labours, although I was not prepared for the extent of desert I encountered — with such a conviction I returned to the abodes of civilized man. . . .

In May, 1844, Captain Grey, the Governor of South Australia, received a private letter from Lord Stanley, referring to a despatch his Lordship had already written to him, to authorise the fitting out of an expedition to proceed under my command into the interior. . . .

I decided on our final departure from Adelaide on the 15th of the month [August]. . . . The sun rose bright and clear over my home on the morning of that day. It was indeed a morning such as is only known in a southern climate; but I had to bid adieu to my wife and family, and could but feebly enter into the harmony of Nature, as everything seemed joyous around me.

I took breakfast with my warm-hearted friend, Mr. Torrens, and his wife, who had kindly invited a small party of friends to witness my departure; but although this was nominally a breakfast, it was six in the afternoon before I mounted my horse to commence my journey. . . . [The party proceeded towards Eyre's property at Moorundi, near present-day Elanchetown.]

My excellent friend, Mr. Eyre, had been long and anxiously expecting us. . . .

In the afternoon of the day following that of our arrival at Moorundi, Mr. Piesse arrived with the drays, and drew them up under the fine natural avenue that occupies the back of the river to the south of Mr. Eyre's residence. . . . Flood also came up with the sheep, so that the expedition was now complete, and mustered in its full force for the first time, and consisted as follows of officers, men and animals:—

> Captain Sturt, *Leader.*
> Mr. James Poole, *Assistant.*
> Mr. John Harris Browne, *Surgeon.*
> Mr. M'Dougate Stuart, *Draftsman.*
> Mr. Louis Piesse, *Storekeeper.*
> Daniel Brock, *Collector.*
> George Davenport, ⎫
> Joseph Cowley, ⎬ *Servants.*
> Robert Flood, *Stockman.*
> David Morgan, *with horses.*

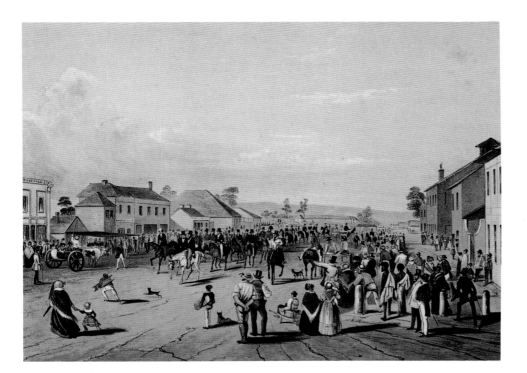

The Departure of Captain Sturt, Aug. 1844' by S. T. Gill.

Hugh Foulkes,
John Jones,
— Turpin,
William Lewis, *sailor,* } *Bullock drivers*
John Mack,
John Kerby, *with sheep.*

11 horses; 30 bullocks; 1 boat and boat carriage; 1 horse dray;
1 spring cart; 3 drays. 200 sheep; 4 kangaroo dogs; 2 sheep
dogs. . . .

[Before the party left Moorundi Sturt addressed the men.] I . . . then said,
that as they might now be said to commence a journey, from which none of
them could tell who would be permitted to return, it was a duty they owed
themselves to ask the blessing and protection of that Power which alone could
conduct them in safety through it; and having read a few appropriate prayers
to the men as they stood uncovered before me, I dismissed them, and told Mr.
Poole he might move off as soon as he pleased. The scene was at once changed.
The silence which had prevailed was broken by the cracks of whips, and the
loud voices of the bullock-drivers. The teams descended one after the other from
the bank on which they had been drawn up, and filed past myself and Mr. Eyre,
who stood near me, in the most regular order. . . .

The journeys of Mr. Eyre had . . . proved the impracticability of a direct
northerly course from Mount Arden. Such a course would have led me into the
horse-shoe of Lake Torrens; and although I might have passed to the westward
of it, I could hope for no advantage in a country such as that which lies to the
north of the Gawler Range. On the other hand, the Surveyor-General of South
Australia [E. C. Frome] had attempted a descent into the interior from the east-
ward, and had encountered great difficulties from the want of water. . . .

As I understood my instructions and the wishes of the Secretary of State
[Lord Stanley] I was to keep on the 138th Meridian (that of Mount Arden) until
I should reach the supposed chain of mountains, existence of which it was the
object of Lord Stanley to ascertain, or until I was turned aside from it by some
impracticable object. . . . little doubt can now be entertained as to the non-
existence of the mountain chains. . . .

**[Sturt left Moorundi a few days after his party, accompanied for some distance
along the Murray by Eyre.]**

On the morrow [12 September], my worthy friend left me, on his return to
Moorundi, together with Kenny and Tenbury, and a young native of the Rufus.
We all saw them depart with feelings of deep regret; but Mr. Eyre had important
business to attend to which did not admit of delay. . . .

[By 24 September they were on the Darling River.] Some days prior to the
29th, Mr. Browne and I, on examining the waters of the river, thought that we
observed a more than usual current in it; grass and bark were floating on its
surface, and it appeared as if the water was pushed forward by some back
impulse. On the 28th it was still as low as ever; but on the morning of the 29th,
when we got up it was wholly changed. In a few hours it had been converted
into a noble river, and had risen more than five feet above its recent level. It
was now pouring along its muddy waters with foaming impetuosity, and carrying
away everything before it. Whence, it may be asked, came these floods? . . .

Our journey up the Darling had been of greater length than I had antici-
pated, and it appeared to me that I could not do better than reduce the ration
of flour at this early stage of the expedition to provide the more certainly for
the future. . . .

It was clear that the natives still remembered the first visit the Europeans
had made to them, and its consequences, and that they were very well disposed
to retaliate. . . . Mr. Poole was short and stout like Sir Thomas Mitchell . . .
moreover he wore a blue foraging cap, as, I believe Sir Thomas did; be that as
it may, they took Mr. Poole for that officer, and were exceedingly sulky, and
Nadbuck informed us that they would certainly spear him. It was necessary,
therefore, to explain to them that he was not the individual for whom they took
him, and we could only allay their feelings by the strongest assurances to that

First view of the Salt Desert "called Lake Torrens —

effect . . . to secure himself still more Mr. Poole put on a straw hat. . . . Taking everything into consideration, I determined on moving the camp to Cawndilla, and on proceeding myself to the north-west as soon as I should have established it in a secure place. [They were in the vicinity of present-day Menindee].

I was employed on the 16th [October] in reporting our progress to the Governor, as Nadbuck and Camboli were to leave us in the afternoon on their return to Lake Victoria. . . .

Cawndilla bears about W.S.W. from the junction of the Williorara with the Darling, at a distance of from six to seven miles. We broke up our camp there on the 28th of October 1844, but, however easily Mr. Browne and I had crossed the plains to the north-west, it was a journey that I felt assured would try the bullocks exceedingly. The weather had again changed, and become oppressively hot, so that it behoved me to use every precaution, in thus abandoning the Darling river. . . . all the natives dreaded the country into which we were going, and fully expected that we should perish. . . .

Our observations . . . placed us in latitude 31° 23' 20"S., so that we were still nearly half a degree to the south of Mount Lyell, and a degree to the south of Mount Serle. . . . [It was now early November.]

Flood, who had ridden a-head, went up . . . in search for water. Mr. Browne and I went downwards, and from appearances had great hopes that at a particular spot we should succeed by digging, more especially as on scraping away a little of the surface gravel with our hands, there were sufficient indications to induce us to set Morgan to work with a spade, who in less than an hour dug a hole from which we were enabled to supply both our own wants and those of the animals. . . .

I hoped, by taking a westerly course, that I should strike the N.E. angle of Lake Torrens, or find that I had altogether cleared it; added to this Mr. Eyre had informed me that he could not see the northern shore of that lake; I therefore thought that it might be connected with some more central body of water, the early discovery of which, in my progress to the N.W., would facilitate my future operations. . . . [They were constantly searching for water as they explored the Main Barrier Range.]

Edward Charles Frome's watercolour of what he thought in 1843 to be Lake Torrens. It was in fact an entirely separate lake, later named after Frome himself. Frome was surveyor-general of South Australia between 1839 and 1849.

It was evident . . . from the result of this excursion, and from the high northerly point Mr. Poole had gained, that he had either struck the lower part of the basin of Lake Torrens or some similar feature. It was at the same time, however, clear that the country was not favourable for any attempt to penetrate, since there was no surface water. I felt indeed that it would be imprudent to venture with heavily loaded drays into such a country; but although I found a westerly course as yet closed upon me, I still hoped that we should find larger waters in the north-west interior, from the fact of the immense number of bitterns, cranes, and other aquatic birds, the party flushed in the neighbourhood of the lakes. Whence could these birds (more numerous at this point than we ever afterwards saw them) have come from? . . .

The heat had now become excessive, the thermometer seldom falling under 96°, and rising to 112° and 125° in the shade. . . . [It was the first week of December and on 4 December Flood was sent out to search for water without which the party could not go forward. Happily he was successful and was back in the camp on 7 December.]

On the 9th we again moved forward, on a course a little to the eastward of north, over the barren, stony, and undulating ground that lies between the main and outer ranges. . . . I . . . rode away to ascend some of the hills and to take bearings from them. . . . From the last point I ascended, as from others, there was a large mountain bearing N.E. by N. from me, distant 50 or 60 miles, which I rightly judged to be Mount Lyell [now Mount Lyall]. . . .

Fortunately, at that part of the creek where the party struck it, there was a small pool of water, at which we gladly halted for the night, having travelled about 28 miles; our journey to Flood's Creek on the following day was comparatively short. Flood had not at all exaggerated his account of this creek, which, as an encouragement, I named after him. It was certainly a most desirable spot to us at that time; with plenty of water, it had an abundance of feed along its banks. . . .

On the 11th [December], I detached Mr. Poole and Mr. Browne, with a fortnight's provisions, to the N.E. in search of water. It may appear that I had given these officers but a short respite from their late labours; but the truth is that a camp life is a monotonous one, and both enjoyed such excursions. . . . I was glad to contribute to their pleasures, and should have rejoiced if it had fallen to their lot to make any new and important discovery. . . .

The reader will observe, that although slowly, we were gradually, and, I think, steadily working our way into the interior. . . .

I was much surprised that the country was not better inhabited than it appeared to be; for however unfit for civilized man, it seemed a most desirable one for the savage, for there was no want of game of the larger kind, as emus and kangaroos, whilst in every tree and bush there was a nest of some kind or other, and a variety of vegetable productions of which these rude people are fond. Yet we saw not more than six or seven natives during our stay in the neighbourhood of Flood's Creek. . . .

On the 23rd I sent Flood and Lewis to the N.E. with instructions to return on Christmas-day. At this time the men generally complained of disordered bowels and sore eyes, but I attributed both to the weather, and to the annoyance of the flies and mosquitos. . . .

It will be obvious to the reader that the great danger I had to apprehend was that of having my retreat cut off from the failure of water in my rear; or if I advanced without first of all exploring the country, of losing the greater number of my cattle. . . . On the 28th [December], at 2 P.M., the wind suddenly flew around to the south, and it became cooler . . . and we left Flood's Creek at half-past 4. As soon as I had determined on moving, I directed Mr. Poole to lead on the party . . . and mounting my horse, rode with Mr. Browne and Mr. Stuart towards the ranges, to take bearings from a hill I had intended to visit. . . . I did not, indeed, like leaving the neighbourhood without going to this hill. The distance, however, was greater than it appeared to be . . . but once on top we stood on the highest and last point of the Barrier Range. . . . We stood, as it were, in the centre of barrenness. . . .

At this time I was exceedingly anxious both about Mr. Poole and Mr.

Browne, who were neither of them well. The former particularly complained of great pain, and I regretted to observe that he was by no means strong.

Sturt's watercolour of the Depôt Glen.

During January 1845 the party moved northwards, examining the country as they went and, as always, on the lookout for water.

I could not but think . . . from the appearance of the country as far as we had gone, that we could not be very far from the outskirts of an inland sea, it so precisely resembled a low and barren sea coast. This idea I may say haunted me. . . .

On 21 January it was 131° in the shade. Poole's discovery of a good supply of water at what came to be known as Depôt Glen prevented the party from being forced to retreat to the Darling. They moved to the new camp on 27 January.

I rode on ahead with Mr. Poole to select the ground on which to pitch our tents. At the distance of seven miles we arrived at the entrance of the little rocky glen through which the creek passes, and at once found ourselves on the brink of a fine pond of water, shaded by trees and cliffs. The scenery was so different from any we had hitherto seen, that I was quite delighted, but the ground being sandy was unfit for us, we therefore turned down the creek towards the long sheet of water Mr. Poole had mentioned, and waited there until the drays arrived, when we pitched our tents close to it, little imagining that we were destined to remain at that lonely spot for six weary months. We were not then aware that our advance and our retreat were alike cut off. . . .

It was not however until after we had run down every creek in our neighbourhood, and had traversed the country in every direction, that the truth flashed across my mind, and it became evident to me, that we were locked up in the desolate and heated region, into which we had penetrated, as effectually as if we had wintered at the Pole. . . . [They were near the present settlement of Milparinka, about 305 kilometres along the Silver City Highway from Broken Hill.]

A few days after we had settled ourselves at the Depôt, Mr. Browne had

'Milvus affinus' by John Gould — one of a number of Gould bird illustrations in Sturt's journal. As a naturalist himself, Sturt was able to provide Gould with information on Australian wildlife.

a serious attack of illness, that might have proved fatal. . . . At this time, too, the men generally complained of rheumatism, and I suspected that I was not myself altogether free from that depressing complaint, since I had violent pains in my hip joints; but I attributed them to my having constantly slept on the hard ground, and frequently in the bed of some creek or other. . . .

I have said that I was not satisfied with the result of my last excursion with Mr. Browne to the north. I could not but think that we had approached within a tangible distance of an inland sea, from the extreme depression and peculiar character of the country we traversed. I determined, therefore, to make another attempt to penetrate beyond the point already gained, and to ascertain the nature of the interior there. . . . Mr. Poole and Mr. Browne being too weak to venture on a protracted excursion of such a kind, I took Mr. Stuart, my draftsman, with me. . . . [Flood and Joseph Cowle also accompanied Sturt.]

We had not ridden four miles on the following morning, when we observed several natives on the plain at a little distance to the south. . . . We stopped with these people for more than two hours, in the hope that we should gain some information from them either as to when we might expect rain, or of the character of the distant interior, but they spoke a language totally different from the river tribes. . . .

On the morning of the 10th [February] we were up early, and had loaded the cart with 69 gallons of water before breakfast, when Joseph and I took our departure, and Mr. Stuart with Flood returned to the hills. . . . Had the country continued as it was, we might have got on tolerably, but as it advanced it changed greatly for the worse. We lost the flats, on a general coating of sand thickly matted with spinifex. . . . The only trees growing in this terrible place were a few acacias in the hollows. . . .

It was 21 February before the party regained the Depôt and Sturt had time for reflection.

The greatest distance I went northwards on this occasion was to the 28th parallel, and about 17 miles to the eastward of the 141st meridian. . . . having therefore failed in discovering any change of country, or the means of penetrating farther into it, I sat quietly down at my post, determined to abide the result, and to trust to the goodness of Providence to release me from prison when He thought best. . . .

When we first pitched our tents at the Depôt the neighbourhood of it teemed with animal life. The parrots and paroquets flew up and down the creeks collecting their scattered thousands, and making the air resound with their cries. Pigeons congregated together; bitterns, cockatoos, and other birds. . . . They all passed away simultaneously in a single day; the line of migration being directly to the N.W. . . .

The month of April set in without any indication of a change in the weather. It appeared as if the flood gates of Heaven were closed upon us for ever. . . . We planted seeds in the bed of the creek, but the sun burnt them to cinders the moment they appeared above the ground. . . .

On the 7th a very bright meteor was seen to burst in the south-east quarter of the heavens; crossing the sky with a long train of light, and in exploding seemed to form numerous stars. . . . The mean of the thermometer for the months of December, January, and February, had been 101°, 104°, and 101° respectively in the shade. Under its effects every screw in our boxes had been drawn, and the horn handles of our instruments, as well as our combs, were split into fine laminae. The lead dropped out of our pencils, our signal rockets were entirely spoiled; our hair, as well as the wool on the sheep, ceased to grow, and our nails had become as brittle as glass. The flour lost more than eight per cent of its original weight, and the other provisions in a still greater proportion. . . .

[It] was only when my mouth became sore, and my gums spongy, that I felt it necessary to trouble Mr. Browne, who at once told me that I was labouring under an attack of scurvy, and I regretted to learn from him that both he and Mr. Poole were similarly affected, but they hoped I had hitherto escaped. . . .

From this period [May 1845] I gave up all hope of success in any future

Another Gould illustration in Sturt's journal. Of the long crested pigeon Sturt observed that 'it never perched on the trees, but on the highest and most exposed rocks, in what must have been an intense heat.'

effort I might make to escape from our dreary prison. Day after day, and week after week passed over our heads, without any apparent likelihood of any change in the weather. . . .

We had gradually been deserted by every beast of the field, and every fowl of the air. . . . We had to witness the gradual and fearful diminution of the water, on the possession of which our lives depended. . . .

The months of May and June, and the first and second weeks of July passed over our heads, yet there was no indication of a change of weather. It had been bitterly cold during parts of this period. . . .

On the 15th of June I commenced my preparations for moving; not that I had any reason so to do, but because I could not bring myself to believe that the drought would continue much longer. . . . Mr. Poole's reduced state of health rendered it necessary that a dray should be prepared for his transport, and I requested Mr. Browne to superintend every possible arrangement for his comfort. A dray was accordingly lined with sheep skins, and had a flannel tilt, as the nights were exceedingly cold, and he could not be moved to a fire. I had also a swing cot made, with pullies to raise him up when he should feel disposed to change his position.

While these necessary preparations were being forwarded, I was engaged writing my public despatches. . . .

On the 11th [July] the wind shifted to the east, the whole sky becoming suddenly overcast, and on the morning of the 12th it was still at east, but at noon veered round to the north, when a gentle rain set in, so gentle that it more resembled a mist, but this continued all the evening and during the night. It ceased however at 10 A.M. of the 13th, when the wind shifted a little to the westward of north. At noon rain again commenced, and fell steadily throughout the night, but although the ground began to feel the effects of it, sufficient had not fallen to enable us to move. Yet, how thankful was I for this change, and how earnestly did I pray that the Almighty would still farther extend his mercy to us, when I laid my head on my pillow. All night it poured down without any intermission, and as morning dawned the ripple of waters in a little gully close to our tents, was a sweeter and more soothing sound than the softest melody I ever heard. On going down to the creek in the morning I found that it had risen five inches, and the ground was now so completely saturated that I no longer doubted the moment of our liberation had arrived.

I had made every necessary preparation for Mr. Poole's departure on the 13th, and as the rain ceased on the morning of the 14th the home returning party mustered to leave us. Mr. Poole felt much when I went to tell him that the dray in which he was to be conveyed, was ready for his reception. . . .

On the morning of the 16th I struck the tents, which had stood for six months less eleven days, and turned my back on the Depôt in grateful thankfulness for our release from a spot where my feelings and patience had been so severely tried. . . .

About seven o'clock P.M. we were surprised by the sudden return of Joseph, from the home returning party; but, still more so at the melancholy nature of the information he had to communicate. Mr. Poole, he said, had breathed his last at three o'clock. . . .

We buried Mr. Poole under a Grevillia that stood close to our underground room; his initials, and the year, are cut in it above the grave, "J.P.1845," and he now sleeps in the desert. . . .

At 9 A.M. accordingly of the 18th [July] we pushed on to the N.W. . . On the 19th I kept the chained line, but in consequence of the heavy state of the ground we did not get on more than 8½ miles. The character of the country was that of open sandy plains, the sand being based upon a stiff, tenacious clay, impervious to water. . . .

On Monday I conducted the whole party to the new depôt, which for the present I shall call the Park [Fort Grey in the northwest corner of New South Wales]. . . . I instructed Mr. Stuart to change the direction of the chained line to 75° to the west of south, direct upon Mount Hopeless. . . .

By the 30th I had arranged the camp in its new position, and felt myself at liberty to follow after the chainers. Before I left [Fort Grey], however, I

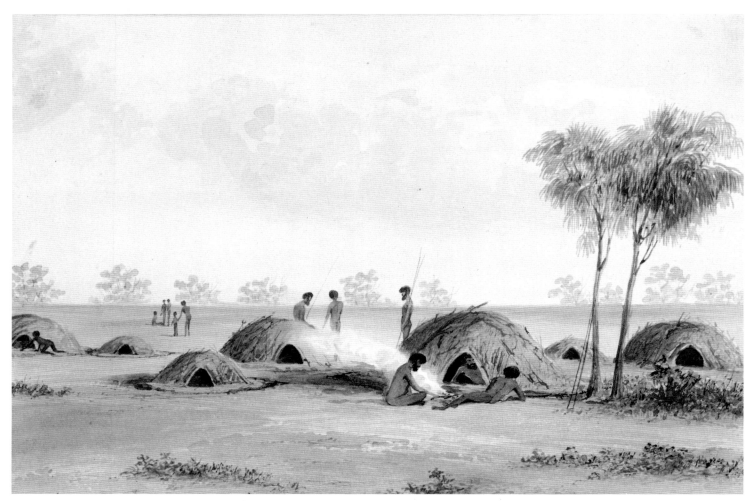

By 1840 S. T. Gill was establishing himself as an Adelaide artist. His watercolour 'A Native village in the Northern Interior' is reproduced in Sturt's journal. In describing these native 'huts' Sturt wrote: 'Like those before seen they had been left in the neatest order by their occupants . . .'

directed a stock-yard to be made, in which to herd the cattle at night, and instructed Davenport to prepare some ground for a garden, with a view to planting it out with vegetables — pumpkins and melons. . . .

My object in the journey I had thus undertaken was . . . to ascertain if the country to the north-west of Lake Torrens, on the borders of which I presumed I had arrived, was practicable or not, and whether it was connected with any more central body of water. It behoved me to ascertain these two points with as little delay as possible, for the surface water was fast drying up, and we were in danger of having our retreat cut off. . . . [Sturt was stopped by the sandy bed of what he thought was Lake Torrens, but was in fact Lake Blanche. He was back at Fort Grey by 8 August. It was just a year since the party had left Adelaide.]

I found that everything had gone on regularly in the camp during my absence . . . Davenport had also dug and planted out a fine garden. . . .

I determined therefore before I again struck the tent to examine the country to the north-west. . . .

I purposed giving the charge of the camp to Mr. Stuart. — I had established it on a small sandy rise, whereon we found five or six native huts. . . . I selected Flood, Lewis, and Joseph to accompany me, and took 15 weeks provisions. . . . My last instructions to Morgan were to prepare and paint the boat in the event of her being required. . . .

On the morning of the 14th Mr. Browne and I mounted our horses, and left the camp at 9 A.M., followed by the men I had selected, and crossing the grassy plain in a N.W. direction, soon found ourselves amidst sand hills and scrub. [By 20 August Sturt was coming upon the watercourses which drain into Cooper Creek.]

I began to hope that we were about to leave behind us the dreary region we had wandered over. . . . however, all our hopes were annihilated. A wall of sand suddenly arose before us, such as we had not before seen. . . . For 20 miles we toiled over as distressing a country as can be imagined, each succeeding sand

ridge assumed a steeper and more rugged character, and the horse with difficulty pulled the cart along. . . .

There was a line of low trees far away . . . to the N.E., and to the north, at a great distance, the sun was shining on the bright point of a sand hill. The plain was otherwise without vegetation, and its horizon was like that of the ocean. In the direction I was about to proceed, nothing was to be seen but the gloomy stone-clad plain, of an extent such as I could not possibly form any just idea. Ignorant of the existence of a similar geographical feature in any other part of the world, I was at a loss to divine its nature. . .

On the 27th [August] we continued onwards. . . . At ten miles there was a sensible fall of some few feet from the level of the Stony Desert, as I shall henceforth call it. . . . It had been impossible to ascertain the fall or dip of the Stony Desert, but somewhat to the west of our course on the earthy plain there were numerous channels, which as we advanced seemed to be making to a common centre towards the N.E. [They were near the lower reaches of the Diamantina River.]

Although I had been unable to penetrate to the north-west of Lake Torrens, that basin appeared to me to have once formed part of the back waters of Spencer's Gulf; still I long kept in view the possibility of its being connected with some more central body of water. . . . I felt doubtful of the immediate proximity of an inland sea, although many circumstances combined to strengthen the impression on my mind that such a feature existed on the very ground over which we had made our way. . . .

[4 September] We had ridden about ten miles from the place where we had slept, and Mr. Browne and I were talking together, when Flood, who was some little distance a-head, held up his hat and called out to us. We were quite sure from this circumstance that he had seen something unusual, and on riding up were astonished at finding ourselves on the banks of a beautiful creek [Eyre Creek], the bed of which was full both of water and grass. . . .

[5 September] We halted an hour after sunset, under a sandhill about 16 miles distant from the creek, without having succeeded in our search for water. . . .

The prospect from the top of the sandhill under which we had formed our bivouac, was the most cheerless and I may add the most forbidding of any that our eyes had wandered over, during this long and anxious journey. To the west and north-west there were lines of heavy sand ridges [the Simpson Desert] so steep and rugged as to deter me from any attempt to cross them with my jaded horses. . . . It had pained me for some time, to see Mr. Browne daily suffering more and more. . . . My men were also beginning to feel the effects of constant exposure, of ceaseless journeying, and of poverty of food, for all we had was 5 lbs. of flour and 2 oz. of tea per week; it is true we occasionally shot a pigeon or a duck, but the wildness of the birds of all kinds was perfectly unaccountable. The horses living chiefly on pulpy vegetation had little stamina and were incapable of enduring much privation or hardship. No rain had fallen since July, nor was there any present indication of a change. Much as I desired it, I yet dreaded having to traverse such a country as that into which I was now about to plunge, in a wet state. . . .

Pushing down one of the valleys, the descent of which was very gradual, and keeping on such clear ground as there was, the ridges rose higher and higher on either side of us as we advanced, all grass and other vegetation disappeared, and at length both valley and sand ridge became thickly coated with spinifex. . . .

On mature deliberation then, I resolved to fall back on the creek. . . .

We had penetrated to a point at which water and feed had both failed. . . . The sand was of a deep red colour, and a bright narrow line of it marked the top of each ridge, amidst the sickly pink and glaucous coloured vegetation around. . . . Indeed, if it was not so gloomy, it was more difficult than the Stony Desert itself; yet I turned from it with a feeling of bitter disappointment. I was at that moment [8 September] scarcely a degree from the Tropic, and within 150 miles of the centre of the continent. If I had gained that spot my task would have been performed, my most earnest wish would have been gratified, but for some wise purpose this was denied to me. . . .

'The Sandy ridges of Central Australia' a painting by S. T. Gill from a Sturt sketch.

We should have had a distance of 85 miles to travel without water, but fortunately the precaution we had taken of digging wells in going out, insured us a supply in one of them, so that our return over this last long and dry tract of country was comparatively light, and we gained the Park [Fort Grey] and joined Mr. Stuart at the stockade on the evening of the 2nd of October, after an absence of seven weeks, during which we had ridden more than 800 miles. . . .

It was a great satisfaction to me to learn that everything had gone on well at the camp during my absence; Mr. Stuart had a good report to make of all. . . . The sheep were in splendid condition. . . .

The stockade had been erected and really looked very well; it was built just as I directed with the flag flying at the entrance. I availed myself of the opportunity, therefore, to call it "Fort Grey," after his Excellency the then Governor of South Australia. [After only a few days rest Sturt was off once more. On the day before he left the temperature had been 41°C in the shade.]

I shook hands with Mr. Browne about half-past eight on the morning of the 9th of October, and left the depôt camp at Fort Grey, with Mr. Stuart, Morgan and Mack, taking with me a ten weeks' supply of flour and tea. I once more struck into the track I had already twice traversed, with the intention of turning to the north as soon as I should gain Strzelecki's Creek [northwest of Lake Blanche]. . . .

[On 12 October a new creek — the Cooper — was discovered.] We dismounted and turned our horses out to feed on the long grass in the bed of this beautiful creek, and whilst Morgan prepared breakfast, Mr. Stuart and Mack took their guns and knocked over three ducks, that were, I suppose, never used to be so taken in; but the remainder would not stand fire long, and flew off to the eastward. As they passed, however, I snatched up a carbine, and, without taking any aim, discharged it into the midst of them, and brought one of their number down — the only bird I had shot for many years. . . .

The morning of the 20th [October] was bitterly cold, with the wind at S.S.E., and I cannot help thinking that there are extensive waters in some parts of the interior, over which it came. . . .

Before mounting, on the morning of the 21st, Mr. Stuart and I went to see if we could make out more than we had been able to do the night before. . . . About half a mile below where we had slept, the valley led to the N.N.E. and on turning, we found it there opened at once upon the Stony Desert. . . .

At this point, which I have placed in lat. 25° 54' and in long. 139° 25' [close to present-day Birdsville], I had again to choose between the chance of success or disaster, as on the first occasion. . . . I was now nearly 50 miles from water, and feared that, as it was, some of my horses would fall before I could get back to it, yet I lingered . . . reluctant to make up my mind, for I felt that if I thus again retired, it would be a virtual abandonment of the task undertaken. . . . I trust the reader will believe that I would not have shrunk from any danger that perseverance or physical strength could have overcome; that indeed I did not shrink from the slow fate, which, as far as I could judge, would inevitably have awaited me if I had gone on; but that in the exercise of sound discretion I decided on falling back. . . . I have never regretted the step I took, and it has been no small gratification to me to find that the Noble President of the Royal Geographical Society, Lord Colchester, when addressing the members of that enlightened body, in its name presenting medals to Dr. Leichhardt and myself, for our labours in the cause of Geography, alluded to and approved "the prudence with which further advance was abandoned, when it could only have risked the loss of those entrusted to my charge". . . .

Before we finally left the neighbourhood, however, where our hopes had so often been raised and depressed, I gave the name of Cooper's Creek [now Cooper Creek] to the fine watercourse we had so anxiously traced, as a proof of my great respect for Mr. Cooper, the Judge of South Australia. . . .

[They arrived back at Fort Grey early in November.] We reached the plain just as the sun was descending, without having dismounted from our horses for more than fifteen hours, and as we rode down the embankment into it, looked around for the cattle, but none were to be seen. We looked towards the little sandy mound on which the tents had stood, but no white object there met our eye; we rode slowly up to the stockade, and found it silent and deserted. . . .

As soon as we had unsaddled the horses, we went to the tree and dug up the bottle into which, as agreed upon, Mr. Browne had put a letter; informing me that he had been most reluctantly obliged to retreat; the water at the Depôt having turned putrid, and seriously disagreed with the men. . . .

Perhaps a physician would laugh at me for ascribing the pains I felt the next morning to so trifling a cause, but I was attacked with pains at the bottom of my heels and in my back. Although lying down I felt as if I was standing balanced on stones; these pains increased during the day, insomuch that I anticipated some more violent attack, and determined on getting to the old Depôt [Depôt Glen] as soon as possible; but as the horses had not had sufficient rest, I put off my journey to 5 P.M. on the following day, when I left Fort Grey with Mr. Stuart, directing Mack and Morgan to follow at the same hour on the following day, and promising that I would send a dray with water to meet them. I rode all that night until 3 P.M. of the 17th [November], when we reached the tents, which Mr. Browne had pitched about two miles below the spot we had formerly occupied. If I except two or three occasions on which I was obliged to dismount to rest my back for a few minutes we rode without stopping, and might truly be said to have been twenty hours on horseback.

Sincere I believe was the joy of Mr. Browne, and indeed of all hands, at seeing us return, for they had taken it for granted that our retreat would have been cut off. I too was gratified to find that Mr. Browne was better, and to learn that everything had gone on well. . . .

Mr. Browne informed me that the natives had frequently visited the camp during my absence. He had given them to understand that we were going over the hills again, on which they told him that if he did not make haste all the water would be gone. It now behoved us therefore to effect our retreat upon the Darling with all expedition. Our situation was very critical, for the effects of the drought were more visible now than before the July rain, — no more indeed had since fallen, and the water in the Depôt creek was so much reduced that we had good reason to fear that none remained anywhere else. On the 18th I sent Flood

'The River Murray above Moorundi' by George French Angas. It was from Eyre's property at Moorundi that Sturt's expedition into central Australia commenced in earnest.

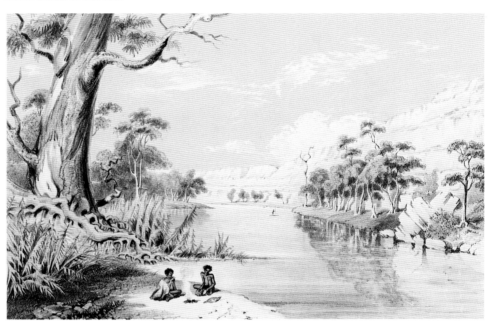

to a small creek, between us and the Pine forest, but he returned on the following day with information that it had long been dry. Thus then were my fears verified, and our retreat to the Darling apparently cut off. About this time too the very elements, against which we had so long been contending, seemed to unite their energies to render our stay in that dreadful region still more intolerable. The heat was greater than that of the previous summer; the thermometer ranging between 110° and 123° [43° and 50°C] every day; the wind blowing heavily from N.E. to E.S.E. filled the air with impalpable red dust, giving the sun the most foreboding and lurid appearance as we looked upon him. The ground was so heated that our matches falling on it, ignited. . . . [Browne then rode forward and found sufficient water in Flood's Creek to enable the party to move homewards.]

The boat was launched [and left behind] upon the creek, which I had vainly hoped would have ploughed the waters of a central sea. We abandoned our bacon and heavier stores, the drays were put in order . . . and on the 6th of December, at 5 P.M., we commenced our retreat, having a distance of 270 miles to travel to the Darling. . . . [On 15 January 1846 Sturt arrived back at Moorundi.]

Here my kind friends made me as comfortable as they could. Mr. Eyre had gone to England on leave of absence, and Mr. Nation was filling his appointment as Resident.

On the 17th I mounted my horse for the first time since I had been taken ill in November, and had scarcely left Moorundi when I met my good friends Mr. Charles Campbell and Mr. A. Hardy in a carriage to convey me to Adelaide. I reached my home at midnight on the 19th of January, and, on crossing its threshold, raised my wife from the floor on which she had fallen, and heard the carriage of my considerate friends roll rapidly away.

Brisbane to Port Essington

Friedrich Wilhelm Ludwig Leichhardt (1813–48?) was born in Prussia and after avoiding German military service, arrived in Sydney in 1842. In 1843 he travelled overland between Newcastle and Moreton Bay, and in 1844 was keen to set out again — this time for Port Essington on the northwest coast. The first paragraphs of his journal[2] tell of his impatience in awaiting the Imperial government's approval of such a venture (which was to have been led by Sir Thomas Mitchell) and of the warnings of his friends. A botanist rather than a bushman, Leichhardt, however, was not one to listen readily to advice and set out without the sanction of government.

This was a significant journey in Australian exploration, in which many rivers were discovered as the party moved north from what is now Brisbane, across 'the top', and into the Northern Territory of today. For this arduous

2. Ludwig Leichhardt, *Journal of an Overland Expedition in Australia, from Moreton Bay to Port Essington, a distance of upwards of 3000 miles, during the Years 1844–1845.* London, 1847.

achievement Leichhardt received the Patrons' Medal of the Royal Geographical Society of London.

Leichhardt's use of the title 'Doctor' appears to have been an honorary one bestowed by colonial friends.

On my return to Moreton Bay, from an exploratory journey in the country northward of that district, which had occupied me for over two years, I found that the subject of an overland expedition to Port Essington on the North Coast of Australia, was occupying much attention, as well on the part of the public as on that of the Legislative Council, which had earnestly recommended the appropriation of a sum of money to the amount of £1000, for the equipment of an expedition under Sir Thomas Mitchell, to accomplish this highly interesting object. [A settlement had been established in 1838 at Port Essington, an inlet on the Cobourg Peninsula in the Northern Territory, although it had disappeared by 1849.] Some delay was, however, caused by the necessity of communicating with the Secretary of State for the Colonies; and in the meantime it was understood that Captain Sturt was preparing to start from Adelaide to proceed across the Continent. From the experience which I had gained during my two years' journeyings . . . I was inspired with the desire of attempting it. . . .

Ludwig Leichhardt, naturalist and explorer.

I was satisfied that, by cautiously proceeding, and always reconnoitring in advance or on either side of our course, I should be able to conduct my party through a grassy and well-watered route. . . . Buoyed up by this feeling, and by confidence in myself, I prevailed against the solicitations and arguments of my friends, and commenced my preparations, which, so far as my own slender means and the contributions of kind friends allowed, were rather hurriedly completed by the 13th August, 1844. . . .

As our movements were to be comparatively in light marching order, our preparations were confined more to such provisions and stores as were actually necessary, than to anything else. But I had frequently reason to regret that I was not better furnished with instruments, particularly Barometers, or a boiling water apparatus, to ascertain the elevation of the country and ranges we had to travel over. The only instruments which I carried, were a Sextant and Artificial Horizon, a Chronometer, a hand Kater's Compass, a small Thermometer, and Arrowsmith's Map of the Continent of New Holland. . . .

On leaving Sydney, my companions consisted of Mr. James Calvert; Mr. John Roper; John Murphy, a lad of about 16 years old: of William Phillips, a prisoner of the Crown; and of "Harry Brown," an aboriginal of the Newcastle tribe: making with myself six individuals.

We left Sydney, on the night of the 13th August, for Moreton Bay, in the steamer "Sovereign," Captain Cape; and I have much pleasure in recording and thankfully acknowledging the liberality and disinterested kindness of the Hunter's River Steam Navigation Company, in allowing me a free passage for my party with our luggage and thirteen horses. The passage was unusually long, and, instead of arriving at Brisbane in three days, we were at sea a week, so that my horses suffered much for food and water, and became discouragingly poor. On arriving at Brisbane, we were received with the greatest kindness by my friends the "Squatters," a class principally composed of young men of good education, gentlemanly habits, and high principles, and whose unbounded hospitality and friendly assistance I had previously experienced during my former travels through the district. . . .

My means, however, had since my arrival been so much increased, that I was after much reluctance prevailed upon to make one change, — to increase my party; and the following persons were added to the expedition: — Mr. Pemberton Hodgson, a resident of the district,; Mr. Gilbert; Caleb, an American negro; and "Charley," an aboriginal native of the Bathurst tribe. . . . Of Mr. Gilbert I knew nothing; he was in the service of Mr. Gould, the talented Zoologist who has added so much to our knowledge of the Fauna of Australia, and expressed himself so anxious for an opportunity of making important observations as to the limits of the habitat of the Eastern Coast Birds, and also where those of the North Coast commence. . . . [John Gilbert kept a diary of this expedition. It was found in 1938 and is now in the Mitchell Library, Sydney.]

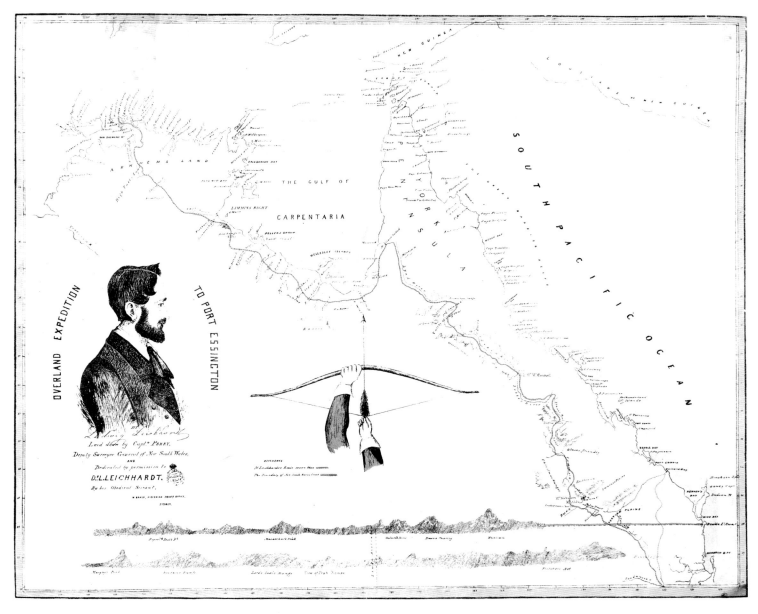

Map of Leichhardt's route to Port Essington in 1844–45.

Perhaps, of all the difficulties I afterwards encountered, none were of so much real annoyance as those we experienced at first starting from Brisbane. Much rain had fallen, which filled the creeks and set them running, and made the road so boggy and soft as to render them almost impassable. . . . Neither my companions nor myself knew much about bullocks, and it was a long time before we were reconciled to the dangerous vicinity of their horns. . . . Every one, at my desire, had provided himself with two pair of strong trowsers, three strong shirts, and two pair of shoes; and I may further remark that some of us were provided with Ponchos, made of light strong calico, saturated with oil, which proved very useful to us by keeping out the wet, and made us independent of the weather; so that we were well provided for seven months, which I was sanguine enough to think would be a sufficient time for our journey. . . .

It was at the end of September, 1844, when we completed the necessary preparations for our journey, and left the station of Messrs. Campbell and Stephens, moving slowly towards the farthest point on which the white man has established himself. We passed the stations of Messrs. Hughs and Isaacs and of Mr. Coxen, and arrived on the 30th September, at Jimba [a station on the Darling Downs], where we to bid farewell to civilization.

These stations are established on creeks which come down from the western slopes of the Coast Range . . . and meander through plains of more or less extent to join the Condamine River. . . .

Oct. 1. . . . Many a man's heart would have thrilled like our own, had he

seen us winding our way round the first rise beyond the station, with a full chorus of "God Save the Queen," which has inspired many a British soldier, — aye, and many a Prussian too — with courage in the time of danger. . . .

Oct. 17. . . . Last night, Mr. Roper brought in three ducks and a pigeon, and was joyfully welcomed by all hands. Charley had been insolent several times, when I sent him out after the cattle, and, this morning, he even threatened to shoot Mr. Gilbert. I immediately dismissed him from our service, and took from him all the things which he held on condition of stopping with us. The wind continued from the west and south-west. . . .

Oct. 18. Towards evening Charley came and begged my pardon. . . . and . . . again entered our service.

Nov. 3. For the past week, the heat was very oppressive during the day, whilst, at night, it was often exceedingly cold. . . .

It had now become painfully evident to me that I had been too sanguine in my calculations, as to our finding a sufficiency of game to furnish my party with animal food, and that the want of it was impairing our strength. We had also been compelled to use our flour to a greater extent than I wished; and I saw clearly that my party, which I had reluctantly increased on my arrival at Moreton Bay, was too large for our provisions. . . .

Whenever it was necessary to delay for any time at one place, our cattle and horses gave us great trouble: they would continually stray back in the direction we came from, and we had frequently to fetch them back five, seven, and even ten miles. . . . These matters caused us considerable delay; but they were irremediable. . . .

Nov. 5. . . . After travelling about four miles in a north-west direction, through a fine, open undulating country, we came to, and followed the course of, a considerable creek flowing to the westward, bounded by extensive flooded gum-flats and ridges, clothed with a forest of silver-leaved Ironbark. Large reedy lagoons, well supplied with fish, were in its bed. Our latitude was 26° 4' 9".

Nov. 6. . . . Fine box and appletree flats were on both sides of the creek . . . which I called the "Dawson," in acknowledgment of the kind support I received from R. Dawson, Esq. of Black Creek, Hunter's River. . . . [They were in the vicinity of present-day Taroom.]

Nov. 20. . . . We now entered a mountainous country; and the banks of the

'Camp at Dried Beef Creek' — a lithograph from Pemberton Hodgson's book Reminiscences of Australia, *of a campsite near the Dawson River. Hodgson was a member of Leichhardt's expedition at the outset but was amongst those who returned to Moreton Bay when it was found that the party was too large.*

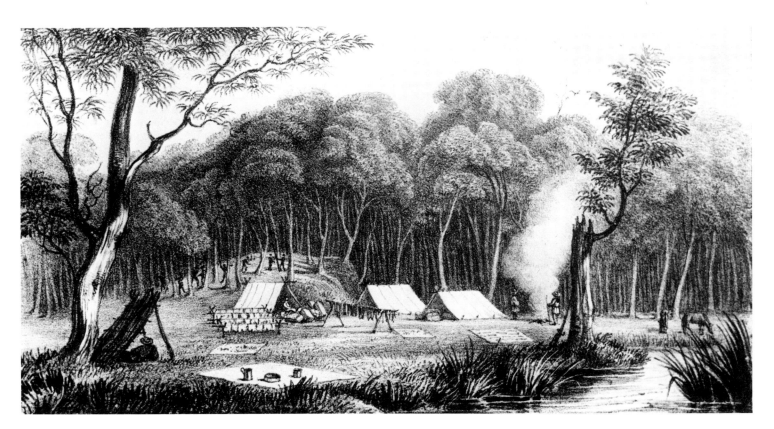

creek became sometimes very steep and broken by narrow gullies, rendering our progress slow and difficult. We had to wind our way through narrow valleys, and over ranges from which the descent was frequently very steep and dangerous. . . .

Appearances indicated that the commencement of the ranges was a favourite resort of the "Black-fellows." The remains of recent repasts of muscles were strewed about the larger water-holes, and, as I passed a native camp, which had only lately been vacated, I found, under a few sheets of bark, four fine kangaroo nets, made of the bark of Sterculia; also several bundles of sticks, which are used to stretch them. As I was in the greatest want of cordage, I took two of these nets; and left, in return, a fine brass-hilted sword, the hilt of which was well polished, four fishing-hooks, and a silk handkerchief. . . .

Dec. 18. . . . The fine lagoons — which I called "Brown's Lagoons" after their discoverer — and the good feed about them, induced me to stop for the purpose of killing the fat bullock which Mr. Isaacs had given us, and of drying it like the charqui of the South Americans. . . . We enjoyed ourselves very much on this occasion, and feasted luxuriously on fried liver at breakfast, on stuffed heart for luncheon, and on a fine steak and the kidneys for supper. . . .

Dec. 28. . . . The sandy bed of the creek was entirely dry, and we must have encamped without water after a long and fatiguing ride, had not a heavy thunder-shower supplied us; we caught the rain in our pannikins as it dropt from our extended blankets.

The thunder-storm had passed, and the sun had set, when Brown, my blackfellow, suddenly threw back the blanket under which we sat, and pointed out to me a fine comet in a small clear spot of the western sky. I afterwards learned that this comet had been observed as early as the 1st December; but our constant travelling in level forest land had prevented us from seeing it before. The creek received the appropriate name of "Comet Creek" [This is now known as the Comet River. Some two weeks later, at the junction of this stream and the newly discovered Mackenzie River, Leichhardt found fragments of good coal. Towards the end of January 1845 the party took a northwesterly course over the Peak Range.]

Feb. 12. . . . A circumstance now occurred, which, as it seemed to augur badly for the welfare of our expedition, gave me much concern and anxiety. My two blacks, the companions of my reconnoitring excursions, began to shew evident signs of discontent, and to evince a spirit of disobedience which, if not checked, might prove fatal to our safety. During my recent reconnoitre, they both left me in a most intricate country, and took the provisions with them. . . . My companions were highly alarmed at the behaviour of the sable gentlemen, believing that they had concerted a plan to decamp, and leave us to our fate. I knew, however, the cowardly disposition of the Australian native too well; and felt quite sure that they would return after they had procured honey and opossums, in search of which they had deserted me. To impress their minds, therefore, with the conviction that we were independent of their services, the party started the next day as usual, and, on reaching a beautiful valley, three emus were seen on a green sunny slope, strutting about with their stately gait: Mr. Roper immediately laid the dog on and gave chase. After a short time, the horse returned without its rider and saddle, and caused us a momentary alarm lest some accident had happened to our companion: shortly afterwards, however, we were made glad, by seeing him walking towards us, with a young emu thrown over his shoulder. . . . We were rejoiced at our success, and lost no time in preparing a repast of fried emu; and, whilst we were thus employed, the two Blackfellows, having filled their bellies and had their sulk out, made their appearance, both considerably alarmed as to the consequences of their ill-behaviour. Charley brought about a pint of honey as a peace-offering; and both were unusually obliging and attentive to my companions. At this time, I was suffering much pain from a severe kick from one of the bullocks, and felt unequal to inflict any punishment, and therefore allowed the matter to pass with an admonition only. But the events subsequently proved that I was wrong, and that a decided and severe punishment would have saved me great trouble. I was, however, glad to find that their conduct met with the general indignation of my com-

panions. . . .

March 5. . . . We have travelled about seventy miles along the Isaacs. [The Isaac River had been discovered on 13 February.] If we consider the extent of its Bastard-box and narrow-leaved Ironbark flats, and the silver-leaved Ironbark ridges on its left bank, and the fine open country between the two ranges through which it breaks, we shall not probably find a country better adapted for pastoral pursuits. There was a great want of surface water at the season we passed through it; and which we afterwards found was a remarkably dry one all over the colony: the wells of the natives, however, and the luxuriant growth of reeds in many parts of the river, shewed that even shallow wells would give a large supply to the squatter in cases of necessity; and those chains of large water-holes which we frequently met along and within the scrubs, when once filled, will retain their water for a long time. The extent of the neighbouring scrubs will, however, always form a serious drawback to the squatter, as it will be the lurking place and a refuge of the hostile natives, and a hiding place for the cattle, which would always retire to it in the heat of the day, or in the morning and evening, at which time the flies are most troublesome.

March 7. I moved my camp through the mountain gorge, the passage of which was rather difficult, in consequence of large boulders of sandstone, and of thickets of narrow-leaved tea-trees growing in the bed of the river. To the northward, it opens into fine gentle Ironbark slopes and ridges, which form the heads of the Isaacs. They seem to be the favourite haunts of emus; for three broods of them were seen, of ten, thirteen, and even sixteen birds. About four miles from the gorge, we came to the heads of another creek, which I called "Suttor Creek" after — Suttor, Esq., who had made me a present of four bullocks when I started on this expedition. . . .

March 28. We travelled down the river [Suttor] to latitude 20° 41′ 35″. The country was improving, beautifully grassed, openly timbered, flat, or ridgy, or hilly; the ridges were covered with pebbles, the hills rocky. The rocks were baked sandstone, decomposed granite, and a dark, very hard conglomerate: the latter cropped out in the bed of the river where we encamped. Pebbles of felspathic porphyry were found in the river's bed. . . . The grasses were very various, particularly in the hollows: and the fine bearded grass of the Isaacs grew from nine to twelve feet in height. Charley brought me a branch of a Cassia with a thyrse of showy yellow blossoms, which he said he had plucked from a shrub about fifteen feet high. . . .

April 2. The Suttor was reported by Charley to be joined by so many gullies and small creeks, running into it from the high lands, which would render travelling along its banks extremely difficult, that I passed to the east side of Mount McConnel, and reached by that route the junction of the Suttor with the newly

discovered river, which I called the Burdekin, in acknowledgment of the liberal assistance which I received from Mrs. Burdekin of Sidney, in the outfit of my expedition. . . . [The Burdekin had been seen on 28 March.]

April 3. We travelled up the Burdekin, in a north-north-west direction, to latitude 20° 31′ 20″. . . .

May 1. . . . I shall here particularise the routine of one of our days, which will serve as an example of all the rest. I usually rise when I hear the merry laugh of the laughing-jackass (Dacelo gigantea), which, from its regularity, has not been unaptly named the settlers' clock; a loud cooee then roused my companions, — Brown to make tea, Mr. Calvert to season the stew with salt and marjoram, and myself and the others to wash, and to prepare our breakfast, which, for the party, consists of two pounds and a-half of meat, stewed over night; and to each a quart pot of tea. Mr. Calvert then gives to each his portion, and by the time this important duty is performed, Charley generally arrives with the horses, which are then prepared for their day's duty. . . . The Burdekin, which has befriended us so much by its direct course and constant stream, already for more than two degrees of latitude and two of longitude, has not always furnished us with the most convenient camps for procuring water. The banks generally formed steep slopes descending into a line of hollows parallel to the river, and thickly covered with a high stiff grass; and then another steep bank covered with a thicket of drooping tea-trees, rose at the water's edge; and, if the descent into the bed of the river was more easy, the stream frequently was at the opposite side, and we had to walk several hundred yards over a broad sheet of loose sand, which filled our mocassins, when going to wash. . . .

Many unpleasant remarks had been made by my companions at my choice of camping places; but, although I suffered as much inconvenience as they did, I bore it cheerfully, feeling thankful to Providence for the pure stream of water with which we were supplied every night. I had naturally a great antipathy against comfort-hunting and gourmandizing, particularly on an expedition like ours; on which we started with the full expectation of suffering much privation, but which an Almighty Protector had not only allowed us to escape hitherto, but had even supplied us frequently with an abundance — in proof of which we all got stronger and improved in health, although the continued riding had rather weakened our legs. This antipathy I expressed, often perhaps too harshly, which caused discontent; but, on these occasions, my patience was sorely tried. I may, however, complete the picture of the day: as soon as the camp is pitched, and the horses and bullocks unloaded, we have all our alloted duties. . . . during the afternoon, every one follows his own pursuits, such as washing and mending clothes, repairing saddles, pack-saddles, and packs; my occupation is to write my log, and lay down my route, or make an excursion in the vicinity of the camp to botanize, &c. or ride out reconnoitring. My companions also write down their remarks, and wander about gathering seeds, or looking for curious pebbles. Mr. Gilbert takes his gun to shoot birds. A loud cooee again unites us towards sunset round our table cloth. . . .

Many circumstances have conspired to make me strangely taciturn, and I am now scarcely pleased even with the chatting humour of my youngest companion, whose spirits, instead of flagging, have become more buoyant and lively than ever. . . . Mr. Roper is of a more silent disposition; Mr. Calvert likes to speak, and has a good stock of "small talk," with which he often enlivens our dinners. . . . Mr. Gilbert has travelled much, and consequently has a rich store of *impressions de voyage*. . . . He is well informed in Australian Ornithology. As night approaches, we retire to our beds. The two Blackfellows and myself spread out each our own under the canopy of heaven, whilst Messrs. Roper, Calvert, Gilbert, Murphy, and Phillips, have their tents. Mr. Calvert entertains Roper with his conversation; John amuses Gilbert; Brown tunes up his corroborri songs, in which Charley, until their late quarrel, generally joined. Brown sings well, and his melodious plaintive voice lulls me to sleep, when otherwise I am not disposed. Mr. Phillips [the convict] is rather singular in his habits; he erects his tent generally at a distance from the rest, under a shady tree, or in a green bower of shrubs, where he makes himself as comfortable as the place will allow . . . even planting lilies in blossom (Crinum) before his tent, to enjoy their sight during

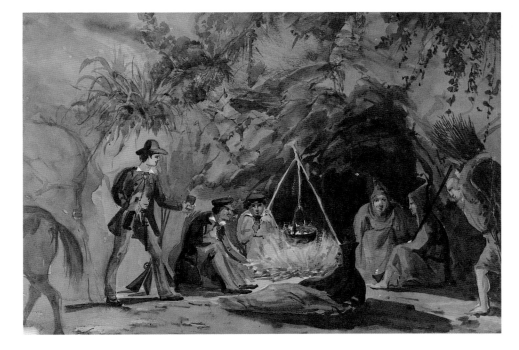

the short time of our stay. . . . The neighing of the tethered horse, the distant tinkling of the bell, or the occasional cry of night birds, alone interrupt the silence of our camp. . . .

May 24. It was the Queen's birth-day, and we celebrated it with what — as our only remaining luxury — we were accustomed to call a fat cake, made of four pounds of flour and some suet, which we had saved for the express purpose, and with a pot of sugared tea. We had for several months been without sugar, with the exception of about ten pounds, which was reserved for cases of illness and for festivals. . . .

May 25. We travelled about eight miles down the Lynd [discovered several days previously]. The country was very mountainous; granitic and pegmatite ranges bounded the valley on both sides. . . .

June 16. We left the Lynd, along which we had journeyed from lat. 17° 58' to lat. 16° 30', and travelled about twelve miles W.N.W., when we encamped at the west side of a very long lagoon. Though I did not see the junction of the two rivers myself, Mr. Roper, Brown, and Charley, informed me, that the Lynd became very narrow, and its banks well confined, before joining the new river; which I took the liberty of naming after Sir Thomas Mitchell, the talented Surveyor-General of New South Wales. . . .

As all our meat was consumed, I was compelled to stop, in order to kill one of our little steers. It proved to be very fat, and allowed us once more to indulge in our favourite dish of fried liver. Although we were most willing to celebrate the anniversary of the battle of Waterloo, and to revive our own ambitious feelings at the memory of the deeds of our illustrious heroes, we had nothing left but the saturated rags of our sugar bags . . . our last flour was consumed three weeks ago; and the enjoyment of fat cake, therefore, was not to be thought of. . . .

June 21. . . .The mornings and evenings were very beautiful, and are sur-passed by no climate that I have ever lived in. . . .The state of our health shewed how congenial the climate was to the human constitution; for, without the com-forts which the civilized man thinks essentially necessary to life; without flour, without salt and miserably clothed, we were yet all in health; although at times suffering much from weakness and fatigue. . . .

June 25. We travelled about ten miles N.N.W. to latitude 15° 51' 26". . . . I determined . . . to leave the Mitchell . . . and to approach the sea-coast — so near at least, as not to risk an easy progress — and to pass round the bottom of the gulf [of Carpentaria]. . . .

June 27. . . . A circumstance occurred to-day which gave me much concern, as it shewed that the natives of this part were not so amicably disposed towards

The diary of John Gilbert, the ornithologist who accompanied Leichhardt on his expedition in 1844.

us as those we had hitherto met: — whilst Charley and Brown were in search of game in the vicinity of our camp, they observed a native sneaking up to our bullocks, evidently with the intention of driving them towards a party of his black companions, who with poised spears were waiting to receive them. . . . Charley, however, fired his gun, which had the intended effect of frightening them. . . .

June 28. . . . We saw smoke rising in every direction, which shewed how thickly the country was inhabited. . . .

At the end of our stage, we came to a chain of shallow lagoons, which were slightly connected by a hollow. Many of them were dry; and fearing that, if we proceeded much farther, we should not find water, I encamped on one of them, containing a shallow pool. . . . Brown had shot six Leptotarsis Eytoni, (whistling ducks) and four teals, which gave us a good dinner; during which, the principal topic of conversation was our probable distance from the sea coast, as it was here that we first found broken sea shells, of the genus Cytherea. . . . Mr. Gilbert was congratulating himself upon having succeeded in learning to plat; and, when he had nearly completed a yard, he retired with John to their tent. This was about 7 o'clock; and I stretched myself upon the ground as usual, at a little distance from the fire, and fell into a dose, from which I was suddenly roused by a loud noise, and a call for help from Calvert and Roper. Natives had suddenly attacked us. . . . Charley and Brown called for caps, which I hastened to find, and, as soon as they were provided, they discharged their guns into the crowd of natives, who instantly fled, leaving Roper and Calvert pierced with several spears, and severely beaten by their waddies. Several of these spears were barbed, and could not be extracted without difficulty. I had to force one through the arm of Roper, to break off the barb; and to cut another out of the groin of Mr. Calvert. . . . Not seeing Mr. Gilbert, I asked for him, when Charley told me that our unfortunate companion was no more! . . . He was lying on the ground at a little distance from our fire, and, upon examining him, I soon found, to my sorrow, that every sign of life had disappeared. . . .

As soon as we recovered from the panic into which we were thrown by this fatal event, every precaution was taken to prevent another surprise; we watched through the night and extinguished our fires to conceal our individual position from the natives.

A strong wind blew from the southward, which made the night air distressingly cold; it seemed as if the wind blew through our bodies. . . .

July 1. We left the camp where Mr. Gilbert was killed, and travelled in all about fourteen miles south-west, to lat. 16° 6′. . . .

July 5. . . . Having crossed the plains, we came to broad sheets of sand, overgrown with low shrubby tea-trees, and a species of Hakea, which always grows in the vicinity of salt-water. . . .

The first sight of the salt water of the gulf was hailed by all with feelings of indescribable pleasure, and by none more than by myself; although tinctured with regret at not having succeeded in bringing my whole party to the end of what I was sanguine enough to think the most difficult part of my journey. We had now discovered a line of communication by land, between the eastern coast of Australia, and the gulf of Carpentaria: we had travelled along never failing, and, for the greater part, running waters: and over an excellent country, available, almost in its whole extent, for pastoral purposes. The length of time we had been in the wilderness, had evidently made the greater portion of my companions distrustful of my abilities to lead them through the journey; and, in their melancholy conversations, the desponding expression, "We shall never come to Port Essington," was too often overheard by me to be pleasant. My readers will, therefore, readily understand why Brown's joyous exclamation of "Salt Water!" was received by a loud hurrah from the whole party. . . .

July 12. . . . We crossed a small river . . . I called it the "Gilbert," after my unfortunate companion. . . .

Nearly a month later Leichhardt thought he had crossed the Albert River discovered by Stokes, but it was in fact a new stream, later named the Leichhardt by A. C. Gregory. The Albert was further on.

August 20. We crossed Beames's brook without difficulty, and travelled about two miles north-west, over a plain, when we came to a river with a broad sandy bed and steep banks, overgrown with large drooping tea-trees. . . .

I called this river the "Nicholson," after Dr. William Alleyne Nicholson, of Bristol, whose generous friendship had not only enabled me to devote my time to the study of the natural sciences, but to come out to Australia. The longitude of the Nicholson was 138° 55' (approx.). . . .

August 31. It rained the whole day. . . . We erected our tents for the first time since Mr. Gilbert's death; using tarpaulings and blankets for the purpose. Our shots amused themselves by shooting Blue Mountainers for the pot; and a strange mess was made of cockatoo, Blue Mountainers, an eagle hawk, and dried emu. I served out our last gelatine for Sunday luncheon. . . .

Sept. 8. We travelled about ten miles north-west by west, to latitude 16° 51'. . . . We encamped at a small river. . . . I named this river the "Calvert," in acknowledgment of the good services of Mr. Calvert during our expedition, and which I feel much pleasure in recording. . . . [They were in what is now the Northern Territory. Leichhardt's latitude readings were not precise.]

Sept. 16. . . . We were just turning to the westward, expecting to find a large salt-water river before us, when we heard Charley's gun, the signal of his having found water. . . . [It was a native well, close to the saltwater river.] When Charley first discovered the well, he saw a crocodile leaning its long head over the clay wall, enjoying a drink of fresh water.

The river or creek at which we encamped, and which I called "Cycas Creek," at two miles lower down, entered a still larger river coming from the westward, which I called the "Robinson," in acknowledgment of the liberal support which I received from J. P. Robinson, Esq., in the outfit of my expedition. Charley saw a shoal of porpoises in it when he went down the river to fetch the horses. . . .

Oct. 19. . . . When we came to the end of the lagoon, which was bounded on the left by a stony rise of flaggy Psammite, I observed a green belt of trees scarcely 300 yards to the northward; and on riding towards it, I found myself on the banks of a large fresh water river. . . . It was the river Mr. Roper had seen two days before, and I named it after him, as I had promised to do. . . . Charley, Brown, and John, who had been left at the lagoon to shoot waterfowl, returned with twenty ducks for luncheon, and went out again during the afternoon to procure more for dinner and breakfast. They succeeded in shooting thirty-one ducks and two geese; so that we had fifty-one ducks and two geese for the three meals. . . .

Oct. 21. After waiting a very long time for our horses, Charley came and brought the dismal tidings that three of the most vigorous of them were drowned, at the junction of the creek with the river. . . .

This disastrous event staggered me, and for a moment I turned almost giddy; but there was no help. Unable to increase the load of my bullocks, I was obliged to leave that part of my botanical collection which had been carried by one of the horses. The fruit of many a day's work was consigned to the fire; and tears were in my eyes when I saw one of the most interesting results of my expedition vanish into smoke. Mr. Gilbert's small collection of plants, which I had carefully retained hitherto, shared the same fate. . . .

Oct. 23. . . . [The Wilton River was discovered and named after another one of Leichhardt's benefactors.] About three miles above the junction of the Wilton with the Roper, we again encamped on the steep banks of the latter, at a spot which I thought would allow our horses and cattle to approach in safety. One unfortunate animal, however, slipped into the water, and every effort to get him out was made in vain.

Nov. 4. . . . Our bullocks had become so foot-sore, and were so oppressed by the excessive heat, that it was with the greatest difficulty we could prevent them from rushing into the water with their loads. One of them — that which carried the remainder of my botanical collection — watched his opportunity, and plunged into a deep pond, where he was quietly swimming about and enjoying himself, whilst I was almost crying with vexation at seeing all my plants thoroughly soaked. . . .

'Lagoon near the S. Alligator' — a lithograph from Leichhardt's journal, which is not heavily illustrated.

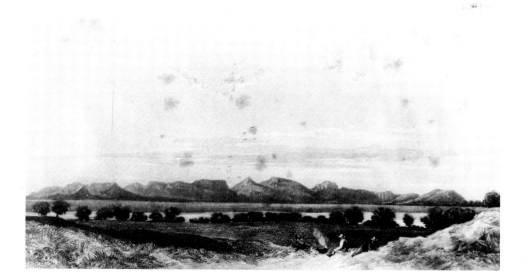

Nov. 13. The two horses ridden by Charley and myself yesterday, had suffered so severely, that I had to allow them a day of rest to recover. In the mean time, I went with Charley and Brown to the spot where we had seen the greatest number of flying-foxes, and, whilst I was examining the neighbouring trees, my companions shot sixty-seven, of which fifty-five were brought to our camp; which served for dinner, breakfast, and luncheon, each individual receiving eight. . . . [They were now crossing Arnhem Land.]

Nov. 24. We travelled about nine miles to the north-west, to lat. 13° 5′ 49″, which a clear night enabled me to observe by a meridian altitude of Castor. We were, according to my latitude, and to my course, at the South Alligator River, about sixty miles from its mouth, and about one hundred and forty miles from Port Essington. . . .

Nov. 27. . . . We encamped . . . and the natives flocked round us from every direction. . . . They continually used the words "Perikot, Nōkot, Mankiterre, Lumbo Lumbo, Nana Nana Nana," all of which we did not understand till after our arrival at Port Essington, where we learned that they meant "Very good, no good, Malays very far". . . .

Dec. 2. Whilst we were waiting for our bullock, which had returned to the running brook, a fine native stepped out of the forest with the ease and grace of an Apollo, with a smiling countenance, and with the confidence of a man to whom the white face was perfectly familiar. He was unarmed, but a great number of his companions were keeping back to watch the reception he should meet with. We received him, of course, most cordially; and upon being joined by another good-looking little man, we heard him utter distinctly the words, "*Commandant!*" "*come here!!*" "*very good!!!*" "*what's your name?!!!!*". . .

Dec. 17. We started, with a willing guide, for the goal of our journey, and travelled to the south-west over a hilly country, covered with groves of the Livistona palm, which, as we proceeded became mixed with Seaforthia (the real cabbage-palm). . . . We crossed several creeks running into the harbour, until we arrived at the Matunna, a dry creek, at which the foot-path from Pitchenelumbo (Van Diemen's Gulf) touched the harbour. . . . We followed it now, crossed the Warvi, the Wainunmema, and the Vollir — all which enlarged into shallow lagoons or swamps, before they were lost between the mangrove thickets. At the banks of the Vollir, some constant springs exist, which induced Sir Gordon Bremer to choose that place for a settlement. . . . On the Vollir, we came on a cart road which wound round the foot of a high hill; and, having passed the garden, with its fine Cocoa-nut palms, the white houses, and a row of snug thatched cottages burst suddenly upon us; the house of the Commandant being to the right and separate from the rest. We were most kindly received by Captain Macarthur, the Commandant of Port Essington, and by the other officers, who, with the greatest kindness and attention, supplied us with every thing we wanted. . . .

After a month's stay at Port Essington, the schooner Heroine, Captain Mackenzie, arrived from Bally, on her voyage to Sydney, *via* Torres Strait and the Inner Barrier, a route only once before attempted with success. We embarked on this vessel, and arrived safely in Sydney, on the 29th of March. . . . [1846]

A watercolour of Port Essington painted about the time of Leichhardt's arrival at the settlement.

In Sydney, Leichhardt and his party were greeted with considerable acclaim, practically expressed by a government grant and private subscriptions, part of which Leichhardt used to equip his next expedition which set out at the end of 1846. He hoped to cross Australia from the Darling Downs to the west coast and ultimately to the Swan River settlement. The party of eight included Hovenden Hely who would later search for him; also Daniel Bunce[3] and John Mann[4] who have both provided accounts of this journey.

Mann's account was highly critical of Leichhardt. It is hard to judge the truth of many of his assertions made long after the events occurred, but clearly, heavy rain and illness largely contributed to the party's return to Sydney by August 1847.

Undeterred Leichhardt was off again the following February, determined to accomplish the thwarted east-west crossing. His last letters came from Macpherson's station near the present-day town of Roma on the Darling Downs. On 4 April 1848 he wrote to the *Sydney Morning Herald*:[5]

I cannot speak in too high terms of my present party, who seem to me well qualified for the long and tedious journey which is before us. We have killed our first bullock at this station to obtain the necessary provisions to carry us to the Victoria [Barcoo River]. We have been extremely favoured by the weather; our mules and bullocks are very quiet, and we have travelled from Canning Downs to Fitz Roy Downs without any accident and without interruption, (with exception of four days stopping at Mr Russel's)[6] from the 3rd of March to the 3rd of April.

Leichhardt and his party were never heard of again, despite numerous attempts to solve the mystery of their disappearance from Hovenden Hely in 1852 onwards. Others such as A. C. Gregory and John Forrest were also amongst those explorers who added to the knowledge of Australian geography as they searched for Leichhardt, but failed in the attempt to find out what had happened or how far the party went. Were they killed by Aboriginals in Queensland or did they perish in the Simpson Desert? The mystery has since inspired a great Australian novel[7] but these questions remain unanswered. Leichhardt, however, deserves to be remembered more for the success of his expedition to Port Essington than for his failure to survive his last journey.

3. Daniel Bunce, *Australasiatic Reminiscences of Twenty-three Years' Wanderings in Tasmania and the Australias; including Travels with Dr. Leichhardt in North or Tropical Australia.* Melbourne, 1857.

4. John F. Mann. *Eight Months with Dr. Leichhardt in the Years 1846–47.* Sydney, 1888.

5. M. Aurousseau (ed.), *The Letters of F. W. Ludwig Leichhardt.* Vol. III, Cambridge, 1968.

6. The account of Leichhardt's visit is in Henry Stuart Russell, *The Genesis of Queensland.* Sydney, 1888.

7. Patrick White, *Voss.* London, 1957.

Mitchell's Northern Journey

Shortly after his journey to western Victoria in 1836, Sir Thomas Mitchell sailed for England where, two years later, he published the account of his first three expeditions and, in 1839, received a knighthood. Sir Thomas, though returning reluctantly to Sydney in 1841, was still anxious to discover more of the interior of Australia and in particular a great northern river.

In December 1845 he set out from Sydney to find an overland route to the Gulf of Carpentaria, not realising that Leichhardt, of whom nothing had been heard for some months, was at the same time just reaching Port Essington. News of Leichhardt's achievement came to Mitchell while he was still within reach of communication from settled areas. This no doubt influenced his later decision to turn back after going only as far north as the junction of the Belyando and Suttor Rivers in the vicinity of the present-day town of Mount Coolon, inland from Mackay.

Perhaps the fact that Leichhardt's success destroyed the primary object of his expedition made Mitchell all the more determined to achieve the glory of discovering a major waterway flowing westward. When he came upon the upper reaches of Cooper Creek in September 1846, he fancied his dream had come true and named the river Victoria. The following year E. B. Kennedy explored the course of the 'Victoria', and renamed it the Barcoo. There was no great northwest waterway any more than there was an inland sea.

Mitchell's carefully planned fourteen-month trek had not succeeded in its main objectives, but some valuable pastoral country was discovered. The first pages of the journal,[8] in which Mitchell tells of his fourth and last expedition, recount the events which led up to its commencement.

A trade in horses required to remount the Indian cavalry had commenced, and the disadvantageous navigation of Torres Straits had been injurious to it: that drawback was to be avoided by any overland route from Sydney to the head of the Gulf of Carpentaria.

But other considerations . . . made it very desirable that a way should be opened to the shores of the Indian Ocean. That sea was already connected with England by steam navigation, and to render it accessible to Sydney by land, was an object in itself worthy of an exploratory expedition. In short, the commencement of such a journey seemed the first step in the direct road home to England, for it was not to be doubted that on the discovery of a good overland route between Sydney and the head of the Gulf of Carpentaria, a line of steam communication would thereupon be introduced from that point to meet the English line at Singapore. . . . The map of Australia . . . suggested reasonable grounds for believing that a considerable river would be found to lead to the Gulf of Carpentaria. . . .

My department having been reduced to a state of inactivity in 1843 [due to restrictions resulting from an economic depression in the colony], I submitted a plan of exploration to Sir George Gipps, the Governor, when His Excellency promised, that if the Legislative Council made such reductions as they seemed disposed to make in the public expenditure, he should be able to spare money for such an expedition. The Legislative Council not only made reductions in the estimates to save much more money than His Excellency had named, but even voted 1000 [pounds] towards the expense of the journey, and petitioned the Governor to sanction it. His Excellency, however, then thought it necessary to refer the subject to the Secretary for the Colonies. Much time was thus lost, and, what was still worse, the naturalist to whom I had explained my plan, and invited to join my party, Dr. Leichardt. This gentleman, tempted by the general interest taken by the colonists at the time in a journey of discovery, which afforded a cheering prospect amid the general gloom and despondency, raised and equipped a small party by public subscription, and proceeded by water to Moreton Bay. Dr. Leichardt, and the six persons who finally accompanied him thence to the northward, had not been heard of, and were supposed to have either perished or been destroyed by natives. . . .

The reply of Lord Stanley was, as might have been anticipated, favourable to the undertaking; but the Governor of the colony still declined to allow the

8. Sir T. L. Mitchell, *Journal of an Expedition into the Interior of Tropical Australia, in Search of a Route from Sydney to the Gulf of Carpentaria*. London, 1848.

journey to be undertaken, without assigning any reason for keeping it back. This was the more regretted by me, when it became known in New South Wales that Captain Sturt was employed, with the express sanction of Lord Stanley, to lead an exploring expedition from Adelaide into the northern interior of Australia, and that he was actually then in New South Wales. . . . The Legislative Council, however, renewed the petition for this undertaking, to which the Governor at length assented, in 1845. . . .

I joined the party encamped at Buree [now Orange] on the 13th of December, having rode there from Sydney in four and a half days, and on the following Monday, 15th of December, 1845, I put it in motion towards the interior. The Exploring party now consisted of the following persons: —

This sketch from the the title page of Mitchell's Journal of an Expedition into the Interior of Tropical Australia *illustrates the explorer's favourite method of scanning the countryside for rivers.*

Sir T. L. Mitchell, Kt., Surveyor General,	Chief of the Expedition
Edmund B. Kennedy, Esq. Assistant Surveyor,	Second in command.
W. Stephenson, M.R.C.S.L.	Surgeon and Collector of objects of Natural History
Peter M'Avoy, Charles Niblett, William Graham,	Mounted Videttes.
Anthony Brown,	Tent-keeper
William Baldock,	In charge of the horses
John Waugh Drysdale,	Store-keeper.
Allan Bond, Edward Taylor, William Bond, William Mortimer George Allcot, John Slater, Richard Horton, Felix Maguire,	Bullock drivers.
James Stephens, Job Stanley,	Carpenters.
Edward Wilson,	Blacksmith.
George Fowkes,	Shoemaker.
John Douglas,	Barometer carrier.
Isaac Reid,	Sailor and Chainman.
Andrew Higgs,	Chainman.
William Hunter, Thomas Smith,	With the horses
Patrick Travers,	Carter and Pioneer
Douglas Arnott,	Shepherd and Butcher
Arthur Bristol,	Sailmaker and Sailor.

8 drays, drawn by 80 bullocks; 2 boats, 13 horses, 4 private do.; and 3 light carts, comprised the means of conveyance; and the party was provided with provisions for a year: — 250 sheep (to travel with the party), constituting the chief part of the animal food. The rest consisted of gelatine, and a small quantity of pork.

With the exception of a few whose names are printed in italics, the party consisted of prisoners of the Crown in different stages of probation, with whom the prospect of additional liberty was an incentive so powerful, that no money payment was asked by them or expected, while, from experience, I knew that for such an enterprise as this I could rely on their zealous services. [Two days after Mitchell left Buree, Leichhardt arrived at Port Essington. Mitchell moved off towards the Bogan River. At Nyngan he cut across to the Macquarie and by the end of February was on the Darling.]

28th February [1846]. . . . We set out early, and after travelling about six miles I came upon a cart-track, which I followed to the westward until overtaken by a stockman. . . . I understood from my guide to this point, that there was a good ford across the river at his station; also that Commissioner Mitchell

[Mitchell's son] had been down the river a short time back, making a map to show all the cattle stations on both banks. . . .

1st March. When, fifteen years before [on his first expedition in 1831], I visited this river at a higher point where it was called the Karaula [Darling River], no trace of hoofs of horses or bullocks had been previously imprinted on the clayey banks. Now, we found it to be the last resource of numerous herds in a dry and very hot season, and so thickly studded were the banks of this river with cattle stations, that we felt comparatively at home.

The party moved towards the Balonne River and into unexplored territory, which is now part of Queensland. On 18 April Mitchell received a despatch 'communicating the news of Dr. Leichardt's return from Port Essington, and enclosing the Gazette with his own account of his journey. Thus it became known to us that we could no longer hope to be the first to reach the shores of the Indian Ocean by land'. A light advance party continued up the Balonne, through fine grazing country.

8th May. . . . The sun rose in splendour; pigeons cooed, and birds were as merry as usual in the woods. . . . I ascended an elevated north-eastern extremity of Mount Abundance, and from it beheld the finest country I had ever seen in a primaeval state. A champaign region, spotted with wood, stretching as far as human vision, or even the telescope, could reach. . . . I determined to name the

Original map showing the routes followed by T. L. Mitchell in his exploration in Queensland of the country between Drysdale's Pond on the west and the River Balonne on the east.

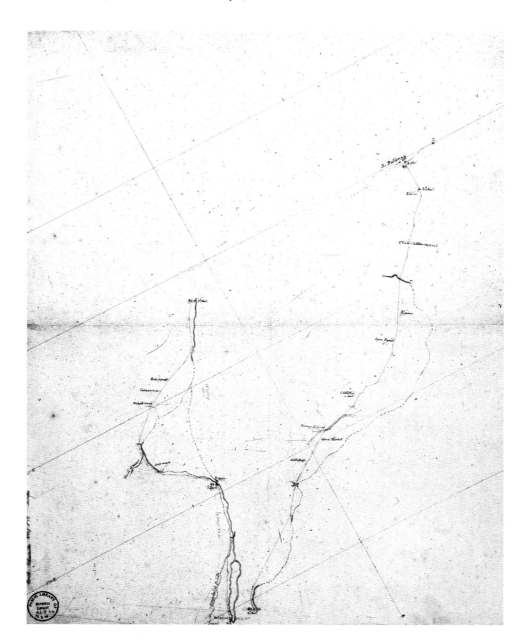

whole country Fitzroy Downs. . . . Trees of a very droll form chiefly drew my attention here. . . .

On 17 May Mitchell, who, as usual, was in advance of his main party, discovered the Maranoa River, on which a new depot was established. By 1 June Kennedy and the others had caught up.

2d June. . . . Mr. Kennedy had brought me a dispatch from Commissioner Mitchell, accompanied by some newspapers, in which I read such passages as the following: — "Australia Felix and the discoveries of Sir Thomas Mitchell now dwindle into comparative insignificance." "We understand the intrepid Dr. Leichardt is about to start another expedition to the Gulf, keeping to the westward of the coast ranges," &c., &c. Not very encouraging to us, certainly; but we work for the future. . . . [Mitchell decided to make a base camp on the Maranoa and to leave his trusted second-in-command, Edmund Kennedy, in charge of it.]

4th June. Every preparation having been made, I bade Mr. Kennedy adieu, for at least four months, and crossed the Maranóa with my party and light carts. It was not without very much regret that I thus left this zealous assistant, and so large a portion of my men, behind, in departing on a hazardous enterprise, as this was likely to be, where the population might be numerous. . . . [With a small party Mitchell pushed on to the north through what is now central southern Queensland, still searching for his great northern river.]

18th June. . . . I was now at a loss for names to the principal summits of the country. No more could be gathered from the natives, and I resolved to name the features, for which names were now requisite, after such individuals of our own race as had been most distinguished or zealous in the advancement of science. . . . I called this hill Mount Owen; a bald-forest hill to the N.E. of it, Mount Clift; a lofty truncated cone, to the eastward of these . . . Mount Ogilby; a broad-topped hill far in the north-west, where I wished to continue my route, Mount Faraday . . . the loftiest part of the coast ranges, visible on all sides, Buckland's Table Land, &c., &c. . . .

28th June. . . . Most of the summits I had previously intersected, and many others, very remarkable, just appeared over an intermediate woody range, through which I was at a loss to discover where our supposed northern river would pass. . . . The cone we had ascended consisted of trap rock . . . I named this cone Mount P. P. King; and, I have since ascertained, by that officer's register and calculations, the height of this summit above the sea, to be 2646 feet. . . .

5th July. Another frosty night succeeded the day of rain, and froze our tents into boards, not easily to be packed up this morning. We proceeded along our horses' track, and the beautiful headland which appeared quite isolated, and just such as painters place in middle distance, I named Mount Salvator. . . . [Oxley had also likened the Australian landscape to the paintings of Salvator.]

14th July. Crossing the river, (which I called the Claude), we travelled, first, through an open forest; and then across one of the richest plains I had ever seen [the Mantuan Downs]. . . . All this rich land was thickly strewed with small fragments of fossil wood, in silex, agate, and chalcedony. . . . I obtained even a portion of petrified bark. . . .

25th July. There was no hill or other geographical feature near our route, whereby it might have been possible to mark there the limit of Tropical Australia. We were the first to enter the interior beyond that line. Three large kangaroos hopping across a small plain, were visible, just as we entered these regions of the sun. . . .

26th July. The river appearing to pursue a W.N.W. course, I set out in that direction, attracted there, also, by some open plain separated by scrub from the river. . . .

27th July. . . . I perceived a blue pic nearly due north, which I named Mount Narrien; and Yurranigh saw from a tree that there was a range in the same direction. . . .

31st July. . . . I pursued a N.W. course. . . . I thus came upon the bed of

'River Maranoa'.

'The Pyramids' — a lithograph in Mitchell's journal from one of his own sketches.

'The Pyramids' — a lithograph in Mitchell's journal from one of his own sketches.

a large river from the south. . . .

11*th August.* Crossing this river [called by the Aboriginals, Belyando] . . . we travelled on, eleven miles, and encamped early, on a fine reach of the main river. Here I had leisure to lay down my late ride on paper, and to connect it with the map; whereupon I concluded, with much regret, that this river must be either a tributary to, or identical with, that which M. Leichardt saw joining the Suttor in latitude 21° 6'S., and which he supposed to come from the west. . . . I could no longer doubt that the division between eastern and western waters was still to the westward. . . .

I accordingly determined to retrace our wheel-tracks back to the head of the Salvator, and to explore from thence the country to the north-west. . . .

12*th August.* I reluctantly ordered my men, (who believed themselves on the high-way to Carpentaria,) to turn the horses' heads homewards, merely saying that we were obliged to explore from a higher point. . . .

29*th August.* Continuing along the old track, we this day quitted the basin of the Belyando. . . . We thus crossed to the basin of another eastern river, the Nogoà. . . .

2*d. September.* We recrossed the perfectly level plain formerly mentioned. . . . I had given the name of Claude to the river; and it occurred to me . . . that this country might, therefore, be distinguished by that of the Mantuan Downs and Plains. . . .

4*th September.* . . . In proceeding over an open part of the plains . . . we perceived a line of about twelve or fourteen natives. . . . They halted on seeing us, but some soon began to run. . . . The men who ran had taken on their backs the heavy loads of the gins, and it was rather curious to see long-bearded figures stooping under such loads. Such an instance of civility, I had never before witnessed in the Australian natives towards their females. . . .

6*th and* 7*th September.* [Pyramids Depôt] It being necessary to rest and refresh the horses for a few days before setting out [for the northwest] with the freshest of them, all being leg-weary, I determined to halt here four clear days; and during these two, I completed my maps, and took a few rough sketches of scenery within a few miles of the camp. The whole of the grass had been assiduously burnt by the natives, and a young crop was coming up. . . .

10*th September.* I set out on a fine, clear morning. . . . [With a small party he travelled westwards and five days later convinced himself that he had discovered the great northern river of his hopes.]

15th September. . . . I . . . beheld downs and plains extending westward beyond the reach of vision, bounded on the S.W. by woods and low ranges, and on the N.E. by higher ranges; the whole of these open downs declining to the N.W., in which direction a line of trees marked the course of a river traceable to the remotest verge of the horizon. [He called it the Victoria — now the Barcoo River.] There I found then, at last, the realization of my long cherished hopes, an interior river falling to the N.W. in the heart of an open country extending also in that direction. Ulloa's delight at the first view of the Pacific [Bilboa — Oxley had also used the same idea] could not have surpassed mine on this occasion, nor could the fervour with which he was impressed at the moment have exceeded my sense of gratitude, for being allowed to make such a discovery. From that rock, the scene was so extensive as to leave no room for doubt as to the course of the river, which, thus and there revealed to me alone, seemed like a reward direct from Heaven for perseverance, and as a compensation for the many sacrifices I had made, in order to solve the question as to the interior rivers of Tropical Australia. . . . [He had not discovered his great northwest river, but the upper reaches of Cooper Creek which, the following year, Kennedy would rename the Barcoo.]

'The River Balonne'.

19th September. . . . The course of our river appeared to be N.W., as seen by Yuranigh, from a tree we found here. . . . We continued N.W. across fine clear downs. . . .

29th September. At 6 A.M., the thermometer was 59°. Re-crossing the river, I travelled, in a straight line, towards my camp of 19th September. . . . The country was, in general, open; the downs well covered with grass, and redolent with the rich perfume of lilies and strange flowers, which grew all over them amongst the grass. . . .

1st October. . . . But the river we were about to leave required a name, for no natives could be made to understand our questions, even had they been more willing than they were to communicate at all. It seemed to me, to deserve a great name, being of much importance, as leading from temperate into tropical regions, where water was the essential requisite, — a river leading to India; the "nacimiento de la especeria," or *region where spices grew*: the grand goal, in short, of explorers by sea and land, from Colombus downwards. This river seemed to me typical of God's providence, in conveying living waters into a dry parched land, and thus affording access to open and extensive pastoral regions, likely to be soon peopled by civilised inhabitants. It was with sentiments of devotion, zeal, and loyalty, that I therefore gave to this river the name of my gracious sovereign, Queen Victoria. . . . [Stokes had already named a river in the Northern Territory by the Queen's name; which was no doubt the reason why Kennedy renamed Mitchell's Victoria by its Aboriginal name, the Barcoo.]

6th October. . . . I had seen much smoke in the direction of our camp [at Pyramids Depôt], and was anxious about the safety of the party left there. We reached it before sunset, and were received with loud cheers. All were well, the natives had not come near, the cattle were in high condition. Mr. Stephenson had a fine collection of insects, and some curious plants. My man Brown had contrived to eke out the provisions so as to have enough to take us back to Mr. Kennedy. . . .

10th October. We commenced our retreat [back to Kennedy's party at the base camp on the Maranoa] with cattle and horses in fine condition, and with water in every crevice of the rocks. . . .

18th October. . . . The morrow was looked forward to with impatience. Four months and a half had the main body of the party been stationary; and that was a long time to look back upon, with the expectation that it had remained undisturbed, although isolated in a country still claimed and possessed by savages. . . .

19th October. The party was early in motion along the old track. . . . Mr. Kennedy ran down the cliffs to meet me, and was the first to give me the gratifying intelligence that the whole party were well; that the cattle and sheep were safe and fat, and, that the aborigines had never molested them. A good stock-yard had been set up; a storehouse had also been built; a garden had been fenced in and contained lettuce, radishes, melons, cucumbers. . . . [A few days later they commenced the return trip to Sydney.]

7

Journeys in the North and South

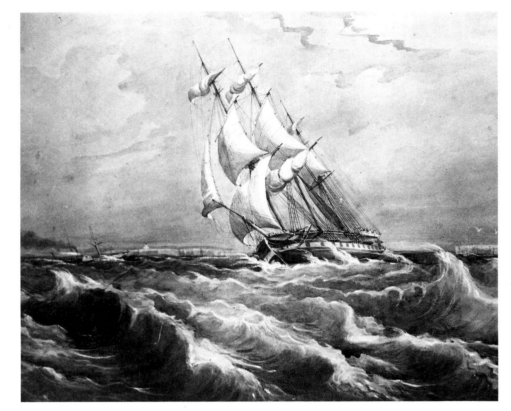

'HMS Rattlesnake off Sydney Heads' by Oswald Brierley. Brierley was the artist on board the Rattlesnake which accompanied the Tam O'Shanter up the coast to Rockingham Bay before proceeding on a navigational voyage in north-eastern waters.

Rockingham Bay to Cape York

Edmund Besley Court Kennedy (1814–48) was an adventurous young surveyor who arrived in Sydney in 1840. For a short time he went surveying at Portland Bay. After an indiscreet affair of the heart and a period of unemployment, he served as second-in-command on Sir Thomas Mitchell's northern expedition of 1846. In the following year Kennedy led his own expedition to discover more of the river which Mitchell had called the Victoria. The following is his own account of his discovery of the true course of the Victoria, which he then renamed with its Aboriginal name, the Barcoo.[1]

[15 August 1847.] I thought it worth while, on my return to the camp, to reperuse the account of Captain Sturt's expedition, published in the 'South Australian Gazette', and the result is, that I am convinced that we are now upon Cooper's Creek, described by the natives as having its source, or rather as being divided into many branches, above where they were. The river has been making directly for the point where Captain Sturt turned back on Cooper's Creek, ever since it was turned in its northerly course by Sir T. Mitchell.

Probably as a result of his efficient leadership on this expedition, as well as his successful maintenance of a four-month base camp when out with Mitchell in 1846, Kennedy was chosen to head the overland trek from Rockingham Bay, near Tully in northern Queensland, to Cape York Peninsula. The botanist on this expedition, William Carron, was one of the three survivors and his is the only account of this fateful journey.[2] An appendix includes the statement of the faithful Aboriginal, Jackey Jackey.

The party left Sydney on the 29 April 1848 in the barque *Tam O'Shanter*, accompanied by HMS *Rattlesnake* whose commander was Captain Owen Stanley; the young T. H. Huxley was assistant surgeon on board and Oswald Brierly was the ship's artist. All left pictorial records of the expedition.

Our party consisted of the following persons: Mr. E. B. Kennedy, (leader,) Mr. W. Carron, (botanist,) Mr. T. Wall, (naturalist,) Mr. C. Niblet, (storekeeper,) James Luff, Edward Taylor, and William Costigan, (carters,) Edward Carpenter, (shepherd,) William Goddard, Thomas Mitchell, John Douglas, Dennis Dunn,

1. E. B. Kennedy, 'Extracts from the Journal of an exploring Expedition into Central Australia, to determine the Course of the River Barcoo (or the Victoria of Sir T. L. Mitchell), in *The Journal of the Royal Geographical Society of London*. London, 1852.

2. Wm. Carron (ed.), *Narrative of an Expedition undertaken under the Direction of the late Mr. Assistant Surveyor E. B. Kennedy, for the Exploration of the Country Lying Between Rockingham Bay and Cape York*. Sydney, 1849.

(labourers,) and Jackey, an aboriginal native of the Patrick's Plains [Hunter River] tribe. . . .

After a tedious passage of twenty-two days, we arrived at Rockingham Bay on the 21st May; and even here, at the very starting point of our journey, those unforeseen difficulties began to arise, which led us subsequently to hardships so great and calamities so fatal. . . .

In the afternoon the vessel was anchored off the landing place, and early on the following morning (May 24th) the tents, tether ropes, and sheepfold were taken ashore, with a party to take care of the horses when landed. At ten o'clock A.M., slings having been prepared, we commenced hoisting the horses out of the hold, and lowering them into the water alongside a boat, to the stern of which the head of each horse was secured, as it was pulled ashore. One horse was drowned in landing, but all the others were safely taken ashore during the day. The weather this day was very cold, with occasional showers of rain. . . .

We pitched our tents about two hundred yards from the beach, forming a square, with the sheepfold in the centre. . . .

The labour of the day being ended, and most of our stores landed, the greater number of our party came ashore to pass the night; and after having tethered the horses in fresh places, we assembled at supper, the *materiel* of which, (beef and biscuit,) was sent from the ship. We then took possession of our tents, one square tent being allotted to Mr. Kennedy; Niblet, Wall, and myself occupied a small round one; Taylor, Douglas, Carpenter, Mitchell, and Jackey, a large round tent; and Luff, Dunn, Goddard, and Costigan, the other.

Mr. Kennedy's tent was 8 feet long, by 6 feet, and 8 feet high, and in it were placed a compact table, constructed with joints so as to fold up, a light camp stool, his books and instruments. The two larger round tents were pyr-

Edmund Beasley Court Kennedy.

'Landing Kennedy's stores' — by Owen Stanley, who was in command of the Rattlesnake.

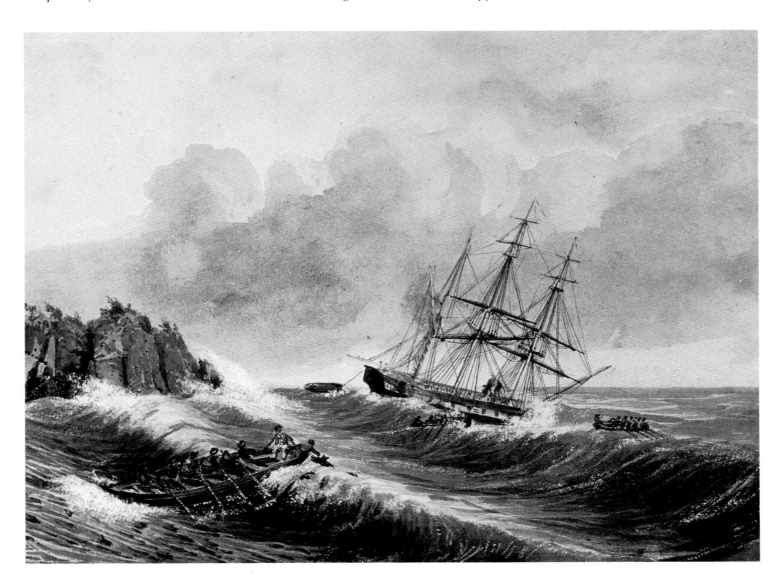

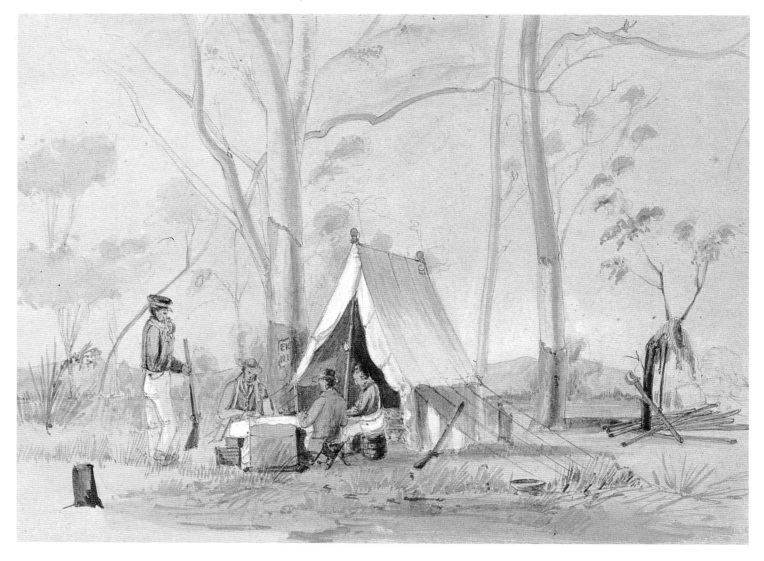

'Kennedy's First Camp' by Owen Stanley.

amidal in shape, seven feet in diameter at the least, and nine feet high. The small tent was six feet diameter, and eight feet high.

Every man was then supplied with one pair of blankets, one cloak, a double-barrel gun or carbine, a brace of pistols, cartridge box, small percussion cap pouch, and six rounds of ammunition.

The arrangement for preserving the safety of the camp from attack, was, that every man, with the exception of Mr. Kennedy, should take his turn to watch through the night — two hours being the duration of each man's watch — the watch extending from 8 P.M. till 6 A.M. During the night the kangaroo dogs were kept chained up, but the sheep dog was at large.

The position of this our first encampment was near the northern extremity of Rockingham Bay, being in latitude 17° 58' 10" south, longitude 146° 8' east. The soil, where our cattle and sheep were feeding, was sandy and very wet. The land, from the beach to the scrub in the swamp beyond, was slightly undulating and very thickly strewed with shells, principally bivalves.

On the morning of the 25th May, a party commenced landing the remainder of our stores; and it being a fine morning, I went out to collect specimens and seeds of any new and interesting plants I might find. . . .

[On] May 30th, Mr. Kennedy and three others of the party rode out to examine the surrounding country, and to determine in what direction the expedition should start, the remainder staying at the camp, busily occupied with preparations for our departure into the wilderness. The flour was put into canvas bags, holding 100lbs. each, made in the shape of saddle-bags, to hold 50lbs. weight on each side. . . . The surplus stores, comprising horse shoes, clothes, specimen boxes, &c., which would not be required before our arrival at Cape York, were sent on board H.M.S. Rattlesnake, which it was arranged should

meet us at Port Albany. During the day one of the party shot a wallaby on the beach, which made very good soup. . . .

It must be remembered . . . that in narrating the particulars of our journey, I am obliged to trust largely to memory, and to very imperfect memoranda; and to these difficulties must I refer, in excuse for the defects, with which I am well aware this narrative abounds. . . .

After travelling . . . about two miles, we came to a large river, emptying itself into Rockingham Bay. . . .

A boat was sent to us by Captain Stanley, of H.M.S. Rattlesnake, to assist us in carrying our stores across, which we effected with some difficulty by ten o'clock, P.M., the horses and some of the sheep swimming across, while the remainder of the latter were taken in the boat. . . .

This was a very harassing day to us, as we were all constantly in the water, loading and unloading the boat. . . .

June 6. Early this morning Lieutenant Simpson, of the Rattlesnake, left us, he having stayed all night at the camp, and we were now left entirely to our own resources. We loaded our carts and pack-horses, and proceeded about three miles inland, but again finding it impossible to cross the swamps, we returned to the beach, and about dusk came to another river, also emptying itself into Rockingham Bay. . . .

June 7. As soon as we had breakfasted this morning, we prepared to cross, to assist us in which undertaking we contrived to construct a sort of punt by taking the wheels and axletrees off one of the carts. We then placed the body of the cart on a large tarpaulin, the shafts passing through holes cut for them, the tarpaulin tightly nailed round them. The tarpaulin was then turned up all round, and nailed inside the cart; by this means it was made almost water-tight. We then fastened our water-bags, filled with air, to the sides of the cart, six on each side, and a small empty keg to each shaft. We tied our tether ropes together, and made one end fast on each side the river, by which means our punt was easily pulled from one side to the other. By this contrivance we managed to get most of our things over during the day, and at night a party slept on either side, without pitching the tents. . . .

June 12. . . . We saw several natives fishing in the river from their canoes, which are about five feet long and one and a-half feet wide, made of bark, with small saplings tied along the side, and are paddled with small pieces of bark held in either hand. We made signs to them to come to us, with which three of them complied. We made them understand that if they would take our rope across, and make it fast to a dead tree on the other side of the river, we would give them a tomahawk. They consented to undertake the task, and after great exertion succeeded in performing it, and received their reward, with which they seemed quite satisfied and highly pleased. We succeeded in getting everything across this river by ten o'clock at night, for the moon being up we would not stop till we had done. . . .

The river we crossed this day was not so deep as either of the former ones. There is, apparently, a sandbank across all the rivers emptying themselves into Rockingham Bay, near the mouth, and this one formed no exception to the rule. The tide runs up very strongly, I should think from a mile and a-half to two miles. . . .

June 13. On our mustering this morning, Carpenter was missed from the camp. It was discovered that he had absconded during the night, carrying off with him a damper, weighing about eleven pounds, two pounds of tea, and ten pounds of sugar. . . .

June 14. . . . In the evening Carpenter returned, and on begging Mr. Kennedy's pardon, he was forgiven. Throughout the expedition he was of very little service, being, in fact, little better than an idiot.

This evening we saw a large alligator, rising to the surface of the water, close to our camp. He seemed about twenty feet long, and appeared to be attentively watching our sheep, which were feeding by the side of the river, on the *dolichos* and *ipomeas* which were growing on the sand.

The natives here had a great many dogs, which, towards evening, rushed our sheep and drove them among the bushes in all directions. We had great

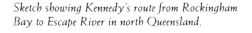

Sketch showing Kennedy's route from Rockingham Bay to Escape River in north Queensland.

difficulty in getting them together before dark.

June 15. We proceeded inland two or three miles, to the edge of the fresh water swamps, and camped there. Mr. Kennedy went with a party into the swamps to ascertain if it were possible to make a road for the carts to pass through. Wall and myself went out collecting specimens. . . .

June 20. The rain continued throughout the day.

June 21 and 22. The rain still continued. Two of our horses were found bogged in a creek near the camp, but were soon released without injury. . . .

Mr. Kennedy returned this evening, and having again found it impossible to cross the swamps we were obliged to return to the beach, where the travelling was far better than among the trees. While travelling inland a man was always obliged to walk before the carts, to cut down small trees. . . .

Mr. Kennedy appeared to be admirably fitted for the leader of an expedition of this character, in every respect.

Although he had innumerable difficulties and hardships to contend with, he always appeared cheerful, and in good spirits. Travelling through such a country as we were, such a disposition was essential to the success of the expedition. He was always diverting the minds of his followers from the obstacles we daily encountered, and encouraging them to hope for better success; careful in all his observations and calculations, as to the position of his camp, and cautious not to plunge into difficulties, without personal observation of the country, to enable him to take the safest path. But having decided, he pursued his deliberate determination with steady perseverance, sharing in the labour of cutting through the scrub, and all the harassment attendant on travelling through such a wilderness, with as much or greater alacrity and zeal than any of his followers. . . .

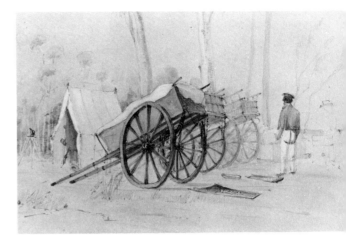

A drawing by Stanley of Kennedy's carts and tents. Kennedy's expedition attracted great interest and T. H. Huxley, the assistant surgeon on the Rattlesnake was one of those who would like to have joined the party.

July 1. Mr. Kennedy returned this morning, having explored the country for about forty miles, over which he thought we might travel safely. . . .

July 4. Mr. Kennedy and three others roamed this morning to some distance from the camp, when they were followed by a tribe of natives, making threatening demonstrations, and armed with spears; one spear was actually thrown, when Mr. Kennedy, fearing for the safety of his party, ordered his men to fire upon them; four of them fell, but Mr. Kennedy could not ascertain whether more than one was killed, as the other three were immediately carried off into the scrub. . . .

July 12 and 13. . . . Our journey still continued through scrub intersected by small creeks, which we had to cross. . . . We were not able to make much progress, travelling on the average from three to five miles a day. We were compelled to cut away the scrub, and the banks of some of the creeks, before we were able to cross them. . . .

July 14. . . . Owing to the irregularities of the surface the axletree of one of our carts gave way this day. We were forced to leave the cart and harness behind. . . . We travelled on till dusk, when we arrived at a small creek, overgrown with grass, which we imagined we should cross with little difficulty; but the carts were set fast in the mud, and some of the horses bogged. . . .

July 18. Having loaded the horses, we started at eight o'clock this morning, in good hope and high spirits, rejoicing to have got rid of one great impediment to our progress. The blacks regarded us with curious interest as we proceeded on our way, forming a train of twenty-six horses, followed by the sheep, and Mitchell occasionally sounding a horn he had brought with him.

We all felt the inconvenience of leaving the carts behind, and I in particular. I was now obliged to make two strong bags to fit my specimen boards, and to hang them over a horse's back, one bag on each side, a very inconvenient method, as it rendered them liable to much damage going through the scrub. The sheep at this time had grown very thin and poor, not averaging more than thirty pounds when skinned and dressed; they had, however, become so habituated to following the horses that they cost us very little trouble in driving them. . . .

July 20, 21, and 22. During these three days we travelled over an irregular, mountainous country, intersected by numerous creeks, running in all directions, but all of them with belts of scrub on each side. We sometimes crossed the same creeks two or three times a day, owing to the tortuous directions they took, and our clothes were kept wet all the day; some of them too had very steep banks, which presented another obstacle to the progress of our horses. Between the creeks, small patches of open forest land intervened, with large blocks of rock scattered over them; most of the creeks had a rocky bottom, and were running to the eastward. . . .

July 28. This morning, having loosed our horses from the tether, one of them fell from the hill on to a ledge of hard rock at the edge of the river, a descent of thirty feet; he was so much injured by the fall that he died during the day. . . .

July 29. . . . I dug up a piece of ground here near the edge of the scrub, and sowed seeds of cabbage, turnip, rock and water melons, parsley, leek, pom-

egranate, cotton, and apple pips.

I here found a beautiful orchideous plant, with the habit of Bletia Tankervilliae, flowering in the same manner, with flower stems about three feet high, and from twelve to twenty flowers on each stem. . . .

August 1. Mr. Kennedy and his party returned to the camp [after a short reconnoitre], having determined on a route by which we should proceed up the mountain. Mr. Kennedy spoke very highly of Jackey, and thought him one of the best men of the party, for cutting away scrub and choosing a path; he never seemed tired, and was very careful to avoid deep gullies. . . .

August 3. . . . It seemed that a great deal of rain had fallen over this country, and it rained at intervals all the time we were in the vicinity of Rockingham Bay — from the 21st May to the middle of August. . . .

August 6. Shortly after we had mustered the cattle this morning, seven or eight natives appeared at the edge of the scrub, in the direction from which we had come.

Just as they approached, an Australian magpie perched upon a tree, and I shot it to show the effect of our fire-arms. On hearing the report of the gun they all ran into the scrub, and we saw them no more. On all occasions it was Mr. Kennedy's order — not to fire on the blacks, without they molested us. I was anxious on this occasion not to let the natives know how few we were, and was glad to send them away in so quiet a manner. One of our sheep died this day, and as we had lost several before, and had but little to employ us, we opened it to see if we could ascertain the cause of its death. We found its entrails full of water. Our party was now divided into three bodies: Mr. Kennedy, Jackey and four others, clearing a way up the mountain; Niblett and three others guarding the stores; whilst myself, Dunn, and Mitchell, had charge of the sheep and horses. It was necessary, therefore, for us to keep a good look-out, and two of us watched together.

August 14. Complaint was made to Mr. Kennedy of the waste and extravagant use of the flour and sugar by Niblett, who had the charge of the stores. Mr. Kennedy immediately proceeded to examine the remainder of the stores, when he found that Niblett had been making false returns of the stores issued weekly. . . .

August 15. We were cutting through scrub nearly all day, and crossed several small creeks running westward. . . .

August 16. . . . Two more of our horses fell several times this day; one of them being very old, and so weak that we were obliged to lift him up. We now made up our minds for the first time, to make our horses, when too weak to travel, available for food. . . . [They were moving towards the location of the present town of Atherton.]

August 30 and 31. The country was very mountainous and so full of deep gullies, that we were frequently obliged to follow the course of a rocky creek, the turnings of which were very intricate; to add to our difficulties, many of the hills were covered with scrub so thickly that it was with much difficulty that we could pursue our course through it. . . .

September 4 and 5. The country continued much the same, making travelling most difficult and laborious. We were now in the vicinity of Cape Tribulation. . . .

September 6. . . . As Mr. Kennedy and myself were walking first of the party . . . I fell with violence and unfortunately broke Mr. Kennedy's mountain barometer, which I carried. . . .

September 10. Finding that the river continued running to the westward, and not as we had hoped towards Princess Charlotte's Bay, we left it and turned in a northerly direction, travelling over very rocky ridges covered with cochlospermums and acacias, insterspersed with occasional patches of open forest land, and strewed with isolated blocks of course granite containing crystals of quartz and laminae of white mica.

We had not seen natives for several days, but this night, whilst one of the party was keeping watch, a short distance from the fire, about eleven o'clock, he heard the chattering of the blacks. Three spears were almost immediately thrown into the camp and fell near the fire, but fortunately without injuring any

of the party. We fired a few shots in the direction from which the spears came; the night being so dark that we could not see them. We entertained fears that some of our horses might be speared, as they were at some distance from the camp, but fortunately the blacks gave us no further molestation.

Prayers as usual at eleven o'clock. . . .

September 15. . . . About ten o'clock we came upon the banks of a very fine river [now known as the Kennedy River], with very broad bed, and steep banks on both sides. . . .

September 16. . . . So careless were some of the party of the fatal consequences of our provisions being consumed before we arrived at Cape York, that as soon as we camped and the horses were unpacked, it was necessary that all the provisions should be deposited together on a tarpaulin, and that I should be near them by day and by night, so that I could not leave the camp at all, unless Mr. Kennedy and Mr. Wall undertook to watch the stores. I was obliged to watch the food whilst cooking; it was taken out of the boiler in the presence of myself and two or three others, and placed in the stores till morning. . . .

Twelve or fourteen natives made their appearance at the camp this evening, in the same direction as on the previous day. Each one was armed with a large bundle of spears, and with boomerangs. Their bodies were painted with a yellowish earth, which with their warlike gestures made them look very ferocious. . . . They approached near enough to throw three spears into our camp, one of which went quite through one of our tents. . . .

October 1. We had prayers this day as usual on Sundays, at eleven o'clock. . . .

October 2. The natives did not come near us, although no doubt they watched us, and saw us proceeding to the part of the plain that was burned. The plain extended a great distance to the westward, and crossing it one of our horses knocked up and could travel no longer; Mr. Kennedy ordered him to be bled, and we not liking to lose the blood, boiled it as a blood-pudding with a little flour, and in the situation we were, enjoyed it very much. . . .

October 9. This morning we came to a river, running into Princess Charlotte's Bay, in lat. 14° 30′ S., long. 143° 56′. . . . Keeping at a distance from the sea-coast to avoid the salt water creeks, and to obtain good grass for our horses, we halted in the middle of the day, and were visited by a great many natives, coming in all directions, and making a great noise. . . . They followed us at some distance, continually throwing spears after us for some time; one was thrown into the thigh of a horse, but fortunately not being barbed was taken out, and the horse was not much injured. We then rode after them in two or three directions and fired at them, and they left us, and we saw no more of them. . . .

October 13. Jackey, Taylor and myself took three horses, and tried to get to the beach more to the northward than yesterday. We passed through a belt of mangroves . . . the tide coming up only occasionally. . . . We returned to our camp, and here Mr. Kennedy abandoned the thought of going to the beach, as he felt sure H.M.S. Bramble (which was to have met us at the beginning of August) would have gone; our journey having occupied so much longer time than we could have possibly anticipated. . . .

October 22. . . . Three of the party, Douglass, Taylor, and Costigan, were suffering from diarrhœa, in consequence of having eaten too freely of the pandanus fruit. . . .

November 3. We were cutting through scrub all day, intersected by deep gullies and rocky hills. . . .

November 10. . . . Mr. Kennedy, here [they were near Cape Weymouth], finding from the weak state of some of the men, that it would be impossible for us to reach Cape York before our provisions were exhausted, resolved to form an advance party, consisting of himself, Jackey, Costigan, Luff, and Dunn.

We had but nine horses left, of which number it was proposed that they should take seven, and proceed to Cape York as quickly as possible, to obtain provisions for the rest of the party from the vessel waiting with supplies for our homeward journey. . . .

November 13. This morning everything was prepared for the departure of

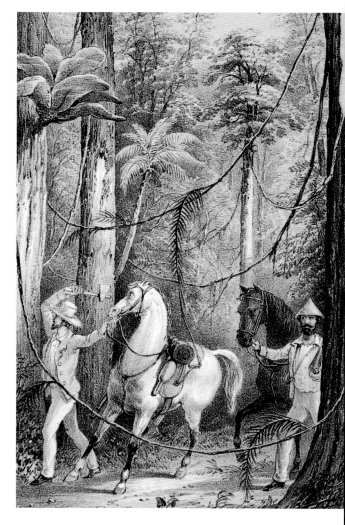

This illustration of cutting through the scrub is by John MacGillivray after a sketch by T. H. Huxley. MacGillivray was a naturalist on the Rattlesnake *and subsequently wrote a narrative of the voyage, in which he included Carron's account of the Kennedy expedition.*

Mr. Kennedy and his party, and the last of our mutton was served out equally to each of the party.

Mr. Kennedy gave me written instructions how to act during our stay at Weymouth Bay, it being his intention to send for us by water, if possible, as he expected to meet H.M.S. Bramble at Port Albany. He calculated that he should be from ten to fifteen days before he reached that place, and directed me to keep a sharp look-out from the hill for a vessel; and should I see one, to hoist a flag on the hill. If the natives were friendly I was to put a ball beneath the flag, and above it should they be hostile. In the evening I was to fire three rockets, at intervals of about twenty minutes.

The party left at the depôt under my charge were eight in number. The provisions consisted of two horses and twenty-eight pounds of flour, the former being very poor and weak.

We removed our camp back across the creek to the side of the high bare hill on which I was to hoist a flag, and from which I could look out for a vessel. It also afforded us a security from the natives, as we could see them at a greater distance. The latitude of this camp was 12° 35′ S.

And thus we settled down in the spot which was to be the burial place of so many of our party — which was fated to be the scene of so much intense suffering, and of such heart-sickening hope deferred. Wearied out by long endurance of trials that would have tried the courage and shaken the fortitude of the strongest, a sort of sluggish indifference prevailed, that prevented the development of those active energies which were so necessary to support us in our critical position. The duties of our camp were performed as if by habit, and knowing how utterly useless complaint must be, the men seldom repined aloud. . . .

November 16. The natives this day brought us a few small pieces of fish, but it was old, and hardly eatable. I would not allow them to come near the camp, but made signs to them to sit down at a distance, and when they-had [sic] done so I went to them and gave them a few fish hooks. Douglas died this morning, and we buried him at dusk when the natives were gone, and I read the funeral service over him. He was the first of our party we had lost, and his death, the sad precursor of so many more, cast an additional gloom over us. . . .

November 19. This morning about fifty or sixty natives, all strongly armed with spears, made their appearance, and by their gestures and manner it was quite evident they intended to attack us if opportunity offered.

November 20. Taylor died this morning, and we buried him in the evening, by the side of Douglas, and I read the funeral service over him. . . .

November 21. About sixty natives came to the camp this morning, well armed with spears, and pieces of fish, which they held up to us, to entice us to come to them. We took no notice, however, of their invitations, but preparing our fire-arms, we turned out.

They were now closing round us in all directions, many of them with their spears in their womeras, ready for throwing; pointing them to their own necks and sides, and showing us by their postures how we should writhe with pain when they struck us. . . .

Sunday, 26. Carpenter died this morning. . . . At eleven o'clock, being Sunday, I read prayers, and in the evening we buried our late companion, in the bed of the creek, and I read the funeral service over him. . . . During the last few days we shot a few pigeons and parrots; also a small blue crane.

November 27. We killed another horse this morning, and had the meat all cut up and on the stage by nine o'clock, with all the appearance of a fine day to dry it. But about eleven o'clock a heavy thunder storm came on, and it rained all day. . . .

November 29. It was raining heavily all day, and our meat became almost putrid. . . .

December 1. The wind was blowing strong from the south-east this morning. On going up the hill in the afternoon I saw a schooner from the northward beating to the southward. I supposed her to be the Bramble, as it was about the time Mr. Kennedy had given me expectation of being relieved by water, and I afterwards found I was right in this supposition.

I naturally concluded she had come for us; and full of hope and joy I immediately hoisted a flag on a staff we had previously erected, on a part of the hill where it could be seen from any part of the bay. . . .

December 2. Early this morning I was up, straining my eyes to catch a view of the bay, and at length saw the schooner standing in to the shore; and during the forenoon a boat was lowered. I now made quite certain they were coming for us, and thinking they might come up the creek in the boat for some distance, I hastened down the hill, and began to pack up a few things, determined to keep them waiting for our luggage no longer than I could help. I looked anxiously for them all the afternoon, wondering much at their delay in coming, until at last I went up the hill, just in time to see the schooner passing the bay. I cannot describe the feeling of despair and desolation which I in common with the rest of our party experienced as we gazed on the vessel as she fast faded from our view. On the very brink of starvation and death, — death in the lone wilderness, peopled only with the savage denizens of the forest, who even then were thirsting for our blood — hope, sure and certain hope, had for one brief moment gladdened our hearts with the consoling assurance, that after our many many trials, and protracted sufferings, we were again about to find comfort and safety.

The bright expectancy faded; and although we strove to persuade ourselves that the vessel was not the Bramble, our hearts sank within us in deep despondency. . . .

December 4. We yesterday finished our scanty remnant of flour; and our little store of meat, which we had been able to dry, could have but very little nourishment in it.

Goddard and I went to the beach and got a bag of shell-fish, but found it very difficult to get back to the camp through the mangroves, we were in so weak a state. . . .

December 13. This morning Mitchell was found dead by the side of the creek, with his feet in the water. He must have gone down at night to get water, but too much exhausted to perform his task, had sat down and died there. None of us being strong enough to dig a grave for him, we sewed the body in a blanket, with a few stones to sink it, and then put it into the brackish water. . . .

December 21. Our kangaroo dog being very weak, and unable to catch anything, we killed, and lived on him for two days. There was very little flesh on his bones, but our dried meat was so bad, that we very much enjoyed the remains of our old companion, and drank the water in which we boiled him. . . .

December 28. Niblett and Wall both died this morning; Niblett was quite dead when I got up, and Wall, though alive, was unable to speak; they were neither of them up the day previous. . . . About eleven o'clock, about fifty natives, armed with spears, and many of them painted with a yellowish earth, made their appearance in the vicinity of our camp. . . .

We had many times tried to catch fish in the creek during our stay at Weymouth Bay, with our fishing lines, but never could get as much as a bite at the bait. . . .

December 29. . . . The six weeks having expired, which Mr. Kennedy had led me to expect would be the longest period we should have to wait, I now began to fear the rainy season had set in, and filled the creeks to the northward, so that his party had been unable to cross them, or that some untoward accident had happened, which prevented us being relieved. . . .

December 30. Early this morning we ate the two pigeons left yesterday, and boiled each a quart of tea, from the leaves we had left; but we had not had any fresh tea to put into the pot for some time. Goddard then went into the bush, to try to get another pigeon or two, and if the natives made their appearance, I was to fire a pistol to recal [sic] him to the camp. After he had been gone, I saw natives coming toward the camp, and I immediately fired a pistol; but before Goddard could come back they were into the camp, and handed me a piece of paper, very much dirtied and torn. I was sure, from the first, by their manner, that there was a vessel in the Bay. The paper was a note to me from Captain Dobson, of the schooner Ariel, but it was so dirtied and torn that I could only read part of it.

For a minute or two I was almost senseless with the joy which the hope of our deliverance inspired. I made the natives a few presents, and gave them a note to Captain Dobson, which I made them easily understand I wanted them to take to that gentleman. I was in hopes they would then have gone, but I soon found they had other intentions. A great many natives were coming from all quarters well armed with spears. . . . We were expecting every moment to be attacked and murdered by these savages, our newly awakened hope already beginning to fail, when we saw Captain Dobson and Dr. Vallack, accompanied by Jackey and a man named Barrett, who had been wounded a few days before in the arm by a barbed spear, approaching towards us, across the creek. I and my companion, who was preserved with me, must ever be grateful for the prompt courage with which these persons, at the risk of their own lives, came to our assistance, through the scrub and mangroves, a distance of about three miles, surrounded as they were all the way by a large number of armed natives.

I was reduced almost to a skeleton. The elbow bone of my right arm was through the skin, as also the bone of my right hip. My legs also were swollen to an enormous size. Goddard walked to the boat, but I could not do so without the assistance of Captain Dobson and Dr. Vallack, and I had to be carried altogether a part of the distance. The others, Jackey and Barrett, kept a look out

for the blacks. We were unable to bring many things from the camp. The principal were, the fire-arms and one parcel of my seeds, which I had managed to keep dry, containing eighty-seven species. All my specimens were left behind, which I regretted very much: for, though much injured, they contained specimens of very beautiful trees, shrubs, and orchideæ. I could also only secure an abstract of my journal, except that portion of it from 13th November to 30th December, which I have in full. My original journal, with a botanical work which had been kindly lent me by a friend in Sydney for the expedition, was left behind. We got safely on board the Ariel; and after a very long passage, arrived in Sydney. . . .

The unfortunate death of our brave and generous leader, deeply and extensively as I know it to have been lamented, can have no more sincere mourner than myself.

The tale of his sufferings and those of his party has already been read and sympathised over by hundreds, and it would ill become me to add anything to the artless narrative of the faithful and true-hearted Jackey, who having tended his last moments, and closed his eyes, was the first, perhaps the most disinterested, bewailer of his unhappy fate.

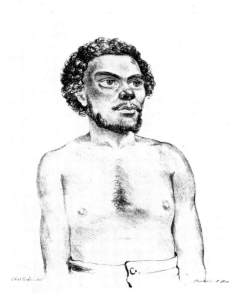

'Jackey Jackey' — by Charles Rodius.

Statement of Jackey Jackey

I started with Mr. Kennedy from Weymouth Bay for Cape York, on the 13th November, 1848, accompanied by Costigan, Dunn, and Luff, leaving eight men at the camp, at Weymouth Bay. . . . [Within a day or so Costigan accidentally shot himself and he, Dunn and Luff were left at a spot called Puddingpan Hill, near Shelburne Bay, while Kennedy and Jackey Jackey went on.] Mr. Kennedy wanted to make great haste when he left this place, to get the doctor to go down to the men that were ill. This was about three weeks after leaving Weymouth Bay. One horse was left with the three men at Pudding-pan Hill, and we (Kennedy and myself) took with us three horses. The three men were to remain there until Mr. Kennedy and myself had gone to and returned from Cape York for them. . . .

[Several days later] Mr. Kennedy told me to go up a tree to see a sandy hill somewhere; I went up a tree and saw a sandy hill a little way down from Port Albany. That day we camped near a swamp; it was a very rainy day. The next morning we went on, and Mr. Kennedy told me we should get round to Port Albany in a day; we travelled on all day till twelve o'clock (noon), and then we saw Port Albany; then he said "there is Port Albany, Jackey — a ship is there — you see that island there," pointing to Albany Island; this was when we were at the mouth of Escape River; we stopped there a little while; all the meat was gone; I tried to get some fish but could not; we went on in the afternoon half a mile along the river side, and met a good lot of blacks, and we camped. . . . I told Mr. Kennedy that very likely those black fellows would follow us, and he said, "No, Jackey, those blacks are very friendly;" I said to him "I know those blackfellows well, they too much speak". . . . we both sat up all night; after this, daylight came, and I fetched the horses and saddled them; then we went on a good way up the river, and we sat down a little while, and we saw three blackfellows coming along our track, and they saw us, and one fellow ran back as hard as he could run, and fetched up plenty more, like a flock of sheep almost; I told Mr. Kennedy to put the saddles on the two horses and go on, and the blacks came up, and they followed us all the day; all along it was raining, and I now told him to leave the horses and come on without them, that the horses made too much track. Mr. Kennedy was too weak, and would not leave the horses. . . .

Then a good many blackfellows came behind in the scrub, and threw plenty of spears, and hit Mr. Kennedy in the back first. Mr. Kennedy said to me, "Oh! Jackey, Jackey! shoot 'em, shoot 'em." Then I pulled out my gun and fired, and hit one fellow all over the face with buck shot; he tumbled down, and got up again and again and wheeled right round, and two blackfellows picked him up and carried him away. They went away then a little way, and came back again, throwing spears all around, more than they did before; very large spears. I pulled out the spear at once from Mr. Kennedy's back, and cut out the jag with

Mr. Kennedy's knife; then Mr. Kennedy got his gun and snapped, but the gun would not go off. The blacks sneaked all along by the trees, and speared Mr. Kennedy again in the right leg, above the knee a little, and I got speared over the eye, and the blacks were now throwing their spears all ways, never giving over, and shortly again speared Mr. Kennedy in the right side; there were large jags to the spears, and I cut them out and put them into my pocket. At the same time we got speared, the horses got speared too, and jumped and bucked all about, and got into the swamp. I now told Mr. Kennedy to sit down, while I looked after the saddle-bags, which I did: and when I came back again, I saw blacks along with Mr. Kennedy; I then asked him if he saw the blacks with him, he was stupid with the spear wounds, and said "No;" then I asked him where was his watch? I saw the blacks taking away watch and hat as I was returning to Mr. Kennedy; then I carried Mr. Kennedy into the scrub, he said, "Don't carry me a good way;" then Mr. Kennedy looked this way, very bad (Jackey rolling his eyes). I said to him, "Don't look far away," as I thought he would be frightened; I asked him often, "Are you well now? and he said, "I don't care for the spear wound in my leg, Jackey, but for the other two spear wounds in my side and back," and said, "I am bad inside, Jackey." I told him blackfellow always die when he got spear in there (the back); he said, "I am out of wind, Jackey;" I asked him, "Mr. Kennedy, are you going to leave me?" and he said, "Yes, my boy, I am going to leave you;" he said, "I am very bad, Jackey; you take the books, Jackey, to the captain, but not the big ones, the Governor will give anything for them;" I then tied up the papers; he then said, "Jackey, give me paper and I will write;" I gave him paper and pencil, and he tried to write, and he then fell back and died, and I caught him as he fell back and held him, and I then turned round myself and cried: I was crying a good while until I got well; that was about an hour, and then I buried him. . . . then I went down the creek which runs into Escape River, and I walked along the water in the creek very easy, with my head only above water, to avoid the blacks, and get out of their way; in this way I went half a mile; then I got out of the creek, and got clear of them, and walked on all night nearly, and slept in the bush without a fire; I went on next morning, and felt very bad, and I spelled for two days; I lived upon nothing but salt water. . . .

On the following morning, I went a good way, went round a great swamp and mangroves, and got a good way by sundown; the next morning I went and saw a very large track of black-fellows; I went clear of the track and of swamp or sandy ground; then I came to a very large river, and a large lagoon; plenty of alligators in the lagoon, about ten miles from Port Albany. I now got into the ridges by sundown, and went up a tree and saw Albany Island; then next morning at four o'clock, I went on as hard as I could go all the way down, over fine clear ground, fine iron bark timber, and plenty of good grass; I went on round the point (this was towards Cape York, north of Albany Island) and went on and followed a creek down, and went on top of the hill and saw Cape York; I knew it was Cape York, because the sand did not go on further; I sat down then a good while; I said to myself, this is Port Albany, I believe, inside somewhere; Mr. Kennedy also told me that the ship was inside, close up to the main land; I went on a little way, and saw the ship and boat; I met close up here two black gins and a good many piccanninies; one said to me "powad, powad;" then I asked her for eggs, she gave me turtles' eggs, and I gave her a burning glass; she pointed to the ship which I had seen before; I was very frightened of seeing the black men all along here; and when I was on the rock cooeying, and murry murry glad when the boat came for me.

The boat was the schooner *Ariel* under the command of Captain Dobson. His statement and that of the schooner's doctor are both included at the end of Carron's journal. Captain Dobson wrote:

Proceeded on the 2nd October last to Port Albany, to meet Mr. Kennedy's exploring party, and to supply it with provisions. We arrived at Port Albany on the 27th October, and remained there till the 23rd December, when, in consequence of a signal, I went on shore, and learnt from Jackey Jackey the death of

Mr. Kennedy, and the unfortunate fate of the expedition; and in consequence of this information we made preparations, and the next day we weighed anchor and sailed to Shelbourne Bay. Jackey informed us that Pudding-pan Hill, between Albany Point and Shelbourne Bay, was where Mr. Kennedy had left the three sick men; on proceeding there Jackey said it was not there, but on a hill like it further down; on arriving at Shelbourne Bay Jackey recognised the hill; we landed early in the morning, and fell in with the natives, and went inland, but could not get through the scrub; we came back to the beach and found a canoe, with the cloak produced in it; on the afternoon previous I thought I saw two natives on the beach, with cloaks or blue shirts on; we then pulled further on, and landed again, and went about six miles inland, but Jackey could not cross the track Mr. Kennedy had taken; he recognised the hill where the camp was, and said we might reach it to-morrow. At starting, Jackey said it would not take us long, and we took no food with us. After a consultation, we agreed to return to the vessel, believing, from the cloaks on the natives, that the men must have perished. We then pursued our way to Weymouth Bay, and rescued Mr. Caron and Goddard. We brought with us what instruments we could from the camp — they were not many — as Mr. Caron was hardly in a state to tell me what was there. We then consulted and determined to come on at once to Sydney, as from what Jackey told us it was thought useless to return to look for the men at Shelbourne Bay. I should have returned to the camp at Weymouth Bay to save everything, but for the hostility of the natives, who surrounded us in great numbers, and as soon as we had left the camp rifled it.

In Sydney, Jackey Jackey was awarded a brass medal by Governor FitzRoy. In 1849 he accompanied a party which went out to look for Kennedy's body or any survivors among those who went with him to the Cape. The search was unsuccessful. Jackey Jackey returned to his own tribe near Muswellbrook and later died on an overlanding journey; it appears that he fell into a fire while under the influence of alcohol.

The engraved brass medal awarded to Jackey Jackey.

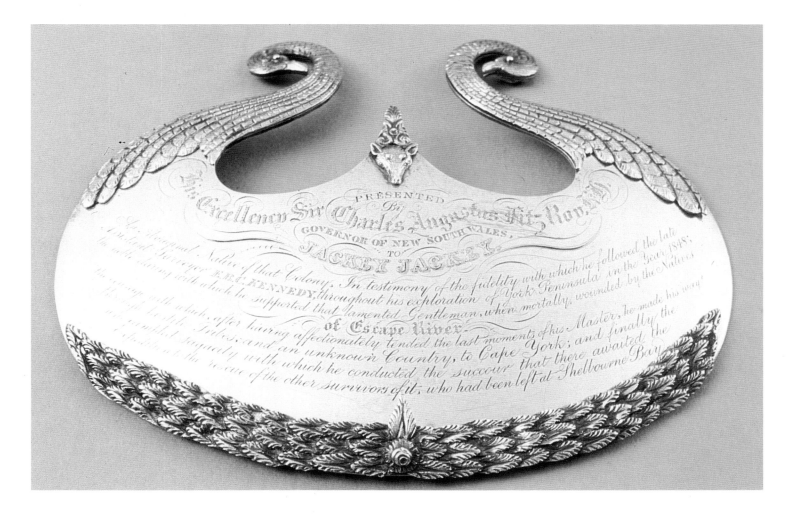

John Septimus Roe in Western Australia

John Septimus Roe (1788–1878) is sometimes referred to as 'the father of Australian exploration', a title no doubt bestowed on him as a result of the length of time he was directly and indirectly involved in both maritime and land exploration in Australia. He arrived in Sydney in 1817 as a young naval officer to work under Captain Phillip Parker King in surveying those sections of the Australian coast which Matthew Flinders had been unable to complete. Roe accompanied King on the three hydrographic voyages of the *Mermaid*[3] and subsequently on that made by the *Bathurst*, returning to England in 1823. In the following year he was back in Australian waters on board the *Tamar*, under the command of Captain J. G. Bremer, on an excursion which established the settlement of Port Essington on the Cobourg Peninsula, at the same time taking possession of the north coast of Australia.

Roe was subsequently appointed first surveyor general of the new colony on the Swan River, arriving there on board the *Parmelia* in 1829. The remainder of his life was devoted to the opening up, establishment and progress of what would become Western Australia. He led several exploratory journeys out from Perth, including the relief party for members of George Grey's expedition. The following brief extracts are from the account of his final journey of exploration in 1848 when he led a party from York to the Russell Range, east of Esperance.[4] Perhaps his guidance of younger explorers, in particular the Gregorys and the Forrests, also contributed to the 'father' concept.

Surveyor-General's Office, Perth, 10th March, 1849.

SIR, I have the honour to report to his Excellency the Governor my return to head-quarters, on the 2nd ultimo, with the expedition under my charge, which left Perth on the 8th of September last, for the purpose of exploring the interior country as far as the Russell range, in accordance with instructions to that effect conveyed in your letter to me, dated the 30th of the previous month. Those instructions, I have the satisfaction to add, have been fully carried out. The expedition examined and passed round the range, and returned to Cape Riche, in 86 days, with the loss only of one horse, although more than once threatened with the loss of all by the dreadful nature of the country they had to force through on the eastern route. . . .

The expedition traversed nearly 1800 miles of country; and although, from the nature of the interior, no great addition has been made to the amount of good land available to the colony, much useful geographical knowledge has been acquired relative to a portion of this continent hitherto entirely unknown. Independent of all other considerations, and as being more immediately and practi-

This painting by Horace Samson shows Perth in 1847, the year the Gregory brothers commenced their explorations north of the Swan River.

3. Phillip P. King, *Narrative of a Survey of the Intertropical and Western Coasts of Australia.*

4. J. S. Roe, 'Report of an Expedition under the Surveyor-General, Mr. J.S. Roe, to the South-Eastward of Perth, in Western Australia, between the months of September, 1848, and February, 1849 to the Hon. the Colonial Secretary', in *The Journal of the Royal Geographical Society of London.* London, 1852.

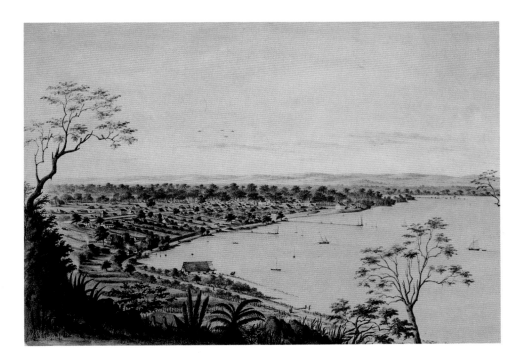

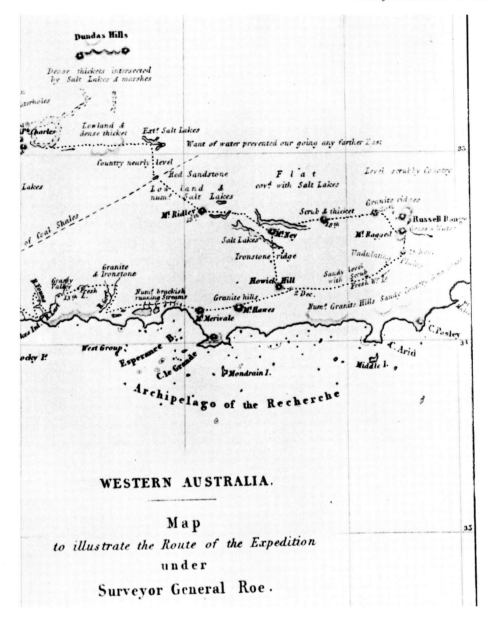

WESTERN AUSTRALIA.

Map

to illustrate the Route of the Expedition

under

Surveyor General Roe.

John Septimus Roe — first surveyor-general of Western Australia, explorer and friend of explorers.

cally beneficial to this colony, *the discovery which has been made on this occasion of coal in two available situations*, at this particular juncture, is alone a sufficient recompense for all the outlay and labour bestowed; especially if my anticipations are realised, that this valuable mineral may be traced even nearer than I found it to the anchorage in Doubtful Island Bay.

It is also to be hoped that, as one of the most valuable and most readily available sources of wealth in this colony, the superb naval timber which I observed in such inexhaustible quantity in the forests behind Bunbury, will not much longer be suffered to remain there idle, but that, on the formation of practicable roads, the axe and saw will shortly resound amongst it, to the mutual advantage of the colony and of its parent country.

The pleasing duty now only remains to me of reporting my entire satisfaction with the praiseworthy conduct of Messrs. Gregory and Ridley, and of privates Lee and Buck of the 96th, who were associated with me on this expedition. To the cheerfulness and alacrity with which each and all were ever at their respective posts, putting forth their best energies and exertions to overcome formidable obstacles, and to further the objects in view, is mainly to be attributed, under Providence, my successful accomplishment of the duties pointed out in his Excellency's instructions; nor can I speak too highly of that spirit of steady endurance and determination with which they met unavoidable privations, and faced difficulties and impediments of no ordinary description, during our long and toilsome journey.

The North Australian Exploring Expedition

Augustus Charles Gregory — leader of the Northern Expedition.

Augustus Charles Gregory (1819–1905) was ten years old when his family, of which he was the second son, arrived at the Swan River settlement in 1829. By the age of twenty-two Augustus was working under the surveyor general of Western Australia, John Septimus Roe, surveying new roads, laying out country towns and acquiring a knowledge of Australian bushcraft. In 1846 Gregory, with two of his brothers, Francis Thomas and Henry Churchman, undertook a short exploratory venture north of the Swan, and two years later he headed the Settlers' Expedition to the Gascoyne River. Both these sallies resulted in the opening up of extensive new pastoral land and discoveries of coal and minerals.

In 1848 he accompanied Governor Fitzgerald to the Geraldine Lead Mine, near the Murchison River. It was Fitzgerald's praise of Gregory that prompted the Imperial government to appoint him leader of the Northern Expedition which started from the mouth of the Victoria River — discovered earlier by Lort Stokes — in September 1855. As this was a joint venture in coastal and land exploration the party arrived from Sydney by boat. Gregory first explored inland along the Victoria River, then pushed to the southwest down a creek named after Sturt. After turning back up the Victoria he set out on the second stage of his expedition leading a section of the party overland to Brisbane.

Gregory's account of this journey,[5] from which the following extracts are taken, is not that of the adventurer seeking excitement, but is a clear statement of events and geographic facts by a man who was both an experienced Australian bushman and a highly competent surveyor and explorer. For this trek Gregory was awarded the Gold Medal of the Royal Geographical Society of London.

The circumstances which led to the organization of the Expedition for exploring Northern Australia, and the special objects of the Imperial Government in undertaking it, are best detailed in the following Despatch from His Grace the Duke of Newcastle, Secretary of State for the Colonies, to Captain Fitzgerald, Governor of Western Australia:—

The Honourable The Secretary of State for the Colonies
to The Governor of Western Australia.
Downing Street,
31st August, 1854.

Sir, — You will probably have been rendered aware by the reports of the Parliamentary Debates of last session, and from other sources, that Her Majesty's Government have been long considering the project of despatching an exploring expedition to lay open, if favoured with success, more of the interior of the great Australian Continent than the many energetic but partial attempts hitherto made have succeeded in developing.

This scheme originated with the Council of the Royal Geographical Society, who corresponded with the Colonial Department on the subject of it during last winter. But it was ultimately considered by Her Majesty's Government that the importance of the subject rendered it more advisable that the expedition should be undertaken under their our [*sic*] superintendence, and as a matter of public concern; and Parliament has now placed at their disposal a sum of £5,000 for the purpose, and will undoubtedly give further assistance should it be requisite. . . .

I enclose copies of certain portions of the correspondence which took place early in the present year between the Colonial Department and Captain Stokes and Mr. Sturt, who were consulted in order to obtain the benefit of their advice, and the former of whom I had at one time the hope to secure for the command of the Expedition.

You will collect from these documents that the general view of those who have considered the subject appears to be that Moreton Bay would be a convenient rendezvous for the land portion of the Expedition; that they might be conveyed by sea to the mouth of the Victoria River, on the north-west coast;

5. Augustus Charles and Francis Thomas Gregory, *Journals of Australian Explorations*. Brisbane, 1884.

that it would be advantageous, if possible, that they should act in concert with a Government vessel, which might be employed in surveying operations in the Gulf of Carpentaria and neighbourhood, while the land explorers were engaged in the interior. . . .

The preliminary arrangements for the North Australian Exploring Expedition being complete, the stores, equipment, and a portion of the party were embarked at Sydney in the barque "Monarch" and schooner "Tom Tough," and sailed for Moreton Bay on the 18th July, 1855, and on the 22nd anchored at the bar of the Brisbane River. . . .

On the 12th August weighed and left Moreton Bay; and this being the last point of communication with the civilised world, the Expedition might be considered to commence on this date.

The party consisted of eighteen persons, as follows: — Commander, A. C. Gregory; assistant commander, H. C. Gregory; geologist, J. S. Wilson; artist and storekeeper, J. Baines; surgeon and naturalist, J. R. Elsey; botanist, F. Müeller; collector and preserver, J. Flood; overseer, G. Phibbs; stockmen, &c., C. Humphries, R. Bowman, C. Dean, J. Melville, W. Dawson, W. Shewell, W. Selby, S. Macdonald, H. Richards, J. Fahey. The live stock comprised of fifty horses and 200 sheep.

The provisions consisted of flour, salt pork, preserved beef, rice, peas, preserved potatoes, sago, sugar, tea, coffee, vinegar, limejuice, &c., calculated to supply the party on full rations for eighteen months. . . .

[By 1 September they had sighted Port Essington.] The following morning passed Vernon Island with a light breeze. At 9.50 p.m. the "Monarch" grounded on a rocky reef off the entrance of Port Patterson [west of present-day Darwin], the master of the vessel not having made due allowance for the indraught of the tide. . . .

As the vessel lay on her side at low tide, the position of the horses was extremely inconvenient, and they suffered a greater amount of injury during these eight days than on the whole of the preceding voyage, and it is to this that the subsequent loss of so large a number of the horses is to be attributed. . . .

After getting off the reef, light winds and calms delayed the voyage to the Victoria River; but as the "Tom Tough" worked along the coast better than the "Monarch," I went on with the schooner to examine the entrance of the river. Ascending the Victoria to Blunder Bay, found that the locality was not suited for landing horses, and therefore returned to Treachery Bay, near which Mr. H. C. Gregory had discovered abundance of grass and water under Providence

The route followed by the North Australian Expedition in 1855–56.

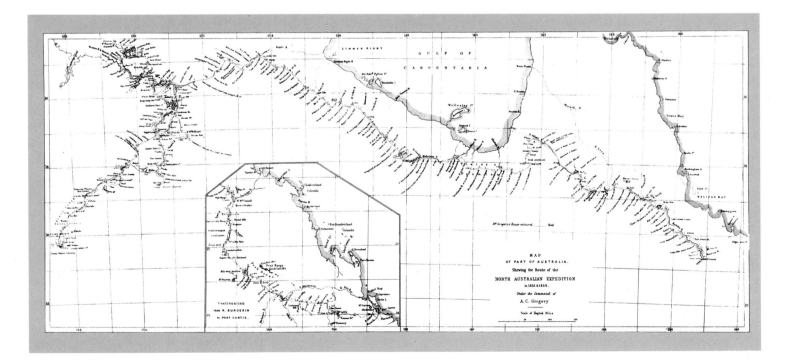

'The Victoria River' by Thomas Baines. The Expedition was well recorded pictorially by Thomas Baines who was the artist on the journey.

Hill of Captain Stokes; commenced landing the horses on the 18th; but, in consequence of the strong tides and extensive mangrove flats, great difficulties were encountered, the horses having to swim more than two miles from the vessel to the shore, and were so exhausted that three were drowned, one lost in the mud and mangroves, and one went mad and rushed into the bush and was lost. Having transferred the stores to the "Tom Tough," on the 24th the "Monarch" sailed for Singapore. Mr. Wilson was instructed to proceed in the schooner up the Victoria River, and to establish a camp at the highest convenient position on the bank of the river, while I proceeded overland with Mr. H. Gregory, Dr. Müeller, and seven of the men, hoping, by easy journeys of eight to ten miles per day, to give the horses time to partially recover the effects of the voyage. . . .

6th October. Started at 8.10 a.m. with the whole party, and, steering east to the running creek, crossed it at the head of the salt water, and proceeding up the stream three-quarters of a mile, encamped. Near the creek we saw a native man and two women, who were much alarmed at the sudden appearance of the party, and retreated across the plain. . . .

16th October. Resumed our journey down the creek at 7.0 a.m., the general course south-south-west; the country became so steep and rocky that at 8.0 we left the valley and steered south, crossing several stony hills with rocky ravines, which were so rugged that they were scarcely passable. At 11.0 sighted the Victoria River, about six miles below Kangaroo Point; but, on attempting to descend the range, was intercepted by a deep valley bounded by sandstone cliffs 50 to 100 feet high. . . .

20th October. At 7.0 a.m. steered north 160 degrees east till 10.0, over a level grassy plain wooded with small eucalypti and melaleuca, &c., the soil varying from a brown loam to a strong clay. . . . At 4.0 I left the camp with Mr. H. Gregory and proceeded west-south-west to the river, which we reached at 5.45, and then followed it up for half-an-hour, when we observed a tent and boat on

the opposite side of the river. Having hobbled the horses, we crossed over to the camp, which was established at a small spring, and found Mr. Elsey and two of the men in charge. Mr. Elsey informed me that the schooner had grounded on the bank below Mosquito Flat, and had received considerable damage. Fourteen of the sheep had been brought up to the camp, and the boat was expected up that evening with another lot of sheep. I now ascertained that a bottle had been buried near the marked trees at Kangaroo Point [as had been pre-arranged; Gregory had found the notched tree on 17 October], and a pencil-mark made on one of the trees indicating its position, but this mark had escaped our observation. In the evening Messrs. Baines and Flood and one of the men arrived at the camp in the long-boat, bringing twelve sheep, having lost several on the passage up the river. . . . The whole stock of provisions at the camp consisting of ten pounds flour, ten pounds pork, six pounds sugar, and twelve pounds beef, I was unable to send the required supplies to the party in charge of the horses, and the sheep were too poor to be fit for food. The "Tom Tough" reached Entrance Island on the 25th September, and the next day anchored off Rugged Ridge; on the 27th was proceeding up the river, and grounded on a ledge of rocks on the south side of the river, about six miles below Mosquito Flats; and from that date was never sufficiently afloat to be under control, but gradually drifted up to about two and a-half miles below Curiosity Peak. From the time of getting on the rocks she had leaked considerably, and a large quantity of stores had been destroyed or damaged, there being at one time four feet of water in the hold; but by nailing battens and tarred blankets over the open seams the leaks had been greatly reduced. The stock of water on board the schooner having been exhausted during her detention, Mr. Wilson had sent the boat up to Palm Island to bring down a supply; but having greatly miscalculated the time requisite for this expedition up the river, the distance being sixty miles, the sheep had been kept several days without a sufficient supply of water, and great number had died. . . .

29th October. At 2 a.m. weighed with the flood, and towed the schooner up the river about four miles; at 6.30 a light northerly breeze enabled us to stem the ebb tide, and at 9.40 the schooner was moored at the camp, in two fathoms, close to the bank. Having obtained a supply of water, I despatched Mr. Baines, with Phibbs, Shewell, and Dawson, in the gig to bring up the sheep, the long-boat also going down the river with a crew from the vessel to bring up the kedge anchor and warp from Alligator Island, and also to assist in bringing up the sheep. In the evening there was a fine breeze from the east, and the thermometer fell to 65 degrees during the night. A few days before our arrival one of the kangaroo dogs had been seized by an alligator, and instantly drowned. The horses had been brought to the camp by the ford at Steep Head, and were looking well. . . .

30th October. Commenced the erection of a shed to protect the stores, as it is necessary to land the cargo of the schooner to effect repairs. . . .

6th November. Messrs. H. Gregory, Elsey, and Müeller, with two men and the master of the schooner, proceeded up the river in the gig to ascertain the most convenient spot for procuring timber for the repair of the vessel; the men variously employed coopering casks, fencing garden, &c. . . . [From this depot Gregory made a three-week exploratory survey of the country ahead.]

14th December. Messrs. Baines and Bowman returned with the stray horses, having found them on the bank of a small river fifteen miles to the west of the camp. This river, which I named the Baines' River, has considerable pools of fresh water in its bed, which comes from the south-west, and flows into a large salt-water creek above Curiosity Peak. On one occasion Messrs. Baines and Bowman had halted to rest during the heat of the day, when they observed some blacks creeping towards them in the high grass; but, on finding they were observed, retired and soon returned openly with augmented numbers and approached with their spears shipped; but Mr. Baines and his companion having mounted their horses, galloped sharply towards them, and the blacks retreated with great precipitation. Mr. H. Gregory brought in the greater part of the horses; but as they had scattered very much in search of green grass, many of the horses were ten miles from the camp. Men employed cutting and carrying timber for the repair of the schooner, which work is progressing satisfactorily; computing astronomical observations. . . .

1st January, 1856. . . . Having completed the preparations for the journey into the interior [Gregory was taking nine of his party down the Victoria on a major reconnoitre to the south], the horses were saddled, and the party was on the point of starting, when a gun was fired on board the schooner, and the horses took fright and rushed wildly into the bush; and it was only after a hard gallop of two miles that they could be turned and driven back to the camp. Many of the saddles and loads were torn off by the horses having run against trees, and, as they had scattered very much, it took some time to collect the bags which had fallen from the horses, and four bags of provisions could not be found. A few of the straps of the colonial-made pack-saddles had given way, but there was no other damage done to them; but the English-made saddle was shaken to pieces. The party were occupied in the evening repairing damages. . . .

4th January. Started at 7 a.m. and followed up the creek; but Dr. Müeller [the botanist] having wandered away into the rocky hills and lost himself, I halted at the first convenient spot, having despatched several of the party to search for him, but it was not till 4 p.m. that the Doctor reached the camp. At noon there was a shower of rain, which reduced the temperature to 92 degrees. . . .

29th January. Preparing equipment for the party proceeding to the interior and making arrangements for the formation of the depôt camp; the party to consist of myself, Mr. H. Gregory, Dr. Müeller and C. Dean, Mr. Baines remaining at the depôt in charge. . . . [This was another base camp from which he could penetrate further inland.]

10th February. As the horses required a day's rest, we remained at our camp, which enabled us to repair our saddles and perform other necessary work. Repaired the chronometer and one of the aneroid barometers, which had been broken by the motion of one of the pack-horses. As there was no practicable route to the south, and the sandstone hills to the north seemed to diminish in elevation to the east, I decided on following the northern limit of the desert to the west till some line of practicable country was found by which to penetrate the country to the south. In selecting a westerly route I was also influenced by the greater elevation of the country on the western side of the Victoria, and the fact that all the larger tributaries join from that side of the valley. It is also probable that, should the waters of the interior not be lost in the sandy desert, they will follow the southern limit of the elevated tract of sandstone which occupies north-west Australia from Roebuck Bay to the Gulf of Carpentaria, both of which points are nearly in the same latitude as our present position, from which it may be assumed that the line of greatest elevation is between the 17th and 18th parallels. None of the rivers crossed by Leichhardt are of sufficient magnitude to drain the country beyond the coast range, and therefore any streams descending from the tableland to the south, will either be absorbed in the sandy desert or follow the southern limit of the sandstone and flow into the sea to the south-west of Roebuck Bay. There is, however, reason to expect that, as the interior of north-west Australia is partly within the influence of the tropical and partly the extra-tropical climates, it does not enjoy a regular rainy season; and though heavy rain doubtless falls at times, it is neither sufficiently general or regular to form rivers of sufficient magnitude to force their way through the flat sandy country to the coast. . . .

On 15 February they came to the head of a small creek which they were to name after another explorer — Sturt.

21st February. . . . According to our longitude, by account, we have this day passed the boundary of Western Australia, which is in the 129th meridian. . . .

22nd February. Leaving the camp at 5.40 a.m., followed the creek to the west-south-west and crossed a small gully from the south; at 11.30 a.m. camped at a fine pool of water in a small creek from the south, close to its junction with the principal creek, which we named after Captain Sturt, whose researches in Australia are too well known to need comment; the grassy plains extended from three to ten miles on each side of the creek, which has a more definite channel than higher up, there being some pools of sufficient size to retain water throughout the year; the plain is bounded on the north by sandstone hills 100 to 200

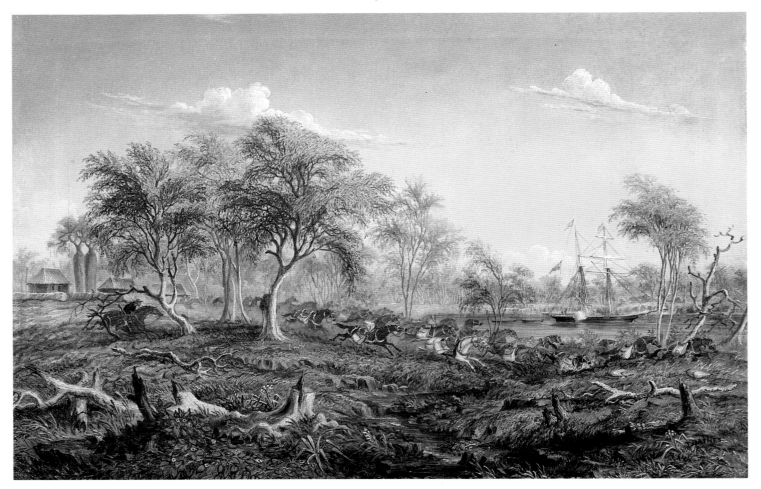

'Stampede of Packhorses' by Baines.

feet high, and there is also a mass of hilly country to the south, the highest point of which was named Mount Wittenoon; about noon a thunder-shower passed to the east and up the creek on which we were encamped, and though the channel was then dry between the pools, at 4.0 p.m. it was running two feet deep; the grass is much greener near this camp, and there has evidently been more rain here than in any part of the country south of Victoria yet visited; a fresh southerly breeze in the morning, thunderstorms at noon, night cloudy with heavy dew. . . .

10th March. . . . As the whole country to the south was one vast sandy desert, destitute of any indications of the existence of water, it was clear that no useful results could arise from any attempt to penetrate this inhospitable region [they had followed Sturt Creek for 300 miles], especially as the loss of any of the horses might deprive the expedition of the means for carrying out the explorations towards the Gulf of Carpentaria. I therefore determined on commencing our retreat to the Victoria River while it was practicable, as the rapid evaporation and increasing saltness of the water in this arid and inhospitable region warned us that each day we delayed increased the difficulty of the return, and it was possible that we were cut off from any communication with the party at the depôt by an impassable tract of dry country, and might be compelled to maintain ourselves on the lower part of the creek till the ensuing rainy season. . . .

28th March. . . . As we were now only two hours ride from the depôt camp, we after a short rest started again at 3.10 p.m., and at 5.15 reached the depôt camp, where we were welcomed by Mr. Baines and his party, and I was glad to find them all enjoying good health, and that the horses were in excellent condition. They had been, however, somewhat annoyed by the blacks, who had made frequent attempts to burn the camp, and also the horses, by setting fire to the grass, and on some occasions had come to actual hostilities, though by judicious management none of the party had been injured; nor was it certain that any of the blacks had been wounded, though it had been necessary to resort to

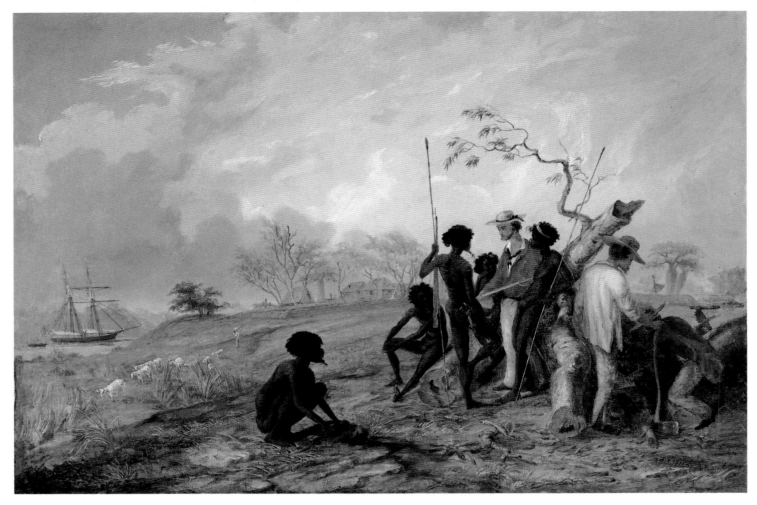

*'The Artist with a group of Aborigines' by
Baines. The vessel in the background is the
schooner* Tom Tough.

the use of firearms in self-defence and for the protection of the horses. . . . [After
another exploration down the Victoria River to the west, Gregory decided to
return to the main depot.]

9th May. At 7.30 a.m. resumed our journey down the valley to the junction
of the creek with the Victoria River, which we followed down, crossing the ridge
at Steep Head at 10.20, and reached the principal camp at 5.30 p.m., where we
were welcomed by Mr. Elsey, who was in charge, Mr. Wilson being absent down
the river at the schooner, which had been laid on the shingle bank near the
Dome to complete repairs. I was glad to learn that all the men belonging to the
Expedition were in good health, except Richards, whose hand was still in a very
unsatisfactory state, though better than when we left in January. The crew of
the schooner had not been so fortunate, as the carpenter, John Finlay, had died,
and three of the men were so ill that they had been left at the camp to be under
the immediate care of the medical officer. This great amount of sickness is owing
to the combined effects of previous disease and the inferior quality of the pro-
visions with which the vessel is supplied. . . .

10th May. . . . The natives have been frequently at the camp in small par-
ties, and on these occasions were very quiet in their demeanour, but had made
hostile demonstrations when met by small detached parties of the Expedition;
and on one occasion Mr. Wilson had deemed it necessary to fire at them; but
only one of the blacks appears to have been wounded, with small shot, in the
arm, as he was afterwards seen at the camp. . . .

13th May. Drawing maps of the late journey and preparing for the
Expedition to the Albert River.

14th May. Preparing maps, sifting flour, packing specimens, burning char-
coal for the forge, preparing horse-shoes. At 6 p.m. Mr. Wilson returned in the
boat from the "Tom Tough." One of the boys belonging to the schooner was
brought to the camp for medical treatment, as he was suffering from scurvy. The
"Tom Tough" had been moored below the shoals, and was now moored in a

secure position below Curiosity Peak. All the leaks had been secured, and she now only made about half-an-inch of water per hour. The crew of the vessel have been so much reduced by sickness that it will be necessary to send men on board to assist in refitting the vessel and procure a supply of wood and water. As it is necessary to replace the stores destroyed or damaged by salt water, it appears desirable that the "Tom Tough" should proceed to the Gulf of Carpentaria, *via* Coupang, in the Island of Timor, where a supply of rice and sugar can be procured for the Expedition, and the vessel will be enabled to complete her stores. It appears desirable that the land party should refit with all possible despatch for the journey to the Gulf of Carpentaria, in order to take advantage of the cool season, and there is reason to expect that the horses will be sufficiently recruited in strength towards the end of June. I am, therefore, in hope that the party will be able to leave the Victoria before the expiration of the ensuing month. A small party of natives came to the camp in the morning and bartered a few trifles, and then retired. . . .

The preparations for the second part of the expedition — to the Albert River — continued during May and June.

13*th June*. Mr. Baines proceeded with Phibbs, Humphries, and Selby in the gig to the "Tom Tough," with stores not required at the camp, and for the purpose of returning with soap and other stores required for the out-fit of the land expedition. Party employed as before. Mr. Wilson completed and furnished to me a sketch of the Western branch of the Victoria River, which had been discovered by Mr. Baines in December, 1855, while searching for stray horses, and which I had then named after him. Preparing maps, &c., for transmission to the Governor-General of Australia. . . .

21*st June*. At 10.0 a.m. left the principal camp on the Victoria with a party consisting of Messrs. H. Gregory, Elsey, and Dr. Müeller, Robert Bowman, Charles Dean, and J. Melville, seven saddle and twenty-seven pack horses, conveying five months' provisions of salt pork and meat biscuits, and six months' supply of flour, tea, sugar, coffee, &c., twenty-six pounds of gunpowder, sixty pounds bullets, 1 hundredweight shot, 5,000 caps, &c. . . . [They moved off, following the courses of the creeks to the northeast. The *Tom Tough*, with the remainder of the party on board, was to meet them at the Albert River.]

13*th July*. . . . The smoke of bush fires were visible to the south, east, and north, and several trees cut with iron axes were noticed near the camp. There was also the remains of a hut and the ashes of a large fire, indicating that there had been a party encamped there for several weeks. . . . It could not have been a camp of Leichhardt's in 1845, as it is 100 miles south-west of his route to Port Essington, and it was only six or seven years old, judging by the growth of the trees; having subsequently seen some of Leichhardt's camps on the Burdekin, Mackenzie, and Barcoo Rivers, a great similarity was observed in regard to the mode of building the hut, and its relative position in regard to the fire and water supply, and the position in regard to the great features of the country was exactly where a party going westward would first receive a check from the waterless tableland between the Roper and Victoria Rivers, and would probably camp and reconnoitre ahead before attempting to cross to the north-west coast. . . . [Perhaps Gregory was wondering whether this hut was a clue to Leichhardt's mysterious disappearance in 1848.]

14*th July*. Resuming our journey at 8.10 a.m., steered north-east down the valley of the creek, which I named Elsey Creek, after the surgeon of the expedition. . . .

15*th July*. Leaving our camp at 7.10 a.m., steering north-east till 9.0, over level country, which appeared to be very swampy in the rainy season. . . . camped at the junction of Elsey Creek and the river which appears to be the Roper of Dr. Leichhardt. . . .

25*th July*. . . . Since leaving the Roper River the general character of the country has been worthless; the small size of the watercourses indicating an arid country to the south-west of our route. Few traces of blacks have been seen, through vast columns of smoke rise to the east and south-east; animals or birds

'Descending Stokes Range on the Victoria River' by Baines. This range had been named after John Lort Stokes who had been in this area in 1839.

are rarely seen. The rocky nature of the country has caused the horses' shoes to wear out rapidly, and the day seldom passes without having to replace the shoes of several of the horses. . . .

29th July. . . . About three miles before we reached the camp Dr. Müeller had fallen some distance behind the party; but as this was a frequent occurrence in collecting botanical specimens, it was not observed till we reached the creek, when he was out of sight; after unsaddling the pack-horses I was preparing to send in search of him, when he came up to the camp, the cause of delay having been that his horse had knocked up. This was unfortunate, as the load of one of the pack-horses had to be distributed among the others, in order to remount the doctor, who requires stronger horses than any other person in the party, having knocked up four since January, while not one of the other riding-horses had failed, though carrying heavier weights. . . .

3rd August. . . . According to my reckoning, we are now only fifty miles from the sea-coast, and therefore much nearer Dr. Leichhardt's track than I could wish to traverse the country; but, however desirable a more inland route might be, it is evident, from the small size of the watercourses hitherto crossed, that we have been skirting a tableland which is doubtless a continuation of the desert into which we followed Sturt's Creek, and the small altitude of the country in which the watercourses trending towards the Gulf take their rise precludes the existence of any considerable drainage towards the interior.

14th August. . . . It is possible that some small tracts of available country may exist between our track and the shores of the Gulf of Carpentaria, but to the south there is little to expect besides a barren sandy desert, as on every occasion that the tableland [now the Barkly Tableland] has been ascended, nothing but sandy worthless country has been encountered. . . .

31st August (Sunday). Rode down the creek with Mr. H. Gregory. At two miles from the camp came to the junction of a smaller creek from the south, the two forming a fine reach of water, which we recognised as the Albert River of Captain Stokes. This spot [in the vicinity of present-day Burketown] between the two creeks was the rendezvous appointed for the two sections of the Expedition, and though, from the short period which had elapsed since leaving the Victoria, the "Tom Tough" could scarcely be expected to have arrived before us, on approaching the spot we saw several marked trees, but were disappointed in our hope that the vessel had reached the Albert, as these marks consisted of several names of seamen, who appeared to have formed the crew of a boat sent up the river by H.M. steamer "Torch". . . . In accordance with arrangements made with Mr. Baines, I marked a tree thus in order to apprise him of our having reached the Albert, and of our prospective movements. . . .

<div align="center">

NAE

AUG 30

DIG 1YD

TO E.

</div>

2nd September. The water in the river being very brackish, it became evident that we should be unable to procure fresh water if we followed it towards the sea, and therefore I decided on leaving the letters I had written to Mr. Baines at this spot, and accordingly marked a tree thus

<div align="center">

NAEXPDN

AUG 30

1856

DIG2YDN

</div>

and buried a tin canister with letters, stating that the exploring party was to start the following morning for Moreton Bay, and instructing Mr. Baines to remain at the Albert till the 29th September, 1856, in case any unforeseen circumstance should compel the party to return to the Albert within that period. . . . [Gregory had not expected the *Tom Tough* to be ahead of him and thought it more expeditious to push on, rather than wait for the arrival of the schooner.]

4th September. Continued a south-east course through large open plains thinly grassed; passed a dry watercourse with a small waterhole in one of the back channels, but insufficient for our horses, and at noon camped at a shallow waterhole in a grassy flat. Mr. Elsey walked half-a-mile to the eastward; came to a river

eighty yards wide, but observing some blacks, returned to the camp. . . . The river proved to be fresh, and in pools separated by rock flats, and is evidently the same that Dr. Leichhardt supposed to be the Albert — a mistake which has caused considerable error in the maps of his route; as it was not named, I called it the Leichhardt. The character of the country is inferior, as the grass which covers the plains is principally aristidia and andropogon; anthisteria or kangaroo grass only in small patches. The soil is a good brown loam.

Lat. by Vega, 18 degs. 18 mins. 5 sec. . . .

5th September. At daybreak we heard the blacks making a great noise up the river, and while the horses were being brought in nineteen blacks came to the camp, all armed with clubs and spears. . . . but just as their leader was in the act of throwing his spear he received a charge of small shot. This checked them, and we charged them on horseback, and with a few shots from our revolvers put them to flight, except one man who climbed a tree where we left him, as our object was only to procure our own safety, and that with as little injury to the blacks as possible. . . .

For the next two months they journeyed on, crossing the Gilbert River and then following the Burdekin and Sutton Rivers south and east.

5th November. . . . Having now passed the latitude of Sir T. Mitchell's last camp on the Belyando, and thus connected his route with that of Dr. Leichhardt, I considered it unnecessary to follow the river further, and decided on taking a south-easterly route to Peak Downs and the Mackenzie River.

Lat. by Pegasi, 21 degs. 57 mins. 45 secs. . . .

17th November. Resumed our journey at 6.40 a.m. Followed the Mackenzie south-east through level country with much scrub till 9.25 a.m., when we crossed a large creek from the south, which proved to be the Comet River of Dr. Leichhardt. . . . Just below the junction of the Comet we found the remains of a camp of Dr. Leichhardt's party on its second journey. The ashes of the fire were still visible, and a quantity of bones of goats were scattered around. A large tree was marked thus —

$$\text{DIG} \downarrow \quad \text{L}$$

but a hollow in the ground at the foot of the tree showed that whatever had been deposited had long since been removed. . . . Marked a tree 120△ this being the 120th camp since starting from the Victoria River. . . .

22nd November. At 6.15 a.m. resumed our route up the [Dawson] river south-east, and at 8.0 came to a dray-track which was followed east-north-east two miles to Messrs. Connor and Fitz' station, where we met with a most hospitable reception. . . . [From here they went to the town of Gladstone at Port Curtis.]

The party having thus reached the occupied country travelled by the dray-tracks past Mr. Hay's station Rannes, on the 25th November; and thence by Rawbelle, Boondooma, Tabinga, Nanango, Collinton, Kilkoy, Durandur, and Cabulture stations, reached Brisbane on the 16th December, 1856.

Two years later Gregory was off again on an expedition whose specific purpose was to search for some trace of Leichhardt and his party. Leaving from the Dawson River, near present-day Taroom, he travelled through the country in which Mitchell had searched for his supposed northern river and confirmed Kennedy's belief that Sturt's Cooper's Creek (now Cooper Creek) and Mitchell's Victoria River (now the Barcoo) were one and the same. Turning south he went along Strzelecki Creek, passing between Lake Torrens and Lake Frome and thus destroying the notion that Lake Torrens was in the shape of a large horseshoe.

The following passages[6] include references to Leichhardt and Sturt. They give Gregory's astute summary of a significant journey which tied up some loose ends in the discovery of Australia's unpredictable river systems, and which further dispelled the myth of an inland sea.

Gregory's Search for Leichhardt

6. Augustus Charles and Francis Thomas Gregory, *Journals of Australian Explorations.*

This illustration of Strzelecki Creek by Herman Melville is from Sturt's journal. A. C. Gregory, visiting Strzelecki Creek in 1858, came upon horses which he thought were those left in the area by Sturt some thirteen years before.

21st April [1858]. . . . Continuing our route along the [Barcoo] river (latitude 24 degrees 35 minutes) . . . we discovered a Moreton Bay ash (*Eucalyptus sp.*), about two feet in diameter, marked with the letter L on the east side, cut through the bark, about four feet from the ground, and near it the stumps of some small trees which had been cut with a sharp axe, also a deep notch cut in the side of a sloping tree, apparently to support the ridge pole of a tent, or some similar purposes; all indicating that a camp had been established here by Leichhardt's party. The tree was near the bank of a small reach of water, which is noted on Sir T. Mitchell's map. This, together with its actual and relative position as regards other features of the country, prove it not to have been either one of Sir T. Mitchell's or Mr. Kennedy's camps, as neither encamped within several miles of the spot, besides which, the letter could not have been marked by either of them to designate the number of the camp, as the former had long passed his fiftieth camp, and the latter had not reached that number on the outward route, and numbered his camp from the farthest point attained on his return journey. Notwithstanding a careful search, no traces of stock could be found. This is, however, easily accounted for, as the country had been inundated last season, though the current had not been sufficiently strong to remove some emu bones and mussel shells which lay round a native camping place within a few yards of the spot. No other indications having been found, we continued the search down the river, examining every likely spot for marked trees, but without success. . . .

14th June. After passing the stony ridge the valley became wider, the hills receding suddenly, in longtitude 140 degrees 30 minutes, both to the north and south; and the whole of the country to the west seemed to consist of a succession of low ridges of red sand and level plains of dry mud, subject to inundation. Shortly before reaching the branch of Cooper's Creek named by Captain Sturt "Streletzki Creek," we observed the tracks of two horses, one apparently a cart-horse, and the other a well-bred animal, but as none of their tracks were within the last month, the rain had obliterated them to such an extent that they could not be traced up, as they had left the bank of the creek on the first fall of rain, as is the usual habit of horses whose wanderings are uncontrolled. There can be little doubt that these horses belonged to Captain Sturt, who left one in an exhausted state near this locality, and also lost a second horse, whose tracks were followed many miles in the direction of this part of Cooper's Creek.

16th June. Streletzki Creek, which separates nearly at a right angle from the main channel, appears to convey about one-third of the waters of Cooper's Creek nearly south, and, as we afterwards ascertained, connects it with Lake Torrens. We, however, continued to follow the channels which trended west for thirty miles, but large branches continually broke off to the south and west, and at length the whole was lost on the wide plains of dry mud between the sand ridges; and, as there was no prospect of either water or grass to the west, I steered south and south-east for fifty miles over a succession of ridges of red drift

sand, ten to fifty feet high, running parallel to each other, and in a nearly north and south direction. Between these ridges we occasionally found shallow puddles of rain-water, or rather mud, as it was so thick with clay as to be scarcely fluid. Fortunately a great quantity of green weeds had grown up since the rain, and the horses improved in condition, and did not require much water.

21st to 25th June. In latitude 28 degrees 24 minutes we again came on Streletzki Creek, and then followed it nearly south-south-west between sandy ridges to latitude 29 degrees 25 minutes, when it turned to the west and entered Lake Torrens. No permanent water was seen in the bed of the creek, though there are many deep hollows which, when once filled, retain water for several months, and this, combined with the existence of a fine reach of water in Cooper's Creek immediately above the point where Streletzki Creek branches off, renders it far the best line of route into the interior which has yet been discovered. Passing between the eastern point of Lake Torrens and what has hitherto been considered the eastern arm, but now ascertained to be an independent lake, the space between (about half-a-mile) was level sandy ground, covered with salicornia, without any apparent connecting channel. The course was continued south-south-west towards Mount Hopeless, at the northern extreme of the high ranges of South Australia, which had been visible across the level country at a distance of sixty miles.

26th June. As we approached the range of hills tracks of cattle and horses were observed, and eight miles beyond Mount Hopeless came to a cattle station which had been lately established by Mr. Baker. As the nature of the country we had traversed was such as not to admit of any useful deviations from it if we returned to New South Wales by land, I deemed it advisable to proceed forthwith to Adelaide, and, disposing of the horses and equipment, return with the party by sea to Sydney.

31st July. We therefore proceeded by easy stages towards Adelaide, experiencing the greatest hospitality at the stations on our route, while our reception in the city was of the most flattering nature. His Excellency Sir Richard Macdonald kindly gave me the use of an extensive paddock for the horses, and provided quarters for the men during the period which necessarily elapsed before the sale of equipment of the expedition was effected. . . .

It is, perhaps, with reference to the physical geography of Australia that the results of the Expedition are most important; as by connecting successively the explorations of Sir T. Mitchell, Mr. Kennedy, Captain Sturt, and Mr. Eyre, the waters of the tropical interior of the eastern portion of the Continent are proved to flow towards Spencer's Gulf, if not actually into it, the barometrical observations showing that Lake Torrens, the lowest part of the interior, is decidedly above the sea level. Although only about one-third of the waters of Cooper's Creek flow into Lake Torrens by the channel of Streletzki Creek, there is strong evidence that the remaining channels, after spreading their waters on the vast plains which occupy the country between them and Sturt's Stony Desert, finally drain to the south, augmented probably by the waters of Eyre's Creek, the Stony Desert, and perhaps some other watercourses of a similar character coming from the westward. This peculiar structure of the interior renders it improbable that any considerable inland lakes should exist in connection with the known system of waters; for, as Lake Torrens is decidedly only an expanded continuation of Cooper's Creek, and therefore the culminating point of this vast system of drainage, if there was sufficient average fall of rain in the interior to balance the effects of evaporation from the surface of an extensive sheet of water, the Torrens Basin, instead of being occupied by salt marshes, in which the existence of anything beyond shallow lagoons of salt water is yet problematical, would be maintained as a permanent lake. Therefore, if the waters flowing from so large a tract of country are insufficient to meet the evaporation from the surface of Lake Torrens, there is even less probability of the waters of the western interior forming an inland lake of any magnitude, even should there be so anomalous a feature as a depression of the surface in which it could be collected, especially as our knowledge of its limits indicate a much drier climate and less favourable conformation of surface than in the eastern division of the continent. . . .

8

Crossing the Continent from South to North

Burke and Wills

By the late 1850's the major part of the work of discovery was done, although the toughest desert journeys were still to come. The early explorers had crossed the eastern divide and had largely solved the mysteries of Australia's unpredictable rivers. Eyre had wended his way round the southern coast, Grey had pushed to Perth from the northwest, Stokes, Leichhardt and Gregory had travelled over the north and Kennedy had moved up the east coast to Cape York. The myth of an inland sea had been almost exploded, as had that of a great northern river flowing west. In 1845 Sturt had struggled through his Stony Desert to a point near the present Northern Territory–Queensland border on latitude 24° 40′ S. Now, patriots and pastoralists in the colonies of both Victoria and South Australia were keen to discover what lay between this northernmost point of discovery and the Gulf of Carpentaria. This was the purpose of the unfortunate expedition led by Burke and Wills in 1860–61.

Robert O'Hara Burke (1812–61) emigrated to Australia from Ireland in 1853. He had commenced his career as an army officer and later became a member of the Mounted Irish Constabulary. Soon after his arrival in Australia he joined the Victorian Police Force. He was personally plucky but had no prior experience in exploration or in bushcraft, nor had he proved himself as a wise leader or sound organiser.

The enterprise which later came to be known as the Burke and Wills Expedition was arranged with more money than sense by the wealthy colony of Victoria, jealous of the exploratory achievements of South Australia and anxious for a Victorian to make the south-north crossing in front of that careful Scot, John McDouall Stuart. Burke in fact reached the north before Stuart, but the cost in lives and in equipment was too high and the practical results too few for him to have been treated kindly by history. He left no proper record of his brave dash to the gulf, admitting amongst his pencilled jottings in a notebook that he found it impossible to keep a regular diary.

William John Wills (1834–61) had come to Australia in 1853 with his brother Thomas, his father, a surgeon, following soon after. Dr Wills practiced at Ballarat and William studied surveying. He then went to work under Professor G. B. Neumayer who, as a member of the Royal Society's exploration committee, encouraged Wills to join the fateful expedition. He appears to have been a much more able man than Burke, but too young and modest to stand up to the older and more flamboyant leader. Wills was the only one of

Robert O'Hara Burke and William John Wills.

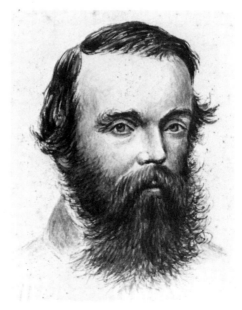

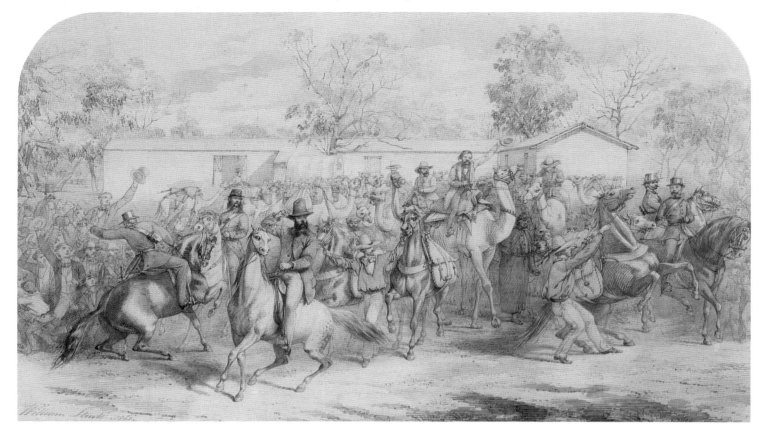

the party to attempt to keep a proper record; this must have been difficult when the object of the journey, as pursued by Burke, was a hasty point-to-point race rather than a careful scientific journey of discovery.

The following story is pieced together from the Reports of the Exploration Committee[1] and from *The Argus* account[2] which was later reprinted as a pamphlet. The latter includes the narratives of both Wills, King and Howitt, as well as Burke's few notes. Wills' journal is also to be found in a sad book published by his father in 1863.[3]

The committee appointed at an Ordinary Meeting of the Philosophical Institute of Victoria, held on the 11th of November, 1857, for the purpose of inquiring into the practicability of fitting out in Victoria an expedition for traversing the unknown interior of the Australian Continent from east to west, beg to offer to the members of the Institute this, the First Report of their Proceedings, and the result arrived at in their inquiries. . . . The desirability of Victoria taking a share in the labors of revealing the unexplored portion of the interior of Australia was unanimously acknowledged, and many members of the Committee supported on that occasion the motion of Dr. Wilkie, namely to adhere to the line of the tropic of Capricorn as far as the nature of the country and other circumstances would permit. A resolution was adopted to the effect that an appeal be made for pecuniary support, both to the Government and the public, as also that a meeting of the colonists should be held in furtherance of the project. Mr. Bonwick [James Bonwick, a well-known author and educationist] was instructed to apply to A.C. Gregory, Esq., the commander of the North Australian Expedition, for the opinion of that gentleman on the proposed route, and generally to request the advice which his valuable experience would dictate. . . .

Gregory replied to the Committee's letter on 25th November 1857:

I . . . consider that it is almost hopeless to attempt to traverse this tract of country from east to west, and that the only prospect of success would be to penetrate it in the direction of its shorter diameter (north or south). . . .

Departure of the Burke and Wills Expedition to explore the Centre of Australia' by William Strutt.

Reports of the Exploration Committee

1. *Progress Reports and Final Reports of the Exploration Committee.* Royal Society of Victoria. Melbourne, 1863.

2. *The Burke and Wills Exploring Expedition: an Account of the Crossing the Continent of Australia, from Cooper's Creek to Carpentaria.* Reprinted from *The Argus*, Melbourne, 1861.

3. William Wills (ed.), *A Successful Exploration through the Interior of Australia, from Melbourne to the Gulf of Carpentaria. From the Journals and Letters of William John Wills.* London, 1863.

Gregory's view prevailed and the committee's fifth report tells of the final arrangements:

In the Report presented by your Committee for 1859, you were congratulated upon the successful accomplishment of the laborious undertaking to raise the sum of £2000 by private subscription, in order to secure the munificent donation of £1000, promised by an anonymous donor, on that condition, for the purpose of organising a party to explore the interior of Australia.

Your Committee also expressed a hope that the Legislature would supplement these amounts with a vote of £6000. This sum was promptly appropriated by Government and duly voted by the Leglislature, for the purpose, and placed at the disposal of your Committee, by the Hon. William Nicholson, Chief Secretary.

The importance of taking advantage of the winter season to penetrate the arid regions of the interior was not overlooked by your Committee, but as a sum of £3000 had been forwarded by Government to India, to purchase camels for this express object, it was deemed, after careful consideration, to be better to wait the arrival of these "ships of the desert," rather than hasten the departure of the Expedition before they arrived. . . .

After much anxious inquiry and careful deliberation, your Committee selected Robert O'Hara Burke, Esq., Superintendent of Police in the Castlemaine district, and formerly a cavalry officer in the Austrian service, whose appointment to this onerous office was duly endorsed by the Government.

Your Committee, feeling strongly that it was of the first importance the Leader of so difficult an undertaking as traversing the wilds of an unknown region should have the free and uncontrolled selection of his officers and men, conceded to Mr. Burke at once the entire management of the organisation of his party. Accordingly the whole number of applicants were invited to meet the leader at the Hall of the Royal Society, when out of about 700 candidates the following were selected, after personal interviews and careful inquiries: —

George James Landels,	second in command
William John Wills,	Surveyor and Astronomer
Herman Beckler,	Medical Officer and Botanist
Ludwig Becker,	Artist and Naturalist, &c.
Charles D. Ferguson,	Assistant and Foreman
William Patton,	Assistant
Patrick Langan,	do.
Owen Cowen,	do.
Robert Fletcher,	do.
Henry Creber,	do.
William Brahe,	do.
John Drakeford,	do.
John King,	do.
Thos. F. M'Donagh,	do.

[Wills became second-in-command at Menindee when Landels quarrelled with Burke and resigned; William Wright joined the party as guide.]

The expedition being fully equipped and prepared, took its departure from the Royal Park, August 20th, 1860, in the presence of a vast concourse of the inhabitants of Melbourne, who enthusiastically cheered the caravan as it started on its perilous and interesting journey; Dr. Richard Eades, Mayor of Melbourne, and Vice-President of the Society, on behalf of the people, wishing Mr. Burke and his companions God-speed. . . .

Your Committee refrains from making any comments on the secession of some officers, and other events of minor importance which have been placed before the public from time to time; and in closing this report, earnestly commends the interest of the Expedition and the fair fame of the gallant leader, with all his devoted officers and brave companions, to the proverbial candour of all honorable men, and the warm sympathy of the Royal Society.

On the 24th [August 1860] the Expedition camped at Sandhurst, and on the following day proceeded *en route* to Swan Hill, reaching it on the 6th September, where it was most hospitably entertained by the leading inhabitants of the township, prior to its taking leave of Victoria. From thence it proceeded to the Darling, which it reached towards the end of the month. There Mr. Burke established his first depôt, at the Laidley Ponds, now named Menindie. An advanced party of eight, under Burke, now pushed on to Cooper's Creek: and as the season had been unusually wet and late, there was such an abundance of grass and water, that they reached that point with comparatively little difficulty on the 11th November. . . . Having made all his arrangements, and written a despatch to the committee on the 13th December, Burke did not wait for the arrival of the remainder of the party under Mr. Wright, whom he had engaged at Menindie, and to whom he had given orders to bring on the bulk of the stores; but leaving the depôt in charge of Brahe, Patton, M'Donough and Dost Mahomed, he set forward, on the 16th December, for Eyre's Creek. . . .

Wright took his time and failed to get to the Cooper before Burke returned from the Gulf. The Royal Commission which inquired into the subsequent tragedy criticised Burke for his action in dividing his party at this point. The following extracts from Wills' journal tell the story.

Sunday, Dec. 16, 1860. The two horses having been shod, and our reports finished, we started at forty minutes past six a.m. for Eyre's Creek, the party consisting of Mr. Burke, myself, King, and Charley [Gray also accompanied them], having with us six camels, one horse, and three months' provisions. We followed down the creek to the point where the sandstone ranges cross the creek, and were accompanied to that place by Brahe, who would return to take charge of the depôt. Down to this point the banks of the creek are very rugged and stony, but there is a tolerable supply of grass and saltbush in the vicinity. A large tribe of blacks came pestering us to go to their camp and have a dance, which we declined. They were troublesome, and nothing but the threat to shoot them will keep them away; they are, however, easily frightened, and, although fine-looking men, decidedly not of a warlike disposition. They show the greatest inclination to take whatever they can, but will run no unnecessary risk in so doing. They seldom carry any weapons, except a shield and a large kind of boomerang, which I believe they use for killing rats, etc; sometimes, but very seldom, they have a large spear; reed spears seem to be quite unknown to them. They are undoubtedly a finer and better looking race of men than the blacks on the Murray and Darling, and more peaceful, but in other respects I believe they did not compare favourably with them, for, from the little we have seen of them, they appear to be mean-spirited and contemptible in every respect. . . .

Wednesday, Dec. 19. Started at a quarter past eight a.m. Leaving what

The expedition wending its way out of Victoria as recorded by George Lacey.

seemed to be the end of Cooper's Creek, we took a course a little to the north of west, intending to try and obtain water in some of the creeks that Stuart mentioned that he had crossed, and at the same time to see whether they were connected with Cooper's Creek, as appeared most probable from the direction in which we found the latter running, and from the manner in which it had been breaking up into small channels flowing across the plains in a N. and N.N.W. direction. We left on our right the flooded flats on which this branch of the creek runs out, and soon came to a series of sand-ridges, the directions of which were between N. ½ W. and N.N.W. The country is well grassed, and supports plenty of saltbush. . . .

Monday, Dec. 24. We took a day of rest on Gray's Creek, to celebrate Christmas. This was doubly pleasant, as we had never in our most sanguine moments anticipated finding such a delightful oasis in the desert. Our camp was really an agreeable place, for we had all the advantages of food and water attending a position on a large creek or river, and were at the same time free of the annoyance of the numberless ants, flies, and mosquitoes that are invariably met with amongst timber or heavy scrub. . . .

Monday, Jan. 7. [1861]. We started at half-past four a.m. without water, thinking that we might safely rely on this creek, for one day's journey. We, however, found the line of timber soon begin to look small; at three miles the channel contained only a few pools of surface water. We continued across the plains on a due north course, frequently crossing small watercourses, which had been filled by the rain, but were fast drying up. Here and there as we proceeded, dense lines of timber on our right showed that the creek came from the east of north. At a distance of thirteen miles we turned to the N.N.E., towards a fine line of timber. We found a creek of considerable dimensions, that had only two or three small waterholes; but as there was more than sufficient for us, and very little feed for the beasts anywhere else, we camped. I should have liked this camp to have been in a more prominent and easily recognized position, as it happens to be almost exactly on the tropic of Capricorn. The tremendous gale of wind that we had in the evening and night prevented me from taking a latitude observation, whereas I had some good ones at the last camp and at Camp 86. My reckoning cannot be far out. I found on taking out my instruments one of the spare thermometers was broken, and the glass of my aneroid barometer cracked—the latter, I believe, not otherwise injured. This was done by the camel having taken it into his head to roll while the pack was on his back.

COOPER'S CREEK TO CARPENTARIA.
FIELD BOOK NO. 8. CAMPS 112 119. LAT. 19¼ DEG. TO 17 DEG. 53MIN. LOWER PART OF CLONCURRY.
RETURNING FROM CARPENTARIA TO COOPER'S CREEK.
FIELD-BOOK NO. 9. SUNDAY, FEBRUARY.

Finding the ground in such a state from the heavy falls of rain, that the camels could scarcely be got along, it was decided to leave them at Camp 119, and for Mr. Burke and I to proceed towards the sea on foot. After breakfast we accordingly started, taking with us the horse, and three day's provisions. Our first difficulty was in crossing Billy's Creek, which we had to do where it enters the river, a few hundred yards below the camp. In getting the horse in here, he got bogged in a quick-sand bank so deeply as to be unable to stir, and we only succeeded in extricating him by undermining him on the creek side and then lunging him into the water. Having got all the things in safety, we continued down the river bank, which bent about from east to west, but kept a general north course. A great deal of the land was so soft and rotten, that the horse, with only a saddle and about twenty-five pounds on his back, could scarcely walk over it. At a distance of about five miles we again had him bogged in crossing a small creek, after which he seemed so weak that we had great doubts about getting him on. We, however, found some better ground close to the water's edge, where the sandstone rock runs out, and we have stuck to it as far as possible. Finding that the river was bending about so much that we were making very little progress in a northerly direction, we struck off due north, and soon came on some table-land where the soil is shallow and gravelly, and clothed with

box and swamp gums. Patches of the land were very boggy, but the main portion was sound enough. Beyond this we came on an open plain, covered with water up to one's ankles. The soil here was a stiff clay, and the surface very uneven, so that between the tufts of grass one was frequently knee deep in water. The bottom, however, was sound, and no fear of bogging. After floundering through this for several miles, we came to a path formed by the blacks, and there were distinct signs of a recent migration in a southerly direction. By making use of this path, we got on much better, for the ground was well trodden and hard. At rather more than a mile, the path entered a forest, through which flowed a nice water-course, and we had not gone far before we found places where the blacks had been camping. The forest was intersected by little pebbly rises on which they had made their fires, and in the sandy ground adjoining some of the former had been digging yams, which seemed to be so numerous that they could afford to leave lots of them about, probably having only selected the very best. We were not so particular, but ate many of those that they had rejected, and found them very good. About half-a-mile further, we came close on a blackfellow, who was coiling by a camp fire, whilst his gin and picaninny were yabbering alongside. We stopped for a short time to take out some of the pistols that were on the horse, and that they might see us before we were so near as to frighten them. Just after we stopped, the black got up to stretch his limbs, and after a few seconds looked in our direction. It was very amusing to see the way in which he stared, standing for some time as if he thought he must be dreaming, and then, having signalled to the others, they dropped on their haunches and shuffled off in the quietest manner possible. Near their fire was a fine hut, the best I have ever seen, built on the same principal as those at Cooper's Creek, but much larger and more complete. I should say a dozen blacks might comfortably coil in it together. It is situated at the end of the forest, towards the north, and looks out on an extensive marsh, which is at times flooded by the sea-water. Hundreds of wild-geese, plover, and pelicans, were enjoying themselves in the watercourses on the marsh, all the water on which was too brackish to be drinkable, except some holes that are filled by the stream that flows through the forest. The neighbourhood of this encampment is one of the prettiest we have seen during the journey. Proceeding on our course across the marsh, we came to a channel through which the sea-water enters. Here we passed three blacks, who, as is universally their custom, pointed out to us, unasked, the best part down. This assisted us greatly, for the ground we were taking was very boggy. We moved slowly down, about three miles, and then camped for the night. The horse, Billy, being completely baked, next morning we started at day-break, leaving the horse short hobbled.

Tuesday. Feb. 19, 1861. Boocha's Camp.

Wednesday. Feb. 20. Pleasant Camp. 5.R. . . .

Tuesday, March 5. Camp 17. R. Started at 2 a.m. on a S.S.W. course, but had soon to turn in on the creek, as Mr. Burke felt very unwell, having been attacked by dysentery since eating the snake. He now felt giddy, and unable to keep his seat. At 6 a.m., Mr. Burke feeling better, we started again, following along the creek, in which there was considerably more water than when we passed down. We camped at 2.15 p.m. at a part of the creek where the date trees were very numerous, and found the fruit nearly ripe, and very much improved on what it was when we were here before.

Wednesday, March 6. We found, yesterday, that it was a hopeless matter about Golah [one of the camels], and we were obliged to leave him behind, as he seemed to be completely done up, and could not come on, even when the pack and saddle were taken off.

Thursday, March 7. Big-Tree Camp 19, R. . . . There is less water here than there was when we passed down, although there is evidence of the creek having been visited by considerable floods during the interval. Feed is abundant, and the vegetation more fresh than before. Mr. Burke almost recovered, but Charley is again very unwell, and unfit to do anything; he caught cold last night through carelessness in covering himself. . . .

Monday, March 25. Native Dog Camp, 27 R. Started at half-past five, looking for a good place to halt for the day. This we found at a short distance

*'Border of the Mud-Desert near Desolation Camp'
by Ludwig Becker, who was the naturalist and
artist on the expedition. The rigours of the journey
proved too much for Becker who died a month after
painting this watercolour.*

down the creek, and immediately discovered that it was close to Camp 89 of
our up journey. Had not expected that we were so much to the westward. After
breakfast took some time altitudes, and was about to go back to last camp for
some things that had been left, when I found Gray behind a tree, eating
skilligolee [thin gruel or soup]. He explained that he was suffering from dysen-
tery, and had taken the flour without leave. Sent him to report himself to Mr.
Burke, and went on. He, having got King to tell Mr. Burke for him, was called
up and received a good thrashing. There is no knowing to what extent he has
been robbing us. Many things have been found to run unaccountably short.
Started at seven o'clock, the camels in first-rate spirits. We followed our old
course back. . . . The first portion of the plains had much the same appearance
as when we came up, but that near camp 88, which then looked so fresh and
green, is now very much dried up, and we saw no signs of water anywhere. In
fact, there seems to have been little or no rain about here since we passed. Soon
after three o'clock we struck the first of several small creeks or billibongs, which
must be portions of the creek with the deep channel that we crossed on going
up, we being now rather to the westward of our former course. . . .

 Sunday, March 31. Camp 43, R. Mia Mia Camp. Plenty of good dry feed,
various shrubs, salt bushes, including cotton bushes and some coarse kangaroo
grass; water in the hollows on the stony pavement. The neighbouring country
chiefly composed of stony rivers and sand ridges. . . .

 Monday, April 8. Camp 50, R. Camped a short distance above Camp 75.
The creek here contains more water, and there is a considerable quantity of
green grass in its bed, but it is much dried up since we passed before. Halted
fifteen minutes to send back for Gray, who gammoned he could not walk. Some
good showers must have fallen lately, as we have passed surface water on the
plains every day. In the latter portion of to-day's journey, the young grass and
portulac are springing freshly in the flats, and on the sides of the sand ridges.

 Tuesday, April 9. Camp 51, R. Camped on the bank of the creek, where
there is a regular field of saltbush, as well as some grass in its bed, very accept-
able to the horse, who has not had a proper feed for the last week until last night,
and is, consequently, nearly knocked up.

 Wednesday, April 10. Camp 52, R. Remained at Camp 52, R, all day to
cut up and jerk the meat of the horse Billy, who was so reduced and knocked

up for want of food that there appeared little chance of his reaching the other side of the desert; and as we were running short of food of every description ourselves, we thought it best to secure his flesh as once. We found it healthy and tender, but without the slightest trace of fat in any portion of the body. . . .

Wednesday, April 17. This morning, about sunrise, Gray died. He had not spoken a word distinctly since his first attack, which was just as we were about to start. . . .

Sunday, April 21. Arrived at the depôt this evening, just in time to find it deserted. A note left in the plant by Brahe communicates the pleasing information that they have started today for the Darling; their camels and horses all well and in good condition. We and our camels being just done up, and scarcely able to reach the depôt, have very little chance of overtaking them. Brahe has fortunately left us ample provisions to take us to the bounds of civilisation, namely:— Flour, 50lb.; rice, 20lb.; oatmeal, 60lb.; sugar, 60lb.; and dried meat, 15lb. These provisions, together with a few horse-shoes and nails and some odds and ends, constitute all the articles left, and place us in a very awkward position in respect to clothing. Our disappointment at finding the depôt deserted may easily be imagined [Brahe, who had been left in charge of the depot, had left the day that Burke arrived back];— returning in an exhausted state, after four months of the severest travelling and privation, our legs almost paralyzed, so that each of us found it a most trying task only to walk a few yards. Such a leg-bound feeling I never before experienced, and hope I never shall again. The exertion required to get up a slight piece of rising ground, even without any load, induces an indescribable sensation of pain and helplessness, and the general lassitude makes one unfit for anything. Poor Gray must have suffered very much many times when we thought him shamming. It is most fortunate for us that these symptoms, which so early affected him, did not come on us until we were reduced to an exclusively animal diet of such an inferior description as that offered by the flesh of a worn out and exhausted horse. We were not long in getting out the grub that Brahe had left, and we made a good supper of some oatmeal porridge and sugar. . . .

Burke's rough notes included the following:

Return party from Carpentaria arrived here [the depot at Cooper Creek] last night, and found that the D. party had started on the same day. We proceed slowly down the creek towards Adelaide by Mount Hopeless, and shall endeavour to follow Gregory's track; but we are very weak, the camels are done up, and we shall not be able to travel faster than five miles a day at most. Gray died on the road, from hunger and fatigue. We all suffered much from hunger, but the provisions left here will, I think, restore our strength. We have discovered a practicable route to Carpentaria, the principal portion of which lies in the 140th meridian of east longitude. Between this and the Stony Desert there is some good country from there to the tropic. The country is dry and stony between the tropic and Carpentaria. A considerable portion is rangy, but is well watered and richly grassed. . . .

It was a good season. Burke, in fact, had everything in his favour. It appears that the decision to make for Adelaide was Burke's; Wills and King wished to follow Brahe. Brahe subsequently met Wright and they returned to the camp on the Cooper, but they missed seeing Burke's message and departed again for Menindie.

The story is continued from the pages of Wills' journal.

Tuesday, April 23. From Depôt. — Having collected together all the odds and ends that seemed likely to be of use to us, in addition to provisions left in the plant, we started at a quarter past nine a.m., keeping down the southern bank of the creek. We only went about five miles, and camped at half past eleven on a billibong, where the feed was pretty good. We find the change of diet already making a great improvement in our spirits and strength. The weather is delightful, days agreeably warm, but the nights very chilly. The latter is more notice-

The return of Burke and Wills to Cooper Creek, as depicted by Nicholas Chevalier.

able from our deficiency in clothing, the depôt party having taken all the reserve things back with them to the Darling. To Camp No. 1.

Thursday, April 25. From Camp No. 2. — Awoke at five o'clock, after a most refreshing night's rest. The sky was beautifully clear and the air rather chilly. The terrestrial radiation seems to have been considerable, and a slight dew had fallen. We had scarcely finished breakfast when our friends the blacks, from whom we obtained the fish, made their appearance with a few more, and seemed inclined to go with us and keep up the supply. We gave them some sugar, with which they were greatly pleased. They are by far the most well-behaved blacks we have ever seen on Cooper's Creek. . . .

Monday, April 29. From Camp No. 6. — Finding Landa [a camel] still in the hole, we made a few attempts at extricating him, and then shot him; and after breakfast, commenced cutting of what flesh we could get at, for jerking. . . .

Tuesday, May 7. Camp No. 9. — Breakfasted at daylight, but when about to start, found that the camel would not rise, even without any load on his back. After making every attempt to get him up, we were obliged to leave him to himself. Mr. Burke and I started down the creek to reconnoitre. At about eleven miles we came to some blacks fishing. They gave us some half-a-dozen fish each for luncheon, and intimated that if we would go to their camp, we should have some more, and some bread. . . .

Wednesday, May 15. . . . Preparing to leave the creek for Mount Hopeless. . . .

Friday, May 17. . . . Started this morning on a black's path, leaving the creek on our left, our intention being to keep a south-easterly direction until we should cut some likely-looking creek, and then to follow it down. On approaching the foot of the first sand-hill King caught sight in the flat of some nardoo seeds, and we soon found that the flat was covered with them. This discovery caused somewhat of a revolution in our feelings, for we considered that with the knowledge of this plant we were in a position to support ourselves, even if we were destined to remain on the creek and wait for assistance from town. Crossing some sand-ridges running N. and S., we struck into a creek which runs out of Cooper's Creek, and followed it down. At about five miles we came to a large waterhole, beyond which the watercourse runs out on extensive flats and earthy plains. Calm night; sky cleared towards morning, and it became very cold. . . .

Wednesday, May 29. Started at seven o'clock, and went on to the duck-holes, where we breakfasted coming down. Halted there at thirty minutes past nine for a feed, and then moved on. At the stones saw a lot of crows quarrelling about something near the water. Found it to be a large fish, of which they had eaten a considerable portion. Finding it quite fresh and good, I decided the quarrel by taking it with me. It proved a most valuable addition to my otherwise scanty supper of nardoo porridge. This evening I camped very comfortably in a mia-mia, about eleven miles from the depôt. The night was very cold, although not entirely cloudless. A brisk easterly breeze sprang up in the morning, and blew freshly all day. In the evening the sky clouded in, and there were one or two slight showers, but nothing to wet the ground. . . . [They were now simply wandering up and down Cooper Creek. All hope of trying to reach Adelaide must have vanished.]

Thursday, June 20. Night and morning very cold, sky clear. I am completely reduced by the effects of the cold and starvation. King gone out for nardoo. Mr. Burke at home pounding seed; he finds himself getting very weak in the legs. King holds out by far the best; the food seems to agree with him pretty well. Finding the sun comes out pretty warm towards noon, I took a sponging all over, but it seemed to do little good beyond the cleaning effects, for my weakness is so great that I could not do it with proper expedition. I cannot understand this nardoo at all; it certainly will not agree with me in any form. . . .

Friday, June 21. Last night was cold and clear, winding up with a strong wind from N.E. in the morning. I feel much weaker than ever, and can scarcely crawl out of the mia-mia. Unless relief comes in some form or other, I cannot possibly last more than a fortnight. It is a great consolation, at least, in this position of ours, to know that we have done all we could, and that our deaths will rather be the result of the mismanagement of others than of any rash acts

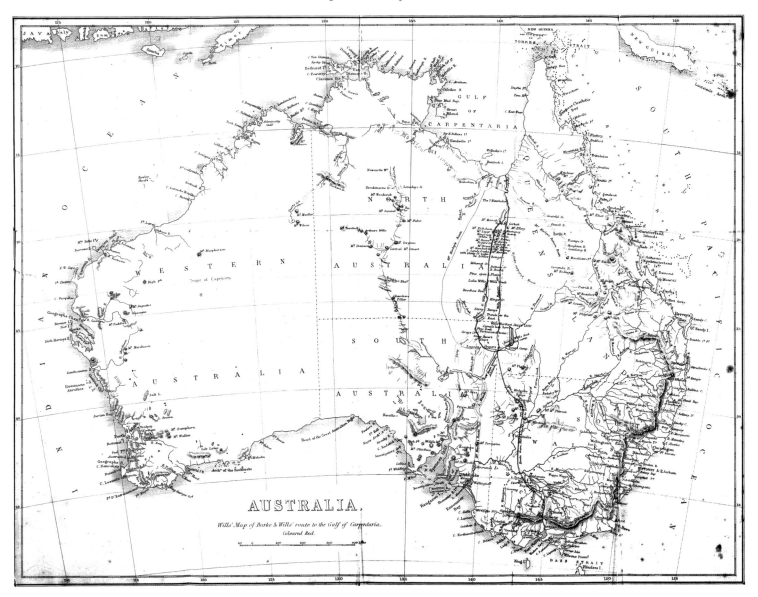

AUSTRALIA.

Wills' Map of Burke & Wills' route to the Gulf of Carpentaria.
Coloured Red.

Wills' map of Burke and Wills' route to the Gulf of Carpentaria.

of our own. [Wills is understandably referring to Brahe and Wright not having been back at the Cooper when needed. Burke's original action in giving responsibility to the imcompetent Wright was a mistake for which he was also censured by the Royal Commission.] Had we come to grief elsewhere, we could only have blamed ourselves; but here we are, returned to Cooper's Creek, where we had every reason to look for provisions and clothing; and yet we have to die of starvation, in spite of the explicit instructions given by Mr. Burke, that the depôt party should await our return, and the strong recommendation to the committee that we should be followed up by a party from Menindie. About noon a change of wind took place, and it blew almost as hard from the west as it did previously from the N.E. . . .

Sunday, June 23. All hands at home. I am as weak as to be incapable of crawling out of the mia-mia. King holds out well, but Mr. Burke finds himself weaker every day.

Monday, June 24. . . . King went out for nardoo, in spite of the wind, and came in with a good load, but he himself terribly cut up. He says that he can no longer keep up the work, and as he and Mr. Burke are both getting rapidly weaker, we have but a slight chance of anything but starvation, unless we can get hold of some blacks.

Tuesday, June 23 (*sic*). [By this time Wills was so weak he was no longer sure of the date.] Night calm, clear, and intensely cold, especially towards morning. Nea daybreak, King reported seeing a moon in the E., with a haze of light stretching up from it he declared it to be quite as large as the moon, and not

dim at the edges. I am so weak that any attempt to get a sight of it was out of the qustion [*sic*]; but I think it must have been Venus in the zodiacal light that he saw, with a corona round her. Mr. Burke and King remain at home cleaning and pounding seed. They are both getting weaker every day. The cold plays the deuce with us, from the small amount of clothing we have. My wardrobe consists of a wide-a-awake, a merino shirt, a regatta shirt without sleeves, the remains of a pair of flannel trousers, two pairs of socks in rags, and a waist-coat of which I have managed to keep the pockets together. The others are no better off. Besides these we have between us for bedding, two small camel pads, some horsehair, two or three little bits of a rag, and pieces of oilcloth saved from the fire. The day turned out nice and warm.

Friday, June 26 (*sic*). Clear cold night, slight breeze fron the E., day beautifully warm and pleasant. Mr. Burke suffers greatly from the cold and is getting extremely weak; he and King start to-morrow up the creek, to look for the blacks — it is the only chance we have of being saved from starvation. I am weaker than ever although I have a good appetite, relish the nardoo much, but it seems to give us no nutriment, and the birds here are so shy as not to be got at. Even if we got a good supply of fish, I doubt whether we could do much work on them and the nardoo alone. Nothing now but the greatest good luck can now save any of us; as for myself, I may live four or five days if the weather continues warm. My pulse are at forty-eight, and very weak, and my legs and arms are nearly skin and bone. I can only look out, like Mr. Micawber, "for something to turn up;" but starvation on nardoo is by no means very unpleasant, but for the weakness one feels, and the utter inability to move oneself, for as far as appetite is concerned, it gives me the greatest satisfaction. Certainly, fat and sugar would be more to one's taste, in fact, those seem to me to be the great stand by for one in this extraordinary continent; not that I mean to depreciate the farinacious food, but the want of sugar and fat in all substances obtainable here is so great that they become almost valueless to us as articles of food, without the addition of something else.

This is the last entry in Wills' diary. By the end of June he was dead. King provides us with the account of the last days of Burke and tells of his own survival amongst the Aboriginals on the Cooper. King and Burke had left Wills on 27 June to look for the Aboriginals in order to obtain food.

In travelling the first day, Mr. Burke seemed very weak, and complained of great pain in his legs and back. On the second day he seemed to be better, and said that he thought he was getting stronger, but, on starting, did not go two miles before he said he could go no further. I persisted in his trying to go on, and managed to get him along several times, until I saw that he was almost knocked up, when he said he could not carry his swag, and threw all he had away. I also reduced mine, taking nothing but a gun and some powder and shot, and a small pouch and some matches. On starting again, we did not go far before Mr. Burke said we should halt for the night, but, as the place was close to a large sheet of water, and exposed to the wind, I prevailed on him to go a little further, to the next reach of water, where we camped. We searched about, and found a few small patches of nardoo, which I collected and pounded, and, with a crow which I shot made a good evening's meal. From the time we halted Mr. Burke seemed to be getting worse, although he ate his supper. He said he felt convinced he could not last many hours, and gave me his watch, which he said belonged to the committee, and a pocketbook, to give to Sir William Stawell, and in which he wrote some notes. He then said to me, "I hope you will remain with me here till I am quite dead — it is a comfort to know that some one is by; and when I am dying, it is my wish that you should place the pistol in my right hand, and that you leave me unburied as I lie." That night he spoke very little and the following morning I found him speechless, or nearly so; and about eight o'clock he expired. . . .

I remained there two days, to recover my strength, and then returned to Mr. Wills. I took back three crows; but found him lying dead in his gunyah, and the natives had been there and had taken away some of his clothes. I buried the

corpse with sand, and remained there for some days; but finding that my stock of nardoo was running short, and being unable to gather it, I tracked the natives who had been to the camp by their footprints in the sand, and went some distance down the creek, shooting crows and hawks on the road. The natives, hearing the report of the gun, came to meet me, and took me with them to their camp, giving me nardoo and fish. They took birds I had shot and cooked them for me, and afterwards showed me a gunyah, where I was to sleep with three of the single men. The following morning they commenced talking to me, and putting one finger on the ground, and covering it with sand, at the same time pointing up the creek, saying, "Whitefellow," which I understood to mean that one white man was dead. From this I knew that they were the tribe who had taken Mr. Wills' clothes. They then asked me where the third white man was, and I also made the sign of putting two fingers on the ground and covering them with sand, at the same time pointing up the creek. They appeared to feel great compassion for me when they understood that I was alone on the creek, and gave me plenty to eat. After being four days with them, I saw that they were becoming tired of me, and they made signs that they were going up the creek, and that I had better go downwards; but I pretended not to understand them. The same day they shifted camp, and I followed them; and, on reaching their camp, I shot some crows, which pleased them so much that they made me a breakwind in the centre of their camp, and came and sat around me until such time as the crows were cooked, when they assisted me to eat them. The same day, one of the women, to whom I had given part of a crow, came and gave me a ball of nardoo, saying that she would give me more only she had such a sore arm that she was unable to pound. She showed me a sore on her arm, and the thought struck me that I would boil some water in the billy and wash her arm with a sponge. During the operation the whole tribe sat round, and were muttering one to another. Her husband sat down by her side, and she was crying all the time. After I had washed it, I touched it with some nitrate of silver, when she began to yell and ran off, crying out, "Mokow! mokow!" (Fire! fire!). From this time, she and her husband used to give a small quantity of nardoo both night and morning, and whenever the tribe were about going on a fishing excursion, he used to give me notice to go with them. . . .

They were very anxious, however, to know where Mr. Burke lay; and one day when we were fishing in the waterholes close by I took them to the spot. On seeing his remains the whole party wept bitterly, and covered them with bushes. After this they were much kinder to me than before; and I always told them that the white men would be here before two moons; and in the evenings, when they came with nardoo and fish, they used to talk about the "whitefellows" coming, at the same time pointing to the moon. I also told them they would receive many presents, and they constantly asked me for tomahawks, called by them "Bomayko." From this time to when the relief party arrived — a period of about a month — they treated me with uniform kindness, and looked upon me as one of themselves. The day on which I was released, one of the tribe who had been fishing came and told me that the whitefellows were coming, and the whole of the tribe who were then in camp sallied out in every direction to meet the party, while the man who had brought the news took me across the creek, where I shortly saw the party coming down. . . .

The 'party' which King referred to, was that led by Alfred William Howitt, one of the four expeditions sent out to search for the 'Northern Expedition'. Howitt was an educated man who had arrived in Australia in 1852 and who by 1861 had already successfully tried his hand at farming, droving, prospecting and exploring. He was a naturalist and knew and loved the Australian bush. He also became an authority on Aboriginal culture. The following passages are taken from his journal, also published in *The Argus* pamphlet.

Camp 25, Cooper's Creek, Sept. 8. Lat. 27 deg. 51 min.; long. 141 deg. 45 min. — (Half a mile above camp sixty of Victorian Expedition.) — Travelled N. 60 deg. W., through a succession of sand hills, with flats of rotten polygonum ground between. The vegetation very green and in full flower, and box-trees

growing on most of the flats. Towards noon, after crossing some high red sand hills, came into the earthy plains through which the various channels of Cooper's Creek run to the westward. The ground very rotten, and cracked by numerous deep fissures; dry channels in every direction. . . .

Camp 31, Sep. 14. Lat., 27 deg. 42 min; [long.] 140 deg. 42 min.—We had a late start this morning, as three of the horses were away, and one ill—indeed, I doubted at first whether he would be able to travel. Followed the course of the creek down for about nine miles, crossing several branches which go out south, and form a reach of water before re-entering the main creek. Here the rocky ridges on both sides close in, and the water has forced a narrow deep channel through a perfect wall of rock, forming below the finest reach of water we have yet seen—about 500 yards wide, and several miles long, and very deep. The rugged hills on the north side, and the fine gums on its banks, produce a fine effect. The rock through which the channel has been worn is of a hard flinty nature, inclined to be columner, but forming huge masses of boulders. Deep round hollows have been worn in these by the floods, and at the water's edge in one place where I tried the depth, the rock is perpendicular below the surface. Waterfowl, fish, and turtle are plentiful. . . .

Camped on a large waterhole, about a quarter of a mile below Mr. Burke's first camp after leaving the depôt. We could see where the camels had been tied up, but found no marked tree. To-day I noticed in two or three places old camel droppings and tracks, where Mr. Brahe informed me he was certain their camels had never been, as they were watched, every day near the depôt, and tied up at night. Mr. Burke's camels were led on the way down. It looked very much as if stray camels had been about during the last four months. The tracks seemed to me to be going up the creek, but the ground was too stony to be able to make sure.

Camp 32, Sept. 15. Lat. 27 deg. 44 min., long 140 deg. 40 min.—On leaving this morning I went ahead with Sandy, to try and pick up Mr. Burke's track. At the lower end of a large waterhole, found where one or two horses had been feeding for some months; the tracks ran in all directions to and from the water, and were as recent as a week. . . . At the lower end of the large reach of water before mentioned I met Sandy and Frank looking for me, with the intelligence that King, the only survivor of Mr. Burke's party, had been found. A little further on I found the party halted, and immediately went across to the blacks' wurleys, where I found King sitting in a hut which the natives had made for him. He presented a melancholy appearance—wasted to a shadow, and hardly to be distinguished as a civilised being but by the remnants of clothes upon him. He seemed exceedingly weak, and I found it occasionally difficult to follow what he said. The natives were all gathered round, seated on the ground, looking with a most gratified and delighted expression. . .

Camp 32, Sept. 16. King already looks vastly improved, even since yesterday, and not like the same man. Have commenced shoeing horses and preparing for our return. Wind from S.W., with signs of rain. The natives seem to be getting ready for it.

Camp 32, Sept. 18. Left camp this morning with Messrs. Brahe, Welsh, Wheeler, and King, to perform a melancholy duty which has weighed on my mind ever since we have camped here, and which I have only put off until King should be well enough to accompany us. We proceeded down the creek for several miles, crossing a branch running to the southward, and followed a native track leading to that part of the creek where Mr. Burke, Mr. Wills, and King camped after their unsuccessful attempt to reach Mount Hopeless and the northern settlements of South Australia, and where poor Wills died. We found the two gunyahs pretty much as King had described them, situated on a sandbank between two water-holes, and about a mile from the flat where they procured the nardoo seed, on which they managed to exist so long. Poor Wills's remains we found lying in the wurley in which he died, and where King, after his return from seeking for the natives, had buried him, with sand and rushes. We carefully collected the remains and interred them where they lay; and, not having a prayer-book, I read chap. xv. of 1 Cor., that we might at least feel a melancholy satisfaction in having shown the last respect to his remains. We

Facsimile copies of pages from Burke's very patchy diary. The published version was slightly altered.

heaped sand over the grave, and laid branches upon it, that the natives might understand by their own tokens not to disturb the last repose of a fellow being. I cut the following inscription on a tree close by, to mark the spot:—

```
W. J. WILLS,
XLV, Yds.
W.N.W.
A.H.
```

The field books, a note-book belonging to Mr. Burke, various small articles lying about, of no value in themselves, but now invested with a deep interest from

the circumstances connected with them, and some of the nardoo seed on which they had subsisted, with the small wooden trough in which it had been cleaned, I have now in my possession. We returned home with saddened feelings; but I must confess that I felt a sense of relief that this painful ordeal had been gone through. King was very tired when we returned; and I must, most unwillingly, defer my visit to the spot where Mr. Burke's remains are lying until he is better able to bear the fatigue. . . .

Sept. 21. Finding that it would not be prudent for King to go out for two or three days, I could no longer defer making a search for the spot where Mr. Burke died, and with such directions as King could give, I went up the creek this morning with Messrs. Brahe, Welsh, Wheeler, and Aitkin. We searched the creek upwards for eight miles, and at length, strange to say, found the remains of Mr. Burke lying among tall plants under a clump of box-trees, within 200 yards of our last camp, and not thirty paces from our track. It was still more extraordinary that three or four of the party and the two black boys had been close to the spot without noticing it. The bones were entire, with the exception of the hands and feet; and the body had been removed from the spot where it first lay, and where the natives had placed branches over it, to about five paces distance. I found the revolver which Mr. Burke held in his hand when he expired partly covered with leaves and earth, and corroded with rust. It was loaded and capped. We dug a grave close to the spot, and interred the remains wrapped in the union jack — the most fitting covering in which the bones of a brave but unfortunate man could take their last rest. On a box-tree, at the head of the grave, the following inscription is cut: —

> R. O'H. B.
> 21/9/61.
> A.H.

William Landsborough and his party who discovered the Barkly Tableland as well as valuable grazing country while searching for Burke and Wills.

It seems a sad postscript to the Burke and Wills expedition that its most substantial result was not its own, but that achieved by the search parties, not only that of Alfred William Howitt, but also of Frederick Walker, William Landsborough and John McKinlay. Space prevents the inclusion of extracts

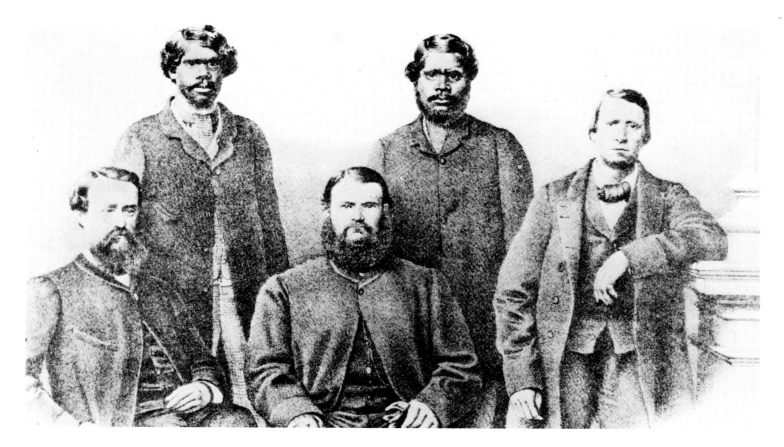

John McKinlay and his party. They found Gray's grave and later pushed on north to the mouth of the Leichhardt River.

from the relevant journals relating to Walker,[4] Landsborough[5] and McKinlay,[6] but their expeditions all contributed to the geographical knowledge of the north and to the opening up of pastoral country around the Gulf of Carpentaria.

McKinlay's explorations in particular deserve more than a passing reference. Like John McDouall Stuart, McKinlay was a Scot who had also thoroughly prepared himself in the art of Australian bushcraft. After searching for Burke and Wills around Cooper Creek and ultimately receiving news of what had happened to them, McKinlay pushed on through Sturt's Stony Desert (in a good season) to the Albert River in the north, then eastward to Port Denison (present-day Bowen) on the Queensland coast. No men were lost on this long and carefully executed journey. McKinlay's record was in the form of a logbook without literary aspirations, but John Davis, a member of his party, prepared with William Westgarth an account calculated to be of more interest to the public.[7]

John McDouall Stuart (1815–66) arrived in South Australia from Scotland in 1839 and started work as a surveyor. From then on his life was largely devoted to South Australian Exploration. His journey with Sturt in 1844–46 had proved his calibre as an explorer and provided him with invaluable experience for the leadership of his own expeditions. His carefully planned journeys towards the Centre in the late 1850s, culminating in his final triumph in crossing the interior of the continent from south to north, provide a sharp contrast to Burke's impetuous and ill-considered dash to the Gulf of Carpentaria.

Stuart's was an outstanding achievement, but he paid a high price for his services to Australian geographical discovery. When he returned to Scotland in 1864 his health was broken. He died two years after the publication of his journals which were edited by William Hardman and from which the following extracts are taken.[8] The Overland Telegraph Line which opened in 1872, linking Australia with the telegraphic systems of the world, followed Stuart's route through the Centre.

South to North through the Centre

PREFACE BY THE EDITOR

The explorations of Mr. John McDouall Stuart may truly be said, without disparaging his brother explorers, to be amongst the most important in the history of Australian discovery. In 1844 he gained his first experiences under the guidance of that distinguished explorer, Captain Sturt, whose expedition he accompanied in the capacity of draughtsman. . . .

The colonists of South Australia have always been distinguished for promoting by private aid and public grant the cause of exploration. They usually kept somebody in the field, whose discoveries were intended to throw light on the caprices of Lake Torrens, at one time a vast inland sea, at another a dry

4. 'Journal of Mr. Walker, from the day he left Macintosh's Station on the Nogoa, to that of his arrival at the Albert River, Gulf of Carpentaria', in *The Journal of Royal Geographical Society*. London, 1863.

5. *Journal of Landsborough's Expedition from Carpentaria, in Search of Burke & Wills*. Melbourne, 1862.

6. *McKinlay's Journal of Exploration in the Interior of Australia (Burke Relief Expedition)*. Melbourne, [1862?]

7. John Davis (ed. William Westgarth), *Tracks of McKinlay and Party Across Australia*. London, 1863.

8. William Hardman (ed.), *The Journals of John McDouall Stuart during the years 1858, 1859, 1860, 1861, & 1862, when he Fixed the Centre of the Continent and Successfully Crossed it from Sea to Sea*. London, 1865.

desert of stones and baked mud. Hack, Warburton, Freeling, Babbage, and other well-known names, are associated with this particular district, and, in 1858 Stuart started to the north-west of the same country, accompanied by one white man (Forster) and a native. In this, the first expedition which he had the honor to command, he was aided solely by his friend Mr. Wm. Finke, but in his later journeys Mr. James Chambers also bore a share of the expense. This journey was commenced in May, 1858, from Mount Eyre in the north to Denial and Streaky Bays on the west coast of the Port Lincoln country. On this journey Mr. Stuart accomplished one of the most arduous feats in all his travels, having, with one man only (the black having basely deserted them), pushed through a long tract of dense scrub and sand with unusual rapidity, thus saving his own life and that of his companion. During this part of the journey they were without food or water, and his companion was thoroughly dispirited and despairing of success. This expedition occupied him till September, 1858, and was undertaken with the object of examining the country for runs. On his return the South Australian Government presented him with a large grant of land in the district which he had explored.

Mr. Stuart now turned his attention to crossing the interior, and, with the [financial] assistance of his friends Messrs. Chambers and Finke he was enabled to make two preparatory expeditions in the vicinity of Lake Torrens—from April 2nd to July 3rd, 1859, and from November 4th, 1859, to January 21st, 1860. The fourth expedition started from Chambers Creek (discovered by Mr. Stuart in 1858, and since treated as his head-quarters for exploring purposes), on March 2nd, 1860, and consisted of Mr. Stuart and two men, with thirteen horses. . . .

The following extracts are from Stuart's own entries of this fourth expedition between March and September 1860, when he penetrated to the geographical centre of Australia thus achieving what he and Sturt had failed to do in 1845.

John McDouall Stuart.

Wednesday, 4th April, Mount Humphries. . . . I have not passed through such splendid country since I have been in the colony. I only hope it may continue. The creek I have named the "Finke," after William Finke, Esq., of Adelaide, my sincere and tried friend and one of the liberal supporters of the different explorations I have had the honour to lead. . . .

Friday, 6th April, Small Gum Creek. . . . We were three-quarters of an hour in crossing the creek, and obtained an observation of the sun, 116°26′15″. We then proceeded on the same course towards the remarkable pillar, through high, heavy sand hills, covered with spinifex, and, at twelve miles from last night's camp, arrived at it. It is a pillar of sandstone, standing on a hill upwards of one hundred feet high. From the base of the pillar to its top is about one hundred and fifty feet, quite perpendicular; and it is twenty feet wide by ten feet deep, with two small peaks on the top. I have named it "Chambers Pillar," in honour of James Chambers, Esq., who, with William Finke, Esq., has been my great supporter in all my explorations. . . .

Thursday, 12th April, The Hugh. . . . We have now entered the lower hills of the range. . . . This is the only real range that I have met with since leaving the Flinders range. I have named it the "McDonnell Range", after his Excellency the Governor-in-Chief of South Australia, as token of my gratitude to him for his kindness to me on many occasions. . . .

Sunday, 22nd April, Small Gum Creek, under Mount Stuart, Centre of Australia. To-day I find from my observations of the sun, 111°00′30″, that I am now camped in the centre of Australia. I have marked a tree and planted the British flag there. There is a high mount about two miles and a half to the north-north-east. I wish it had been in the centre; but on it to-morrow I will raise a cone of stones and plant a flag there, and name it "Central Mount Stuart". . . . [It appears that in his original diary Stuart named this feature Central Mount Sturt, after his old exploring friend, but that in the first published account the name was changed to Central Mount Stuart.[9]]

Monday, 23rd April, Centre. Took Kekwick [a member of Stuart's party who also accompanied him on his journey in the following year] and the flag, and went to the top of the mount, but found it to be much higher and more difficult

9. Mona Stuart Webster, *John McDouall Stuart.* Melbourne, 1958.

of ascent than I anticipated. After a deal of labour, slips, and knocks, we at last arrived on the top. . . . The view to the north is over a large plain of gums, mulga, and spinifex, with watercourses running through it. . . . Built a large cone of stones, in the centre of which I placed a pole with the British flag nailed to it. Near the top of the cone I placed a small bottle, in which there is a slip of paper, with our signatures to it, stating by whom it was raised. We then gave three hearty cheers for the flag, the emblem of civil and religious liberty, civilization, and Christianity is about to break upon them. . . .

George French Angas's illustrations were used in the journals of both Stuart and Forrest. This one is of Chambers Pillar.

Stuart pushed on northwards past Newcastle Waters until forced to turn back towards the end of June 1860, due to the usual problems of desert explorers—lack of water and food and the resultant scurvy. Stuart was greatly disappointed at being forced to retreat after travelling so far. For this journey he was awarded the gold medal of the Royal Geographical Society of London. He made a second unsuccessful attempt to break through between January and September 1861. Hardman tells the story of Stuart's return to Adelaide and his setting forth again on his final expedition on which the continent would be crossed from south to north.

Mr. Stuart made his public entry into Adelaide on Monday, 23rd September [1861], and reported himself to the authorities. Almost at the same time the Victorian Government obtained their first traces of the survivors of the ill-fated expedition under Burke and Wills. The South Australian Government had such confidence in Mr. Stuart that, on his expressing his readiness to make another attempt to cross the continent, they at once closed with his offer, and in less than a month (on October 21st) the new expedition started from Adelaide to proceed to Chambers Creek, and get everything in order there for a final start. . . .

In no way discouraged either by his own unlucky accident [not long before setting out a horse had knocked him over and walked on his hand] and previous

want of success, or by the melancholy end of his brother explorers, Burke and Wills, Mr. Stuart arrived at Moolooloo [a station belonging to the Chambers brothers] on Friday, December 20th, and at Finniss Springs on the 29th.

The names of the party were as follows; —

John McDouall Stuart,	Leader of the Expedition.
William Kekwick,	Second Officer.
F. W. Thring,	Third Officer.
W. P. Auld,	Assistant.
Stephen King.	
John Billiatt.	
James Frew.	
Heath Nash.	
John McGorrerey,	Shoeing Smith.
J. W. Waterhouse,	Naturalist to the Expedition.

Besides these, there were at starting, Woodforde and Jeffries; but at Finniss Springs, the latter struck one of his companions, and, on being called to account by his leader, refused to go any further. As to the former, when quitting Mr. Levi's station on January 21st [1862], it was arranged, in order to lighten the weak horses, that the great-coats of the party should be left, but Woodforde objected to this, and said he would not go unless he had his great-coat with him. Mr. Stuart had very properly decided not to take any man who refused to obey orders, and he therefore started without him.

The party pushed north, passing the Centre on 12 March and reaching Newcastle Waters in early April. They were now moving into unfamiliar country. Extracts from Stuart's log entries follow.

Wednesday, 7th May, Howell Ponds. Resting. The natives have not again visited us, but their smoke is seen all around. . . .

Thursday, 8th May, Howell Ponds. . . . I am very much disappointed in the water-bags; in coming this distance of twenty-one miles they have leaked out nearly half. . . .

Saturday, 10th May, The Forest. Started at five minutes to seven o'clock a.m. (same course 290°). Almost immediately encountered a dense forest of tall mulga, with an immense quantity of dead wood lying on the ground. It was with the greatest difficulty that the horses could be made to move through it. . . .

Sunday, 11th May, The Forest. This morning the horse that was so bad last night was found dead, which puts us in a very awkward position — without a pack horse. We had to leave behind the pack-saddle, bags, and all other things we could not carry with us on our riding horses. . . . To make the Victoria through the country I have just passed into would be impossible. I must now endeavour to find a country to the northward and make the Roper. . . . [Stuart does not say why he altered his course, but it appears that he was probably influenced by a letter he would have received at the commencement of his journey from Frank Helpmann, who was on the *Beagle's* explorations in northern waters in 1839.]

Saturday, 31st May, Daly Waters. As there are no appearances of rain, the weather very hot, and I have a good deal of work in plans, &c. to bring up, I shall remain here until Monday. I feel this heavy work much more than I did the journey of last year; so much of it is beginning to tell upon me. I feel my capability of endurance beginning to give way. There are a number of small fish in this water, from three to five inches long, something resembling a perch; the party are catching them with hooks; they are a great relish to us, who have lived so long upon dry meat. Any change is very agreeable. . . .

Sunday, 22nd June, Rock Camp, River Strangways. A few heavy clouds about. We are now in the country discovered by Mr. Gregory [on the Northern Expedition]. There is a great deal of very good timber in the valley, which is getting larger and improving as we advance. It is still very thick — so much so, that the hills cannot be seen until quite close to them. Wind variable. Latitude,

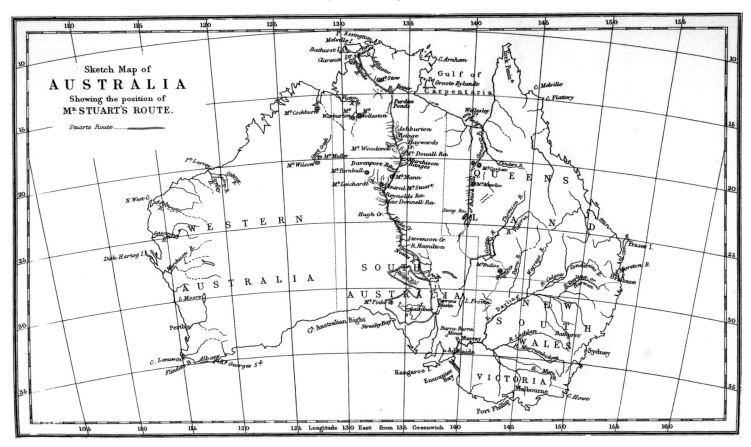

Sketch Map of
AUSTRALIA
Showing the position of
Mr STUART'S ROUTE.

Stuarts Route........

Sketch map of Australia showing Stuart's route, from The Journals of John McDouall Stuart.

15° 10' 30''. . . .

Tuesday, 24th June, Mussel Camp, River Strangways. With the sun there came up a very thick and heavy fog which continued for about two hours; it then cleared off and the day became exceedingly hot. The river, after rounding the hills (where we were camped), ran nearly east for three miles, meeting there a stony hill which again throws it into a northerly course. . . . The grass above our heads was so high and thick that the rear-party lost me and could not find the rocks; by "cooeing" I brought them to me again. Before I had heard them I had sent Thring back to pick up their tracks and bring them to the clear ground I was on with the rest of the party, but they arrived before he made up to them. The scrub is also very thick close to the river. Mr. Kekwick found cane growing in the bed, and also brought in a specimen of a new water-lily — a most beautiful thing it is; it is now in Mr. Waterhouse's collection. At twelve miles, finding some water, the horses being tired in crossing so many small creeks, and working through the scrub and long grass, I camped at the open ground. The country gone over to-day is again splendidly grassed in many places, especially near the river; it has very lately been burned by the natives. There are a great number of them running along the banks; the country now seems to be thickly inhabited. Towards the east and the north-east the country is in a blaze; there is so much grass the fire must be dreadful. I hope it will not come near us. The day has been most oppressively hot, with scarcely a breath of wind. Latitude, 14° 51' 51''.

Wednesday, 25th June, River Strangways. . . . I expect, in two or three miles, to meet with the Roper. At three miles struck a large sheet of deep clear water, on which were a number of natives, with their lubras and children; they set up a fearful yelling and squalling, and ran off as fast as they could. Rounded the large sheet of water and proceeded along it. At a mile, three men were seen following; halted the party, and went up to them. One was a very old man, one middle-aged, the third a young, stout, well-made fellow; they seemed to be friendly. Tried to make them understand by signs that I wished to get across the river; they made signs, by pointing down the river, by placing both hands together, having the fingers closed, which led me to think I could get across further down.

They made signs for us to be off, and that they were going back again. I complied with their request, and after bidding each other a friendly good-bye, we followed down the banks of the river, which I now find is the Roper. At seven miles tried to cross it, but found it to be impossible. . . . We are now north of Mr. Gregory's tracks. . . .

Saturday, 28th June, Roper River. As I shall be short of meat, I remain here to-day to cut up the horse and dry him. The water of this river is most excellent; the soil is also of the first description; and the grass, although dry, most abundant, from two to five feet high. This is certainly the finest country I have seen in Australia. . . .

Tuesday, 8th July, Water Creek in Stony Rises. . . . This [large creek] I have named the "Fanny", in honour of Miss Fanny Chambers, eldest daughter of John Chambers, Esq. . . . At two miles came upon another large creek. . . . This I have named the Katherine, in honour of the second daughter of James Chambers, Esq. . . .

Thursday, 10th July, Kekwick's Large Group of Springs. Started at eight o'clock; crossed the springs without getting any of the horses bogged. Proceeded on a north-west course, but at a mile and a half again came upon springs and running water; the ground too boggy to cross it. Changed to north; at three miles and a half on the course changed to north-west. Ascended some very rough stony hills, and got on the top of sandy table land thick with splendid stringy-bark, pines, and other trees and shrubs, amongst which, for the first time, we have seen the fan palm, some of them growing upwards of fifteen feet high; the bark on the stem is marked similar to a pineapple's; the leaf very much resembles a lady's fan on a long handle, and, a short time after it is cut, closes in the same manner. At half-past one crossed the table land — breadth thirteen miles. The view was beautiful. Standing on the edge of a precipice, we could see underneath, lower down, a deep creek thickly wooded running on our course; then the picturesque precipitous gorge in the table land; then the gorge in the distance; to the north-west were ranges of hills. The grass on the table land is coarse, mixed with a little spinifex; about half of it had been burnt by the natives some time ago. We had to search for a place to descend, and had great difficulty in doing so, but at last accomplished it without accident. The valley near the creek, which is a running stream, is very thickly wooded with tall stringy-bark, gums, and other kinds of palm-trees, which are very beautiful, the stem growing upwards of fifty feet high, the leaves from eight to ten feet in length, with a number of long smaller ones growing from each side, resembling an immense feather; a great number of these shooting out from the top of the high stems, and falling gracefully over, has a very pretty, light, and elegant appearance. Followed the creek for about two miles down this gorge, and camped on an open piece of ground. The top course of the table land is a layer of magnetic ironstone, which attracted my compass upwards of 20°; underneath is a layer of red sandstone, and below that is an immense mass of white sandstone, which is very soft, and crumbling away with the action of the atmosphere. In the valley is growing an immense crop of grass, upwards of four feet high; the cabbage palm is still in the creek. We have seen a number of new shrubs and flowers. The course of the table land is north-north-west and south-south-east. The cliffs, from the camp in the valley, seem to be from two hundred and fifty to three hundred feet high. Beyond all doubt we are now on the Adelaide river. Light winds, variable. Latitude, 13° 44' 14". [He was not on the Adelaide — that river lay farther to the west — but had discovered a new river which still bears the name of the Mary, a name which he bestowed on what he thought was a tributary of the Adelaide.]

Friday, 11th July, Adelaide River, North-west Side, Table Land. The horses being close at hand, I got an early start at 7.20, course north-west. In a mile I got greatly bothered by the boggy ground, and numbers of springs coming from the table land, which I am obliged to round. At two miles got clear of them, and proceeded over a great number of stony rises, very steep; they are composed of conglomerate quartz, underneath which is a course of slates, the direction of which is north-west, and lying very nearly perpendicular, and also some courses of ironstone, and a sharp rectangular hard grey flint stone. My horses being nearly all without shoes, it has lamed a great many of them, and, having struck

'The Gorge on the Mary River' by Stephen King who was a member of Stuart's expedition.

the river again at fifteen miles, I camped. They have had a very hard day's journey. The country is nearly all burnt throughout, but those portions which have escaped the fire are well grassed. I should think this is a likely place to find gold in, from the quantity of quartz, its colour, and having so lately passed a large basaltic and granite country; the conglomerate quartz being bedded in iron, and the slate perpendicular, are good signs. The stony rises are covered with stringy-bark, gum, and other trees, but not so tall and thick as on the table land and close to it, except in the creek, where it is very large; the melaleuca is also large. Since leaving the table land we have nearly lost the beautiful palms; there are still a few at this camp, but they are not growing so high; the cabbage palm is still in the creek and valleys. Light winds from south-east. Country burning all round. Latitude, 13° 38' 24". This branch I have named the "Mary", in honour of Miss Mary Chambers. [This stream was independent of the Adelaide.]

Saturday, 12th July, The Mary, Adelaide River. Started at 7.30; course, north-west. At one mile and a half came upon a running stream coming from the north-east; had great difficulty in getting the horses across, the banks being so boggy. One got fixed in it and was nearly drowned; in an hour succeeded in getting them all safe across. At six miles I ascended a high, tall, and stony hill; the view is not good, except to the westward. In that direction there is seemingly a high range in the far distance, appearing to run north and south; the highest point of the end of the range is west, to which the river seems to tend. My horse being so lame for the want of shoeing, I shall strike in for the river and follow it for another two miles, as it seems to run so much to the westward. I have resolved to use some of the horseshoes I have been saving to take me back over the stony country of South Australia. . . .

Sunday, 20th July, Anna Creek. The mosquitoes at this camp have been most annoying; scarcely one of us has been able to close his eyes in sleep during the whole night: I never found them so bad anywhere — night and day they are at us. The grass in, and on the banks of, this creek is six feet high; to the westward there are long reaches of water, and the creek very thickly timbered with melaleuca, gum, stringy-bark, and palms. Wind, south-east.

Monday, 21st July, Anna Creek and Springs. Again passed a miserable night with the mosquitoes. Started at eight o'clock; course, north-north-west. At three miles came upon another extensive fresh-water marsh, too boggy to cross. . . .

Thursday, 24th July, Thring Creek, Entering the Marsh. [Now known as Thrings Creek.] Started at 7.40, course north. I have taken this course in order to make the sea-coast, which I suppose to be distant about eight miles and a half, as soon as possible; by this I hope to avoid the marsh. I shall travel along the beach to the north of the Adelaide. I did not inform any of the party, except Thring and Auld, that I was so near to the sea, as I wished to give them a surprise on reaching it. . . .

At eight miles and a half came upon a broad valley of black alluvial soil, covered with long grass; from this I can hear the wash of the sea. On the other side of the valley, which is rather more than a quarter of a mile wide, is growing

a line of thick heavy bushes, very dense, showing that to be the boundary of the beach. Crossed the valley, and entered the scrub, which was a complete network of vines. Stopped the horses to clear a way, whilst I advanced a few yards on to the beach, and was gratified and delighted to behold the water of the Indian Ocean in Van Diemen Gulf, before the party with the horses knew anything of its proximity. Thring, who rode in advance of me, called out "The Sea!" which so took them all by surprise, and they were so astonished, that he had to repeat the call before they fully understood what was meant. Then they immediately gave three long and hearty cheers. The beach is covered with a soft blue mud. It being ebb tide, I could see some distance; found it would be impossible for me to take the horses along it; I therefore kept them where I had halted them, and allowed half the party to come on to the beach and gratify themselves by a sight of the sea, while the other half remained to watch the horses until their return. I dipped my feet, and washed my face and hands in the sea, as I promised the late Governor Sir Richard McDonnell I would do if I reached it.

The mud had nearly covered all the shells; we got a few however. I could see no sea-weed. There is a point of land some distance off, bearing 70°. After all the party had had some time on the beach, at which they were much pleased and gratified, they collected a few shells; I returned to the valley, where I had my initials (J.M.D.S.) cut on a large tree, as I did not intend to put up my flag until I arrived at the mouth of the Adelaide. Proceeded, on a course of 302°, along the valley; at one mile and a half, coming upon a small creek, with running water, and the valley being covered with beautiful green grass, I have camped to give the horses the benefit of it. Thus have I, through the instrumentality of Divine Providence, been led to accomplish the great object of the expedition, and take the whole party safely as witnesses to the fact, and through one of the finest countries man could wish to behold — good to the coast, and with a stream of running water within half a mile of the sea. From Newcastle Water to the sea-beach, the main body of the horses have been only one night without water, and then got it within the next day. If this country is settled, it will be one of the finest Colonies under the Crown, suitable for the growth of any and everything — what a splendid country for producing cotton! Judging from the number of the pathways from the water to the beach, across the valley, the natives must be very numerous; we have not seen any, although we have passed many of their recent tracks and encampments. The cabbage and fan palm-trees have been very plentiful during to-day's journey down to this valley. This creek I named "Charles Creek", after the eldest son of John Chambers, Esq.: it is one by which some large bodies of springs discharge their surplus water into Van Diemen Gulf; its banks are of soft mud, and boggy. Wind, south. Latitude, 12° 13′ 30″.

Friday, 25th July, Charles Creek, Van Diemen Gulf. [It seems likely that Charles Creek and Thrings Creek are the same; an entry on the original diary indicates that Stuart may have realised this. Charles Creek is not on present-day maps.] I have sent Thring to the south-west to see if he can get round the marsh. If it is firm ground I shall endeavour to make the mouth of the river by that way. After a long search he has returned and informs me that it is impracticable, being too boggy for the horses. As the great object of the expedition is now attained, and the mouth of the river already well known, I do not think it advisable to waste the strength of my horses in forcing them through, neither do I see what object I should gain by doing so; they have still a very long and fatiguing journey in recrossing the continent to Adelaide, and my health is so bad that I am unable to bear a long day's ride. I shall, therefore, cross this creek and see if I can get along by the sea-beach or close to it. Started and had great difficulty in getting the horses over, although we cut a large quantity of grass, putting it on the banks and on logs of wood which were put into it. We had a number bogged, and I was nearly losing one of my best horses, and was obliged to have him pulled out with ropes; after the loss of some time we succeeded in getting them all over safely.

Proceeded on a west-north-west course over a firm ground of black alluvial soil. At two miles came upon an open part of the beach, went on to it, and again

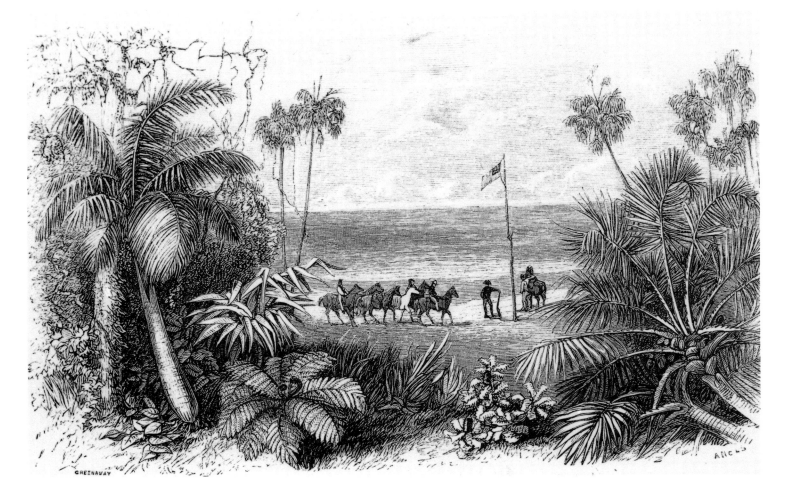

George French Angas's illustration of the historic moment when Stuart planted the British flag on the shores of the Indian Ocean.

found the mud quite impassable for horses; in the last mile we have had some rather soft ground. Stopped the party, as this travelling is too much for the horses, and, taking Thring with me, rode two miles to see if the ground was any firmer in places; found it very soft where the salt water had covered it, in others not so bad. Judging from the number of shells banked up in different places, the sea must occasionally come over this. I saw at once that this would not do for the weak state in which my horses were, and I therefore returned to where I had left the party, resolving to recross the continent to the City of Adelaide. I now had an open place cleared, and selecting one of the tallest trees, stripped it of its lower branches, and on its highest branch fixed my flag, the Union Jack, with my name sewn in the centre of it. When this was completed, the party gave three cheers, and Mr. Kekwick then addressed me, congratulating me on having completed this great and important undertaking, to which I replied. Mr. Waterhouse also spoke a few words on the same subject, and concluded with three cheers for the Queen and three for the Prince of Wales. At one foot south from the foot of the tree is buried, about eight inches below the ground, an air-tight tin case, in which is a paper with the following notice: —

"South Australian Great Northern Exploring Expedition.

"The exploring party, under the command of John McDouall Stuart, arrived at this spot on the 25th day of July, 1862, having crossed the entire Continent of Australia from the Southern to the Indian Ocean, passing through the centre. They left the City of Adelaide on the 26th day of October, 1861, and the most northern station of the Colony on 21st day of January, 1862. To commemorate this happy event, they have raised this flag bearing his name. All well. God save the Queen!"

(Here follow the signatures of myself and party.)

As this bay has not been named, I have taken this opportunity of naming it "Chambers Bay," in honour of Miss Chambers, who kindly presented me with the flag which I have planted this day, and I hope this may be the first sign of

'The Chambers's River' — also by Angas.

the dawn of approaching civilization. Exactly this day nine months the party left North Adelaide. . . . We then bade farewell to the Indian Ocean, and returned to Charles Creek, where we had again great difficulty in getting the horses across, but it was at last accomplished without accident. We have passed numerous and recent tracks of natives today; they are still burning the country at some distance from the coast. Wind, south-east. Latitude, 12° 14′ 50″. [He was near the mouth of the Mary River.]

RETURN.

Saturday, 26th July, Charles Creek, Chambers Bay, Van Diemen Gulf. This day I commence my return, and feel perfectly satisfied in my own mind that I have done everything in my power to obtain as extensive a knowledge of the country as the strength of my party will allow me. I could have made the mouth of the river, but perhaps at the expense of losing many of the horses, thus increasing the difficulties of the return journey. . . . [The party headed home over its own outward tracks, beset by hardships and with Stuart in very poor health.]

Monday, 11th August, River Chambers. Two of the horses having strayed this morning, it was a quarter past nine before I could get a start. I had to proceed very slowly, in consequence of five of the horses being so ill that they were unable to walk quickly. Proceeded on my former tracks, cutting off the bends of the river. In some places it is very stony. Late in the afternoon managed to get all the horses to the first camp on this river. Light winds, south-east.

Tuesday, 12th August, River Chambers. Horses missing again this morning. Started at half-past eight. Proceeded to the south-east end of the reedy swamp, and at half-past three o'clock camped. An hour before halting, we surprised a number of native women and children who were preparing roots and other things for their repast. The moment they saw us they seized on their children, placed them on their shoulders, and ran off screaming at a great rate, leaving all their things behind them, amongst which we saw a piece of iron used as a tomahawk; it had a large round eye into which they had fixed a handle; the edge was about the usual tomahawk breadth; when hot it had been hammered together. It had apparently been a hinge of some large door or other large article; the natives had ground it down, and seemed to know the use of it. Left their

articles undisturbed, and proceeded to the river Roper. My horses are still look-ing very bad. The cause must be the dry state of the grass; it is so parched up that when rubbed between the hands it becomes a fine powder, and they must derive very little nourishment from it. I can hear natives talking and screaming on the other side of the river, which at this place is a strong running stream about thirty yards wide and apparently deep. Wind, south-east, blowing strong. . . .

Wednesday, 20th August, Rocky Gorge, River Strangways. . . . I am yet suffering very much from scurvy; my teeth and gums are so bad that it causes me excess-ive pain to eat anything, and what I do eat I am unable to masticate properly, which causes me to feel very ill indeed. Light winds, south-east. . . .

Tuesday, 2nd September, East Newcastle Water. Proceeded to Lawson Creek, but found no water in the lower part. Went up into the gorge, and there found as much as will do; it also is nearly gone, but there are still a few feet of it. I had no idea that such a body of water could have evaporated so quickly, which now makes me very doubtful of the waters to the southward. Wind, south-east. . . .

Friday, 31st October, Clay-pans East of Mount Hay. I felt a little improvement this morning, which I hope will continue; and I think I have reached the turn of this terrible disease. On Tuesday night I certainly was in the grasp of death; a cold clammy perspiration, with a tremulous motion, kept creeping slowly over my body during the night, and everything near me had the smell of decaying mortality in the last stage of decomposition and of the grave. I sincerely thank the Almighty Giver of all Good, that He, in His infinite goodness and mercy, gave me strength and courage to overcome the grim and hoary-headed king of terrors, and has kindly permitted me yet to live a little longer in this world. Auld, who was in attendance upon me on that night, informed me that my breath smelt the same as the atmosphere of a room in which a dead body had been kept for some days. What a sad difference there is from what I am now and what I was when the party left North Adelaide! My right hand nearly useless to me by the accident from the horse; total blindness after sunset — although the moon shines bright to others, to me it is total darkness — and nearly blind during the day; my limbs so weak and painful that I am obliged to be carried about; my body reduced to that of a living skeleton, and my strength that of infantine weakness — a sad, sad wreck of former days. Wind variable.

Saturday, 1st November, Clay-pans East of Mount Hay. Although in such a weak state, I shall try if I can ride in the stretcher as far as Hamilton Springs. Started early; found the stretcher to answer very well. . . .

Friday, 14th November, Mulga Scrub. Started at six o'clock a.m. Examined the different creeks in which I found water on my journey to the north, but there was not a drop. At twelve miles reached the Coglin — none there. Country all in the same dry state. Proceeded on to the Lindsay, where I am sure of water. At four o'clock arrived there and found plenty. Camped. Thanks be to God, I am once more within the boundary of South Australia! I little expected it about a fortnight ago. If the summer rain has fallen to the south of this, there will be little difficulty in my getting down. I am again suffering very much from exhaus-tion, caused by a severe attack of dysentery, which has thrown me back a good deal in the strength I was collecting so quickly, but I hope it will not continue long. Wind, south-east. . . .

Thursday, 27th November, Mount Margaret Station. Resting horses. Sent out and had the one that knocked up about two miles from here brought in. I am still very ill, but am able to walk a few yards without assistance. I hope a few days will benefit me much. Day very hot. Wind, south-east. Clouds. . . .

Tuesday, 9th December, Mr. Glen's Station. Proceeded to Mount Stuart Station, where I had the pleasure of meeting Mr. John Chambers, who received me with great kindness. . . .

Wednesday, 10th December. . . . Accompanied by Mr. Chambers, proceeded to Moolooloo, and arrived there in the afternoon completely tired and exhausted from riding in the saddle. Day hot. Wind, east.

In conclusion, I beg to say, that I believe this country (*i.e.*, from the Roper to the Adelaide and thence to the shores of the Gulf), to be well adapted for the settlement of an European population, the climate being in every respect suitable, and the surrounding country of excellent quality and of great extent. . . .

9

The Great Sandy Desert

Peter Egerton Warburton (1813–99) started his career as a midshipman in the Royal Navy. He later went to India where he served as an army officer in Bombay until 1853 when he arrived in Adelaide to become commissioner of police. Falling into disfavour with the colonial government, he was dismissed from his post in 1867. Two years later he was appointed colonel of the Volunteer Military Force in South Australia.

During these years in South Australia, Warburton made a number of exploratory journeys out from Adelaide — recorded in South Australian Parliamentary Papers. But it was his journey of 1873 which made him famous.

He was 58 when he set out. The South Australian government had considered him to be too old to be given the leadership of the official expedition and instead appointed William Christie Gosse. Warburton, however, obtained the patronage of Thomas Elder and W. W. Hughes and set off from Alice Springs in 1873. His goal was the Oakover River on the west coast which the party reached some eight months later. His wanderings across the Great Sandy Desert and the hardships he encountered are vividly related in his journal from which the following extracts are taken.[1]

Gosse also left from Alice Springs in April 1873, but moved to a more southerly route, coming close to where Giles was also searching for assured water supplies that would enable him to make the western colony. Gosse went as far as the Barrow Range in Western Australia before he was forced to turn back. The information he carefully charted increased the knowledge of the country and assisted John Forrest when he made his successful west to east crossing through this region in the following year. Gosse's geographical consolation prize was his discovery of what would become Australia's great tourist attraction — Ayers Rock, which he noted in his diary[2] on 19 July, naming it after Sir Henry Ayers who was then premier of South Australia. To Warburton, however, went the honour of making the first transcontinental crossing through the interior.

We left Adelaide on the 21st September, 1872, reached Beltana Station on the 26th, and started thence for Alice Springs on the 3rd October. . . .

On the 21st December, 1872, we arrived at the station which was to be our starting-point for our journey westward, namely, Alice Springs. . . .

The party now consisted of myself, my son (Richard Egerton Warburton), J. W. Lewis, Sahleh and Halleem (two Afghan camel-drivers), Dennis White (cook and assistant camel-man), and "Charley" (a native lad). We had four riding, twelve baggage, and one spare camel, with six months' provisions, and started from Alice Springs on the 15th April, 1873. From this date I shall offer you extracts from my daily journal, which will enable you to follow out our course on the map more readily.

April 15th, 1873. As was to be expected, our first day's work was a mere getting under weigh. Two saddles broke, and the loads were unsteady. Partly owing to the camels being so fat, the saddles would not fit over their humps. This is a fault on the right side. . . .

May 1st. Following a south-westerly course, we found a shallow clay-pan and watered the camels. We came upon a large creek; but running the wrong way for the Finke; two hours afterwards struck another creek, also running in the wrong direction. This is our last hope, and it is now quite certain that the Finke does not run *through* the McDonnell Ranges but takes its rise in the midst of them. . . .

At 2 p.m. struck a small, poor-looking creek, but it had a pool of surface water, so we camped here, congratulating ourselves upon our first camp near surface water. The camels drank with apparent satisfaction, but when it came to our turn the water was so intensely bitter we could not use it. This water was beautifully clear, and had every appearance of being perfectly drinkable. Its bitterness was most intense, though none of the party were able to ascertain from whence this arose. The creek crosses the Tropic of Capricorn. . . .

Peter Egerton Warburton, his son Richard and J. W. Lewis. This photograph was taken in 1874, the year after the indomitable Warburton led his party over the Great Sandy Desert.

1. Peter Egerton Warburton, *Journey Across the Western Interior of Australia with an Introduction and Additions.* London, 1875.

2. 'Report and Diary of Mr. W. C. Gosse's Central and Western Exploring Expedition, 1873', in *South Australian Parliamentary Papers,* No. 48. 1874.

'The Waterhole' by Arthur Boyd. This painting captures the desolation and loneliness experienced by pioneers and explorers.

6th. The camels went off in the night; no great wonder, as they had nothing else to do. Starting at noon, we travelled eleven miles over the same country as yesterday, and reached the western end of Central Mount Wedge. We could not find any water, and things were not looking well. Camped in the afternoon under the mount and on the edge of our first salt-lake. In the night wild dogs were heard, and water-birds flew over us — both good signs. . . .

One of the water-searchers returned in the evening, having found some splendid waters in glens in the range. The Afghans, who had also gone out in the morning, returned; they had found no water, but, what was much worse, had contrived to lose a camel, or rather to let it run away with saddle and all equipments. This camel was a serious loss. . . .

12th. . . . I was much vexed at my carelessness in not knowing there was to be a total eclipse of the moon. I might have been prepared to some extent by rating my Adelaide timekeeper, and getting my true time at camp, and though I had no telescope that would note the different contacts and phases accurately, I might have approximately corrected my longitude. . . .

14th. . . . One camel useless from a sore back. This never ought to have happened, but the fault cannot now be remedied, so it need not be laid upon any particular shoulders. . . .

22nd. Five miles south-west along the foot of the range brought us to the water found yesterday. . . . It is the best place we have yet seen for a camp; running water, bulrushes, and gum-trees, with good feed for the camels, are not found every day in the centre of Australia in a year of drought.

The name "Eva Springs" with our camp brand W., and the year, are carved on a tree. . . .

23rd. I started with Richard and Charley (the black boy), south-west along the range, over villainous country. Something in the scrub frightened the leading camel, it turned suddenly round, and ran off as fast as it could; of course the

'The Start' — an illustration from Warburton's journal showing him at the head of his party as they move off westward from Alice Springs.

'24th of May. — "The Queen" ' — an
illustration from Warburton's journal.

other two followed its example, and shared its fright, though they could not have seen what caused it. Three men rushing wildly through the bush on runaway camels, which they dared not try to pull up for fear of breaking the nose-ropes, must have been a ludicrous sight, and when we collected our scattered forces and recovered our dropped articles, we all had a hearty laugh at each other. . . .

24*th*. Started for the hills over good travelling country, lightly scrubbed. At twelve miles struck a large gum-creek, bordered by exuberant vegetation, and forming a very fine piece of country. We crossed the creek, expecting to find water amongst the gum-trees ahead, but found none. Coming upon some good patches of cotton-bush, we camped, thinking to do the camels a kindness, but they would not remain on them because we had put them there.

It was a most uncomfortable place for us; the ants swarmed over everything, and over us; indeed they wanted to take away the cockatoos we had for dinner, but we rescued them. We had a little drop of rum, and did not forget to drink the health of "the Queen," this being her Majesty's birthday. Finding the camels would not stay where we wanted, there was no inducement for us to remain, so we saddled up and went back to the creek, where we had at least clean sand and no ants.

Sunday, 25*th*. We were obliged to move, not having found any water since leaving our depôt. We examined the mouth of the creek, which expended itself by inundating a large tract of level country, the vegetation exuberant but dry, with dry beds of back-water lagoons. Were it not a year of absolute drought, we should here have found plenty of water. . . .

28*th*. It rained all night, and we spent the whole morning drying our clothes. . . . it rained again heavily during the night, but, being now on a slope, we were not obliged, as we had been the night before, to dig trenches round our blankets to prevent being flooded out. The rain is a blessing; personal discomfort, therefore, is of no consequence. . . .

30*th*. Hoping to push through the bad country before us on the rain that had fallen, I broke up the camp and started west. . . .

5*th* [June]. Left the camp standing. Took Lewis and started west, for four miles through level scrub country between sand ridges; five more through a burnt, bare casuarina forest. Two miles farther a slight but extensive depression under a sand ridge. Here the vegetation was exuberant, tea-tree (*Leptospermum* or *Melaleuca*), spinifex, and scrub; searched all over it diligently for water, but found none; in fact, surface water cannot lodge on this country much longer than ten minutes, it must sink through the sand. This was a place which evidently received such excess of water as the surrounding country could not at once absorb, but it held none within our reach. We continued our journey; country slightly changing, and apparently improving. Camped, after doing forty miles,

under a low stony hill. We were now some few miles within Western Australia; being the first, I think, who had entered that province from South Australia, excepting just on the coast line. I greatly wished to go on next day, but our camels were not over-fresh, and it would have entailed an extra two days' halt on the main party, and have made it ten days before we could reach our nearest known water.

6th. . . . Reached the camp at 7 p.m. The only result of our eighty-mile ride being a conviction that for the present, at least, we must return to the clay pans of the 31st ult., and, if dried up, then back to the depôt creek [Eva Springs].

7th. The morning broke with an appearance of rain, but it will do us little good beyond what we can collect in a tarpaulin. As usual, when most wanted, ten camels had strayed back on the track and delayed our start.

Rain came on in the afternoon when we were on better holding-ground, and enabled us to water the camels. On to camp at eighteen miles.

Sunday, 8th. Continued on our back-tracks. All the surface water of the previous afternoon was dried up, and there was a cold south-easterly wind all day. Ascended a hill a few miles off the track, to examine what appeared a distant range to the northward, running east and west. We thought very favourably of it, and hoped to make west again into Western Australia by its aid. Camped at the place where we had been on the 2nd. . . .

18th. Returning. Caught sight of a *Lubra* (a native woman) with a small boy and an infant. My companions gave chase, but their camels did not like leaving the track, and would not step out; they bellowed lustily, which made the woman run faster; she tossed away everything but the baby, and escaped. Charley, however, captured the lad, who showed not the slightest fear, but looked at us and our camels as if quite accustomed to the sight. We put him on the camel, in front of Charley, and made signs for him to show us where we could find water. Even this unusual exaltation and mode of progression did not seem to frighten the urchin, who kept chattering and pointing to the west. We turned in that direction, but before we had got far Charley's sharp eyes detected some diamond-sparrows rising from the ground, and he immediately ran off to look for water.

He found a native well with some water, and we soon saw another close by. This discovery caused us immense joy, for we saw the water draining in as fast as we drew it out, and we thought we had now got the key of the country and would be able to get water by sinking in any suitable flat. . . . Watered the camels and filled our bags, then went on our way rejoicing that our long ride had not been useless. These we named the "Waterloo Wells". . . .

23rd, 24th, and 25th. Returned with the whole party to Waterloo Wells. We enlarged, cleared, and deepened them, getting an abundant supply of delicious water. Sahleh, one of the camel-men, was now very ill with scurvy; the other one is also lame and ailing, but not so bad. Towards evening Sahleh made his will, which he dictated to me in Hindustanee. . . .

26th. Sahleh is no worse to-day, but he won't allow that he is any better. The two wells which we cleared and enlarged yesterday have an abundant supply of water; they have sufficient for a depôt, should we be driven back again in our endeavours to cross this high table-land; but I hope we shall not be compelled to use them.

We started at 10 a.m. towards the west. After five miles' march we turned north-west, across a sand ridge; the country becoming slightly undulating with low hills visible to the north-west. Camped at 4 p.m., after travelling eighteen miles, between two widely separated sand ridges. Spinifex, scrub, and sands as usual. . . .

July 1st. Camels again absent. Started at 9 a.m.; more digging to-day, and no water. . . .

4th, 5th, and 6th. Sahleh has been nearly dead; he has lost the use both of his legs and arms; cannot move; can scarcely speak, and cannot take any food but rice-water. He is utterly powerless, and unable to travel unless I strap him on to a camel like a bag of flour, and this would probably kill him; so I shall remain here, and send out a reconnoitring party to-morrow.

7th. I sent Lewis and Dennis with three camels, a good supply of water,

and ten days' provisions. Lewis' instructions are to hunt and dig for water in any likely-looking places, in any direction except one with easting in it. . . .

9th and 10th. Sahleh is certainly better; we have discovered a small yellow berry in the scrub, which, after proving it not to be poisonous, we have made him eat.

11th and 12th. Ice a quarter of an inch thick in the buckets in the morning. . . .

19th. Lewis is not yet returned, and I am getting anxious about him. Six natives came to the camp, but we could not understand each other. We watched these scamps with the utmost care and closeness, as we thought, but they were too much for us, and stole an axe; this of course put an end to their visits. These blacks had been seen prowling about in the neighbourhood of the camp, and, by means of shouting and beckoning, were induced to visit it. They were fine, well-made men, most of them bearded, and, considering the wretched hand-to-mouth life they lead, were in very fair bodily condition. Clothing they possessed none; they were armed with spears and waddies, or short clubs, the latter of which they use to knock over the wallabies, a small species of kangaroo, on which they seem mainly to subsist.

After sunset Lewis returned, to our great relief. He brings good news, having found a place 100 miles distant, where water is procurable by digging. This is all we want, and gives us another secure step in our journey. . . .

Sunday, 20th. A happy day, at the prospect of leaving this place to-morrow.

In the evening, our native, Charley, who shepherds the camels, reported that three had run away southward. He had followed the tracks for several miles, and one camel had broken its hobbles. This was bad news, but Halleem, the camel-man, requested to be allowed to go after them, and said he would bring them back. I lent him "Hosee," my riding camel, and he started a little before 5 p.m. I expected him to push on five or six miles, then camp for the night, and to run the tracks smartly at daylight on Monday, when he would overtake the runaways and bring them back by midday.

21st. Looking every moment for Halleem and the camels. . . .

22nd. I sent my son and Charley with a week's provisions on our back-tracks, to try for Halleem first; but, in the event of not finding his *foot* tracks, to continue on, and endeavour to recover the camels. Lewis also went in the other direction, to run up Hosee's tracks, so that I hoped that by one or other of these means I should learn what had become of Halleem. Unfortunately, Lewis, supposing he had only a few hours' work, took neither food nor water. Now, 6 p.m., it is beginning to rain, and Lewis has not returned. I know he will stick to the tracks as long as he can, but I wish he were back; if Halleem be demented, he may urge the camel on sixty or seventy miles without stopping, and thus get a start in his mad career that will make it impossible for Lewis to help him.

23rd. It has rained lightly all night. Lewis is still absent; I am greatly grieved at his having nothing to eat.

1 p.m. Lewis returned; he had camped with Richard, and so was all right. . . . Richard returned having seen Halleem, and promised to take out provisions to meet him on his return. . . .

29th. The camel-hunters returned in the evening, but without the camels. This is a double loss; the camels are gone, and so is our time; our means of locomotion are much reduced, whilst the necessity of getting on is greatly increased. Halleem has, however, done all he could do; he followed the camels nearly 100 miles, but as they travelled night and day, whilst he could only track them by day, he never could have overtaken them. No doubt these animals will go back to Beltana, where alarm will be created as soon as they are recognized as belonging to our party.

The bolting of the camels was caused by a young bull, who cut off two cows and drove them away before him.

I had hoped to have been close to Perth by this time; how greatly have my expectations been disappointed! . . .

30th. Lewis, when last out, sunk a well about twelves miles from here, the only one out of nearly fifty in which water was procured. [This was the only

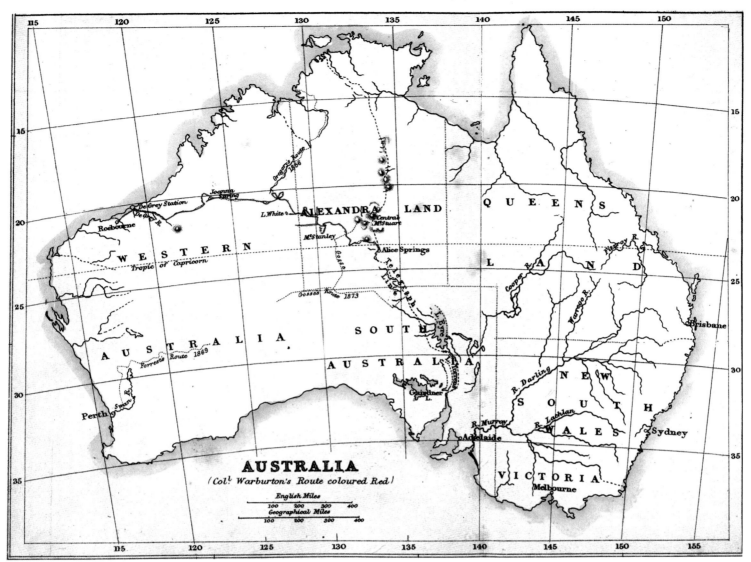

AUSTRALIA
(Col.ᵗ Warburton's Route coloured Red.)

time they succeeded in finding water by digging for it themselves.] We started for it to-day. After deepening the well and cleaning out dead rats, we had not time to get the water before one whole side fell in, and the work had to be done over again. I hope we have now bid a final adieu to the Waterloo Wells. . . .

August 1st. We continued the same general course for seventeen miles. Weather very sultry; rain seems to be near. The spinifex is so slippery the camels cannot keep their footing on it. Rain in the morning, and continued all night. . . .

5th. Travelled towards Mary Springs, passing a fine rock-hole, with water. Mount Russell, an isolated hill of no great altitude, but a good land-mark for finding the rock-hole, lies south-west from the water, distant about twelve miles. Mary Springs is a notable place; it is the nearest permanent water on the boundary. The supply is abundant and easily got at, in a sandy gully between two sandstone hills. Unfortunately I have lost the book containing the calculations of astronomical observations, but to the best of my recollection the variation of the compass was so slight at Mary Springs (under thirty minutes) as to justify the belief that the line of no variation runs very close to that place. This is the third time we have crossed into Western Australia; I hope our footing there is at last secure. . . .

7th. A camel calved this morning. We cut the calf's throat and deferred the start till the afternoon. This is our second calf; the camel-men ate the first at Waterloo Wells. . . .

9th. Travelled fifteen miles northward and westward. A strong easterly wind prevailed, blowing up clouds of sand and ashes from the burnt ground. Truly this is a desert! . . .

11th. I sent three parties out to look for water in different directions. . . .

Warburton's route across Australia from his Journey Across the Western Interior of Australia.

We were, however, induced to think there must be water somewhere in the direction taken by the third searcher, as he reported having seen flock-pigeons. . . . This is our last chance; if it fail, we must go over those terrible sand-hills again to our last water!

16*th*. We had scarcely travelled five miles to-day before a thick smoke arose close before us. How the blacks let themselves into this trap I don't know; they never would have set fire to the country had they seen us so close. Of course they paid the penalty of their carelessness, for we soon invaded their camp and took possession of an excellent well. This gave me an opportunity of fixing the camp for some days, whilst my son and I went out to see if we could find any break in the country to indicate the vicinity of Sturt Creek, discovered by A. C. Gregory in 1856. . . .

17*th*. Ascended the hill, but could see no sign at all of Sturt Creek or the lake. . . .

19*th*. My son and I started again north by east towards a high-looking range, in search of some signs of Sturt Creek. Travelled twenty miles over a most desolate, burnt country. Camels will eat almost all sorts of scrub, but we had difficulty in finding a mouthful for them here, and we ourselves were tormented all the afternoon and night by small black ants. We could get no firewood, so altogether had a pretty miserable time of it. . . .

22*nd*. Returning to our standing camp, we came upon some soft boggy ground on which the camels would not put a foot. . . . In good seasons there must be water about, and I daresay we might have found it by digging, but we had no spade. . . .

30*th*. Proceeded thirteen miles north-north-west to a fine fresh-water lake — large, but not deep all over. There were plenty of ducks, flock-pigeons and parrots. . . .

September 1*st*. . . . On the 30th, just before reaching the lake, we had captured a young native woman; this was considered a great triumph of art, as the blacks all avoided us as though we had been plague-stricken. We kept her a close prisoner, intending that she should point out native wells to us; but whilst we were camped to-day the creature escaped from us by gnawing through a thick hair-rope, with which she was fastened to a tree. We were quickly on her tracks, directly we discovered our loss, but she was too much for us, and got clear away. We had not allowed her to starve during her captivity, but she supplied herself from the head of a juvenile relation with an article of diet which our stores did not furnish. . . .

4*th*. Marched six miles west, and found a native camp and well. Could not catch a native there, they being too quick for us; not far, however, from the camp a howling, hideous old hag was captured, and, warned by the former escape, we secured this old witch by tying her thumbs behind her back, and haltering her by the neck to a tree. She kept up a frightful howling all night, during which time we had to watch her by turns, or she would have got away also. I doubt whether there is any way of securing these creatures if you take your eyes off them for ten minutes. North of us there is rather a good-looking range, running east and west, with a hopeful bluff at its western end; but I cannot go farther north whilst there is a hope of getting west. . . .

6*th*. Followed a general westerly course, eight miles. Smoke being seen a little to the south, we ran it up, and found a camp and well, but could not see any natives.

We let the old witch go. She was the most alarming specimen of a woman I ever saw; she had been of no use to us, and her sex alone saved her from punishment, for under pretence of leading us to some native wells, she took us backwards and forwards over heavy sand-hills, exhausting the camels as well as my small stock of patience. The well we found was in the opposite direction to the one she was taking us to. . . . [This turned out not to contain even sufficient water for one camel, so that the majority of the party had to backtrack to the well found on 4 September.]

8*th*, 9*th and* 10*th*. I and my comrade remained at camp. At 11.30 a.m. the party and camels returned; there had been much difficulty and hard work in watering them, the supply being scanty, and it took a whole night as well as the

day to satisfy them. The heat is now very great, and the camels are suffering from travelling during the day over the hot sand and steep hills; we are therefore obliged to send them on in the evening, but I shall continue day travelling myself, as long as I can get a camel to stand up. . . .

Sunday, 14th. Having no water to halt upon, we are obliged to move on. Baggage started with the moon; the course variable so as to cross the sand-hills at the easiest slope.

On reaching our camp eighteen miles distant, we found that the advance party had found a splendid well, or rather had made one in a good place; we have reason to be thankful, as this well saves us from going back over the stiff sand-hills we have crossed. The country has not improved, as I had hoped. I shall resume a west course to-morrow; my riding-camel has completely broken down, and could not bring me into camp to-day. She lay down, and we could only get her on her legs again by lighting some spinifex under her tail; but it was of no use, she could not travel, so I tied her to a bush and walked in.

I sent a man to lead in my camel; it is quite clear I must give up day travelling, the camels will be ruined by it.

15th. Obliged to halt; our master bull camel has eaten poison, and is very ill; this animal is of immense value, not only on account of his great strength, but because without his aid we shall scarcely be able to keep the young bulls in order, and they may run off with all our camels. Our lives almost depend on this sick camel. We have nothing to give the poor beast but a bottle of mustard, and that does not seem to do it much good. . . .

18th. Made eleven miles more to the west. Obliged to abandon two riding-camels at our last camp; they could not stir. We at first thought they were poisoned, but it now appears that they have been struck in the loins by the night wind. My son's riding-camel is also struck, it cannot draw its hind legs after it, so we kill it here for meat instead of leaving it to die. What destruction to us! our strongest bull and three riding-camels all gone in a day or so! What is to become of us, if this continue, I know not. . . .

20th. It is one year to-day since we left Adelaide! The two parties started as determined upon yesterday; owing to the reduced number (two only) and weak state of our riding-camels, we have been obliged to throw away the tents and most of our private property — keeping only guns and ammunition, and clothing enough for decency. The party on foot returned unsuccessful. They found a well, but could not dig to water, as the sand poured in from the sides faster than they could take it out. . . .

At 1 p.m. Charley returned with news that they had tracked the natives round from north-west to south-west, and found their well. . . .

21st. Closely as I am pressed for time, I think it best to remain here a few days. The season is one of drought, the country thickly covered with sand-hills and spinifex, the destructive heat makes it impossible to work our few camels during the day, and it is almost equally impossible to get over this rough ground in the dark. . . .

23rd. Halt. A small bit of hoop iron sharpened at one end, like a chisel, has been found here; I can only suppose it to have been obtained from the kegs, which Mr. F. Gregory abandoned some twelve years ago on his way to Mount McPherson. Two of our party have been away to-day; they have just returned, and report the discovery of a good well about seven miles off. . . .

Sunday, 28th. Halt to-day for the purpose of trying the country all round for water before we turn back; as we must do if unsuccessful. I sent out two of the party to search. The sand-hills are running us down too much to the north, but we cannot cross them in the dark without danger to our camels. In addition to the common flies which are quite bad enough, and the ants which nearly eat us up, we have the Australian bee or honey-fly to torment us. These insects stick to one most perseveringly, and though they don't sting, they smell badly, which is perhaps the reason they persist in walking up our nostrils.

Our water-searchers returned unsuccessful. Painful as retrogression is, it is the only safe course under the circumstances in which we are placed, so that in ten days we shall only have made a few miles progress. We are now on very short allowance, and seem to have the prospect of starvation before us. . . .

2nd [October]. . . . Our condition is indeed becoming very serious, owing to our want of provisions. We are placed in this dilemma: if we press forward, we run the chance of losing our camels and dying of thirst; if we stand still, we can only hope to prolong our lives, as God may enable us, on sundried camel flesh.

3rd. . . . Those improvident Afghans have consumed all their flour and meat, so I shall be obliged to give them some of our meat. We were all supplied originally with equal quantities, but whilst we have economized our store, they, who profess to be able to do with less than any one else, have now none at all.

Richard, Lewis, and Charley all out, looking for tracks. Our condition is so critical that I am determined, should it please God to give us once more water, so that we may not be compelled to go farther back, to risk everything, and make a final push for the river Oakover. Some of us might reach it, if all could not. I do not imagine the country we are now in is really any worse than that we have come through, but the loss of our riding-camels [only seven remained and three were very weak], and the length of time it has taken us to get through it, has left us without the means of searching, and without food, if we were able to search.

This day completes the year since we left Beltana. . . .

6th. . . . The intense heat, and the difficulty of the ground, when added to the poor food and the insufficient supply of water, are quite sufficient to account for the camels failing so quickly, and I know full well that every camel we lose carries away with it one of the hopes of our being able to save our lives. We are in the hands of God, and there is always hope whilst there is life. I am thankful to say I have neither fear nor fretfulness. . . .

7th. A strong hot wind from the south is blowing to-day. Our camels returned in the evening from water; they had gone off from the well of their own accord straight to a good water-hole, with limestone and sand; this is the first time they ever found water for themselves. All credit be to them for the same. . . .

13th. Cloudy to-day, but no rain. The camels seem pretty fresh now, so I shall break ground to-morrow at sunset, and go to the native camp, about three miles distant, towards the south-west; this will save our carrying water for a short distance over the sand-hills. Dennis White is ill; what is the matter with him, or what has caused his illness, I cannot tell; he seems to imagine the salt-bush is at fault, but I think I have eaten more of it than any one else, and have felt no ill effects. Most probably the camel-meat is the delinquent. Got a good latitude by a lucky hit in the middle of the night; Alpha Arietis and Canopus put me in latitude 20° 7′ 30″, so I have nearly one degree of latitude to play upon should want of water compel me to make more southing than my westerly course requires. Half a gale of wind from the south-east.

14th. Cloudy in the morning, but cleared up at eight o'clock. Dennis White still ailing, but not worse; he has had all the medicine our means afford, and our medical ignorance can prescribe. Fortunately sickness in the bush is rare.

Sent my son and Charley to the native camp, to make the blacks a little present in return for the wallaby, but they had left, taking a west-south-west course. [On 8 October Warburton had averted an attack by a group of Aboriginals, managing instead to obtain water and food from their camp.] I shall do the same; for as they had their women and children, as well as the lame man on one leg and a stick, with them, they are not likely to have gone away far from water. It is seldom that a crippled native is seen. This man had met with some accident by which the sinew of his leg became contracted. I shall stop at the well to-morrow to fill the bags and casks, and to look for the best course. If we can only get on fifty or sixty miles more to the west, and find a water to rest the camels on once more, I shall make a final push for the Oakover River. . . .

29th. A short rain-squall passed over us last evening; it has cooled the ground a little. Economy is of course the order of the day in provisions. My son and I have managed to hoard up about one pound of flour and a pinch of tea; all our sugar is gone. Now and then we afford ourselves a couple of spoonfuls of flour, made into paste. When we indulge in tea the leaves are boiled twice over. I eat my sun-dried camel-meat uncooked, as far as I can bite it; what I

cannot bite goes into the quart-pot, and is boiled down to a sort of poor-house broth. When we get a bird we dare not clean it, lest we should lose anything. . . .

31st. Half a gale from the eastward; most disagreeable, as it blows the sand over everything, and prevents our lighting a fire.

We started from camp No. 98 at 4.15 a.m., our general course being slightly to the westward of south for eleven miles. The camels did the journey well. The wind choked up the well, but it answers our purpose when cleared. We are all most thankful to have got away from No. 98 at last. We have now two known waters to the southward, which will give us all the southing we want; but unfortunately no westing, and leaves us a longer distance for our rush than I like; but I fear we must try it. . . .

Sunday, 2nd [November]. . . . The ants prevent our doing anything; they leave us no peace. I am afraid of losing the moon; and the comparatively cool nights; we are also eating up our small stock of camel-meat, so I must try to commence our flight on the 4th.

The gale of adversity sends us scudding under bare poles; but it seems our only chance to make a rush for the Oakover. We cannot hit upon any water more to the westward to start from, so we must take our chance of finding a little somewhere in the 150 miles of desert which separate us from that river. We had the misfortune to lose our bottomless bucket by the falling in of our well yesterday; fortunately no one was down it at the time, or he would have been instantly killed, and we should have known nothing about it for a long time. The depth of this well was unusually great, being over nine feet.

3rd. Hot day. The camels' well is a good one, and sufficient for their wants.

4th. We are to commence our flight to the Oakover at sunset. God grant us strength to get through! Richard is very weak, and so am I. To get rid of a small box, we selected a few bottles of homœopathic medicines for use and ate up all the rest. . . .

5th. A strong east wind is blowing. We are compelled to give up smoking whilst on short allowance of water. It is a deprivation, for smoke and water stand

'The Dust Storm. — Under the Lee'. — an illustration from Warburton's journal.

A modern painting of a dust storm in the desert, by Russell Drysdale.

in the place of food. We started west-south-west at 6.30 p.m., and made twenty-five miles, though we had most trying sand-hills to cross. I became quite unable to continue the journey, being reduced to a skeleton by thirst, famine, and fatigue. I was so emaciated and weak I could scarcely rise from the ground, or stagger half a dozen steps when up. Charley had been absent all day, and we were alarmed about him when he did not return at sunset. I knew not what to do. Delay was death to us all, as we had not water enough to carry us through; on the other hand, to leave the camp without the lad seemed an inhuman act, as he must then perish. It was six against one, so I waited till the moon was well up, and started at 9 p.m. We made about eight miles, and whilst crossing a flat heard, to our intense delight, a "cooee," and Charley joined us. Poor lad, how rejoiced we were to see him again so unexpectedly! The lad had actually walked about twenty miles after all the fatigue of the previous night's travelling; he had run up a large party of natives, and gone to their water. This news of more water permitted us to use at once what we had with us, and the recovery of Charley put us in good spirits. It may, I think, be admitted that the hand of Providence was distinctly visible in this instance. . . .

11*th*. . . . We killed our last meat on the 20th October; a large bull-camel has therefore fed us for three weeks. It must be remembered that we have no flour, tea, or sugar, neither have we an atom of salt, so we cannot salt our meat. We are seven in all, and are living entirely upon sun-dried slips of meat which are as tasteless and innutritious as a piece of dead bark. . . . Most of us are nearly exhausted from starvation, and our only resource is a camel, which would disappear from before us in a twinkling. . . .

12*th*. We find no appearance of change in the country, and suppose that we are either more to the eastward than we suppose, or else the head of the Oakover is laid down more to the eastward than it is. The error is most probably mine, as it is difficult to keep the longitude quite correct after travelling so many months on a general westerly course. Our position is most critical in consequence of the weakness of the camels. They cannot get over this terrible country and stand the fierce heat without frequent watering and rest. Without water we are helpless.

3 p.m. I have decided to send Lewis, the two camel-men, and the black boy on ahead with the best and strongest camels, to try and reach the river, returning to us with water if successful. . . .

My party at least are now in that state that, unless it please God to save us, we cannot live more than twenty-four hours. . . .

We have tried to do our duty, and have been disappointed in all our expectations. I have been in excellent health during the whole journey, and am so still, being merely worn out from want of food and water. Let no self-reproaches afflict any one respecting me. I undertook the journey for the benefit of my family, and I was quite equal to it under all the circumstances that could be reasonably anticipated, but difficulties and losses have come upon us so quickly for the last few months that we have not been able to move; thus our provisions are gone, but this would not have stopped us could we have found water without such laborious search. The country is terrible. I do not believe men ever traversed so vast an extent of continuous desert. . . .

14*th*. . . . At midday, whilst I was sipping in solitude a drop of water out of a spoon, Lewis came up with a bag of water. Never shall I forget the draught of water I then got, but I was so weak that I almost fainted shortly after drinking it. The advance party had run up a smoke and found a well about twelve miles off. Our lives were saved, but poor Charley was nearly killed. He had gone forward alone (at his own request, and as he had done before) to the native camp, the remainder of the party with the camels, keeping out of sight. The blacks treated Charley kindly, and gave him water, but when he cooed for the party to come up, and the camels appeared, then I suppose the men were frightened, and supposed Charley had entrapped them; they instantly speared him in the back and arm, cut his skull with a waddy, and nearly broke his jaw. . . .

15*th*. We made another effort at daylight to get on, but one of the camels broke down, though it had not carried a saddle. . . . My son and White returned to the well for more water and to bring out camels to carry the meat. Lewis

remained with me to cut up the camel and prepare it for carriage. We sent the head and tail, with the liver and half the heart and kidneys, to make soup for Charley, and a little picking for the rest. . . .

15th. Last night there was a moist sea air and things we have not had for a long time. Lewis and I stand steadily to the flesh-pots, the meat is now all ready for transport when the camels come up. A little food, plenty of water, and a sound night's rest have done me much good, though I am still too shaky to walk more than a few yards. I took a latitude that night 21° 0′ 28″, and time altitudes; watches 0° 1′ 25″ slow. I have lost the shades of my prismatic compass, and don't like meddling much with the sun, having already lost the sight of my left eye.

Richard came up with the camels. Took ourselves and our small quantity of scraggy meat to camp, where I found Charley better than I had expected, and I have now strong hopes he will survive. Native Australians take an immense deal of piercing and pounding without much permanent damage.

'Worn out by Starvation'.

17th. Dew again, and a westerly wind at night. We have found at this camp two large seashells, an old iron tomahawk, and part of the tire of a dray, which looks hopeful. . . . I will risk it no more, but shall send Lewis, who is the strongest of the party, and one companion with the two best camels, on a course from west by south to west-south-west. Two long night-marches ought, I think, to bring him to some change in the country indicative of the vicinity of the Oakover.

A few days ago I thought we had done with the sand-hills. It was a bitter mistake, we are as thick in them now as we were some months ago. Charley progressing favourably. . . .

19th. . . . My son is very ill, and so weak he can hardly move. We have finished all the meat we could scrape up to boil, and are now reduced again to a few bits of dried camel and water for our daily fare. Very great heat.

20th. . . . My great anxiety is now how to keep the party alive. . . .

22nd. Shot a kite, which served for dinner. . . .

25th. A very cool morning, which is a comfort to us. We have cleared up all the wild fruit in the vicinity of our camp, and are not able to go far to look for more.

I must defer killing till the last moment, but I don't see how I can put it off beyond to-morrow. 5 p.m. Lewis has returned; from his report I infer that he has struck the higher sources of the Oakover. . . .

28th. I sent off this morning to recover the gun and the rest of the things we had left behind. I had a narrow escape from a snake-bite last night. Whilst making from the camp-fire to my rug, I saw the reptile clearly in the moonlight, but not in time to alter my stride, and trod upon it about six inches above the tail. It turned upon me, of course, but whether it bit my trousers or not I don't know; if it did, I derived some advantage from my extra thinness, as it could not find the leg inside them. . . .

December 1st. . . . I trust we may get off with the moonlight. . . .

2nd. Toiled along for twenty miles; hoped to have got an hour or two of sleep, but the ants forbade it. Night-work, tropical heat, no sleep, poor food, and very limited allowance of water, are, when combined, enough to reduce any man's strength; it is no wonder then that I can scarcely crawl. What a country! did ever men traverse such a tract of desert? I think not.

3rd. Another twenty miles. Again tormented with ants, and could get no rest. They will not allow us to have any shade. I cannot stay under a bush, but am compelled in sheer despair to throw myself on the burning sand, and let the sun pour down upon me; this makes it too hot for the ants, and almost too hot for me also.

4th. Moved off this wretched place at noon; the camels did not feed, and we could get no rest, so there was no use in stopping; but one camel quickly knocked up with the heat, and we camped till 7 p.m. I became so ill this afternoon that I was quite unable to sit on the camel, and had to be tied at full length on the animal's back. What a jolting I got, as the long-legged animal took me head-foremost down the steep sand-hills.

These sand-hills never left us till we got on to the stony range, where at 2.15 a.m. we camped on a rocky creek, tributary to the Oakover.

'The Last Camel. — Camp on the Oakover' —
illustration from Warburton's journal.

We are all most thankful to have escaped with our lives out of the horrible desert which has so long hemmed us in on every side. . . .

6th. Started early down the creek. What a change from the terrible country we have so long been on! How beautiful the trees and the rank vegetation looked! . . .

Sunday, 7th. A most miserable day. Trifling as it may appear, the ants prevent our having a moment's rest, night or day, and we don't know when or how to escape them. . . .

11th. We continued down the creek, and cut the Oakover at the distance of about seven miles, a little below where the creek joins it. Our latitude is 21° 11' 23". We branded a tree, to mark the spot at which we came upon the river. . . .

13th. I sent off Lewis and one Afghan on the only two camels that would travel. They are to look for the station of Messrs. Harper and Co.; we do not know how far it may be, or whether it may not have been abandoned; but must take our chance; it is the only one we have. . . .

20th. To our great surprise we were awakened at 3 a.m. by the roaring of running water. The river was down, running with a current of about three knots an hour. In the evening there was not a drop of water in the bed of the river, — in the morning a stream 300 yards wide was sweeping down with timber and ducks floating on it. It was well for us we had shifted our camp and got on high ground. The sight was most beautiful at sunrise, and indeed this is a noble river, even high up it as we are. . . .

Christmas Day. [1873] We cannot but draw a mental picture of our friends in Adelaide sitting down to their Christmas dinner, whilst we lie sweltering on the ground starving, and should be thankful to have the pickings out of any pig's trough. This is no exaggeration, but literal truth. We cut out three bee-holes to-day, but found no honey in any of them. No sign of Lewis. If he is not here by the close of Sunday next, I shall be obliged to suppose he has gone to Roebourne, in which case there can be no hope of his return for the next three weeks, and, except God grant us His help, we cannot live so long on our present supply.

Our lives have been preserved through many and great dangers, so my trust is in God's mercy towards us; it never fails, though it does not take always

'The Relief' — also from Warburton's journal.

the course we look for. . . .

29th. Sahleh's finger is very bad indeed from the scorpion sting. The state of our blood allows no wound to heal of itself, and I have no medicine suitable to his case. If it continues to get worse without any prospect of surgical aid, some one (not I) will have to chop his finger off with a tomahawk, or he will lose his arm and his life.

Lewis not having returned, I am compelled to think either that there is no station on the De Grey [River], or that he has missed it and gone on to Roebourne, in which case he cannot be back for a fortnight. . . . Our difficulties are, to make our meat last, though, so far from doing us good, we are all afflicted with scurvy, diarrhœa, and affection of the kidneys from the use of it. We cannot catch the fish, we cannot find opossums or snakes, the birds won't sit down by us, and we can't get up to go to them. . . .

We must wait patiently. I am sure Lewis will do all that can be done. His endurance, perseverance, and judgment are beyond all praise, and his various services have been most valuable. My great fear is that the summer rains may set in and stop his return, but we must hope for the best.

A few hours after making the above entry in my journal Lewis returned with an ample supply for all our wants, and with six horses to carry us down! . . . We all feel most grateful to Messrs. Grant, Harper, and Anderson for their promptitude and liberality. . . .

I have now only to close my journal. All distances forwards and backwards included, our land travelling, as nearly as I can estimate it, has amounted to 4000 miles, and our sea voyage to 2000.

We have all got through our trials better than could have been expected. I believe my son and myself are the only two European sufferers. I have lost the sight of one eye, and my son is much shaken in health. Sahleh the Afghan left his finger in Roebourne. Beyond this I know of no harm that has been done.

We started with seventeen camels and ended with two. . . .

And now, in conclusion, I would desire first to acknowledge with praise and thanksgiving the goodness and mercy of the Almighty God towards us in saving our lives through many perils. Then I would express our gratitude to the whole colony of Western Australia. . . . All our wants were anticipated; we were received as honoured guests, and welcomed everywhere by all classes.

10

John Forrest's Explorations

In Search of Leichhardt

Sir John Forrest, surveyor, explorer, politician.

1. John Forrest, *Explorations in Australia:*
I. — Explorations in search of Dr. Leichhardt and
party. II — From Perth to Adelaide, around the Great
Australian Bight. III — From Champion Bay, across
the desert to the Telegraph and to Adelaide. London,
1875.

2. Alex. Forrest, 'Journal of Expedition from
deGrey to Port Darwin', in *Western Australian*
Parliamentary Papers, No. 3. 1880.

Sir John Forrest, 1st Baron Forrest of Bunbury (1847–1918), was born and educated in Western Australia. He trained as a surveyor and by the age of eighteen had commenced work in the office of the surveyor general of Western Australia. He remained here until 1890, finally becoming surveyor general and commissioner of Crown lands. Exploration was but one portion of a long and influential career — he was subsequently Western Australia's first premier and held various positions in early Federal governments until the year of his death.

Forrest was a meticulous surveyor, which gave meaning to his journey around the Bight — a trek which Eyre had already accomplished thirty years before. Despite Warburton's achievement of 1873, Forrest's third expedition to the newly completed Overland Telegraph Line was his most important journey. New ground was covered and the veil of mystery over Australia's inland was almost dispelled. The extracts below come from the account of his three major journeys published during a visit to London.[1]

Forrest was ably assisted by his brother, Alexander, who also became an explorer in his own right. In 1879 Alexander explored the Kimberley district and the rich pastoral country of the northwest, to which graziers flocked and which greatly accelerated the development of Western Australia.[2]

Early in 1869, Dr. Von Mueller, of the Melbourne Botanic Gardens, a botanist of high attainments, proposed to the Government of Western Australia that an expedition should be undertaken from the colony for the purpose of ascertaining, if possible, the fate of the lost explorer, Leichardt.

I was then, as now, an officer of the Survey Department, and employed in a distant part of the colony. . . . I had long felt a deep interest in the subject of Australian exploration, and ardently desired to take my share in the work. I at once arranged the equipment of the expedition, but, while so engaged, the mail from Melbourne brought a letter from Dr. Von Mueller, to the effect that his other engagements would not permit him to take the lead as proposed, and I was appointed to take his place in the expedition. . . .

The Hon. Captain Roe, R.N., the Surveyor-General, who had himself been a great explorer undertook the preparation of a set of "Instructions" for my guidance. . . .

Survey Office, Perth,
13th April, 1869

Sir, — His Excellency the Governor having been pleased to appoint you to lead an expedition into the interior of Western Australia for the purpose of searching for the remains of certain white men reported by the natives to have been killed by the aborigines some years ago, many miles beyond the limits of our settled country, and it being deemed probable that the white men referred to formed part of an exploring party under the command of Dr. Leichardt, endeavouring to penetrate overland from Victoria to this colony several years ago, I have been directed to furnish the following instructions for your guidance on this interesting service, and for enabling you to carry out the wishes of the Government in connexion therewith.

2. Your party will consist of six persons in the whole, well armed, and made up of Mr. George Monger as second in command, Mr. Malcolm Hamersley as third in command, a farrier blacksmith to be hired at Newcastle, and two well-known and reliable natives, Tommy Windich and Jemmy, who have already acquired considerable experience under former explorers. . . .

The party left Perth on 15 April and by 5 May reached Mount Churchman. A few days more and they were at Lake Barlee which they named after Western Australia's colonial secretary.

A photograph of Perth taken from Mt. Eliza in 1868.

21st [May 1869]. Went over to the lake in company with Messrs. Monger, Hamersley, and Tommy Windich, with four horses. Succeeded in getting all the loads to the mainland, carrying them about three quarters of a mile up to our knees in mud, from which point the lake became a little firmer, and the horses carried the loads out. I cannot speak too highly of the manner in which my companions assisted me on this trying occasion. Having been obliged to work barefooted in the mud, the soles of Mr. Hamersley's feet were in a very bad state, and he was hardly able to walk for a fortnight. Seeing a native fire several miles to the southward, I intend sending Tommy Windich and Jemmy in search of the tribe tomorrow, in order that I may question them respecting the reported death of white men to the eastward. . . . [It was Jemmy who had given Monger the story of the murdered white men.]

18th [June]. Having thus made an exhaustive search in the neighbourhood where Jemmy expected to find the remains of the white men, by travelling over nearly the whole of the country between latitude 28° and 29°30' south and longitude 120° and 121° east, I determined to . . . proceed as far eastward as possible. . . . [Forrest passed and named Mount Malcolm, Mount Flora, Mount Margaret and Mount Weld. Early in July he weighed the rations and decided to return to Perth, which he reached a month later. On this journey he had travelled over 3000 kilometres.]

'The Horses bogged at Lake Barlee' by George French Angas who drew the illustrations for the engravings in Forrest's journal.

With reference to the country travelled over, I am of opinion that it is worthless as a pastoral or agricultural district; and as to minerals I am not sufficiently conversant with the science to offer an opinion, except that I should think it was worth while sending geologists to examine it thoroughly. . . .

So far as the mystery on which the fate of Leichardt is involved was concerned, my expedition was barren of results; but the additional knowledge gained of the character of the country between the settled districts of Western Australia and the 123rd meridian of east longitude, well repaid me, and those of the party, for the exertions we had undergone.

Immediately on my return to Perth a new expedition was suggested by Dr. Von Mueller, whose anxiety for the discovery of Leichardt was rather increased than abated by the disappointment experienced. . . .

I should have been well satisfied to undertake an expedition in the proposed direction, starting from the head of the Murchison, and trying to connect my route with that of Mr. A. Gregory's down Sturt Creek; but the difficulty of obtaining funds and lack of support caused the project to be set aside or at least delayed. Mr. Weld, then Governor of Western Australia, who always heartily supported explorations, was in favour of an attempt to reach Adelaide by way

Around the Bight

of the south coast, and offered me the command of an expedition in that direction. . . .

Of the route nothing was known except the disastrous experience of Mr. Eyre in 1840 and 1841. . . . The fearful privations he endured, his narrow escape from the most terrible of all forms of death, were certainly not encouraging; but his experience might often be of service to others, pointing out dangers to be avoided, and suggesting methods of overcoming difficulties We were not, however, deterred from the attempt, and on the 30th of March, 1870, we started from Perth on a journey which all knew to be dangerous, but which we were sanguine enough to believe might produce considerable results. . . .

My party was thus composed: — I was leader; the second in command was my brother, Alexander Forrest, a surveyor; H. McLarty, a police constable; and W. Osborne, a farrier and shoeing smith, — these with Tommy Windich, the native who had served me so faithfully on the previous expedition, and another native, Billy Noongale, an intelligent young fellow, accompanied us.

Before I enter upon the details of my journey it may be useful to state as briefly as possible the efforts made to obtain a better acquaintance with the vast territory popularly known as No Man's Land, which had been traversed by Eyre, and afterwards to summarize the little knowledge which had been obtained.

In 1860 Major Warburton . . . contrived to reach eighty-five miles beyond the head of the Bight, and made several journeys from the coast in a north and north-westerly direction for a distance of about sixty miles. Traces of Eyre's expedition were then visible. . . .

Two years afterwards other explorations were attempted, and especially should be noted Captain Delessier's. He was disposed to think more favourably of the nature of the country. The enterprise of squatters seeking for "fresh fields and pastures new," — to whom square miles represent less than acres to graziers and sheep farmers in England — is not easily daunted. They made a few settlements; but the scanty pasturage and the difficulty of obtaining water, by sinking wells, in some instances to the depth of over 200 feet, have been great drawbacks.

It might naturally be inquired why no attempts were made to reach the coast of the Great Bight by sea? But for hundreds of miles along the shores of the Bight no vessel could reach the shore or lie safely at anchor. Long ranges of perpendicular cliffs, from 300 to 400 feet high, presented a barrier effectually forbidding approach by sea. About 1867, however, an excellent harbour was discovered about 260 miles to the west of Fowler's Bay. The South Australian Government at once undertook a survey of this harbour, and Captain Douglas, President of the Marine Board, the officer entrusted with this duty, reported in the most favourable terms. The roadstead, named Port Eucla, was found to afford excellent natural protection for shipping. . . .

We started from Perth on the afternoon of Wednesday, the 30th of March, 1870. His Excellency the Governor accompanied us for about three miles on the Albany Road. We had fifteen horses, and provisions sufficient for the journey to Esperance Bay, a distance of about 450 miles, where, it was arranged, further supplies would await us [The governor's instructions also stated that the schooner *Adur* was to meet the party at certain points around the coast with provisions.]

24*th* [April] (*Sunday*). Left camp in company with Billy Noongale, and proceeded to Esperance Bay, distant twenty-four miles. . . . Was very kindly received by Mrs. Andrew Dempster; the Messrs. Dempster being away on Mondrain Island. . . .

29*th* On ascending the Look-out Hill this evening, was rejoiced to espy the "Adur" near Cape Le Grand, making in for the Bay, and at 8 o'clock went off in Messrs. Dempster's boat, and had the great pleasure of finding all hands well. . . .

The Messrs. Dempster, whose hospitality was so welcome, are good specimens of the enterprising settlers who are continually advancing the frontiers of civilization, pushing forward into almost unknown regions, and establishing homesteads which hereafter may develop into important towns

May 9th. After collecting the horses, we saddled up and started *en route* for

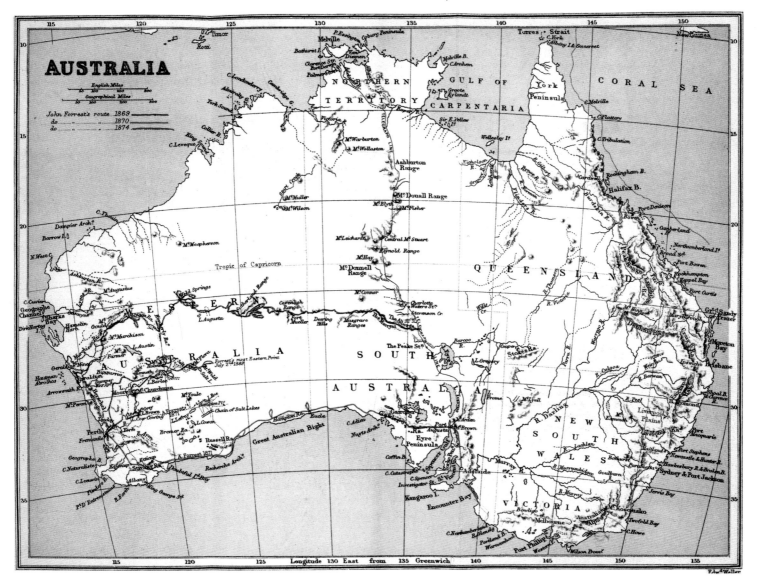

The journeys of John Forrest from his Explorations in Australia.

Israelite Bay, where I had instructed the master of the "Adur" to meet us. . . .

18*th*. After starting the party, went in advance with Billy to prepare camp at Israelite Bay. . . . Our friends on the "Adur" were looking anxiously for us. We were two days behind the appointed time. . . .

I had fixed the 30th as the time for our fresh start, and we had enough to do in packing bags, and making general repairs and improvements in our outfit. Eucla Bay, the only other point at which we should be able to communicate with the coaster, was 350 miles to the east of Israelite Bay. The nature of the country was quite unknown, except so far as indicated by the not very encouraging record of Eyre's journey. . . . I deemed it right to give explicit directions to Mr. Waugh, the master of the schooner, so that, in the event of not meeting with us at the appointed place, he should have no difficulty as to the course to pursue. . . .

On Sunday, the 29th of May, all hands came ashore to dinner. It was certainly a festive party under rather extraordinary circumstances, but it was heartily enjoyed. . . . We had rested for eleven days. Good food had restored the condition of the horses, and we rested in our camp in good spirits, ready for the work we were to begin on the following morning. . . .

May 30th. After bidding good-bye to the crew of the "Adur" . . . we left Israelite Bay *en route* for Eucla, and steered in a northerly direction for about fifteen miles over salt marshes and clay pans, with dense thickets intervening, destitute of grass. . . .

5*th* [June] (*Sunday*). Rested at camp. Read Divine Service. Intend making preparations to-morrow for starting on Tuesday morning, and attempt to reach

the water shown on Mr. Eyre's track, in longitude 126°24′E., 150 miles distant, by carrying thirty gallons of water with us and walking in turns, so as to have the horses to carry the water. Intend allowing each man one quart and each horse two quarts per day. Feel very anxious as to the result, as it will take five or six days; but it is the only resource left. After explaining my views to my companions, and pointing out the great probability of our meeting with small rock water-holes, was much relieved by the sanguine way in which they acquiesced in the plans, and the apparent confidence they placed in me. . . .

8*th*. Started early and steered about N.E. through dense mallee thickets. . . . Marked a tree at camp, "F., 1870." My brother, I am sorry to say, left his revolver at our last night's bivouac, and did not notice it until this evening, when it was too far to send back for it. . . .

10*th*. . . . Our horses appear fearfully distressed this evening. For the last ninety-six hours they have only had two gallons each. . . .

13*th*. Made an early start, and steering a little to the south of east, keeping straight for the water in longitude 126°24′E. [This was the waterhole marked on Eyre's map mentioned earlier.] At eighteen miles got a view of the sea, and beheld the sand-hills about fifteen miles ahead. Here we saw some natives' fires close to us. Approaching them, we came upon an old woman, and my brother and Tommy soon brought a man to bay. There were about twenty round us; they appeared very frightened. After detaining them half an hour, and treating them as kindly as possible, we bade them farewell and continued our journey. . . .

14*th*. . . . Tommy found a place used by the natives where water could be procured by digging. . . . we were all thankful to that Providence which had guarded us over 150 miles without finding permanent water. We soon pitched camp, and took the horses to the feed, which was excellent. Returning, we were surprised to see a vessel making in for the land, and soon made her out to be the "Adur". . . . I afterwards ascertained that they were not sure of their longitude, having no chronometer on board, and therefore wished to see some land mark.

23*rd*. Made preparations for a start for Eucla to-morrow, and put everything in travelling order. . . . In looking round the camp, Tommy Windich found shoulder-blade of a horse, and two small pieces of leather. They no doubt belonged to Mr. Eyre's equipment, and, on reference to his journal, I find he was here obliged to kill a horse for food. . . . I cut off part of the shoulder blade, and have since given it, together with the pieces of leather, to his Excellency Governor Weld. . . .

2*nd* [July]. Made an early start and steered straight for the anchorage, distant about five miles, having first ascended the range to have a view of the country, which was very extensive. Far as the eye could reach to the westward the Roe Plains and Hampton Range were visible; while to the eastward lay Wilson's Bluff and the Delissier sand-hills; and three miles west of them we were delighted to behold the good schooner "Adur," riding safely at anchor in Eucla harbour, which formed by no means the least pleasing feature of the scene to our little band of weary travellers. Made at once for the vessel, and, on reaching her, found all well and glad to see us. . . .

We had now accomplished rather more than half the distance between Perth and Adelaide, but there was still a gap of 140 miles to be bridged over. We bade good-bye to our friends on board the "Adur," and were now thrown entirely on our own resources.

July 8*th*. Started in company with my brother and Billy, having three riding horses and a pack horse, to penetrate the country to the northward. Travelled in a northerly direction for about twenty-seven miles, over plains generally well grassed, and then bivouacked. From the camp only plains were in sight, not a tree visible. Did not meet with a drop of water on our way, and, having brought none, we had to do without it. This season is too dry to attempt to cross these vast grassy plains, and I shall return to camp to-morrow — the attempt to get inland without rain only exhausting ourselves and horses to no purpose. . . .

11*th*. Osborn busy with the shoeing. Went with Billy to Wilson's Bluff, and saw the boundary-post between South and Western Australia, placed by Lieuten-

ant Douglas. Returned at sun-down.

12*th*. Erected the flagstaff with the Union Jack flying, and nailed a copper plate to the staff, with the following engraved on it:

"WESTERN AUSTRALIA. ERECTED BY

J. FORREST, JULY 12TH, 1870". . . .

14*th*. Bidding farewell to Eucla and the Union Jack, which we left on the flagstaff, we started for the Head of the Bight, carrying over thirty gallons of water with us, and walking in turns. . . .

16*th*. At 1 a.m. went with Billy to bring back the horses, which had again made off. . . . At eighteen miles came to the sea, but could find no water. . . . This is the third day without a drop of water for the horses, which are in a frightful state. Gave them each four quarts from our water-drums, and I hope, by leaving a little after midnight, to reach the Head of the Bight to-morrow evening, as it is now only forty miles distant. By observation, camp is in latitude 31°32'27"S., and longitude 130°30'E.

17*th*. Was obliged to get up twice to bring back the horses, and at four o'clock made a start. The horses were in a very exhausted state; some having difficulty to keep up. About noon I could descry the land turning to the south-ward, and saw, with great pleasure, we were fast approaching the Head of the Great Australian Bight. Reached the sand-patches at the extreme Head of the Bight just as the sun was setting, and found abundance of water by digging two feet deep in the sand. We all felt very tired. During the last sixty hours I have only had about five hours' sleep, and have been continually in a great state of anxiety — besides which, all have had to walk a great deal.

18*th*. This is a great day in my journal and journey. After collecting the horses we followed along the beach half a mile, when I struck N. for Peelunabie well, and at half a mile struck a cart track from Fowler's Bay to Peelunabie. After following it one mile and a quarter, came to the well and old sheep-yards, and camped. Found better water in the sand-hills than in the well. There is a board nailed on a pole directing to the best water, with the following engraved on it: "G. Mackie, April 5th, 1865, Water ☞ 120 yards." Upon sighting the road this morning, which I had told them we should do, a loud and continued hurrahing came from all the party, who were overjoyed to behold signs of civilization again. . . .

23*rd*. Although the feed was short, our horses did not stray, and after saddling up we continued along road for two and a half miles, and reached Colona, the head station of Degraves and Co., of Victoria, where we were most hospitably received by Mr. Maiden, the manager. . . .

24*th*. Rested at Colona. In the afternoon was rather surprised at the arrival of Police-trooper Richards and party, who were on their way to try and find out

'Arrival at the Great Australian Bight', from Forrest's journal.

'Public Welcome at Adelaide' — from Forrest's journal.

our whereabouts. He handed me a circular for perusal, stating that anything I required would be paid for by the South Australian Government. . . .

27*th*. Travelled towards Fowler's Bay, and at ten miles reached Yallata, the residence of Mr. Armstrong, where we had dinner, and afterwards reached Fowler's Bay and put up at the police-station. . . .

On August 24th reached Riverton, and on the 25th Gawler. On the 26th we arrived at Salisbury, twelve miles from Adelaide. Through all these towns we have been most cordially received, and I shall never forget the attention and kindly welcome received on the journey through South Australia.

On the 27th August we left Salisbury and for an account of our journey from there to Adelaide I cannot do better than insert an extract from the *South Australian Register* of August 27th, 1870: —

"On Saturday morning the band of explorers from Western Australia, under the leadership of Mr. Forrest, made their entrance into Adelaide. They left Salisbury at half-past nine o'clock, and when within a few miles of the city were met by Inspector Searcy and one or two other members of the police force. Later on the route they were met by an escort of horsemen, who had gone out to act as a volunteer escort. . . . The whole party at once rode up to Government House, where they were received by his Excellency, who was introduced to all the members of the expedition, and spent a quarter of an hour in conversation with Mr. Forrest, and in examining with interest the horses and equipments, which all showed signs of the long and severe journey performed. Wine having been handed round, the party withdrew, and were again greeted at Government Gate by hearty cheers from the crowd, which now numbered several hundreds. They then proceeded by way of Rundle Street to the quarters assigned them at the police barracks. The men are to remain at the barracks and the officers are to be entertained at the City of Adelaide Club". . . .

[After two weeks in Adelaide, Forrest returned onboard the *Branch* mail steamer to Perth where further celebrations awaited him.]

A four-in-hand drag was despatched to bring us into the city, and a procession, consisting of several private carriages, a number of the citizens on horseback, and the volunteer band, escorted us. The city flag was flying at the Town Hall, and there was a liberal display of similar tokens from private dwellings. The Governor and his aide-de-camp came out five miles to meet us. . . .

The success which had attended my previous expeditions, and the great encouragement received from the Government and public of each colony, made me wish to undertake another journey for the purpose of ascertaining whether a route from Western Australia to the advanced settlements of the Southern colony was practicable. . . .

In July, 1872, I addressed the following letter to the Honourable Malcolm Fraser, the Surveyor-General: —

> Western Australia, Perth,
> July 12th, 1872.
>
> Sir, — I have the honour to lay before you, for the consideration of his Excellency the Governor, a project I have in view for the further exploration of Western Australia.
>
> My wish is to undertake an expedition, to start early next year from Champion Bay, follow the Murchison to its source, and then continue in an east and north-east direction to the telegraph line now nearly completed between Adelaide and Port Darwin; after this we would either proceed north to Port Darwin or south to Adelaide.
>
> The party would consist of four white and two black men, with twenty horses, well armed and provisioned for at least six months.
>
> The total cost of the expedition would be about 600 [pounds], of which sum I hope to be able to raise, by subscriptions, about 200 [pounds].
>
> The horses will be furnished by the settlers, many having already been promised me.
>
> The geographical results of such an expedition would necessarily be very great; it would be the finishing stroke of Australian discovery; would be sure to open new pastoral country; and, if we are to place any weight in the opinions of geographers (among whom I may mention the Rev. Tenison Woods),[3] the existence of a large river running inland from the watershed of the Murchison is nearly certain.
>
> Referring to the map of Australia you will observe that the proposed route is a very gigantic, hazardous, and long one; but, after careful consideration, I have every confidence that, should I be allowed to undertake it, there are reasonable hopes of my being able to succeed. . . .
>
> Trusting you will be able to concur in the foregoing suggestions.
>
> I have, &c.,
> JOHN FORREST. . . .

Governor Weld, however, decided that it might be better to postpone my expedition, as it would not be advisable to appear to enter into competition with the other colony; besides which it might be of considerable advantage to wait and avail ourselves of the results of any discoveries that might be made by the South Australian explorers. Another reason for delay was that I was required to conduct a survey of considerable importance, which it was desirable should be completed before undertaking the new expedition.

It may assist my readers to understand the references in the latter part of my Journal if I state that in April, 1873, Mr. Gosse, one of the South Australian explorers, quitted the telegraph line about forty miles south of Mount Stuart; that the farthest point in a westerly direction reached by him was in longitude 126°59'E.; and that Mr. Giles, a Victorian explorer, had reached longitude 125°, but had been unable to penetrate farther.

Some records of these expeditions, and a copy of the chart made by Mr. Gosse, were in my possession, when at length, in March, 1874, I set to work on the preliminary arrangements for the expedition. . . .

From the West Coast to the Centre

3. Julian E. Tenison Woods, *A History of the Discovery and Exploration of Australia*. London, 1865.

Members of John Forrest's expedition of 1874, which included his brother Alexander, also a competent surveyor and an explorer in his own right.

Forrest's instructions from the surveyor general, Malcolm Fraser, were as follows:

The chief object of the expedition is to obtain information concerning the immense tract of country from which flow the Murchison, Gascoigne, Ashburton, DeGrey, Fitzroy, and other rivers falling into the sea on the western and northern shores of this territory, as there are many good and reasonable grounds for a belief that those rivers outflow from districts neither barren nor badly watered.

Mr. A. C. Gregory, coming from the northwards by Sturt's Creek, discovered the Denison Plains, and it may be that from the head of the Murchison River going northwards there are to be found, near the heads of the rivers above alluded to, many such grassy oases; and, looking at the success which has already attended the stocking of the country to the eastward of Champion Bay, and between the heads of the Greenough River and Murchison, it will be most fortunate for our sheep farmers if you discover any considerable addition to the present known pasture grounds of the colony; and by this means no doubt the mineral resources of the interior will be brought eventually to light. Every opinion of value that has been given on the subject tells one that the head of the Murchison lies in a district which may prove another land of Ophir.

In tracing up this river from Mount Gould to its source, and in tracing other rivers to and from their head waters, detours must be made, but generally your course will be north-east until you are within the tropics; it will then be discretionary with you to decide on your route, of which there is certainly a choice of three, besides the retracing of your steps for the purpose, perhaps, of making a further inspection of the good country you may have found.

Firstly, — There is to choose whether you will go westward, and fall back on the settlements at Nicol Bay or the De Grey River, on the north-west coast.

Secondly, — To consider whether you might advantageously push up Sturt's Creek, keeping to the westward of Gregory's track.

Thirdly, — To decide whether or not you will go eastward to the South Australian telegraph line.

Possibly this latter course may be the most desirable and most feasible to accomplish, as the telegraph stations, taking either Watson's Creek or Daly Waters, are not more than 300 miles from the known water supply on Sturt's Creek, and, supposing you do this successfully, the remaining distance down the telegraph line to Port Darwin is a mere bagatelle, provided an arrangement can be made with the South Australian Government to have a supply of provisions at Daly Waters. . . .

I hope that before you individually leave we shall have the pleasure of welcoming Colonel Warburton, and I have no doubt will be able to obtain some valuable information from him.

Having now dwelt generally on the objects of the expedition, I will go more into details.

Your party will consist of yourself as leader, Mr. Alexander Forrest as surveyor and second in command, James Sweeney (farrier), police-constable James Kennedy, and two natives, Tommy Windich and Tommy Pierre, making six in number and twenty horses. The party will be well armed; but by every means in your power you will endeavour to cultivate and keep on friendly relations with all the aborigines you may fall in with, and avoid, if possible, any collision with them. . . .

Having the assistance of Mr. Alexander Forrest as surveyor to the party, you will do as much reconnaissance work in connexion with the colonial survey as it may be possible; and also, by taking celestial observations at all convenient times, and by sketching the natural features of the country you pass over, add much to our geographical knowledge. . . .

On the 18th of March, 1874, the expedition quitted Perth. . . . On the 31st March we were entertained at dinner by Mr. Crowther (Member of the Legislative Council for the district) at the Geraldton Hotel. It was from that point we considered the expedition really commenced, and my Journal will show that we numbered our camps from that place. . . .

By half-past nine on the morning of the 18th [April 1874] we had made a fair start. . . .

I may mention here that Colonel Warburton and other explorers who endeavoured to cross the great inland desert from the east had the advantage of being provided with camels — a very great advantage indeed in a country where the water supply is so scanty and uncertain as in Central Australia. . . .

The 19th was Sunday, and, according to practice, we rested. Every Sunday throughout the journey I read Divine Service, and, except making the daily observations, only work absolutely necessary was done. Whenever possible, we rested on Sunday, taking if we could, a pigeon, a parrot, or such other game as might come in our way as special fare. Sunday's dinner was an institution for which, even in those inhospitable wilds, we had a great respect. . . . While thus resting, Police constable Haydon arrived from Champion Bay, bringing letters and a thermometer (broken on the journey), also a barometer. When he left we bade good-bye to the last white man we were destined to see for nearly six months. . . .

I now take up the narrative in the words of my journal. . . .

24*th*. At one mile reached the Murchison River, and followed along up it. . . .

20*th*. [May]. . . . In the afternoon I went with Pierre about one mile N.E. of camp to the summit of a rough range and watershed, which I believe is the easterly watershed of the Murchison River. All the creeks to the west of this range (which I named Kimberley Range, after the Right Honourable Lord Kimberley, the Secretary of State for the Colonies) trend towards the Murchison, and finally empty into the main river. From this range we could see a long way to the eastward. The country is very level, with low ranges, but no conspicuous hills. Not a promising country for water, but still looks good feeding country. This range is composed of brown hematite, decomposing to yellow (tertiary), and is very magnetic, the compass being useless. . . .

A modern painting of a Kimberley landscape by Russell Drysdale. The opening up of this area came about as a result of the exploration by John Forrest's brother Alexander, after the period covered by this book. The Kimberleys had actually been first discovered by George Grey in 1837.

2nd [June]. Early this morning went with Pierre to look for water, while my brother and Windich went on the same errand. . . . They had only found sufficient water to give their own horses a drink; they also rejoiced to find so fine a spot. Named the springs the Weld Springs, after his Excellency Governor Weld, who has always taken such great interest in exploration, and without whose influence and assistance this expedition would not have been organized. . . .

22nd. Left camp in company with Tommy Pierre, with a pack-horse carrying fifteen gallons of water. . . . I then turned east, and at about seven miles reached the hill seen this morning, which I named Mount Moore, after Mr. W. D. Moore, of Fremantle, a subscriber to the Expedition Fund. . . . To the south, about nine miles we saw a lake. . . . I made south towards the lake, and at one mile and a half came on to a gully in the grassy plain, in which we found abundance of water, sufficient to last for months. We therefore camped for the night, with beautiful feed for the horses. I was very thankful to find so much water and such fine grassy country, for, if we had not found any this trip, we should have been obliged to retreat towards Weld Springs, the water where I left the party being only sufficient to last a few days. . . .

23rd. Steering south for about eight miles, we reached the lake, which I named Lake Augusta. [The party was just north of Lake Carnegie.] The water is salt, and about five miles in circumference. Grassy country in the flat; red sand-hills along the shore. It appeared deep, and swarmed with ducks and swans. Pierre shot two ducks, after which we pushed on N.E. for about twelve miles to a low rocky bluff, which we ascended and got a view of the country ahead — rough broken ranges to the east and south. We continued on east for six miles, when, on approaching a rocky face of a range, we saw some natives on top of it, watching us. . . . A good deal of grassy country the first part of the day. Kangaroos very numerous, and emus also. Evidence of the natives being in great numbers. . . .

July 1st. Got off early and continued easterly . . . over spinifex sandy country. . . . No feed and scarcely any water. Saw a range about twenty-five miles farther east — spinifex all the way to it. . . .

3rd. . . .Spinifex everywhere; it is a most fearful country. We cannot proceed farther in this direction, and must return and meet the party, which I hope to do to-morrow night. [Forrest and Tommy Windich were in advance of the main party.] We can only crawl along, having to walk and lead the horses, or at least drag them. The party have been following us, only getting a little water from gullies, and there is very little to fall back on for over fifty miles. I will leave what I intend doing until I meet them. I am nearly knocked up again to-night; my boots have hurt my feet, but I am not yet disheartened. . . .

9th. . . . My brother and Pierre started on the flying trip. . . . [Members of the party had constantly to move ahead in search of water.]

10th. Finished repairs and got everything ready for a good start to-morrow morning, when we will follow my brother's and Pierre's tracks. Cloudy day, but barometer does not fall. Marked a tree $\frac{F}{59}$, being our 59th bivouac from Geraldton. . . .

12th. . . . We got off early, and, steering east followed my brother's and Pierre's tracks for eight miles . . . and soon beheld my brother and Pierre returning. They had good news for us, having found some springs about twenty-five miles to the eastward. . . .

13th. Steering straight for the water found by my brother, about E.S.E. for twenty-five miles, over most miserable spinifex country, without a break. . . . I have no doubt water is always here. I named it the Alexander Spring, after my brother, who discovered it. . . .

16th. Left Alexander Spring, in company with Windich, to look for water ahead. . . .

18th. This morning we began searching the ranges for water. . . . It is certainly a wretched country we have been travelling through for the last two months, and, what makes it worse, the season is an exceptionally dry one. . . . We have been most fortunate in finding water, and I am indeed very thankful for it. . . .

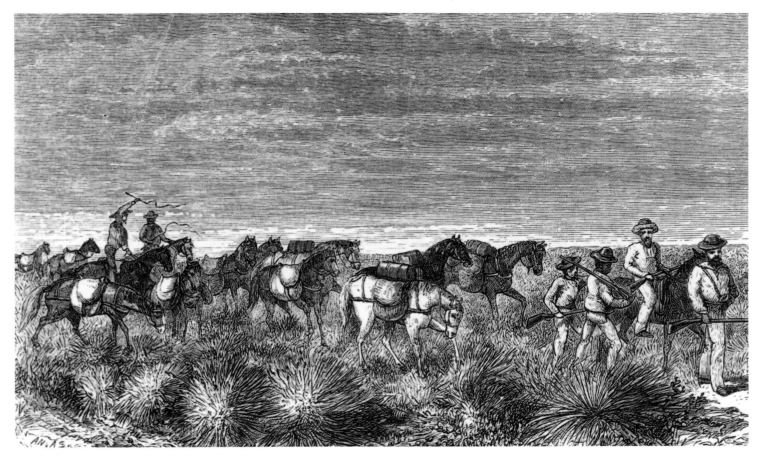

2nd [August]. (*Sunday*). My brother and Pierre went on a flying trip to the S.E. in search of water. . . .

I now began to be much troubled about our position, although I did not communicate my fears to any but my brother. We felt confident we could return if the worst came, although we were over 1000 miles from the settled districts of Western Australia. The water at our camp was fast drying up, and would not last more than a fortnight. The next water was sixty miles back, and there seemed no probability of getting eastward. I knew we were now in the very country that had driven Mr. Gosse back. I have since found it did the same for Mr. Giles. No time was to be lost. . . . The thought of having to return, however, brought every feeling of energy and determination to my rescue, and I felt that, with God's help, I would even now succeed. I gave instructions to allowance the party, so that the stores should last at least four months, and made every preparation for a last desperate struggle. . . .

4th. A light shower of rain this morning. Rested at camp. My brother and Pierre returned this evening, having found a few small water-holes, but not sufficient to shift on. . . .

5th. . . . We pushed on E.N.E., to a range visited by my brother on his last flying trip, and which I named the Baker Range, and the highest point Mount Samuel, after Sir Samuel Baker, the great African Explorer, and could see that lately rain had fallen, although much more in some places than in others. . . .

8th. Early this morning Windich and I went on foot to search the hills and gullies close around, as our horses were knocked up for want of water. . . . We . . . found a tree with the bark cut off one side of it with an *axe* which was sharp. . . . We are now in the country traversed by Mr. Gosse, although I am unable to distinguish any of the features of the country, not having a map with me, and not knowing the latitude. . . . However, I will leave our position geographically for the present, and treat of what is much more important to us, viz., the finding of water. . . .

11th. Continued on to the water found ahead, and on our way saw some clay-holes with water and satisfied the horses. . . . We are not in the latitude of Mr. Gosse's track by fifteen miles, yet there are tracks only about two miles

'On the march — the Spinifex Desert' — from Forrest's journal.

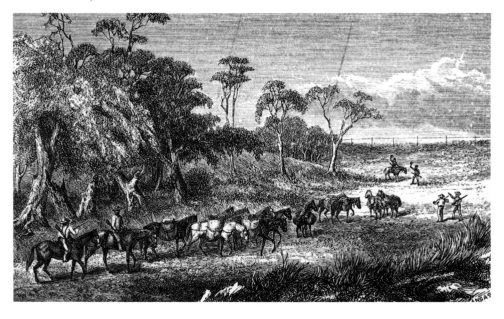

south of us! I cannot account for this. The tracks may be Mr. Giles's, as I cannot think Mr. Gosse could be out in his latitude. . . .

16*th* (*Sunday*). Steering about E.N.E. towards the ranges, we passed over very miserable spinifex plains and red sand-hills the whole way, about thirty miles. After reaching the ranges we followed up a fine grassy wide flat, splendidly grassed, although old; and on the flat were innumerable horse-tracks — unmistakable evidence of horses being camped for months in this neighbourhood. Kept on up the gully and flat for about a mile and a half, when Windich found a gum-tree marked

E. GILES
OCT.7,73

My former suspicions that Mr. Giles must have been in this neighbourhood were now confirmed. Soon after we came on a cart-track, which rather astonished us, and soon found that it must have belonged to Mr. Gosse, who also camped close here. A deep, well-beaten track went along up the gully, which we followed, knowing it was the daily track of the horses to the water, and soon after found their old camp at a beautiful spring running down the gully a quarter of a mile. A stock-yard had been built, and gardens made, besides a large bush hut to shelter the party from the sun as well as rain. . . . Mr. Gosse and Mr. Giles were within a few miles of each other at the same time, and did not meet. . . .

18*th*. Rested at spring. Marked a tree sixty yards south of camp $\frac{F}{74}$, being 74th camp from Geraldton. Also erected a pile of stones on peak, thirty chains W.S.W. of camp, with a pole in centre, on which is marked

"J. FORREST, AUGUST 17, '74."

Took four sets of lunars, which place spring in longitude 128°E. of Greenwich. . . .

22*nd*. Early this morning we continued on, Windich's horse scarcely able to walk. After about ten miles, found a rock hole with three gallons of water in it, which we gave to our horses. Followed Mr. Gosse's track to see if there was any water about his depôt No. 12, but we either missed it or had not reached it. About noon Windich's horse could go no farther, and mine was not much better. . . .

31*st*. . . . Reached the Mann Ranges. . . . I intended following his [Gosse's] return track and make in to the telegraph line, down the Alberga, and on to the Peake. . . .

27*th* [September]. (*Sunday*). Continuing E.N.E. for two miles, came to the Alberga, and following along its right bank over many clay-pans with water, about east for twelve miles, and then E.N.E. for three miles, and reached the telegraph line between Adelaide and Port Darwin, and camped. Long and con-

tinued cheers came from our little band as they beheld at last the goal to which we have been travelling for so long. . . .

The telegraph line is most substantially put up, and well wired, and is very creditable at this spot; large poles of bush timber, often rather crooked, and iron ones here and there. I now gave up keeping watch, having kept it regularly for the last six months. Marked a tree $\frac{F}{104}$, being 104th camp from Geraldton. We had not much to refresh the inner man with, only damper and water, but we have been used to it now more than a month, and do not much feel it. The horses are all very tired, and many of them have sore backs. I hope to reach the Peake [telegraph station] on Wednesday night, where we shall be able to get something to eat. We find making the damper with boiling water makes it much lighter and softer and is a great improvement. Latitude 27° 7' 50" south. . . .

30*th*. Got off early as usual, all in high glee at the prospect of meeting civilized habitations again. Travelled along the road and saw cattle, and shortly afterwards reached the Peake, and rather surprised the people. Mr. Bagot, the owner of the cattle station, was the first I met; and after telling him who we were, he said he had surmised it was so. He soon told us that Mr. Giles had returned, and also Mr. Ross, who had been despatched by the Honourable Thomas Elder with camels and a good equipment to find an overland route to Perth, but was unable to get over to Western Australia. . . . [This was the South Australian explorer, John Ross, who had in 1870 headed the advance exploration party for the Overland Telegraph Line.]

I now beg to make a few remarks with reference to the character and capability of the country traversed. . . .

The whole of the country, from the settled districts near Champion Bay to the head of the Murchison, is admirably suited for pastoral settlement, and in a very short time will be taken up and stocked; indeed, some already has been occupied.

From the head of the Murchison to the 129th meridian, the boundary of our colony, I do not think will ever be settled. Of course there are many grassy patches, such as at Windich Springs, the Weld Springs, all round Mount Moore, and other places; but they are so isolated, and of such extent, that it would never pay to stock them. . . .

In reading this journal, it may be wondered why we followed so much along Mr. Gosse's track, when a new route for ourselves might have been chosen more to the south. The reason is, I had intended, as soon as I reached the 129th meridian (the boundary of our colony), to make a long trip to the south, near to Eucla, and thus map that important locality; but on reaching there I was prevented by the following causes: — The weather was excessively warm; the country to the south seemed most uninviting — sand-hills as far as could be seen, covered with spinifex; our horses were very poor, our rations were running short, the meat and tea and sugar being nearly gone; water was very scarce, and I could clearly see that, although Mr. Gosse had travelled the route last year, it did not follow that we should be able to do it easily this, as all the water thus far where he had camped was gone. . . .

The last chapter of Forrest's book is devoted entirely to the public receptions which the explorers received at Adelaide and at Perth.

Since then, in the summer of 1875, I have visited Europe and received many proofs of the interest felt by Englishmen in Australian exploration. In the colonies, too, I find that the spirit of adventure which stimulates settlers to follow eagerly in the steps of the pioneer has been active. Already stations are being advanced on each side along the shores of the Great Bight, and a telegraph line is being constructed from King George's Sound to Adelaide, along my route of 1870, which will connect Western Australia with the telegraph systems of the world. Farther north, towards the head waters of the Murchison, advances have been made, and I and other explorers must feel a gratification, which gives ample reward for all our toil, in knowing that we have made some advance at least towards a more complete knowledge of the interior of vast and wonderful Australia.

11

The Desert Journeys of Giles

Ernest Giles.

1. Ernest Giles, *Australia Twice Traversed: The Romance of Exploration, being a Narrative Compiled from the Journals of Five Exploring Expeditions into and through Central South Australia and Western Australia, from 1872 to 1876.* London, 1889.

2. Ernest Giles, *Geographic Travels in Central Australia From 1872 to 1874.* Melbourne, 1875.

3. Ernest Giles, *The Journal of a Forgotten Expedition.* Adelaide, 1880.

Ernest Giles (1835–97) was fifteen years of age when he arrived in Australia, following his family who had already emigrated. Like his friend and co-explorer, William Henry Tietkins, he had been educated at Christ's Hospital, London. Perhaps it was here that he acquired his taste for romantic writing — his journals are full of flowery phrases and literary quotations. After prospecting for gold in Victoria, Giles became a post office clerk in Melbourne. Later he went jackerooing on stations along the River Darling. Here, in the early 1860s, working on new grazing lands near the fringes of settlement, he obtained invaluable experience in Australian bushcraft.

The two volumes from which the following extracts are taken provide the complete story of Giles' explorations,[1] although earlier accounts had been published in 1875[2] and 1880[3]. On each of his first four expeditions Giles had one aim — to cross the centre of the continent to the west coast. Three times he was forced to retreat, but finally succeeded in 1875, although by that time Warburton and Forrest had both forestalled him.

Giles, however, when he achieved the success for which he had laboured so long, turned round and travelled back to South Australia. These five journeys, with those of Gosse, Warburton and Forrest, finally destroyed any lingering hopes of extensive and permanent water existing in central Australia.

In a preface to his work Giles sets himself against the background of his time and place in Australian history:

South Australia includes a vast extent of country called the Northern Territory, which must become in time a separate colony, as it extends from the 26th parallel of latitude, embracing the whole country northwards to the Indian Ocean at the 11th parallel. South Australia possesses one advantage over the other colonies, from the geographical fact of her oblong territory extending, so to speak, exactly in the middle right across the continent from the Southern to the Indian Ocean. The dimensions of the colony are in extreme length over 1800 miles, by a breadth of nearly 700, and almost through the centre of this vast region the South Australian Transcontinental Telegraph line runs from Adelaide, viâ Port Augusta, to Port Darwin.

At the time I undertook my first expedition in 1872, this extensive work had just been completed, and it may be said to divide the continent into halves, which, for the purpose I then had in view, might be termed the explored and unexplored halves. For several years previous to my taking the field, I had desired to be the first to penetrate into this unknown region, where, for a thousand miles in a straight line, no white man's foot had ever wandered, or, if it had, its owner had never brought it back, nor told the tale. I had ever been a delighted student of the narratives of voyages and discoveries, from Robinson Crusoe to Anson and Cook, and the exploits on land in the brilliant accounts given by Sturt, Mitchell, Eyre, Grey, Leichhardt, and Kennedy, constantly excited my imagination, as my own travels may do that of future rovers, and continually spurred me on to emulate them in the pursuit they had so eminently graced.

My object, as indeed had been Leichhardt's, was to force my way across the thousand miles that lay untrodden and unknown, between the South Australian telegraph line and the settlements upon the Swan River....

There was room for snowy mountains, an inland sea, ancient river, and palmy plain, for races of new kinds of men inhabiting a new and odorous land, for fields of gold and golcondas of gems, for a new flora and a new fauna, and, above all the rest combined, there was room for me! Many well-meaning friends tried to dissuade me altogether, and endeavoured to instil into my mind that what I so ardently wished to attempt was simply deliberate suicide, and to persuade me of the truth of the poetic line, that the sad eye of experience sees beneath youth's radiant glow, so that, like Falstaff, I was only partly consoled by the remark that they hate us youth. But in spite of their experience, and probably on account of youth's radiant glow, I was not to be deterred, however,

and at last I met with Baron von Mueller, who, himself an explorer with the two Gregorys, has always had the cause of Australian exploration at heart, and he assisting, I was at length enabled to take the field. Baron Mueller and I had consulted, and it was deemed advisable that I should make a peculiar feature near the Finke river, called Chambers' Pillar, my point of departure for the west. . . .

The personnel of my first expedition into the interior consisted in the first instance of myself, Mr. Carmichael, and a young black boy. . . .

We arrived at the Charlotte Waters station on the 4th of August, 1872; this was actually my last outpost of civilisation. My companion, Mr. Carmichael, and I were most kindly welcomed by Mr. Johnstone, the officer in charge of this depot, and by Mr. Chandler, a gentleman belonging to a telegraph station farther up the line. In consequence of their kindness, our stay was lengthened to a week. . . .

On reaching the Finke we encamped. [It was now the end of August.] In the evening I ascended a mountain to the north-westward of us. . . . From here I could see that the Finke turned up towards these hills through a glen, in a north-westerly direction. . . .

Entering the mouth of the glen, in two miles we found ourselves fairly enclosed by the hills, which shut in the river on both sides. We had to follow the windings of the serpentine channel; the mountains occasionally forming steep precipices overhanging the stream, first upon one side, then upon the other. We often had to lead the horses separately over huge ledges of rock, and frequently had to cut saplings and lever them out of the way, continually crossing and recrossing the river. On camping in the glen we had only made good eleven miles, though to accomplish this we had travelled more then double the distance. . . .

The flowers alone would have induced me to name this Glen Flora; but having found in it also so many of the stately palm trees, I have called it the Glen of Palms. Peculiar indeed, and romantic too, is this new-found watery glen, enclosed by rocky walls, "Where dial-like, to portion time, the palm-trees's shadow falls". . . . [But the party had to leave this idyllic spot (now a well-known tourist attraction) for less hospitable country.]

During the night of the 18th September a few heat-drops of rain fell. . . . A hot wind blew all day, the sand was flying about in all directions. . . . The flies were an intolerable nuisance . . . so insufferably pertinacious. I think the tropic fly of Australia the most abominable insect of its kind. . . .

Mount Udor was the only spot where water was to be found in this abominable region. . . . I have marked a eucalyptus or gum-tree in this gully close to

West to Lake Amadeus

'Palm Tree found in the Glen of Palms'.

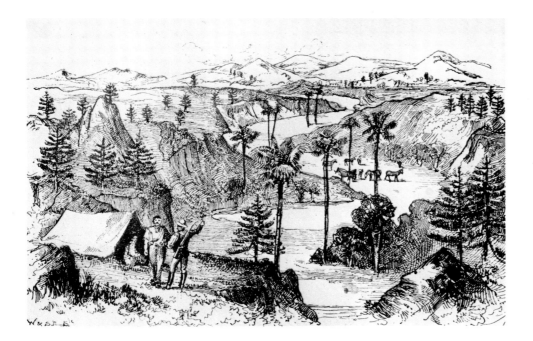

'View in the Glen of Palms' — an engraving from Giles' journal.

the foot of the rock where I found the water $\frac{E}{21}G$, as this is my twenty-first camp from Chambers' Pillar.... After watering my two horses I started away by myself for the ranges out west.... I ... walked into dozens of gullies and rocky places, and I found some small holes and basins but all were dry. At this spot I was eighty miles from a sufficient supply of water; that at the camp, forty-five miles away, may be gone by the time I return. Under these circumstances I could not go any farther west....

[1 October] We continued until we had travelled forty miles from Mount Udor, but no signs of a creek or any place likely to produce or hold water had been found. The only difference in the country was that it was now more open, though the spinifex was as lively as ever....

At one point I discerned a notch or gap. The horses were now very troublesome to drive, the poor creatures being very bad with thirst. I turned on the bearing that would take me back to the old creek, which seemed the only spot in this desolate region where water could be found, and there we had to dig to get it. At one place on the ridges before us appeared a few pine-trees (*Callitris*) which enliven any region they inhabit, and there is usually water in the neighbourhood. The rocks from which the pines grew were much broken; they were yet, however, five or six miles away. We travelled directly towards them, and upon approaching, I found the rocks upheaved in a most singular manner, and a few gum-trees were visible at the foot of the ridge....

The whole length of this cave had frequently been a large encampment. Looking about with some hopes of finding the place where these children of the wilderness obtained water, I espied about a hundred yards away, and on the opposite side of the little glen or valley, a very peculiar-looking crevice between two huge blocks of sandstone, and apparently not more than a yard wide. I rode over to this spot, and to my great delight found a most excellent little rock tarn, of nearly an oblong shape, containing a most welcome and opportune supply of the fluid I was so anxious to discover. Some green slime rested on a portion of the surface, but the rest was all clear and pure water.... No one who has not experienced it, can imagine the pleasure which the finding of such a treasure confers on the thirsty, hungry, and weary traveller; all his troubles for the time are at an end. Thirst, that dire affliction that besets the wanderer in the Australian wilds, at last is quenched....

I called this charming little oasis Glen Edith, after one of my nieces. I marked two gum trees at this camp, one $\boxed{\begin{array}{c}\text{Giles}\\24\end{array}}$, and another $\boxed{\begin{array}{c}\text{Glen Edith}\\\text{24. Oct.9,72.}\end{array}}$.

Mr. Carmichael and Robinson also marked one with their names. The receptacle in which I found the water I have called the Tarn of Auber, after Allan Poe's beautiful lines, in which that name appears, as I thought them appropriate to the spot. He says: —

> "It was in the drear month of October,
> The leaves were all crispe'd and sere,
> Adown by the dank Tarn of Auber,
> In the misty mid regions of Weir"....

In the bright gleams of the morning, in this Austral land of dawning, it was beautiful to survey this little spot; everything seemed in miniature here — little hills, little glen, little trees, little tarn, and little water....

On the 11th [October] Mr. Carmichael and I got fresh horses, and I determined to try the country more to the south, and leaving Alec Robinson and the little dog Monkey again in charge of glen, and camp, and tarn, away we went in that direction.... [On this excursion, Giles discovered water at a spot further south which he called the Vale of Tempe. He and Carmichael returned to Robinson and they all left the camp at Glen Edith on 15 October.]

We travelled now by a slightly different route, more easterly, as there were other ridges in that direction, and we might find another and a better watering place than that at the pass. It is only at or near ridges in this strange region that the traveller can expect to find water, as in the sandy beds of scrub intervening between them, water would simply sink away. We passed through some very thick mulga, which being mostly dead, ripped our pack-bags, clothes, and skin, as we had continually to push the persistent boughs and branches aside to pen-

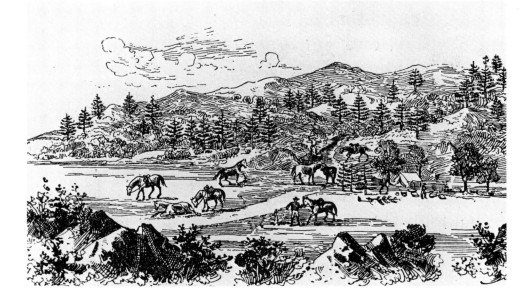

etrate it. . . . We took a stroll up into the rocks and gullies of the ridges, and found a Troglodytes' cave ornamented with the choicest specimens of aboriginal art. The rude figures of snakes were the principal objects, but hands, and devices for shields were also conspicuous. One hieroglyph was most striking; it consisted of two Roman numerals — a V and an I, placed together and representing the figure VI; they were both daubed over with spots, and were painted with red ochre. . . . Our only intellectual occupation was the study of a small map of Australia, showing the routes of the Australian explorers. . . .

We continued upon our course, and on ascending a high sandhill I found we had upon our right hand, and stretching away to the west, an enormous salt expanse [Lake Amadeus], and it appeared as if we had hit exactly upon the eastern edge of it, at which we rejoiced greatly for a time. Continuing on our course over treeless sandhills for a mile or two, we found we had not escaped this feature quite so easily, for it was now right in our road; it appeared, however, to be bounded by sandhills a little more to the left, eastwards; so we went in that direction, but at each succeeding mile we saw more and more of this objectionable feature; it continually pushed us farther and farther to the east until, having travelled about fifteen miles, and had it constantly on our right, it swept round under some more sandhills which hid t from us, till it lay east and west right athwart our path. It was most perplexing to me to be thus confronted by such an obstacle. We walked a distance on its surface, and to our weight it seemed firm enough, but the instant we tried our horses they almost disappeared. The surface was dry and encrusted with salt, but brine spurted out at every step the horses took. We dug a well under a sandhill, but only obtained brine.

This obstruction was apparently six or seven miles across, but whether what we took for its opposite shores were islands or the main, I could not determine. We saw several sandhill islands, some very high and deeply red, to which the mirage gave the effect of their floating on an ocean of water. Farther along the shore eastwards were several high red sandhills; to these we went and dug another well and got more brine. We could see the lake stretching away east or east-south-east as far as the glasses could carry the vision. Here we made another attempt to cross, but the horses were all floundering about in the bottomless bed of this infernal lake before we could look round. I made sure they would be swallowed up before our eyes. We were powerless to help them, for we could not get near owing to the bog, and we sank up over our knees, where the crust was broken, in hot salt mud. All I could do was to crack my whip to prevent the horses from ceasing to exert themselves, and although it was but a few moments they were in this danger, to me it seemed an eternity. They staggered at last out of the quagmire, heads, backs, saddles, everything covered with blue mud, their mouths were filled with salt mud also, and they were completely exhausted when they reached firm ground. We let them rest in the

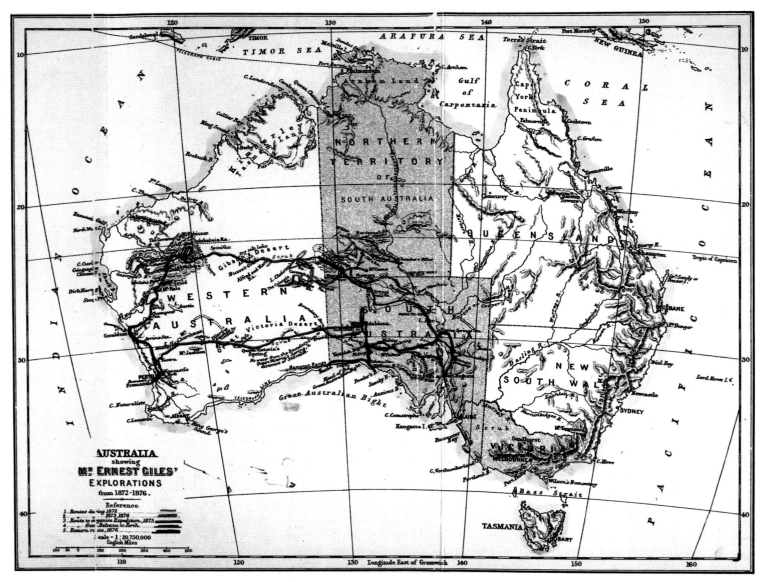

The routes followed by Ernest Giles in his explorations, from his Australia Twice Traversed.

shade of some quandong trees, which grew in great numbers round about here. From Mount Udor to the shores of this lake the country had been continually falling. The northern base of each ridge, as we travelled, seemed higher by many feet than the southern, and I had hoped to come upon something better than this. I thought such a continued fall of country might lead to a considerable watercourse or freshwater basin; but this salt bog was dreadful, the more especially as it prevented me reaching the mountain which appeared so inviting beyond. . . . [It was the middle of October, 1872.]

I named this eminence Mount Olga, and the great salt feature which obstructed me Lake Amadeus, in honour of two enlightened royal patrons of science [the King and Queen of Spain].

[Giles now considered sending Alex Robinson back to Adelaide.] In our journey up the Finke two or three creeks had joined from the west, and as we were now beyond the sources of any of these, it would be necessary to discover some road to one or the other before Robinson could be parted with. By dispensing with his services, as he was willing to go, we should have sufficient provisions left to enable us to hold out for some months longer: even if we had to wait so long as the usual rainy season in this part of the country, which is about January and February, we should still have several month's provisions to start again with. In all these considerations Mr. Carmichael fully agreed. . . . We got back to Robinson [who was once again looking after the camp] and the camp. . . . My old horse that carried the pack had gone quite lame, and this caused us to travel very slowly. Robinson was alive and quite well, and the little dog was overjoyed to greet us. Robinson reported that natives had been frequently in the

neighbourhood, and had lit fires close to the camp, but would not show themselves. . . . [They were still at the Vale of Tempe camp at the end of October, but Giles' hopes of starting again for the west were soon to be dashed.]

After our frugal supper a circumstance occurred which completely put an end to my expedition. Mr. Carmichael informed me that he had made up his mind not to continue in the field any longer, for as Alec Robinson was going away, he should do so too. Of course I could not control him; he was a volunteer, and had contributed towards the expenses of the expedition. We had never fallen out, and I thought he was as ardent in the cause of exploration as I was, so that when he informed me of his resolve it came upon me as a complete surprise. My arguments were all in vain; in vain I showed how, with the stock of provisions we had, we might keep the field for months. I even offered to retreat to the Finke, so that we should not have such arduous work for want of water, but it was all useless.

It was with distress that I lay down on my blankets that night, after what he had said. I scarcely knew what to do. I had yet a lot of horses heavily loaded with provisions; but to take them out into a waterless, desert country by myself, was impossible. We only went a short distance — to Bagot's Creek, where I renewed my arguments. Mr. Carmichael's reply was, that he had made up his mind and nothing should alter it. . . .

My expedition was over. I had failed certainly in my object, which was to penetrate to the sources of the Murchison River, but not through any fault of mine, as I think any impartial reader will admit. . . .

On the 21st November we reached the telegraph line at the junction of the Finke and the Hugh. . . .

I reached Adelaide late in January, 1873, and as soon as funds were available I set to work at the organisation of a new expedition. I obtained the services of a young friend named William Henry Tietkins — who came over from Melbourne to join me — and we got a young fellow named James Andrews or Jimmy as we always called him. I bought a light four-wheeled trap and several horses, and we left Adelaide early in March, 1873. We drove up the country by way of the Burra mines to Port Augusta at the head of Spencer's Gulf, buying horses

Into the Gibson Desert

The Burra Burra Mine, as painted by S. T. Gill.

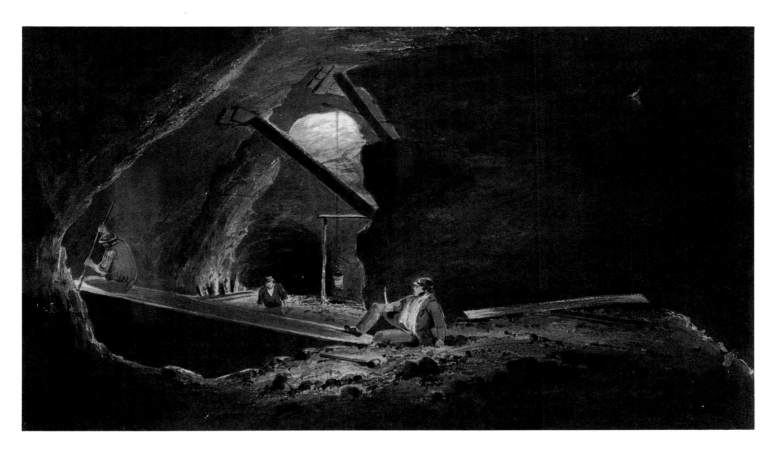

as we went; and having some pack saddles on the wagon, these we put on our new purchases as we got them. . . .

Nothing of a very interesting nature occurred during our journey up to the Peake [telegraph station], where we were welcomed by the Messrs. Bagot at the Cattle Station, and Mr. Blood of the Telegraph Department. . . . Here a short young man accosted me, and asked me if I did not remember him, saying at the same time that he was "Alf." I fancied I knew his face, but thought it was at the Peake that I had seen him, but he said, "Oh no, don't you remember Alf with Bagot's sheep at the north-west bend of the Murray? my name's Alf Gibson, and I want to go with you." I said, "Well, can you shoe? can you ride? can you starve? can you go without water? and how would you like to be speared by the blacks outside?" He said he could do everything I had mentioned, and he wasn't afraid of the blacks. He was not a man I would have picked out of a mob, but men were scarce, and as he seemed so anxious to come, and as I wanted somebody, I agreed to take him. . . .

I had decided to make a start upon this expedition from a place known as Ross's Water-hole in the Alberga Creek, at its junction with the Stevenson, the Alberga being one of the principal tributaries of the Finke. . . .

The expedition consisted of four members — namely, myself, Mr. William Henry Tietkins, Alfred Gibson, and James Andrews, with twenty-four horses and two little dogs. . . . We finally left the encampment on the morning of Monday, the 4th [August, 1873]. . . .

[During August they discovered and named Tietkins' Birthday Creek and by early September a region which caught Giles' imagination.] The valley is surrounded by picturesque hills, and I am certain it is the most charming and romantic spot I ever shall behold. I immediately christened it the Fairies' Glen, for it had all the characteristics to my mind of fairyland. Here we encamped. I would not have missed finding such a spot, upon — I will not say what consideration. Here also of course we saw numbers of both ancient and modern native huts, and this is no doubt an old-established and favourite camping ground. And how could it be otherwise? No creatures of the human race could view these scenes with apathy or dislike, nor would any sentient beings part with such a patrimony at any price but that of their blood. But the great Designer of the universe, in the long past periods of creation, permitted a fiat to be recorded, that the beings whom it was His pleasure in the first instance to place amidst these lovely scenes, must eventually be swept from the face of the earth by others more intellectual, more dearly beloved and gifted than they. Progressive improvement is undoubtedly the order of creation, and we perhaps in our turn may be as ruthlessly driven from the earth by another race of yet unknown beings, of an order infinitely higher, infinitely more beloved, than we. On me, perchance the eternal obloquy of the execution of God's doom may rest, for being the first to lead the way, with prying eye and trespassing foot, into regions so fair and so remote; but being guiltless alike in act or intention to shed the blood of any human creature, I must accept it without a sigh. . . .

[10 September] We left this pretty glen with its purling stream and reedy bed, and entered very shortly upon an entirely different country, covered with porcupine grass. We went north-west to some ridges at seventeen miles, where there was excellent vegetation, but no water. I noticed to-day for the first time upon this expedition some of the desert oak trees (Casuarina Decaisneana). Nine miles farther we reached a round hill, from which Mount Olga bore north. We were still a considerable distance away, and as I did not know of any water existing at Mount Olga, I was anxious to find some, for the horses had none where we encamped last night. From this hill I could also see that the Musgrave chain still ran on to the west; though broken and parted in masses, it rose again into high mounts and points. This continuation is called the Mann Range. . . .

We generally managed to get away early from a bad camp, and by the middle of the next day we arrived at the foot of Mount Olga. Here I perceived the marks of a wagon and horses, and camel tracks; these I knew at once to be those of Gosse's expedition. Gosse had come down south through the regions, and to the watering places which I discovered in my former journey. He had evidently gone south to the Mann range, and I expected soon to overtake him.

'The Olgas — Northern Aspect' by Lloyd Rees, 1976.

I had now travelled four hundred miles to reach this mount, which, when I first saw it, was only seventy-five or eighty miles distant.

The appearance of this mountain is marvellous in the extreme, and baffles an accurate description. I shall refer to it again, and may remark here that it is formed of several vast and solid, huge, and rounded blocks of bare red conglomerate stones, being composed of untold masses of rounded stones of all kinds and sizes, mixed like plums in a pudding, and set in vast and rounded shapes upon the ground. Water was running from the base, down a stony channel, filling several rocky basins. The water disappeared in the sandy bed of the creek, where the solid rock ended. We saw several quandongs, or native peach-trees, and some native poplars on our march to-day. . . . Some very beautiful black and gold butterflies, with very large wings, were seen here and collected. The thermometer to-day was 95° in the shade. We enjoyed a most luxurious bath in the rocky basins. We moved the camp to softer ground, where there was a well-grassed flat a mile and a half away. To the east was a high solitary mound, mentioned in my first journal as ranges to the east of Mount Olga, and apparently lying north and south; this is called Ayers Rock. . . . [Gosse had left Adelaide in April 1873 and was also trying to reach the west coast. He did not succeed but he did discover Ayers Rock. At the time of which Giles is writing he would not have known of Gosse's discovery.]

[29 September] I went to sleep that night dreaming how I had met Mr. Gosse in this wilderness, and produced a parody upon 'How I found Livingstone'. We travelled nearly thirty miles to-day upon all courses, the country passed over being principally very fine valleys, richly clothed with grass and almost every other kind of valuable herbage. . . .

[5 October] On reaching the lower grassy ground we saw Mr. Gosse's dray track again, and I was not surprised to see that the wagon had returned upon its outgoing track, and the party were now returning eastwards to South Australia. I had for some days anticipated meeting him; but now he was going east, and I west, I did not follow back after him. . . .

Giles was soon within the Western Australian border and established a depot at Fort Mueller in the Cavenagh Range from which they went out in search of the water supply needed if they were to continue going west. After several unsuccessful attempts they turned north in January 1874, and later discovered the Rawlinson Range.

Since we left Sladen Water [a previous watering-place] the horses have not done well, and the slopes of this range being so rough and stony, many of them display signs of sore-footedness. I cannot expect the range to continue farther than another day's stage; and though I cannot see its end, yet I feel 'tis near.

Many delays by visiting places caused it to be very late when we sat down amongst stones and triodia to devour our frugal supper. A solitary eagle was the monarch of this scene; it was perched upon the highest peak of a bare ridge, and formed a feathery sky-line when looking up the gorge — always there sat the solemn, solitary, and silent bird, like the Lorelei on her rock — above — beautifully, there, as though he had a mission to watch the course of passing events, and to record them in the books of time and fate. There was a larger and semicircular basin still farther up the gorge; this I called the Circus, but this creek and our rock-hole ever after went by the name of the Circus. In a few miles the next day I could see the termination of the range. In nine miles we cross three creeks, then ascended a hill north of us, and obtained at last a western view. It consisted entirely of high, red sandhills with casuarinas and low mallee, which formed the horizon at about ten miles. The long range that had brought us so far to the west was at an end. . . .

Nearer to us, north-westerly, and stretching nearly to west, lay the dry, irregular, and broken expanse of an ancient lake bed. On riding over to it we found it very undefined, as patches of sandhills occurred amongst low ridges of limestone, with bushes and a few low trees all over the expanse. There were patches of dry, soda-like particles, and the soil generally was a loose dust-coloured earth. Samphire bushes also grew in patches upon it, and some patches of our arch-enemy, triodia. Great numbers of wallaby, a different kind from the rock, were seen amongst the limestone rises; they had completely honeycombed all we inspected. Water there was none, and if Noah's deluge visited this place it could be conveniently stowed away, and put out of sight in a quarter of an hour. . . .

My readers will form a better idea of this peculiar and distant mountain range when I tell them that it is more than sixty miles long, averaging five or six miles through. It is of bold and rounded form; there is nothing pointed or jagged in its appearance anywhere, except where the eagle sat upon the rock at the Circus; its formation is mostly a white conglomerate, something between granite, marble, and quartz, though some portions are red. It is surrounded except to the east, by deserts, and may be called the monarch of those regions where the unvisited mountains stand. It possesses countless rocky glens and gorges, creeks and valleys, nearly all containing reservoirs of the purest water. When the Australian summer sunset smooths the roughness of the corrugated range, like a vast and crumpled garment, spread by the great Creator's hand, east and west before me stretching, these eternal mountains stand. It is a singular feature in a strange land, and God knows by what beady drops of toilsome sweat Tietkens and I rescued it from its former and ancient oblivion. Its position in latitude is between the 24th and 25th parallels, and its longitude between 127° 30' and 128° 30'. I named it the Rawlinson Range, after Sir Henry Rawlinson, President of the Royal Geographical Society of London. I found a singular moth, and fly-catching, plant in this range; it exudes a gummy substance, by which insects become attached to the leaves. The appearance of this range from a distance is white, flat, corrugated, rounded, and treeless. It rises between 1100 and 1200 feet in its highest portions, about the centre, in the neighbourhood of Fort McKellar, above the surrounding country, though its greatest elevation above the sea is over 3000 feet. . . .

In March the Petermann Range was discovered, but they returned to the Rawlinson where a base camp was established named Fort McKellar. Their problems included several attacks by Aboriginals.

On the 19th April I told the party it was useless to delay longer, and that I had made up my mind to try what impression a hundred miles would make on the country to the west. I had waited and waited for a change, not to say rain, and it seemed as far off as though the month was November, instead of April. I might still keep on waiting, until every ounce of our now very limited supply of rations was gone. We were now, and had been since Billy was killed, living entirely on smoked horse; we had only a few pounds of flour left, which I kept in case of sickness; the sugar was gone; only a few sticks of tobacco for Mr. Tietkins and Gibson — Jimmy and I not smoking — remained. I had been disappointed at the Charlotte Waters at starting, by not being able to get my old horse, and had started from the Alberga, lacking him and the 200 pounds of flour he would have carried — a deficiency which considerably shortened my intended supply. A comparatively enormous quantity of flour had been lost by the continual rippings of bags in the scrubs farther south, and also general loss in weight of nearly ten per cent., from continual handling of the bags, and evaporation. We had supplemented our supplies in a measure at Fort Mueller and the Pass, with pigeons and wallabies, as long as our ammunition lasted, and now it was done. When I made known my intention, Gibson immediately volunteered to accompany me, and complained of having previously been left so often and so long in the camp. I much preferred Mr. Tietkens, as I felt sure the task we were about to undertake was no ordinary one, and I knew Mr. Tietkins was to be depended upon to the last under any circumstances; but, to please Gibson, he waived his right, and, though I said nothing, I was not at all pleased.

April 20th, 1874. Gibson and I having got all the gear we required, took a week's supply of smoked horse, and four excellent horses, two to ride, and two to carry water, all in fine condition. . . .

21st April. . . . As we rode away, I remarked to Gibson that the day, was the anniversary of Burke and Wills's return to their depot at Cooper's Creek, and then recited to him, as he did not appear to know anything whatever about it, the hardships they endured, their desperate struggles for existence, and death there, and I casually remarked that Wills had a brother who also lost his life in the field of discovery. He had gone out with Sir John Franklin in 1845. Gibson then said, "Oh! I had a brother who died with Franklin at the North Pole, and my father had a deal of trouble to get his pay from Government". . . . We had a meal of smoked horse; and here I discovered that the bag with our supply of horseflesh in it held but a most inadequate supply for two of us for a week, there being scarcely sufficient for one. Gibson had packed it at starting, and I had not previously seen it. . . .

The following morning (23) there was a most strange dampness in the air, and I had a vague feeling, such as must have been felt by augers, and seers of old, who trembled as they told, events to come; for this was the last day on which I ever saw Gibson. . . .

We were now ninety miles from the Circus water, and 110 from Fort McKellar. The horizon to the west was still obstructed by another rise three or four miles away; but to the west-north-west I could see a line of low stony ridges, ten miles off. To the south was an isolated little hill, six or seven miles away. I determined to go to the ridges, when Gibson complained that his horse could never reach them, and suggested that the next rise to the west might reveal something better in front. . . . The hills to the west were twenty-five to thirty miles away, and it was with extreme regret I was compelled to relinquish a farther attempt to reach them. Oh, how ardently I longed for a camel! . . . These far-off hills were named the Alfred and Marie Range, in honour of their Royal Highnesses the Duke and Duchess of Edinburgh. Gibson's horse having got so bad had placed us both in a great dilemma; indeed, ours was a most critical position. We turned back upon our tracks, when the cob refused to carry his rider any farther, and tried to lie down. We drove him another mile on foot, and down he fell to die. . . .

When we got back to about thirty miles from the Kegs . . . I called to Gibson to halt till I walked up to him. . . . [On 22 April, two 5 gallon kegs of water had been left in the branches of a tree.] We were both excessively thirsty, for walking had made us so, and we had scarcely a pint of water left between

*'First view of the Alfred and Marie Range' —
engraving in Giles' journal.*

'Alone in the desert' — from Giles' journal.

us. However, of what we had we each took a mouthful, which finished the supply, and I then said — for I couldn't speak before — "Look here, Gibson, you see we are in a most terrible fix with only one horse, therefore only one can ride, and one must remain behind. I shall remain: and now listen to me. If the mare does not get water soon she will die; therefore ride right on; get to the Kegs, if possible, to-night, and give her water. Now the cob is dead there'll be all the more for her; let her rest for an hour or two, and then get over a few more miles by morning, so that early to-morrow you will sight the Rawlinson, at twenty-five miles from the Kegs. Stick to the tracks, and never leave them. Leave as much water in one keg for me as you can afford after watering the mare and filling up your own bags, and, remember, I depend upon you to bring me relief. Rouse Mr. Tietkens, get fresh horses and more water-bags, and return as soon as you possibly can. I shall of course endeavour to get down the tracks also."

He then said if he had a compass he thought he could go better at night. I knew he didn't understand anything about compasses, as I had often tried to explain them to him. . . . However, he was so anxious for it that I gave it to him, and he departed. I sent one final shout after him to stick to the tracks, to which he replied, "All right," and the mare carried him out of sight almost immediately. That was the last ever seen of Gibson. . . .

April 24th to 1st May. So soon as it was light I was again upon the horse tracks, and reached the Kegs about the middle of the day. Gibson had been here, and watered the mare, and gone on. He had left me a little over two gallons of water in one keg, and it may be imagined how glad I was to get a drink. . . .

By next morning I had only got about three miles away from the Kegs, and to do that I have travelled mostly in the moonlight. The next few days I can only pass over as they seemed to pass with me, for I was quite unconscious half the time, and I only got over about five miles a day. . . .

At last I reached the Circus [depot], just at the dawn of day. Oh, how I drank! . . . Just as I got clear of the bank of the creek, I heard a faint squeak, and looking about I saw, and immediately caught, a small dying wallaby, whose marsupial mother had evidently thrown it from her pouch. It only weighed about two ounces, and was scarcely furnished yet with fur. The instant I saw it, like an eagle I pounded upon it and ate it, living, raw, dying — fur, skin, bones, skull, and all. The delicious taste of that creature I shall never forget. . . . On the 1st of May, as I afterwards found, at one o'clock in the morning, I was walking again, and reached the Gorge of Tarns long before daylight, and could again indulge in as much water as I desired; but it was exhaustion I suffered from, and I could hardly move.

My reader may imagine with what intense feelings of relief I stepped over the little bridge across the water, staggered into the camp at daylight, and woke Mr. Tietkens, who stared at me as though I had been one, new risen from the dead. . . .

Not to worry my reader more than I can help, I may say we had to return to the Kegs, to get the bags left there, and some indispensable things: also Gibson's saddle, which he left nine or ten miles beyond the Kegs in a tree. Going all that distance to get these things, and returning to where Gibson's tracks branched off, we had to travel 115 miles, which made it the third night the horses had been out. We gave them some of the water we carried each night, and our supply was now nearly all gone. It was on the 6th May when we got back to where Gibson had left the right line. We fortunately had fine, cool weather. As long as Gibson remained upon the other horse-tracks, following them, though not very easy, was practicable enough; but the unfortunate man had left them, and gone away in a far more southerly direction, having the most difficult sandhills now to cross at right angles. He had burnt a patch of spinifex, where he left the other horse-tracks, and must have been under the delusion that they were running north. . . .

We began to see that our chance of finding the remains of our lost companion was very slight. . . .

I called this terrible region that lies between the Rawlinson Range and the next permanent water that may eventually be found to the west, Gibson's Desert, after this first white victim to its horrors. . . .

When we arrived again at the fort [Fort McKellar], on Monday, I knew something had happened, for Jimmy was most profuse in his delight at seeing us again. It appeared that while we were preparing to start on Saturday, a whole army of natives were hidden behind the rocks, immediately above the camp, waiting and watching until we departed, and no sooner were we well out of sight and sound, than they began an attack upon poor Jim. . . . Towards night he seems to have driven them off, and he and the little dog watched all night. . . .

Had Gibson not been lost I should certainly have pushed out west again and again. To say I was sorry to abandon such a work in such a region, though true, may seem absurd, but it must be remembered I was pitted, or had pitted myself against Nature, and a second time I was conquered. The expedition had failed in its attempt to reach the west, but still it had done something. It would at all events leave a record. Our stores and clothes were gone, we had nothing but horseflesh to eat, and it is scarcely to be wondered at if neither Mr. Tietkins nor Jimmy could receive of my intention to retreat otherwise than with pleasure. . . .

On the afternoon of Thursday, 21st May, we began our retreat, and finally left Fort McKellar, where my hopes had been as high as my defeat was signal. . . . [They reached the telegraph line on 10 July 1874.]

Giles' third expedition, between March and May 1875, was little more than a preliminary reconnaissance for the fourth. It commenced at Fowlers Bay, where he had undertaken some survey work at the request of his patron, Sir Thomas Elder. He then visited Eucla on the border of the colonies of Western and South Australia. From here he returned towards Fowlers Bay, branching off to travel north and then east to Beltana. It was from here, at Sir Thomas Elders' station and camel depot, that his fourth expedition started off.

S ir Thomas Elder was desirous that the new expedition from [sic] Perth, for which camels were to be the only animals taken, should start from Beltana [in South Australia] by the 1st of May. I was detained a few days beyond that time, but was enabled to leave on Thursday, May the 6th [1875]. The members of the party were six in number, namely myself, Mr. William Henry Tietkens, who had been with me as second on my last expedition with horses — he had been secured from Melbourne by Sir Thomas Elder, and was again going as second; Mr. Jess Young, a young friend of Sir Thomas's lately arrived from England; Alexander Ross, mentioned previously; Peter Nicholls, who had just come with me from Fowler's Bay, and who now came as cook; and Saleh, the Afghan camel-driver as they like to be called. . . .

Everything being at length ready, the equipment of the expedition was most excellent and capable. Sir Thomas had sent me from Adelaide several large

The Victoria Desert

Sir Thomas Elder's Mansion — an engraving from an illustrated newspaper of 1886. Elder supplied camels to both Warburton and Giles on their major desert explorations.

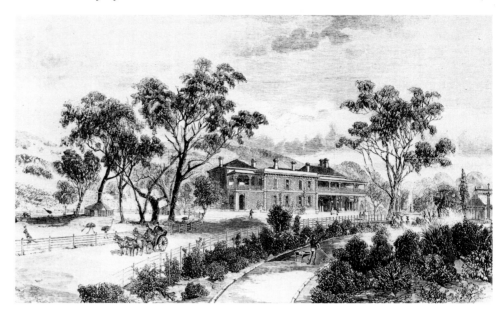

Sir Thomas Elder's Mansion — an engraving from an illustrated newspaper of 1886. Elder supplied camels to both Warburton and Giles on their major desert explorations.

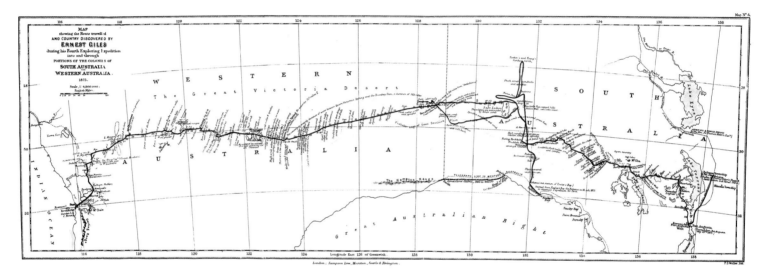

The route travelled by Ernest Giles during his fourth expedition.

pairs of leather bags, one to be slung on each side of a camel; all our minor, breakable, and perishable articles were thus secured from wet or damp. In several of these large bags I had wooden boxes at the bottom so that all books, papers, instruments, glass, &c., were safe. . . . [The party moved off in a southerly direction towards Port Augusta.]

When we left Port Augusta, I had fifteen pack- or baggage-camels and seven riding ones. . . .

[5 July.] We were safely landed at the Youldeh depot [which Giles had visited in March on his third expedition] once more; and upon the whole I may say we had an agreeable journey from Port Augusta. . . . I had some camels to deliver at Fowler's Bay, and some private business, necessary to be done before a magistrate, which compelled me personally to return thither. . . . [Giles' business done, the party finally left Youldeh on 27 July.]

It took us five days and a half to reach Ooldabinna, and by the time we arrived there I had travelled 1010 miles from Beltana on all courses. I found Ooldabinna to consist of a small, pretty, open space amongst the scrubs; it was just dotted over with mulga-trees, and was no doubt a very favourite resort of the native owners. . . . After I had been there two days, and the water supply was getting gradually but surely less, I naturally became most anxious to discover more, either in a west or northerly direction; and I again sent my two officers, Messrs. Tietkens and Young, to the north, to endeavour to discover a supply in that direction, while I determined to go myself to the west on a similar errand. . . .

When Alec Ross and I returned from the west the others had been back for some days, and were most anxious to hear how we had got on out west. [They had found water on the South Australian–Western Australian border; it was later named the Boundary Dam.]

The usual anxiety at the camp was the question of water supply; I had found so little where I had been, and the water here was failing rapidly every day. Had it not been for last night's rain, we should be in a great difficulty this morning. . . . On the 24th August, having filled up everything that could hold a drop of water, we departed from this little isolated spot, having certainly 160 miles of desert without water to traverse, and perhaps none to be found at the end. Now, having everything ready, and watered our camels, we folded our tents like the Arabs, and as silently stole away. In consequence of having to carry so much water, our loads upon leaving Ooldabinna were enormously heavy, and the weather became annoyingly hot just as we began our journey. . . .

On the 3rd of September we arrived, and were delighted to find that not only had the dam been replenished, but it was full to overflowing. A little water was actually visible in the lake-bed alongside of it, at the southern end, but it was unfit for drinking.

The little reservoir had now six feet of water in it; there was sufficient for all my expected requirements. The camels could drink at their ease and pleasure. The herbage and grass was more green and luxuriant than ever, and to my eyes it now appeared a far more pretty scene. There were the magenta-coloured vetch, the scarlet desert-pea, and numerous other leguminous plants, bushes and trees, of which the camels are so fond. . . . This little dam was situated in latitude 29° 19′ 4″, and longitude 128° 38′ 16″, showing that we had crossed the boundary line between the two colonies of South and Western Australia, the 129th meridian. I therefore called this the Boundary Dam. . . .

I had managed to penetrate this country up to the present point, and it was not to be wondered at if we all ardently longed for a change. Even a bare, boundless expanse of desert sand would be welcomed as an alternative to the dark and dreary scrubs that surrounded us. However, it appeared evident to me, as I had traversed nothing but scrubs for hundreds of miles from the east, and had found no water of any size whatever in all the distance I had yet come, that no waters really existed in this country, except an occasional native well or native dam, and those only at considerable distances apart. Concluding this to be the case, and my object being that the expedition should reach the city of Perth, I decided there was only one way to accomplish this — viz. to go thither, at any risk, and trust to Providence for an occasional supply of water here and there in the intermediate distance. I desired to make for a hill or mountain called Mount Churchman by Augustus Charles Gregory in 1846. I had no written record of water existing there, but my chart showed that Mount Churchman had been visited by two or three other travellers since that date, and it was presum-

'In Queen Victoria's Desert' — from Giles journal.

able that water did permanently exist there. The hill was, however, distant from this dam considerably over 600 miles in a straight line. . . . The last water we had met was over 150 miles away; the next might be double that distance. Having considered all these matters, I informed my officers and men that I had determined to push westward, without a thought of retreat . . . we must push through or die in the scrubs. . . .

I represented that we were probably in the worst desert upon the face of the earth, but that fact should give us all the more pleasure in conquering it. We were surrounded on all sides by dense scrubs, and the sooner we forced our way out of them the better. It was of course a desperate thing to do, and I believe very few people would or could rush madly into a totally unknown wilderness, where the nearest known water was 650 miles away. But I had sworn to go to Perth or die in the attempt, and I inspired the whole of my party with my own enthusiasm. . . .

On the 10th of September everything was ready, and I departed, declaring that —

> "Though the scrubs may range around me,
> My camel shall bear me on;
> Though the desert may surround me,
> It hath springs that shall be won."

Mounting my little fairy camel Reechy, I "whispered to her westward, westward, and with speed she darted onward". . . . Our course was therefore on a bearing of south 76° west; this left the line of salt lakes Alec Ross and I had formerly visited, and which lay west, on our right or northwards of us. Immediately after the start we entered thick scrubs as usual; they were mostly composed of the black oak, casuarina, with mulga and sandal-wood, not of commerce. . . .

It was evident that the regions we were traversing were utterly waterless, and in all the distance we had come in ten days, no spot had been found where water could lodge. It was totally uninhabited by either man or animal, not a track of a single marsupial, emu, or wild dog was to be seen, and we seemed to have penetrated into a region utterly unknown to man, and as utterly forsaken by God. We had now come 190 miles from water, and our prospects of obtaining any appeared more and more hopeless. . . . And now, when days had many of them passed away, and no places had been met where water was, the party presented a sad and solemn procession, as though each and all of us was stalking slowly onward to his tomb. . . . Whenever we camped, Saleh would stand before me, gaze fixedly into my face and generally say: "Mister Gile, when you get water?" I pretended to laugh at the idea, and say: "Water? pooh! there's no water in this country, Saleh . . .". When he found he couldn't get any satisfaction out of me he would begin to pray, and ask me which was the east. I would point south: down he would go on his knees, and abase himself in the sand, keeping his head in it for some time. . . .

On Saturday, the 25th of September, being the sixteenth day from the water at the Boundary Dam, we travelled twenty-seven miles, still on our course, through mallee and spinifex, pines, casuarinas, and quandong-trees, and noticed for the first time upon this expedition some very fine specimens of the Australian grass-tree, Xanthorrhœa; the giant mallee were also numerous. . . . We had come 323 miles without having seen a drop of water. There was silence and melancholy in the camp; and was it to be wondered at if, in such a region and under any circumstances, there was —

> "A load on each spirit, a cloud o'er each soul,
> With eyes than could scan not, our destiny's scroll."

Every man seemed to turn his eyes on me. I was the great centre of attraction. . . . Towards the line of dark sandhills, which formed the western horizon, was a great fall of country into a kind of hollow, and on the following morning, the seventeenth day from the dam, Mr. Tietkens appeared greatly impressed with the belief that we were in the neighbourhood of water. . . . Alec Ross and Peter Nicholls declared that they heard Tommy calling out "water!" I never will believe these things until they are proved, so I kept the party still going on. However, even I, soon ceased to doubt, for Tommy came rushing through the scrubs full gallop, and, between a scream and a howl, yelled out quite loud

enough now even for me to hear, "Water! water! plenty of water here! come on! come on! this way! this way! come on, Mr. Giles! mine been find 'em plenty water!". . . .

How much longer and farther the expedition could have gone on without water we were now saved the necessity of guessing, but this I may truly say, that Sir Thomas Elder's South Australian camels are second to none in the world for strength and endurance. . . . Mount Churchman, the place I was endeavouring to reach, was yet some 350 miles distant; this discovery, it was therefore evident, was the entire salvation of the whole party. . . .

Geographical features have been terribly scarce upon this expedition, and this peculiar spring is the first permanent water I have found. I have ventured to dedicate it to our most gracious Queen. The great desert in which I found it, and which will most probably extend to the west as far as it does to the east, I have also honoured with Her Majesty's mighty name, calling it the Great Victoria Desert, and the spring, Queen Victoria's Spring. In future times these may be celebrated localities in the British Monarch's dominions. . . . [Giles calculated that this spring was situated at latitude 30° 25' 30" S, longitude 123° 21' 13" E.]

While at this water we occasionally saw hawks, crows, corellas, a pink-feathered kind of cockatoo, and black magpies, which in some parts of the country are also called mutton birds, and pigeons. . . .

We had now been at this depot for nine days, and on the 6th of October we left it behind to the eastward, as we had done all the other resting-places we had found. I desired to go as straight as possible for Mount Churchman. . . .

The country of course was all scrubs and sandhills. . . . At twenty miles we actually sighted a low hill. . . .

From the summit of this little hill, the first I had met for nearly 800 miles — Mount Finke was the last — another low scrubby ridge lay to the westward, and nearly across our course, with salt lakes intervening, and others lying nearly all round the horizon. . . .

On the 9th and 10th October we had all scrubs; on the 11th, towards evening, we had some scrubby ridges in front of us, and we were again hemmed in by salt lakes. To save several miles of roundabout travelling, we attempted to cross one of these. . . . Unfortunately a number of the leading camels became apparently hopelessly embedded in a fearful bog, and we had great difficulty in getting then safely out. . . . We then had to carry out all their loads ourselves, and also the huge and weighty pack saddles. We found it no easy matter to carry 200 lbs., half a load — some of the water-casks weighed more — on our backs, when nearly up to our necks in the briny mud, on to the firm ground. [On 13 October, Tommy again found — at a native well — the first water since the 200 mile trek from Queen Victoria's Spring.]

Yesterday, the 15th October, Mr. Young managed to get the name of this

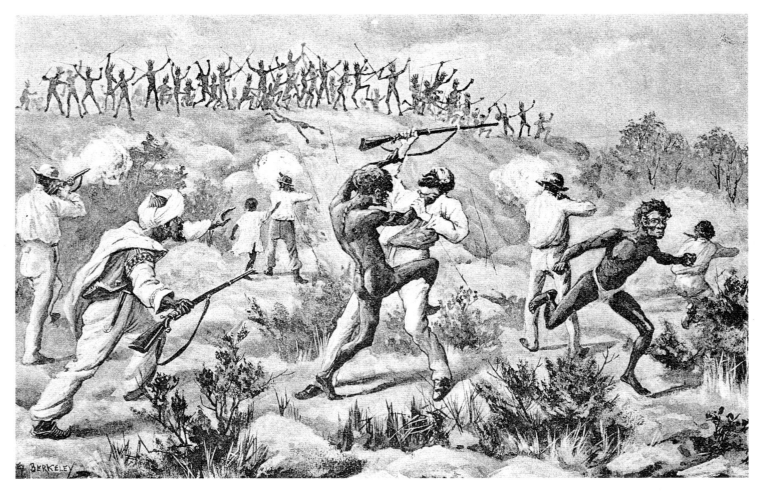

'Attack at Ularring' from Ernest Giles' Australia
Twice Traversed.

place from the natives. They call it Ularring, with the accent on the second
syllable. It is a great relief to my mind to get it, as it saves me the invidious task
of selecting only one name by which to call the place from the list of my
numerous friends. . . . What a delightful oasis in the desert to the weary traveller!
The elder aboriginals, though the words of their mouths were smoother than
butter, yet war was in their hearts. . . .

The 16th October, 1875, was drawing to a close, as all it predecessors from
time's remotest infancy have done; the cheery voice of the expedition cook had
called us to our evening meal; as usual we sat down in peaceful contentment,
not dreaming that death or danger was lurking near, but nevertheless, outside
this peaceful scene a mighty preparation for our destruction was being made by
an army of unseen and unsuspected foes.

> "The hunting tribes of air and earth
> Respect the brethren of their birth;
> Man only mars kind Nature's plan,
> And turns the fierce pursuit on man."

Our supper was spread, by chance or Providential interference, a little
earlier than usual. Mr. Young, having finished his meal first, had risen from his
seat. I happened to be the last at the festive board. In walking towards the place
where his bedding was spread upon the rocks, he saw close to him, but above
on the main rock, and about the level of his eyes, two unarmed natives making
signs to the two quiet and innoffensive ones that were in the camp, and instan-
taneously after he saw the front rank of a grand and imposing army approaching,
guided by the two scouts in advance. I had not much time to notice them in
detail, but I could see that these warriors were painted, feathered, and armed
to the teeth with spears, clubs, and other weapons, and that they were ready
for instant action. Mr. Young gave the alarm, and we had only just time to seize
our firearms when the whole army was upon us. At first glance this force was
most imposing; the coup d'œil was really magnificent; they looked like what I

'The First White Man Met in Western Australia'
— an engraving in Giles' journal.

should imagine a body of Comanche Indians would appear when ranged in battle line. The men were closely packed in serried ranks, and it was evident they formed a drilled and perfectly organised force. . . . One of the quiet and inoffensive spies in the camp, as soon as he saw me jump up and prepare for action, ran and jumped on me, put his arms around my neck to prevent my firing, and though we could not get a word of English out of him previously, when he did this, he called out, clinging on to me, with his hand on my throat, "Don't, don't!" . . . At last I disengaged myself, and he let go suddenly and slipped instantly behind one of the thick acacia bushes, and got away, just as the army in front was wavering. All this did not occupy many seconds of time, and I believe my final shot decided the battle. . . .

The following day was Sunday. What a scene our camp would have presented to-day had these reptiles murdered us! . . . We neither saw nor heard anything more of our sable enemies, and on the 18th we departed out of their coasts. . . .

Early on the morning of the 27th of October I stood upon the summit of Mount Churchman; and, though no mention whatever is made upon the chart of the existence of water there, we found a native well which supplied all our wants. In the afternoon some natives made their appearance; they were partly clothed. The party consisted of an oldish man, a very smart and good-looking youngfellow, and a handsome little boy. The young fellow said his own name was Charlie, the boy's Albert, and the older one's Billy. [Charlie] knew the country all the way to Perth, and also to Champion Bay. . . . He told me the nearest station to us was called Nyngham, Mount Singleton on the chart, in a north-west direction. . . .

[Early] on the 4th [November] we came upon an outlying sheep-station; its buildings consisting simply of a few bark-gunyahs. There was not even a single, rude hut in the dingle; blacks' and whites' gunyahs being all alike. Had I not seen some clothes, cooking utensils, &c., at one of them, I should have thought that only black shepherds lived there. A shallow well, and whip for raising the water

into a trough, was enclosed by a fence, and we watered our camels there. The sheep and shepherd were away, and although we were desperately hungry for meat, not having had any for a month, we prepared to wait until the shepherd should come home in the evening. While we were thinking over these matters, a white man came riding up. He apparently did not see us, nor did his horse either, until they were quite close; then his horse suddenly stopped and snorted, and he shouted out, "Holy sailor, what's that?" He was so extraordinarily surprised at the appearance of the caravan that he turned to gallop away. However, I walked to, and reassured him, and told him who I was and where I had come from. Of course he was an Irishman, and he said, "Is it South Austhralia yez come from? Shure I came from there meself. Did yez crass any say? I don't know, sure I came by Albany; I never came the way you've come at all. Shure, I wilcome yez, in the name of the whole colony". . . . And away he went, and soon returned with the shepherd, sheep, black assistants and their wives; and we very soon had a capital meal of excellent mutton.

Their progress was now easy, as they moved from sparse to closer settlement, and by the end of November they were on the outskirts of Perth. The whole caravan entered the city in what Giles described as regular desert-marching order. Fellow-explorer, John Forrest, was amongst those who went to meet them.

After traversing the long wooden causeway that bridges the Swan, we soon reached the city bounds, and were met by the Mayor, Mr. George Shenton, and the other members of the City Council, companies of volunteers lined the streets on either side, and the various bodies of Freemasons, Oddfellows, and Good Templars, accompanied by the brass band of the latter, took a part in the procession. A great crowd of citizens assembled, and the balconies of the houses on both sides were thronged with the fair sex, and garlands of flowers, were showered down upon us. . . .

After this a round of festivities set in; among these were a public banquet and ball in our honour by the Mayor and Corporation of the city of Perth and a dinner and ball at Government House. . . .

Crossing the Gibson Desert

After having crossed the unknown central interior, and having traversed such a terrible region to accomplish that feat, it might be reasonably supposed that my labours as an explorer would cease . . . but I regarded what had been done as only the half of my mission; and I was as anxious now to complete my work as I had been to commence it, when Sir Thomas Elder started me out. The remaining portion was no less than the completion of the line I had been compelled to leave unfinished by the untimely loss of Gibson, during my horse expedition of 1874. My readers will remember that, having pushed out west from my depot at Fort McKellar, in the Rawlinson Range, I had sighted another line of hills, which I had called the Alfred and Marie Range, and which I had been unable to reach. . . . That Gibson's Desert existed, well I knew; but how far west from the Rawlinson it actually extended, was the problem I now wished to solve. As Sir Thomas Elder allowed me carte blanche, I began a fresh journey with this object. . . .

Both my officers left for South Australia by the mail steamer. Mr. Tietkens was the more regretted. I did not wish him to leave, but he said he had private business to attend to. . . . The remainder of the party stayed until the 13th of January, 1876, when the caravan departed from Perth on its homeward route to South Australia, having a new line of unexplored country to traverse before we could reach our goal. My projected route was to lie nearly 400 miles to the north of the one by which I arrived; and upon leaving Perth we travelled up the country, through the settled districts, to Champion Bay, and thence to Mount Gould, close to the river Murchison. . . . [By 11 May, Giles was on the Ashburton River.] No traveller had ever reached so high a point up it previously; of course its flow was to the west. . . .

On the 13th of May we came to a very strange spot, where a number of

'Camp in the Desert' painted by S. T. Gill when accompanying an ill-fated journey to Spencer Gulf led by J. A. Horrocks in 1846.

whitish, flat-topped hills hemmed in the river, and where the conjunction of three or four other creeks occurred with the Ashburton, which now appeared to come from the south, its tributaries coming from the east and north-east. On the most northerly channel, Peter Nicholls shot a very large snake; it was nearly nine feet long, was a foot round the girth, and weighed nearly fifty pounds. It was a perfect monster for Australia. . . . I called this place the Grand Junction Depot, as the camp was not moved from there for thirteen days. . . .

I had hoped to discover some creeks or rivers that might carry me some distance farther eastward; but now it was evident they did not exist. I called this range, whose almost western end Alec ascended, Ophthalmia Range, in consequence of my suffering so much from that frightful malady. I could not take any observations, and I cannot be very certain where this range lies. . . . By careful estimate it was quite fair to assume that we had passed the Tropic of Capricorn by some miles, as my estimated latitude here was 23° 15′, and longitude about 119° 37′. . . .

This was the 18th of May, and though the winter season ought to have set in, and cool weather should have been experienced, yet we had nothing of the kind, but still had to swelter under the enervating rays of the burning sun of this shadeless land; and at night, a sleeping-place could only be obtained by removing stones, spinifex, and thorny vegetation from the ground. . . .

By the 29th, the river or creek-channel had become a mere thread; the hills were lowering, and the country in the glen outside was all stones and scrub. We camped at a small rain-water hole about a mile and a half from a bluff hill, from whose top, a few stunted gum-trees could be seen a little farther up the channel. Having now run the Ashburton up to its head, I could scarcely expect to find any more water before entering Gibson's Desert, which I felt sure commences here. . . . I was greatly disappointed to find that the Ashburton River did not exist for a greater distance eastwards than this, as when I first struck it, it seemed as though it would carry me to the eastwards for hundreds of miles. . . .

The morning of the 31st of May was again cold, the thermometer falling to 27°, and we had a sharp frost. . . .

The question which now arose was, what kind of country existed between us and my farthest watered point in 1874 at the Rawlinson Range? In a perfectly straight line it would be 450 miles. The latitude of this camp was 24° 16′ 6″. I called it the Red Ridge camp. Since my last attack of ophthalmia, I suffer great pain and confusion when using the sextant. . . . The desert had to be crossed, or at least attempted, even if it had been 1000 miles in extent; I therefore wasted no time in plunging into it, not delaying to encamp at this last rocky reservoir. . . . [There was now little for the camels to eat except a plant which made them sick and which Giles called Gyrostemon.]

On the 8th of June more camels were attacked, and it was impossible to get out of this horrible and poisonous region. The wretched country seems smothered with the poisonous plant. I dread the reappearance of every morning, for fear of fresh and fatal cases. . . .

The weather now is very variable. The thermometer indicated only 18° this morning, and we had thick ice in all the vessels that contained any water over-night; but in the middle of the day it was impossible to sit with comfort, except in the shade. The flies still swarmed in undiminished millions; there are also great numbers of the small and most annoying sand-flies, which, though almost too minute to be seen, have a marvellous power of making themselves felt. The well we put down was sunk in a rather large flat between the sandhills. The whole country is covered with spinifex in every direction, and this, together with the poisonous bushes and a few blood-wood-trees, forms the only vegetation. The pendulous fringe instead of leaves on the poison bush gives it a strange and weird appearance, and to us it always presents the hideous, and terrible form of a deadly Upas-tree. . . .

[18 June] The flies were still about us, in persecuting myriads. The nature of the country during this march was similar to that previously described, being quite open, it rolled along in ceaseless undulations of sand. The only vegetation besides the ever-abounding spinifex was a few blood-wood-trees on the tops of some of the red heaps of sand, with an occasional desert oak, an odd patch or clump of mallee-trees, standing desolately alone, and perhaps having a stunted specimen or two of the quandong or native peach-tree, and the dreaded Gyrostemon growing among them. The region is so desolate that it is horrifying even to describe. The eye of God looking down on the solitary caravan, as with its slow, and snake-like motion, it presents the only living object around, must have contemplated its appearance on such a scene with pitying admiration, as it forced its way continually on; onwards without pausing, over this vast sandy region, avoiding death only by motion and distance, until some oasis can be found. . . . [Giles was now approaching the Alfred and Marie Range and the familiar country of his 1873 expedition.]

At the northern end [of the Alfred and Marie Range] we came upon a small shallow kind of stony pan, where a little rain-water was yet lying, proving that the rains we had experienced in May, before leaving the western watershed, must have extended into the desert. We reached this drop of water on the 25th June, and the camels drank it all up while we rested on the 26th. After five days' more travelling over the same kind of desert as formerly described, except that the sand-mounds rose higher yet in front of us, still progressing eastwards, the well-remembered features of the Rawlinson Range and the terrible Mount Destruction rose at last upon my view. On reaching the range, I suppose I may say that the exploring part of my expedition was at an end, for I had twice traversed Australia. . . .

I have called my book The Romance of Exploration; the romance is in the chivalry of the achievement of difficult and dangerous, if not almost impossible, tasks. . . .

The history of Australian exploration, though not yet quite complete, is now so far advanced towards its end, that only minor details now are wanting, to fill the volume up; and though I shall not attempt to rank myself amongst the first or greatest, yet I think I have reason to call myself, the last of the Australian explorers.

List of Illustrations

Every effort has been made to trace copyright holders. Because of the nature of some original material this was not always possible.

Bibliography

Antill H. C., 'Journal of an excursion over the Blue or Western Mountains of New South Wales to visit a tract of newly discovered country, in company with His Excellency Governor and Mrs Macquarie, and a party of Gentlemen', in *Records of the Education Society*. Sydney, 1914.

Aurousseau M. (ed.), *The Letters of F. W. Ludwig Leichhardt*. 3 vols. Cambridge, 1968.

Baker J. N. L., *A History of Geographical Discovery and Exploration*. New York, 1967.

Beaglehole J. C. (ed.), *The Endeavour Journal of Joseph Banks 1768–1771*. Sydney, 1962.

Beale, Edgar, *Kennedy of Cape York*. Sydney, 1970.

Berry, Alexander, 'On the Geology of part of the Coast of New South Wales', in Barron Field, *Geographical Memoirs on New South Wales: by Various Hands. . . .* London, 1825.

Birman, Wendy and Bolton, Geoffrey, *Augustus Charles Gregory*. Melbourne, 1972.

Bland, W. (ed.), *Journey of Discovery to Port Phillip, New South Wales, by Messrs. W. H. Hovell and Hamilton Hume: in 1824 and 1825*. Sydney, 1831.

Blaxland, Gregory, *A Journal of a Tour of Discovery across the Blue Mountains in New South Wales*. London, 1823.

Bonwick, James, *Port Phillip Settlement*. London, 1883.

Bunce, Daniel, *Australasiatic Reminiscences of Twenty-three Years' Wanderings in Tasmania and the Australias; including Travels with Dr. Leichhardt in North or Tropical Australia*. Melbourne, 1857.

The Burke and Wills Exploring Expedition: an Account of the Crossing of the Continent of Australia, from Cooper's Creek to Carpentaria. Reprinted from *The Argus*. Melbourne, 1861.

'*Progress Reports and Final Reports of the Exploration Committee*'. Royal Society of Victoria. Melbourne, 1863. [Refers to Burke and Wills].

Byerley, Frederick J. (ed.), *Narrative of the Overland Expedition of the Messrs. Jardine, from Rockhampton to Cape York, Northern Queensland*. Brisbane, 1867.

Calvert, Albert, *The Exploration of Australia*. 2 vols. London, 1895/6.

Carron, Wm. (ed.), *Narrative of an Expedition undertaken under the Direction of the late Mr. Assistant Surveyor E. B. Kennedy, for the Exploration of the Country Lying Between Rockingham Bay and Cape York*. Sydney, 1849.

Chisholm, Alec H., *Strange New World The Adventures of John Gilbert and Ludwig Leichhardt*. Sydney, 1941.

A Narrative of Proceedings of William Cox Esq. — of Clarendon . . . in Constructing a Road from Capt. Woodriffe's farm on the Nepean River, opposite Emu Plains over the Blue Mountains, and from thence to Bathurst Plains, on the Banks of the Macquarie River in the years 1814 and 1815, n.d., National Library of Australia Pamphlets, Vol. 9.

Crowley, F. K., *Forrest 1847–1918. Volume 1, 1847–91. Apprenticeship to Premiership*. Queensland, 1971.

Cumpston, J. H. L., *Augustus Gregory and his Inland Sea*. Canberra, 1972.

Cumpston, J. H. L., *Charles Sturt His Life and Journeys of Exploration*. Melbourne, 1951.

Cumpston, J. H. L., *The Inland Sea and the Great River The Story of Australian Exploration*. Sydney, 1964.

Cumpston, J. H. L., *Thomas Mitchell Surveyor General & Explorer*. London, 1954.

Cunningham, Allan, 'Brief View of the Progress of Interior Discovery in New South Wales', in *The Journal of the Royal Geographical Society of London*, 1832.

Cunningham, Allan, 'Journal of a Route from Liverpool Plains, in New South Wales', in Barron Field, *Geographical Memoirs*.

Currie, Mark John, 'Journal of an Excursion to the Southward of Lake George in New South Wales', in Barron Field, *Geographical Memoirs*.

Dampier, William, *A Voyage to New-Holland, &c. In the Year, 1699*. London, 1709.

Darwin, Charles, *Journal of Researches into the Geology and Natural History of the Various Countries visited by H.M.S. Beagle, under the command of Captain Fitzroy, R.N. from 1832 to 1836*. London, 1839.

Davis, John (ed. William Westgarth), *Tracks of McKinlay and Party Across Australia*. London, 1863.

Dunlop, Eric, *John Oxley*. Melbourne, 1960.

Dutton, Geoffrey, *Australia's Last Explorer: Ernest Giles*. London, 1970.

Dutton, Geoffrey, *The Hero as Murderer. The Life of Edward John Eyre*. Melbourne, 1967.

Eden, Charles H., *Australia's Heroes. . . .* London, c. 1874.

Erdos, Renée, *Ludwig Leichhardt*. Melbourne, 1963.

The journals of G. W. Evans are to be found in *Historical Records of Australia*. Series 1, Volume VIII, Sydney, 1916.

Eyre, Edward John, *Journals of Expeditions of Discovery into Central Australia, and Overland from Adelaide to King George's Sound, in the Years 1840–1*. London, 1845.

Favenc, Ernest, *The History of Australian Exploration From 1788 to 1888*. Sydney, 1888.

Feeken, Erwin H. J., Feeken, Gerda E. E., and Spate, O. H. K., *The Discovery and Exploration of Australia*. Melbourne, 1970.

Fitzpatrick, Kathleen, *Australian Explorers. A Selection from their Writings with an Introduction*. London, 1958.

Flinders, Matthew, *A Voyage to Terra Australis*. London, 1814.

Forrest, Alex., 'Journal of Expedition from deGrey to Port Darwin', in *Western Australian Parliamentary Papers*, No. 3. 1880.

Forrest, John, *Explorations in Australia: I. — Explorations in search of Dr. Leichardt and party. II. — From Perth to Adelaide, around the Great Australian Bight. III. — From Champion Bay, across the desert to the Telegraph and to Adelaide*. London, 1875.

Gardiner, Lyndsay, *Thomas Mitchell*. Melbourne, 1962.

Giles, Ernest, *Australia Twice Traversed: The Romance of Exploration, being a Narrative Compiled from the Journals of Five Exploring Expeditions into and through Central South Australia, and Western Australia, From 1872 to 1876*. London, 1889.

Giles, Ernest, *Geographic Travels in Central Australia From 1872 to 1874*. Melbourne, 1875.

Giles, Ernest, *The Journal of a Forgotten Expedition*. Adelaide, 1880.

'Report by Count Streleski', in 'Copy of a Despatch from Sir G. Gipps, Governor of New South Wales, to the Secretary of State for the Colonies, transmitting a report of the progressive Discovery and Occupation of that Colony during the Period of Administration of the Government'. *House of Commons Papers*, Volume XVII, 1841.

'Report and Diary of Mr. W. C. Gosse's Central and Western Exploring Expedition, 1873', in *South Australian Parliamentary Papers*, No. 48. 1874.

Green, Louis, *Ernest Giles*. London, 1963.

Gregory, Augustus Charles and Francis Thomas, *Journals of Australian Explorations*. Brisbane, 1884.

Grey, George, *Journals of Two Expeditions of Discovery in North-west and Western Australia, during the years 1837, 38, and 39, under the authority of Her Majesty's Government describing many newly discovered, important, and fertile districts, with observations on the moral and physical condition of the aboriginal inhabitants, &c. &c.*, London, 1841.

Grimm, George, *The Australian Explorers. Their Labours, Perils, and Achievements being a Narrative of Discovery from the Landing of Captain Cook to the Centennial Year*. Sydney, 1888.

Hancock, W. K., *Australia*. Sydney, 1945.

Hardman, William (ed.), *The Journals of John McDouall Stuart during the years 1858, 1859, 1860, 1861, & 1862, when he Fixed the Centre of the Continent and Successfully Crossed it from Sea to Sea*. London, 1865.

Hawdon, Joseph, *The Journal of a Journey from New South Wales to Adelaide*. Melbourne, 1952.

Historical Records of Australia. Series I, Vol. XIII, Sydney, 1920; Vol XVI, Sydney, 1923.

Howitt, William. *The History of Discovery in Australia, Tasmania and New Zealand from the Earliest Date to the Present Day*. 2 vols. London, 1865.

Hume, Hamilton, *The Life of Edward John Eyre, late Governor of Jamaica*. London, 1867.

Hyde, Victor, *Gregory Blaxland*. Melbourne, 1958.

Jackson, Andrew, *Robert O'Hara Burke and the Australian Exploring Expedition of 1860*. London, 1862.

Joy, William, *The Explorers*. Adelaide, 1964.

Kennedy, Donald, *Charles Sturt*. Melbourne, 1958.

Kennedy, E. B., 'Extracts from the Journal of an exploring Expedition into Central Australia, to determine the Course of the River Barcoo (or the Victoria of Sir T. L. Mitchell)', in *The Journal of the Royal Geographical Society of London*. London, 1852.

King, Phillip P., *Narrative of a Survey of the Intertropical and Western Coasts of Australia. Performed Between the Years 1818 and 1822*. London, 1827.

Journal of Landsborough's Expedition from Carpentaria, in Search of Burke & Wills. Melbourne, 1862.

Lee, Ida (ed.), *Early Explorers in Australia. From the Log-books and Journals: including the Diary of Allan Cunningham, Botanist, from March 1, 1817, to November 19, 1818*. London, 1925.

Leichhardt, Ludwig, *Journal of an Overland Expedition in Australia, from Moreton Bay to Port Essington, a distance of upwards of 3000 miles, during the Years 1844–1845*. London, 1847.

Lhotsky, John, *A Journey from Sydney to the Australian Alps, undertaken in the months of January, February, and March, 1834. Being an account of the geographical & natural relation of the country traversed, its aborigines &c. together with some general information respecting the colony of New South Wales*. Sydney, 1835.

Lord, W. B. and Baines, T., *Shifts and Expedients of Camp Life, Travel, and Exploration*. London, 1871.

McKinlay's Journal of Exploration in the Interior of Australia (Burke Relief Expedition). Melbourne, [1862?].

Memorandum of Trip by A. McMillan, from Maneroo District, in the Year 1839, to the South-West of that District, towards the Sea-coast in Search of New Country, in Thomas Francis Bride, *Letters from Victorian Pioneers. A Series of Papers on the early Occupation of the Colony, the Aborigines, etc*. Melbourne, 1898.

Macquarie, Lachlan, *Journals of his Tours in New South Wales and Van Diemen's Land 1810–1822*. Sydney, 1956.

Malte-Brun, Conrad, *Annales des Voyages, de la Géographie, et de l'Histoire*. Paris, 1809–14.

Mann, John F., *Eight Months with Dr. Leichhardt in the Years 1846–47*. Sydney, 1888.

Maslen, T. J., (ascribed to) *The Friend of Australia; or, A Plan for Exploring the Interior and for carrying on a survey of the whole continent of Australia*. London, 1830.

Mitchell, Sir T. L., *Journal of an Expedition into the Interior of Tropical Australia, in Search of a Route from Sydney to the Gulf of Carpentaria*. London, 1848.

Mitchell, T. L., *Three Expeditions into the Interior of Eastern Australia: with descriptions of the recently explored region of Australia Felix, and of the present colony of New South Wales*. London, 1839.

Moorehead, Alan, *Cooper's Creek*. London, 1963.

National Library of Australia. Exploration Box 4.

'Discovery of Lake Warrewaa', National Library of Australia Pamphlets, Vol. 297.

Oxley, John, *Journals of Two Expeditions into the Inteior of New South Wales, undertaken by order of the British Government in the years 1817–18*. London, 1820.

Pike, Douglas, *John McDouall Stuart*. Melbourne, 1958.

Prest, Jean, *Hamilton Hume and William Hovell*. Melbourne, 1963.

Roe, J. S., 'Report of an Expedition under the Surveyor-General, Mr. J. S. Roe, to the South-Eastward of Perth, in Western Australia, between the months of September, 1848, and February, 1849 to the Hon. the Colonial Secretary', in *The Journal of the Royal Geographical Society of London*. London, 1852.

Russell, Henry Stuart, *The Genesis of Queensland: an account of the First Exploring Journeys to and over Darling Downs: . . .* Sydney, 1888.

Scott, Ernest, *Australian Discovery by Land*. London, 1929.

Scott, Ernest, 'The Exploration of Australia, 1813–1865,' in *Cambridge History of the British Empire*, Vol. 7, Part 1. Cambridge, 1933.

Scott, G. Firth, *The Romance of Australian Exploring*. London, 1899.

Sharp, Andrew, *The Discovery of Australia*. Oxford, 1963.

Stokes, J. Lort, *Discoveries in Australia; with an account of the coasts and rivers explored and surveyed during the voyage of H.M.S. Beagle, in the years 1837–38–39–40–41–42–43. By command of the Lords Commissioners of the Admiralty. Also a narrative of Captain Owen Stanley's visits to the Arafūa Sea*. London, 1846.

Sturt, Charles, *Narrative of an Expedition into Central Australia, performed under the Authority of Her Majesty's Government, during the years 1844, 5, and 6 together with a Notice of the Province of South Australia, in 1847*. London, 1849.

Sturt, Charles, *Two Expeditions into the Interior of Southern Australia, during the years 1828, 1829, 1830, and 1831: with Observations on the Soil, Climate, and General Resources of the Colony of New South Wales*. London, 1833.

Charles Throsby's letter recounting his excursion south of Lake George, in *The Australian Magazine; or Compendium of Religious, Literary, and Miscellaneous Intelligence*. Sydney, 1821.

Uren, Malcolm, *Edward John Eyre*. London, 1964.

'Journal of Mr. WALKER, from the day he left Macintosh's Station on the Nogoa, to that of his arrival at the Albert River, Gulf of Carpentaria', in *The Journal of the Royal Geographical Society*. London, 1863.

Warburton, Peter Egerton, *Journey Across the Western Interior of Australia with an Introduction and Additions*. London, 1875.

Weatherburn, A. K., *George William Evans Explorer*. Sydney, 1966.

Webster, Mona Stuart, *John McDouall Stuart*. Melbourne, 1958.

Wentworth, W. C., *A Statistical, Historical and Political Description of The Colony of New South Wales and Its dependent Settlements in Van Diemen's Land: With a Particular Enumeration of the Advantages which these Colonies offer for Emigration and their Superiority in many Respects over those Possessed in the United States of America*. London, 1819.

Journals of Several Expeditions made in Western Australia, during the years 1829, 1830, 1831, and 1832; under the sanction of the Governor, Sir James Stirling, containing the latest authentic information relative to that country, Accompanied by a Map. London, 1833.

White, Patrick, *Voss*. London, 1957.

Williams, Gwenneth, *South Australian Exploration to 1856*. Adelaide, 1919.

Wills, William (ed.), *A Successful Exploration through the Interior of Australia, from Melbourne to the Gulf of Carpentaria. From the Journals and Letters of William John Wills*. London, 1863.

Woods, Rev. Julian E. Tenison, *A History of the Discovery and Exploration of Australia, . . .* 2 vols. London, 1865.

SELECT BIBLIOGRAPHY

Australian Encyclopedia, 12 vols. Sydney, 1983. (Article on exploration by land and entries under names of individual explorers.)

Australian Dictionary of Biography. Entries under names of individual explorers.

Index

The index covers people, places, ships and subjects mentioned in the text and in the captions to pictures and maps.
All references are to page numbers. Page numbers in **bold type** indicate the major treatment of a subject. Page numbers in *small italic type* indicate pictures or maps.
All Australian places mentioned in the text are indexed, except for Sydney and the names of colonies, states and territories (except Tasmania).
To aid identification of each place, the name of the state or territory in which it is now located is given in brackets.
The index entries are arranged in alphabetical order, word by word.
Names of persons come before places with the same name, e.g. Wentworth, W.C. precedes Wentworth (N.S.W.).

C